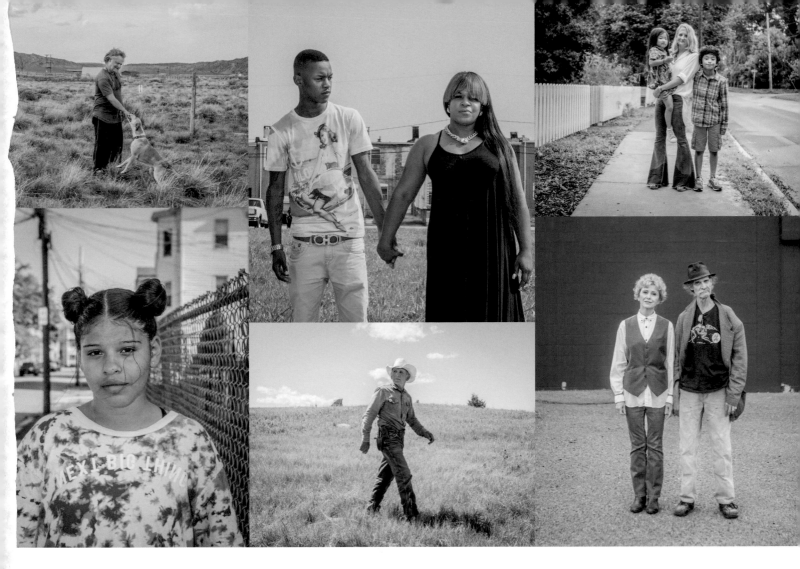

American
Dreams

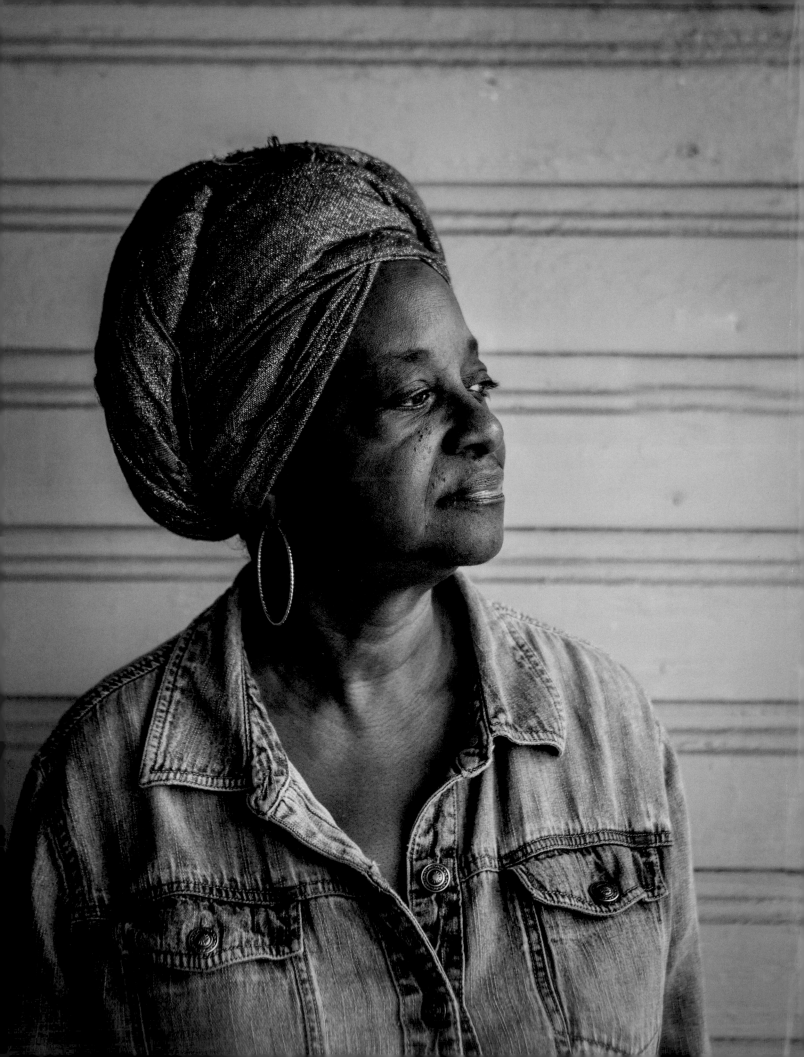

American Dreams

Portraits & stories of a country

Ian Brown

TEN SPEED PRESS
California | New York

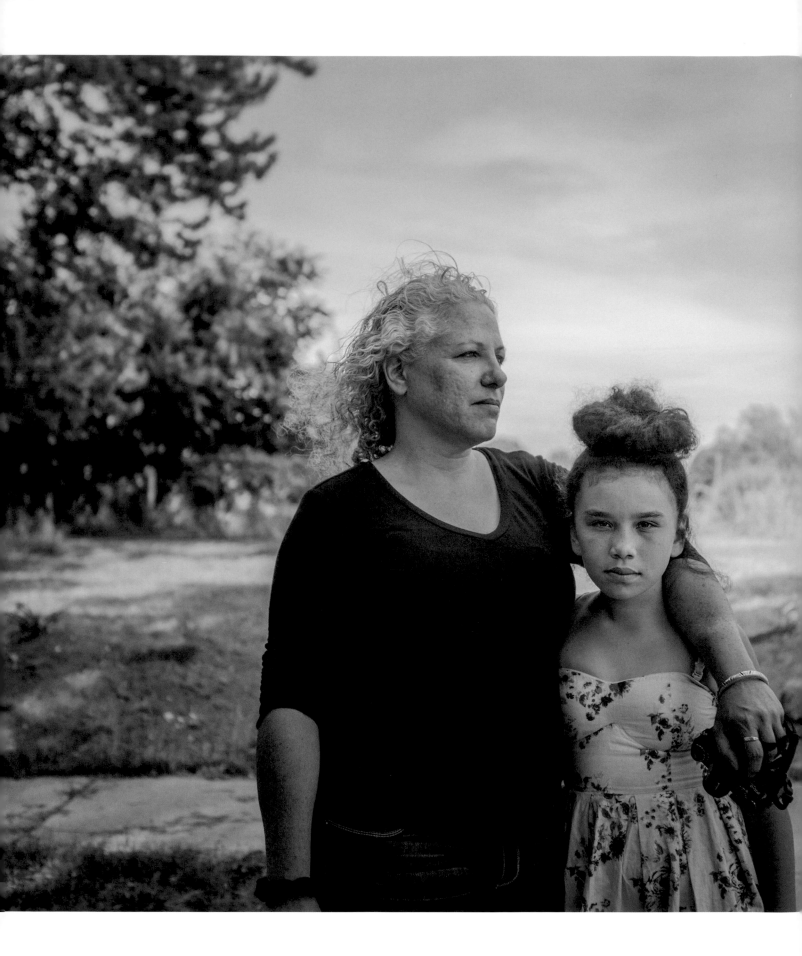

Contents

Introduction

I still remember the voice, booming and sure, with an accent that was different from any I'd heard before. "Headed north," it said. "Goin' to see snow."

It was the summer of 1979, and I was on my annual summer visit with my grandparents. We had stopped to fill up on gas on the way to the quaint Canadian town of Lakefield, Ontario. My sister and I loved these forays into simple country life, where we had a ritual of getting ice cream and eating it at the bakery or by the lake. It was a typical Ontario summer day: hot, sticky, and humid, with the sound of cicadas singing and the hum of lawn mowers in the air.

I couldn't see the expression on my grandfather's face from my spot in the back seat of his yellow 1976 Dodge Aries, but I imagine him smiling broadly as he responded. "Snow? You'll be driving for quite a while until that happens."

I strained to look out the window and observe the man with the booming voice—he was very large and stood beside a big car with a back seat full of kids and a trunk packed with bags and suitcases. After a few minutes of pleasant conversation, my grandfather got back in the car and we headed into town. He explained that the loud-voiced guy was an American from somewhere "down South" who had packed up his family to drive north to Canada—in the summer, no less—to see snow.

Granted, the internet hadn't yet been invented, so it's not as if the man could have googled it. But it was the late 1970s, so maps, books, newspapers, and television all did exist. And even though I was only in grade school, it seemed wildly presumptuous—and maybe even a little ignorant—to think that there would be snow in Ontario in the summer.

As we pulled up to the Lakefield bakery to get ice cream, my grandparents shared a good laugh. "Americans!" they said knowingly to each other.

The encounter with the loud man was the first time I understood that Americans were different. The voice, the tone, the accent, and the sureness with which he spoke made an impression on me. This man was certain that he was going to see snow, and he was willing to disregard the fact that he was sweating, the asphalt was searing hot, and the grass was brown. It was so intriguing, and made Americans seem particularly interesting to me. Who were they?

As the northern neighbor of the world's most powerful country, Canada has a unique perspective on the United States. As former Prime Minister Pierre Trudeau said in 1969, "Living next to you is in some ways like sleeping with an elephant. No matter how friendly and even-tempered the beast, if I can call it that, one is affected by every twitch and grunt."

The majority of Canada's thirty-seven million people live within a hundred miles of the US border. We have all the same news sources, for the most part (Canada has their own stations, of course, but we tend to get our news from global sources), and anyone who grew up (as I did) in the 1970s and '80s watched more American TV channels than Canadian ones. Living in Toronto, we got our US news feeds from Buffalo, New York. There was always something strangely fascinating about the number of fires and snowstorms that

seemed to be reported on the Buffalo news. And Buffalo sports coverage was mostly about American football, while ours was mostly about hockey.

When President Reagan was shot in March 1981, I was thirteen years old, sitting on the living room carpet with my mom in an anxious hush, listening to the breaking news on the radio. It was around that time that I started to become aware that there were things going on in America that had little bearing on us in Canada. I also recognized that not much that happened in my country had much relevance in America. It was as if the border—only an hour and a half away from where I lived—was not just a boundary that separated the two countries, but a demarcation line that separated cultures and ideals. "Cross the border and it's instantly different," I recall people saying about visiting America.

My own travels to the United States when I was growing up mostly consisted of trips to Florida in the winter to visit relatives. We would fly down for school break and spend the majority of our time at the pool in a mobile-home complex of retired "snowbirds." Up until then, I hadn't really spent much time on the ground in America. My impression of the American landscape was formed from looking out the window of an airplane, and from watching movies and television, like much of the rest of the world.

As I grew older, I began to travel more. I spent a summer backpacking across Europe with virtually no money. I went back with even less money the following year, doing what was essentially a version of homeless traveling. Distance offers clarity, and each time I returned home, I felt acutely aware of the subtle differences that every culture and place present. Travel gave me an understanding of the ways in which we believe *our* circumstances and *our* way of life to be our "normal," and how being exposed to different ways of being inevitably grows our capacity for empathy and compassion.

Sometime in the mid-'90s, while I was in my twenties, I ended up on a road trip through some of the Rust Belt towns of northern Pennsylvania and Ohio. Even then, it was evident that the manufacturing prowess of these towns was in decline. As we drove, I became increasingly distressed—I hadn't imagined that there would be so many boarded-up shops, so many junked cars left to rot in fields. There was an edge, a sense of despair that I hadn't thought I'd see in America. And yet, a few minutes' drive from some of the blighted sites, we'd pass through a prosperous-looking strip of stores, then enclaves of huge, beautiful homes. The whole tableau would repeat itself again—areas of obvious struggle and decay abutting areas of prosperity and affluence. The disparity was striking.

Around the time of the 2000 American presidential election, I began to notice how the "American Dream" seemed to be referenced more frequently by politicians and the media. Think pieces questioned whether the American Dream was dead, politicians expressed hope for the reemergence of the American Dream, and advertisers and mortgage lenders sold things to people using their idea of the American Dream.

This idea of the American Dream has always been rooted in the fundamental mythology of American culture, despite the fact that it's not written into the Constitution or any other important founding document. And, true to the mythological nature of the concept, it doesn't have any one definition. At its most basic, the American Dream is understood to be the idea that if a person works hard enough, they'll have an opportunity to better their life. Author James Truslow Adams was one of the first writers to popularize the phrase in his 1931 book, *The Epic of America:*

But there has been also the American dream, that dream of a land in which life should be better and richer and fuller for every man, with opportunity for each according to his ability or achievement.

Though it hasn't been formalized or legally encoded in any way, the American Dream is something that many people believe in, and that people around the world have heard referenced, whether or not they have ever set foot in the United States. Every American has, at some point, learned about the opportunity to live the American Dream, and likely grew up hearing that America is the greatest country on earth. Former vice president Dick Cheney wrote of America in his memoir: "We are, as a matter of empirical fact and undeniable history, the greatest force for good the world has ever known."

The premise that a whole nation could be persuaded by the promise of a shared dream intrigued me. As a photographer interested in the human condition, I was taken by the idea that a model of success could be shared by—or imposed upon—the citizens of a whole country. It seemed like a really fuzzy concept to me, this idea that America, over any other country, is the best place to achieve your dreams. People all over the world aspire to build better lives for themselves and their families. But no one's ever heard of the "British Dream" or the "Japanese Dream" or the "Canadian Dream" . . . It's such a distinctly American idea, this notion that has been so tightly woven into the fabric of the national psyche, despite the distance between the mythology of the dream and reality for most Americans. Even in the richest and most powerful country on earth, there is such an abrupt division between wealth and struggle, and such a wide spectrum of deeply held ideals. The expectations, the hope, and the irony built into the American Dream became completely fascinating.

In 2005, as the United States approached another presidential election, it seemed to me, from my vantage point as an interested but impartial observer, that America was coming to a crossroads. People were unsure about where the country was going, and, more important, where they *wanted* it to go. Americans were divided, assigned into opposing factions. And just as they held differing views on the best direction for the country, they also couldn't agree on what factors made someone a "real" American, with each side claiming ownership of the true definition. The mood was abrasive, and the American electorate was more divided, partisan, and vitriolic than ever before. And what of the American Dream? Was it still alive, and if so, what did it mean to people in this fractured political and cultural landscape?

I figured the best way to get answers was not to read books or listen to pundits, but to get out on the road and ask everyday Americans, on the ground, what they thought about it. What would people say if they were asked to share their own feelings about their country, their future, and the American Dream? How would different people define that dream?

So, in early 2006, I got in my truck—a beat-up 1988 Toyota Land Cruiser that I'd salvaged from a farmer's field—and, along with my dog, Duncan, set out to do a road trip through the United States. My goal was to meet and photograph people, and ask them a simple question: "What is your American Dream?"

At first, it didn't go so well.

I drove across several states, and while I did manage to meet some interesting people, most didn't have a good answer when I asked them what their American Dream was. Put on the spot, they tensed up, and you could see it in their portraits. Folks became reluctant to introduce me to other people I might photograph, and, in general, the whole thing felt like perhaps it was too broad and ambitious of a project. I began to think that maybe the American Dream was not actually something most Americans thought or cared about, or at least, not something they wanted to discuss with an outsider like me. After a few weeks on the road, I decided to return home, and shelved the project, unsure if I would return to it.

Life went on: I had to earn money, deal with family responsibilities, and I was asked to work on a photography project in Africa. Still, I found myself continuing to think about the American Dream and wondering why my attempt to understand and document the idea didn't work as I hoped it would. Maybe there was a way to combine the written word with the immersive quality of still portraits?

I'd been enamored with photography since a young age, and had never lost the sense of wonder over this magical invention—the camera—that allowed you to record a moment in time with the simple push of a button. In my late teens, I was diagnosed with cancer. After completing treatment, I had a few months of recovery ahead of me, and I spent time investigating photography and cameras, experimenting and trying to take photos. In the era of film, I learned quickly the idea that every exposure was important and needed to count. I also began researching photographers. One of the first images that particularly resonated with me was Henri Cartier-Bresson's *Behind the Gare Saint-Lazare*—a famous 1932 photograph of a Parisian man jumping over a puddle. In the black-and-white image, the man's heel is about to touch the water as he leaps through the air, in what Cartier-Bresson termed the "decisive moment." This had a profound impact on me as, for the first time, I realized the power of photography to make the viewer stop and consider a moment, to appraise and contemplate.

And just as photography can be a powerful storytelling tool, it also offers a unique perspective as a currency between people, a way to connect on a deeper level by creating a shared experience. Through my early photography projects, I developed an understanding of the value of respect and intention, of being invited into people's lives. Photographing someone can be a very intimate experience, and there's a level of trust that should be honored.

After that first trip to the United States to begin this photography project was a bust, I realized that it's one thing to arbitrarily approach people and ask to take their portrait (some people agree and some don't), but it's entirely different to ask to photograph them *and* ask them to share their most heartfelt and intimate thoughts on their life and the fundamental promise of their country. It was at this point that the gravity of this project set in: If I was going to do this work justice, I'd need to make real connections with people from across the United States. It would be a long and epic undertaking, requiring my time and energy to figure it out.

So, a few months after my first failed attempt, I set out again—this time in Pennsylvania and then upstate New York—to connect with people and learn about their American Dream. I soon recognized that it would be more meaningful to ask people to *write down* their American Dream, or what the American Dream meant to them, on a piece of paper, in their own handwriting, and their own words. I didn't want to impose any restrictions, so each person was free to write whatever they wanted.

The work developed at a slow and steady pace: I knew some people who knew some people who I might be able to visit and photograph. I did research and I blindly reached out to other folks. I met people in local diners, outside post offices, and in the parking lots of small factories. I slept in my car or camped. I drove down roads in rural areas, not really knowing who I would meet. I tried to explain what I was doing and then asked if I could take a portrait of them and whether they'd write about their American Dream. I didn't know how people would react or what to expect. It's nerve-racking to walk up to a complete stranger and ask to take a picture of them.

And then something kind of remarkable happened.

People actually *wanted* to write something down. Not everyone—but some people agreed to take a moment to write a few words. Other people invited me to come back to their homes, to talk more about it. Neighbors came over or friends showed up, and there were discussions and arguments and laughter. People reflected, and more than a few confided that this was the first time in their lives they'd really considered what the American Dream meant to them. Some people broke down and wept while they reflected on their lives. Others were proud to recall their achievements. Many people spoke about their fears about where their country was headed. A few teachers asked their students to participate in the project and revealed how engaged the kids were in thinking about their own futures. People seemed moved to share their lives and tell their stories.

One early experience solidified in my mind the importance and relevance of what this project could be. I visited New York City in 2007 and was connected with a variety of people, including Soo Chung (page 141), a single woman in her twenties, and Gerald Nelson (page 262), a retired gentleman living across from an auto garage in the South Bronx. I reached out to them, explained the idea for the project, and asked if they would be willing to write down their thoughts on the American Dream. It was a sweltering summer day; I met Soo in the morning on the East Side of Manhattan, and I met Gerald later that same afternoon. In both cases, it was my first time meeting them.

Soo and I talked about her life. The daughter of Korean immigrants, she had done volunteer work overseas and was trying to figure out her next steps, what she wanted for her career and her life. She wrote a page on her American Dream, and when I read it, I realized how intimate and important this whole concept was to her. The last line of her piece really hit me: "It's my American Dream to build the home I never had."

A few hours later, I knocked on the door of Gerald's small apartment. We ate lunch at a local diner by the elevated subway track and talked about life in New York. He was so happy to share details about his bowling league and his time as an auxiliary police officer. He told me about his youth and about moving to New York from Trinidad as a young man, not knowing how things would unfold in his new city and country. Most of all, he was proud of his kids, and he spoke warmly of them. We walked around his neighborhood and spent some time taking photos across the street from his home. He had written his American Dream on yellow legal paper and explained that he'd had his sister proofread it. After seeing his spelling mistakes, he took care to white out the errors and rewrite over the top. As I was leaving, we shook hands and hugged, and I thanked him for being involved in the project. He got quite emotional and said, "Thank you for listening to my story. I'm just a simple man living alone in the Bronx."

Around this time, in the lead-up to Barack Obama's historic presidential election in 2008, there was a sense of the country being on the advent of a transformational period. For some, it really did feel like the United States was on the cusp of change. Many people were engaged and enthusiastic about the prospects of the coming time. Others did not feel hopeful about the change to come. There was possibility, but there was also friction.

Since then, I've witnessed an acute shift in how people from across America view their country, and it goes beyond just conservative versus progressive. The divide is greater now than ever before, and the very definition of what makes an "American" is being challenged in profound ways. A perfect storm of influences has upended American society, and issues such as equality, civil rights, immigration, gun control, abortion, religious freedom, and climate change have created a rancorous and divisive political and cultural environment. The great "unwinding" outlined by the *New Yorker* journalist George Packer in his 2013 book has enveloped America and, indeed, the world, in a sense of unease and uncertainty.

At the heart of this unraveling is the very notion of what America is and what being an American means. The epic, mythological ideal at the core of American identity—freedom—is being interpreted in opposing manners. The pillars of democracy that the nation was built on—equity, representation, justice—are being confronted in new and ever more serious ways. In the face of this confrontation, this project seeks to understand: Is the American Dream still alive? And, if it is, what does it mean?

Since that day in New York, meeting and photographing Soo and Gerald, I have spent the intervening decade seeking out and taking the opportunity to hear and share in people's stories. I've traveled more than eighty thousand miles across America, I've gone to every state, and I've photographed hundreds of people from all walks of life—from the one percent to the poorest and those who live in between. All of these people are everyday Americans who don't often get asked to tell their stories or talk about their dreams.

Through conversations on front porches and at kitchen tables, people have described and written down some of their most intimate feelings about their own lives and what it means to them to be an American. People have shared profound and personal things, things they hadn't really told anyone else, and things that they hadn't ever deeply considered. Some told stories of their struggles, some wrote about their hopes and dreams, and others wrote about their own anxieties and misgivings. They wrote about their towns, their wishes for their kids, and their fears. Their stories were heartbreaking, provocative, inspiring, beautiful, compelling, and often raw—much like America itself.

What has become evident to me is that the American Dream offers a unique tether to each and every person throughout the country. It transcends political, cultural, religious, and economic divides. The Dream can be made more difficult to achieve, but it can never be taken away or denied. It exists both as a universal idea and as something deeply personal. It's the common thread and the equalizer for each and every person across America. It's available to anyone who wants it, anyone who dreams it up for themselves and makes it their own.

Our "American Dream" is to live free from the frivolous needs of society. Break away from the hypocrisy and practice a life of self sufficientcy. Give up on the gridlock of everday strife and make everday matter by experiencing.

Life...

Bethlyn and Nick, *Stinson Beach, California, photographed in 2007*
Bethlyn and Nick now live in Salt Lake City, Utah.

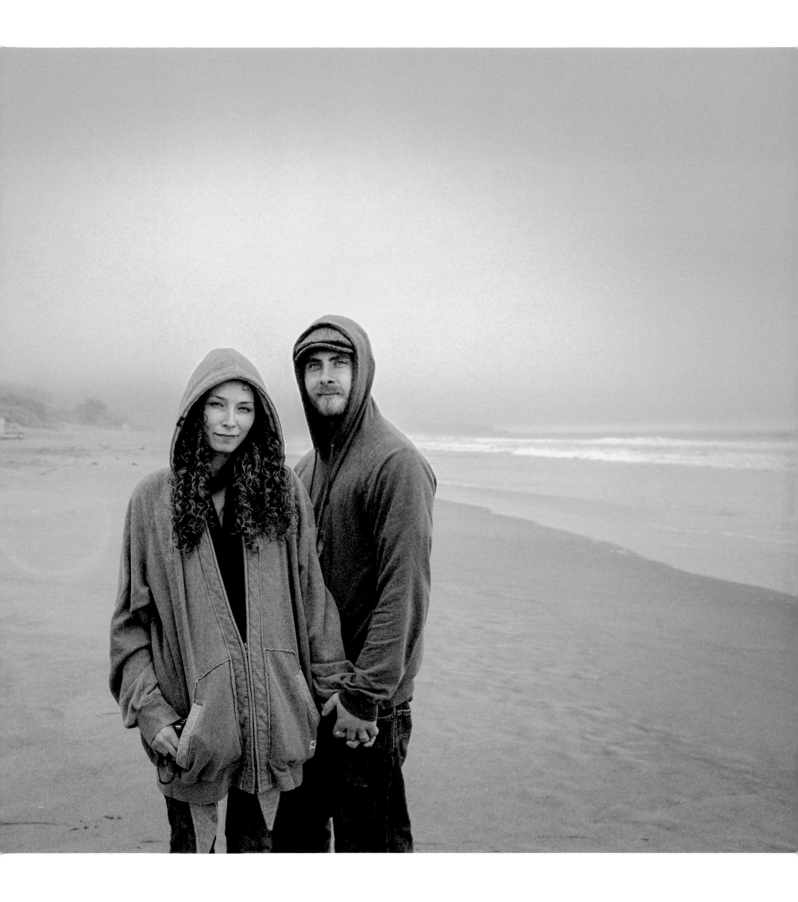

My American Dream

~~College education~~

~~$ $ $ $~~

~~Homeownership (white picket fence + outdoor pool)~~

~~Beamer or Benz~~

~~Investment Portfolio~~

~~Travel~~

~~Marriage (Idris Elba preferred)~~

~~Equal Rights~~

~~Start a Business~~

~~Vacation Home (Italy?)~~

~~Friends in high places~~

~~Love. Peace + Soul!~~

Aid American dreamers in achieving
their American dream. Make a contribution
to humanity. Live + let live. Poems.
Oh, and clean water for my city,
my children, and myself.

Qiana Towns, *Flint, Michigan, photographed in 2015*
Qiana holds an MFA in poetry and is a lifelong resident of Flint.

I have always been a "pusher." Testing my limits: physical pain, tolerance, and mental strength. When someone tells me NO, how can I turn that into YES? Someone sees all black but I see a smidge of white, how can I show them. Challenges entice me. No one governs your capabilities other than YOU. This is a lesson and a way of life that I always find myself "falling back on" when I fail. Failure can be beautiful, it drives you to dig deeper to find a better solution/method which helps you discover a different more powerful side of yourself. Having lost my right calf in the 2013 Marathon Bombings, I suffered physical and mental pain which I overcame with the mentality expressed above. I was broken in every way. I took on a whole new list of challenges and succeeded in finding happiness. I help people daily with finding the right home. I am healthy. I contribute one hour per day to physical activity. I make time to communicate with all of my blessings as often as possible. This life I live today is my American Dream.

Kaitlynn Cates, *Boston, Massachusetts, photographed in 2015*
Kaitlynn was severely injured and lost part of her calf while standing
at the finish line of the Boston Marathon when it was bombed in 2013.

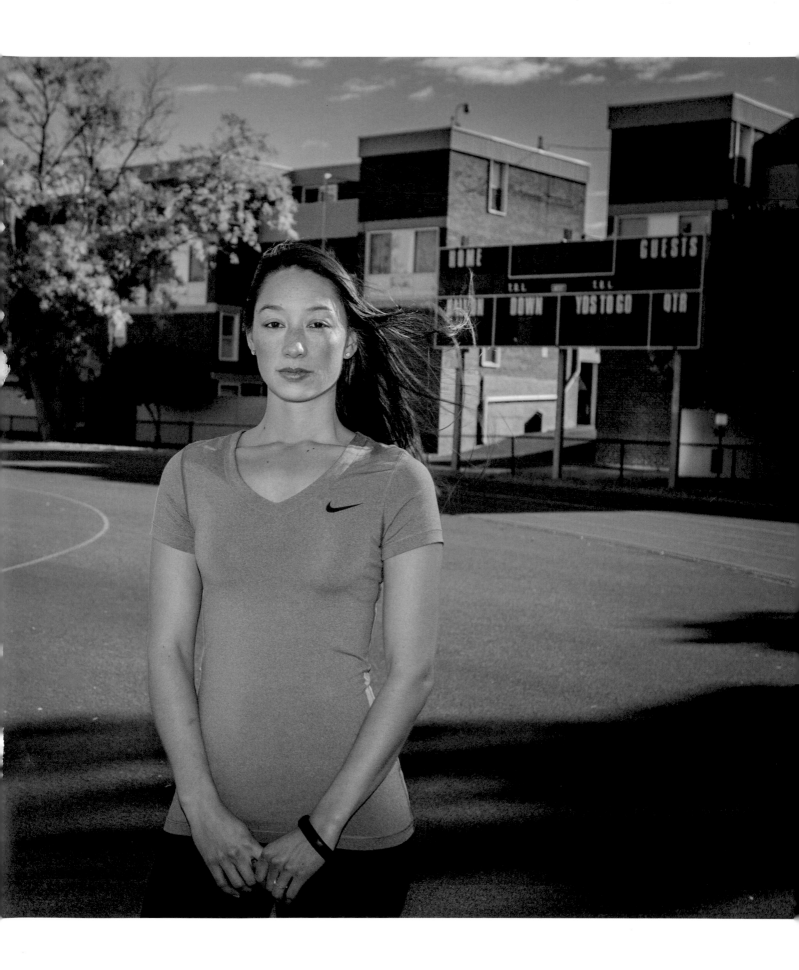

My American Dream

I dream of an America in which the gun rights of all citizens are respected and are not infringed.

I wasn't always a Second Amendment. Ten years ago, my ambivalence faded away when I was robbed at gun-point in my driveway. Suddenly, nothing became more important than being able to take on a more active role in my personal safety.

Luckily, I survived the incident with little more than a bruised ego. In the aftermath, I sought out any and all info that I could find on crime prevention, personal protection, and firearm safety. Eventually, I became a Firearm Instructor to empower and protect others.

Over the last decade, I have had the great experience of training thousands of students from every conceivable walk of life. Among my students have been the following: women, men, students, professionals, blue collar folks, law enforcement, lawyers, judges, and more. Nothing is more exciting than bestowing confidence and tools to enable a chance at safety to formerly intrepid students.

Firearms are not the answer to every problem. However, it is the only answer to the following concerns: killers, rapists, home-invaders, and carjackers. Police are not on every corner. Further, if they were, then we would have a police state. Obviously, freedom can not exist in a country in which only the government only have access to arms.

The biggest reason to own a gun is that the police have no legal and enforceable duty to guarantee that citizens will not be hurt or killed by criminals. Safety is your job and no one else.

Eventually, a gun owner will become politically aware of the forces that seek to disarm him. Those entities use a variety of illogical and infringing arguments, if ever enacted, would not prevent a motivated bad guy from gaining access to a gun to do evil.

In my American Dream, all gun laws would be repealed. As such, no permits would be required to own, possess, or carry a firearm. Also, no firearm would need to be registered. Registration offers no crime fighting advantage for law enforcement; It only creates a list for confiscation if guns are ever outlawed.

Rick Ector, *Detroit, Michigan, photographed in 2013*
Rick is a firearms enthusiast.

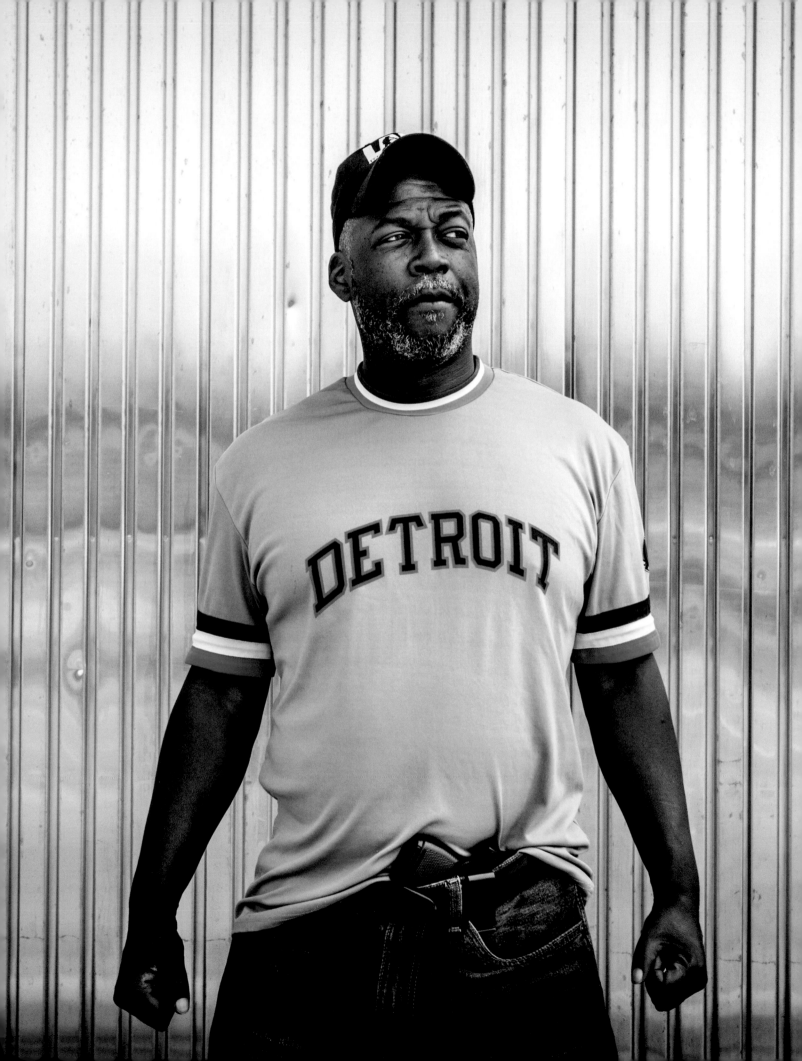

My name is Sura, I am from Iraq, befor I came to America, I thought that I could save money, that I could have money to change my family's life. I thought I would be working and earning enough money to save. But after I came here, I reealized that it's hard. We don't know how to start. I can't start ajob with my a degree from Iraq. Learning English is the first step. All of our money goes to taxes and we can't buy ahouse. Consequently, all my thoughts about here are to save money for my kids college. And my husband has changed many jobs. He has agood CV. but because there is no work in his degree he decided to study and is starting to change his life. Because there are many chances here but he needed money to have a down payment. My husband is always saying "God is always with us and we don't need anything". Even though it is hard here, my sons are safe from war and I have freedom to choose everything in my life. I will feel happier when my family comes here because I miss them. They cannot visit without avisa and my life will be agood life when I get work. I have adream I hope to achieve in America. I hope to take a certificate of askin health and I have my own work.
I belive I will have a successful business and it will bebig and have amultipale branchs every where in the world, then I can help my familly and every body needs help.

April, 24, 2019

Sur

Sura, *Salt Lake City, Utah, photographed in 2019*
Sura, her husband, and their two children immigrated to Utah
from Iraq. She is currently enrolled in adult education courses.

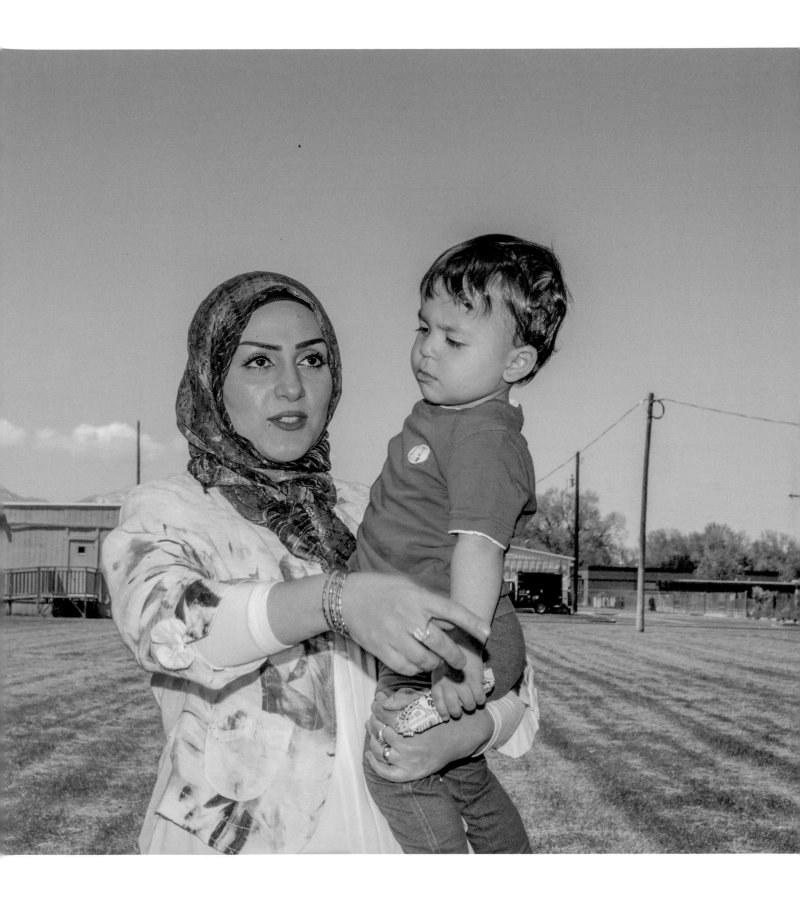

My American Dream of today lies far less in the material than it used to. It used to be filled with power and money and notoriety— suits and business meetings. I realize now I was playing out a trope but it didn't fit and it never had. My Dream these days is to live closer to the Earth. To make things with my hands. To dig in the dirt. To live better with less. My Dream is to nourish the love I've found, to raise kind, intelligent children and spend my life in love with life and living it to my full potential. My Dream is that when I go, regrets will be few and that those I leave behind will remember me as kind, generous and fun as hell.

Julia, *Kennicott Glacier, Alaska, photographed in 2019*
Julia grew up in California. She went to Alaska for a two week trip, but ended up staying and meeting her now-husband. They live with their dogs in a small cabin near Wrangell-St. Elias National Park and Preserve, the largest national park in the United States.

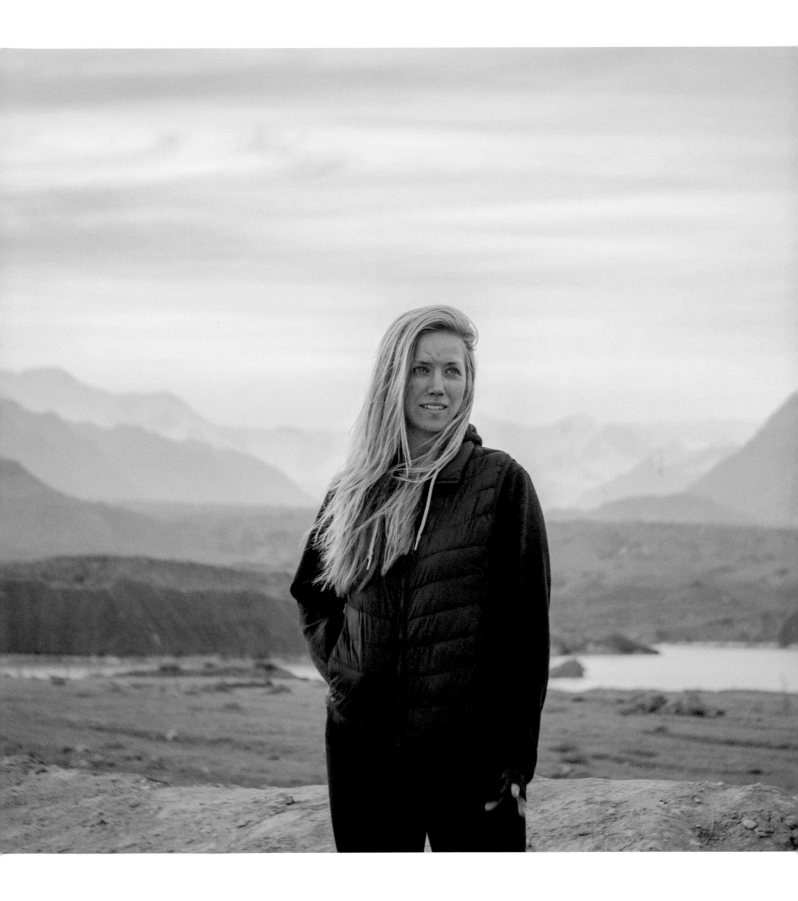

Going from a homeless drunk living in his car and finding recovery while going through a fight with cancer. Now having an apartment and a reason to get up in the morning - no hangover - not worrying about who I offended last night I now have a life to look forward too. I am now living my American dream. I don't know what is ahead for me, but with Gods help I'm sure it will be much better.

John G. F.

John F., *Fargo, North Dakota, photographed in 2018*
Previously homeless, John was photographed a week after he'd moved into a new apartment. He recently received his three-year sobriety chip.

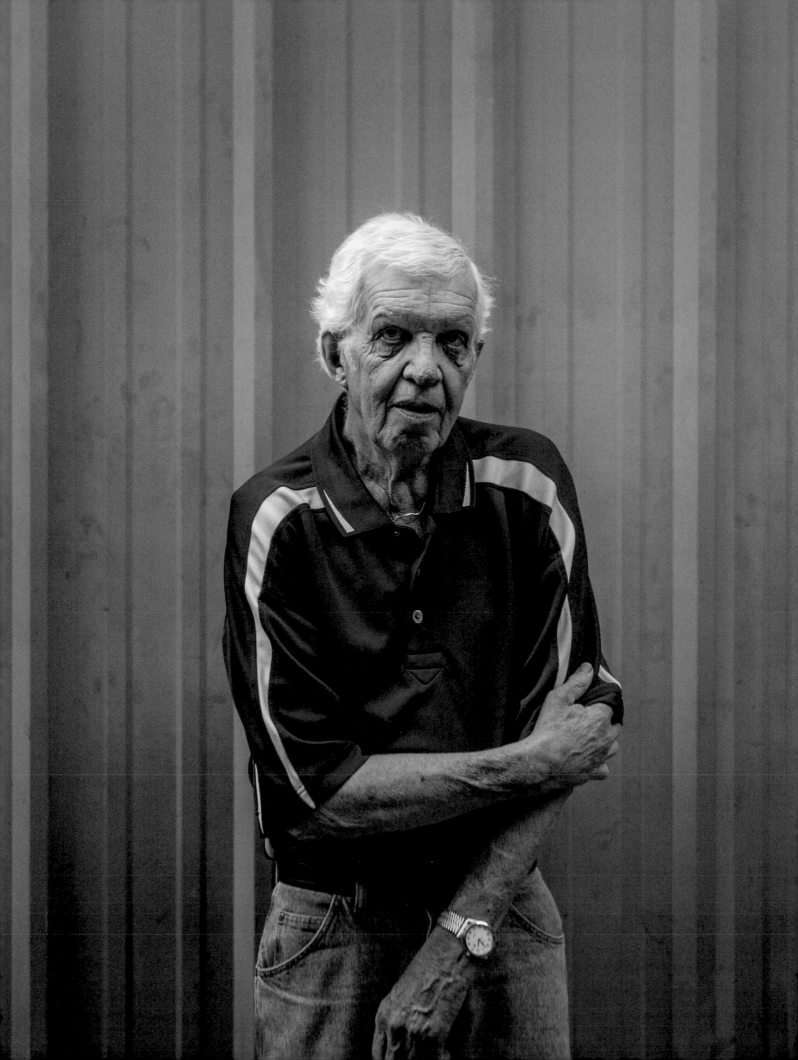

I feel like my standards for "My American Dream" scale down with each passing year. If you would have asked me this in high school, I probably would have said "to be a rich and famous movie director"; I wanted to graduate, move out to the west coast and I guess I just thought fame would come from there. It didn't work out that way, and instead I ended up moving to Flint and going to school, leaving with 20K in student loan debt and a graphic design degree that still hasn't landed me more than the occasional freelance gig. Writing this, I can't help but feel like the epitome of the "entitled millennial" that the Fox News generation likes to rage about.

I guess traditionally the American Dream meant starting from nothing and working your way to the top... or at least thats how I always thought of it. However when you grow up a middle class, straight, white kid, youre kind of born into the Dream, and its not until you fail to take advantage of the privileges that you were born into that the American Dream is put into perspective.

God, I sound depressing. What I was getting at is that my American Dream today is much more humble than it used to be. I am renting a cheap house in Flint with some of my best friends, and am in a great place creatively. I've got a full time job that I hate, but it allows me to still write and film movies on the weekends. No longer do I feel the need for money and fame. My American Dream is to keeping getting better at doing what I love (filming), and if that somehow leads to fame and money, I sure as hell won't turn it down. But if the alternative is to keep making fun short films to entertain the people I love, then that ain't so bad either.

– Cody Larue

P.S. I have a black eye because I got punched by some Michigan State Frat Boys, I don't always look like this.

Cody Larue, *Flint, Michigan, photographed in 2015*
Cody works a day job at a courier company, and he started
a small independent film company called Flint Rat Films.

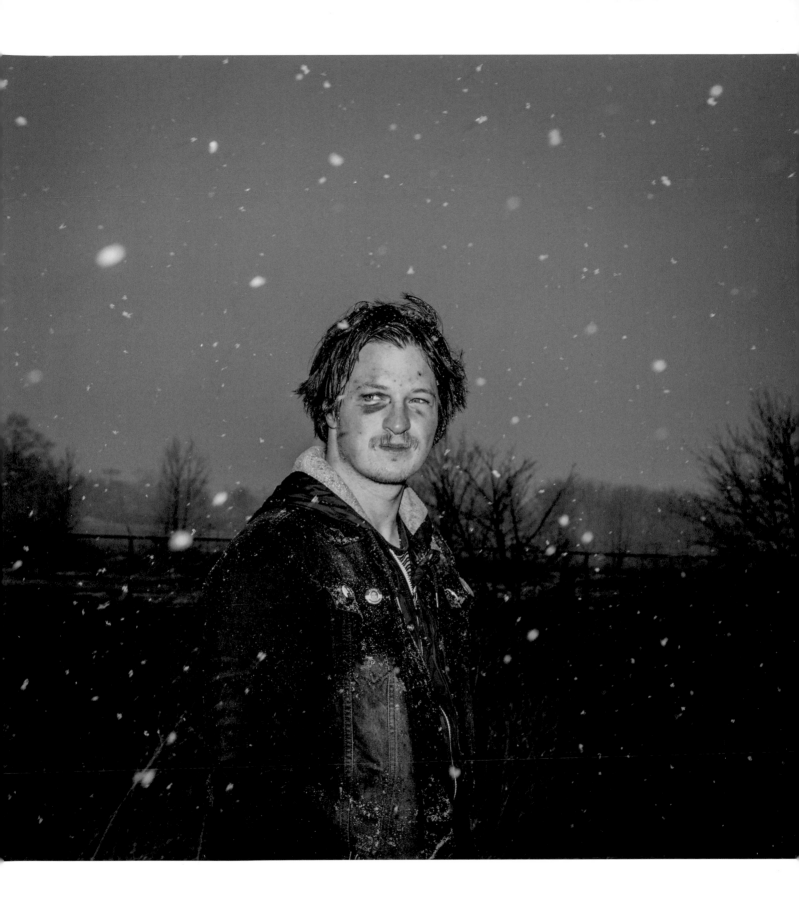

Never give up hope

What the American DREAM means to me?

Brainwashed, corruption, mis-trust ———.
But, there is Hope with a HAWAIIAN DREAM.

A Dream of our Kupuna's (elders).
To live respectfully, To have Ke Akua (God) as the center of your life, To care for your Ohana (family) and to take care of yourself. Be responsible for your Kuleana (responsibilities).

We must take care of our 'Aina (Land) our culture and our heritage.

ALOHA FROM Hawaii — (Born on the island of Maui)

Mahalo - Mopsy Aarona

Francine Aarona, *Paia, Hawai'i, photographed in 2019*
Francine worked for a telephone company for many years before retiring. Her family has owned property on Maui for generations, and she been outspoken against the construction of a telescope on Mauna Kea, a dormant volcano on the island of Hawai'i that is considered sacred by many native Hawaiians.

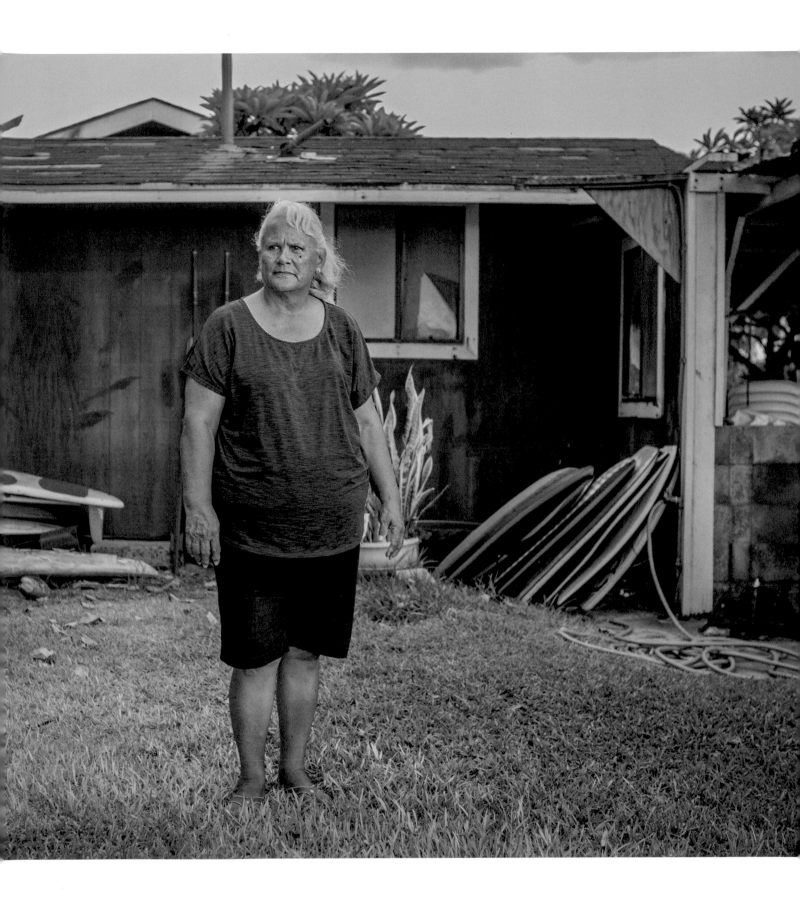

The American Dream to me is Growing up Not Worring about Where the Nett Bit of money is Coming from Having the aBility to find a JoB that takes Care of Everything you NEED So your Spouce DOSEN'T Have to Work.

Greg, *East Liverpool, Ohio, photographed in 2016*
Greg was told he would be charged $175 to hold his baby son after birth (known as "skin to skin"), because it was deemed to be outcome-based medicine and could therefore be considered a billable service. He is pictured with his family.

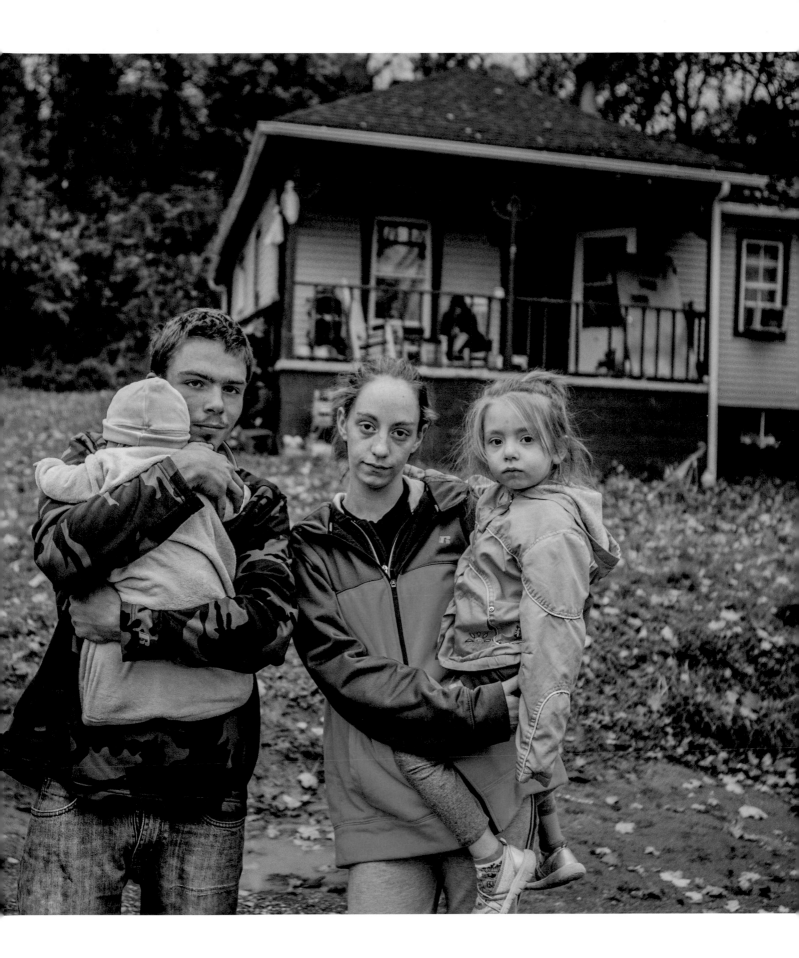

So far the American Dream, I want you to know I can talk better than write, so here goes.

My American Dream is what I'm living today. I always wanted a good & healthy family which I have been blessed with.

The big part of my dream is horses & cattle w/ a special emphasis on the horse. I currently have 2 driving horses, 2 riding horses & enjoy them all as they have great dispositions & are very nice looking & seem to enjoy doing their jobs.

I also enjoy the small portion of the Wessington Springs hills that we own & graze our livestock on. The pastures are beautiful & functional & serve as a mood softener if you know what I mean.

Elton Kaus, *Wessington Springs, South Dakota, photographed in 2014*
Elton is a rancher. In 2014, his town was ravaged by a tornado that narrowly missed his home.

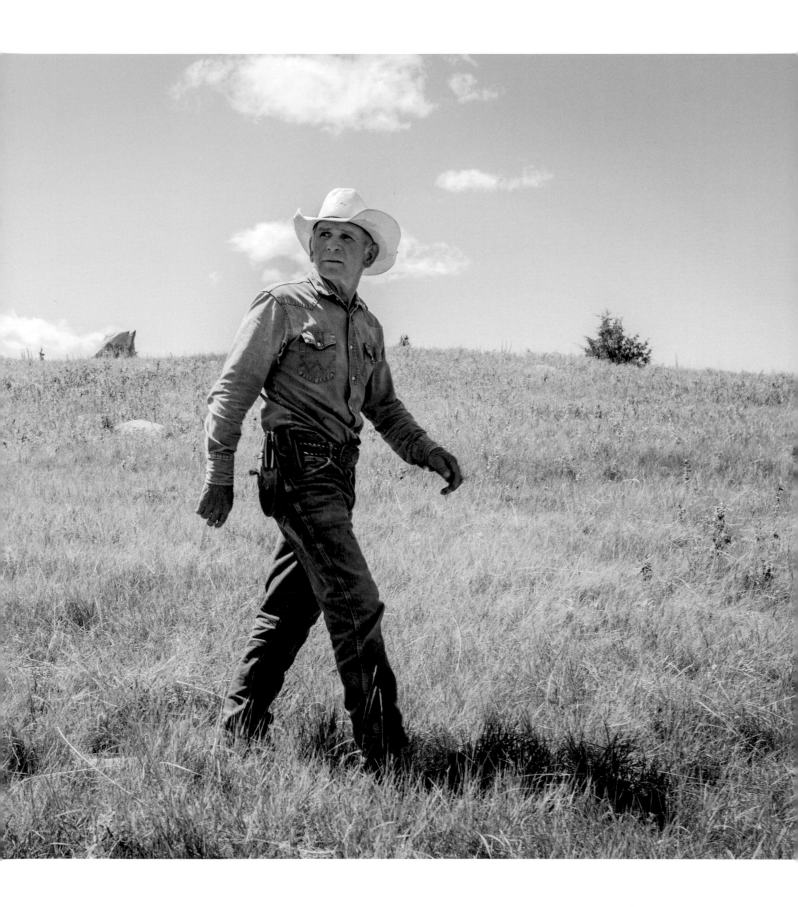

Dietta Gueye 6-24-15

When I think of the American Dream,
I think of the unexpected. I think
of the brave, the conqueror, the left
out and behind, the uneducated, the
second chancer, the fat girl/guy?, the
skinny girl/guy, and the broken
family. The meaning of the American
Dream to me, is a person that can
go through life with all it's bumps
and bruises, and still be able to
show all the doubters!

"Never let anyone else's truth be your
truth and never let anyone else's
truth about you be your truth.
Truth is learned not taught!"

Dietta Gueye, *Detroit, Michigan, photographed in 2015*
Dietta was shot in the leg during a home invasion at her small eastside house
in Detroit. She had a firearm and shot back at her assailants. She has worked
as a tax preparer and also started a clothing boutique for plus-size women.

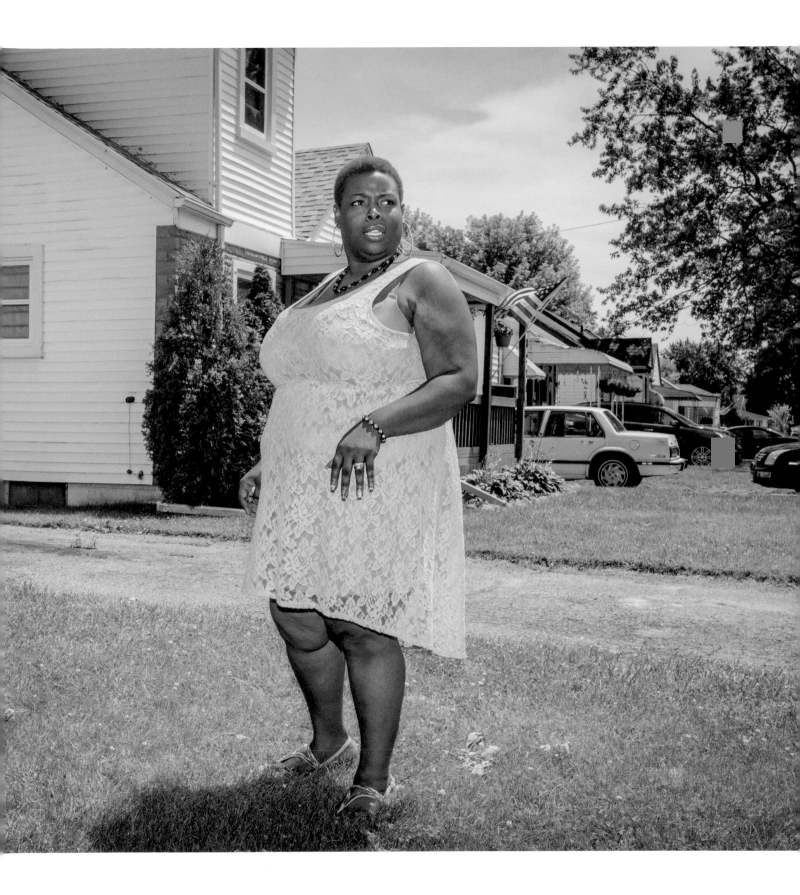

The American Dream is rooted in liberty. The freedom _to_ do as one pleases, and perhaps more importantly, the freedom _from_ persecution, and unjust force. It is the freedom to excel, and outcompete one's peers, but often overlooked, it is the freedom to be middling, and live in forgettable mediocrity, if one so wishes. Being unexceptional, and content, simply living, has its merits. Working hard to make history, or choosing unnecessary danger, and living impulsively, also has its merits. The Dream is to make your own choices, and live with your own outcomes.

Austin Flaugh
July 1st, 2015

Austin Flaugh, _Lexington, Kentucky, photographed in 2014_
Austin was photographed at the Keeneland horse-racing complex during the annual Blue Grass Stakes. He wrote his dream a year and a half later while attending law school.

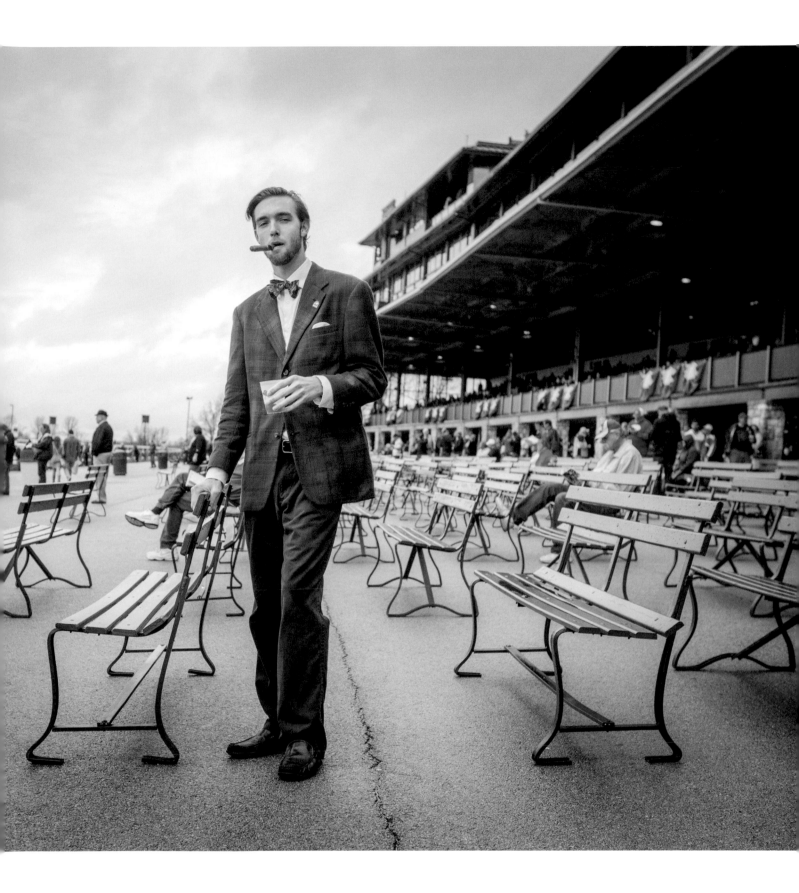

What is the American Dream? Thousands of immigrants come to the United States in search of a dream of success and freedom. Being Native American, my ancestors were already here before others came seeking this dream and in many ways they lived the "American Nightmare". Personally, my "American Dream" is to give a voice to my people, who have been voiceless and muted, and live in a world without racism, cruelty, or bias. Through my work as Curator for the Osage Nation Museum, I endeavor to teach and educate the public about the history of the Osage people while performing a job that I love. I want to show Native people that success and freedom are achievable for all of us. I also want to be happy and live a life full of love, laughter, and kindness that emanates to those around me.

Hallie Winter, *Tallgrass Prairie Preserve, Oklahoma, photographed in 2017*
Hallie is a member of the Osage Nation and worked as a curator for the Osage
Nation Museum, which is the oldest tribally owned museum in the United States.

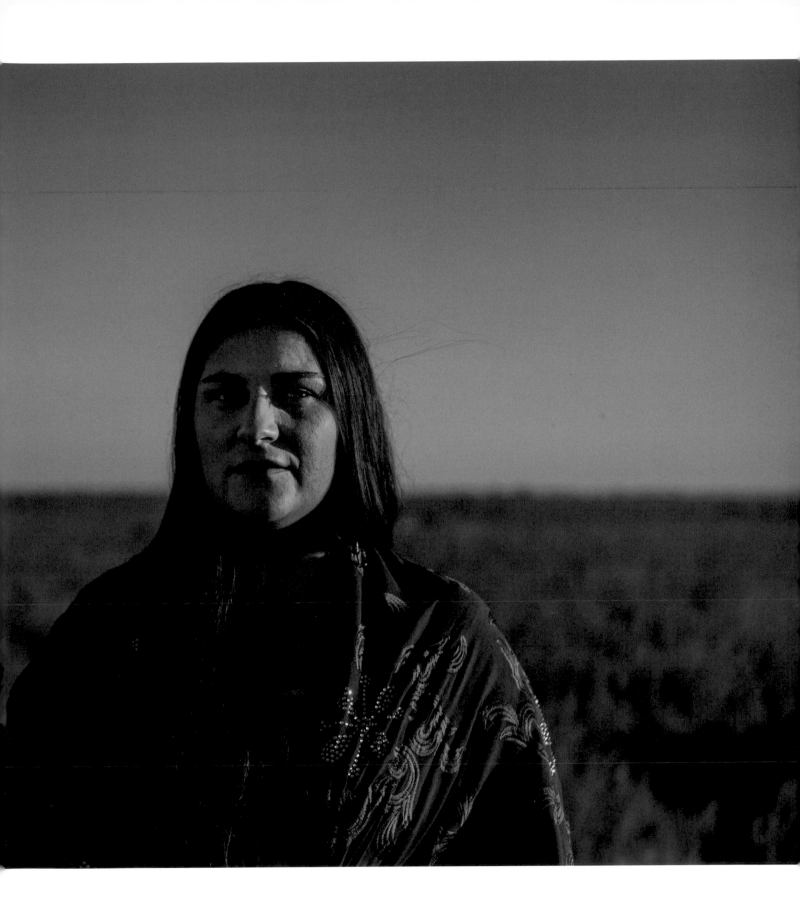

Mi sueño americano es trabajar aquí
y tener mi propio ganado
para salir adelante y para
no salir mas de Mexico.
Quiero ahorrar dinero para
regresar y estar con la
familia.

Fermin

Fermin, *Wisconsin, photographed in 2017*
Fermin is an undocumented migrant worker from Mexico. The owner of the farm that Fermin works on
says that he can't find local "American" workers who are willing to put in the long, hard hours required.
Fermin lives in a simple room and sends money to his wife back in Mexico to help raise their kids.

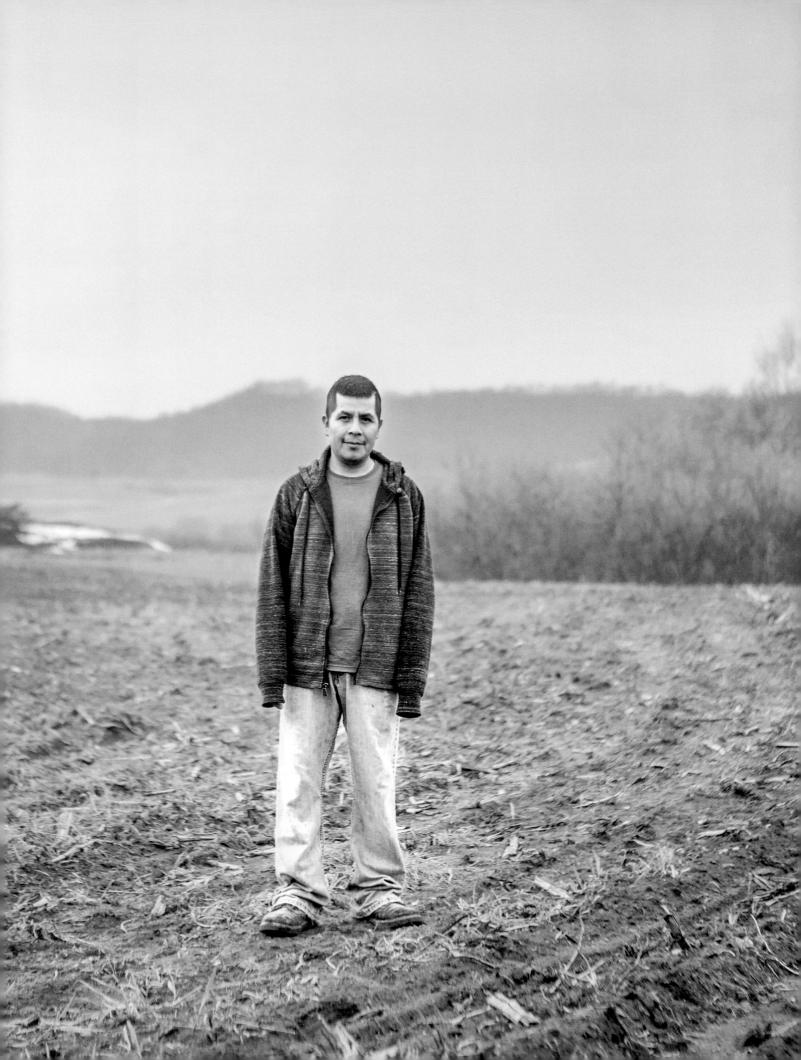

Urban and suburban living didn't work out well for me. I prefer natural sounds, sights, rhythms, and surroundings. The conventions and rules necessary when humans live in large groups seemed confining. I wanted space, freedom, independance, and self-sufficiency. So here I am - living my American dream. It's interesting how it worked out. Environmental issues weren't a big factor when I started this experiment, but many of the choices I've made, may have application in a world dealing with climate change. I wanted to reduce my dependance on money as much as practical, and it seems that doing that is good for the environment too.

Bill Campbell, *Bolton Landing, New York, photographed in 2015*
Bill lives off the grid with his dog in a solar- and biofuel-powered
home he built in the Adirondack Mountains.

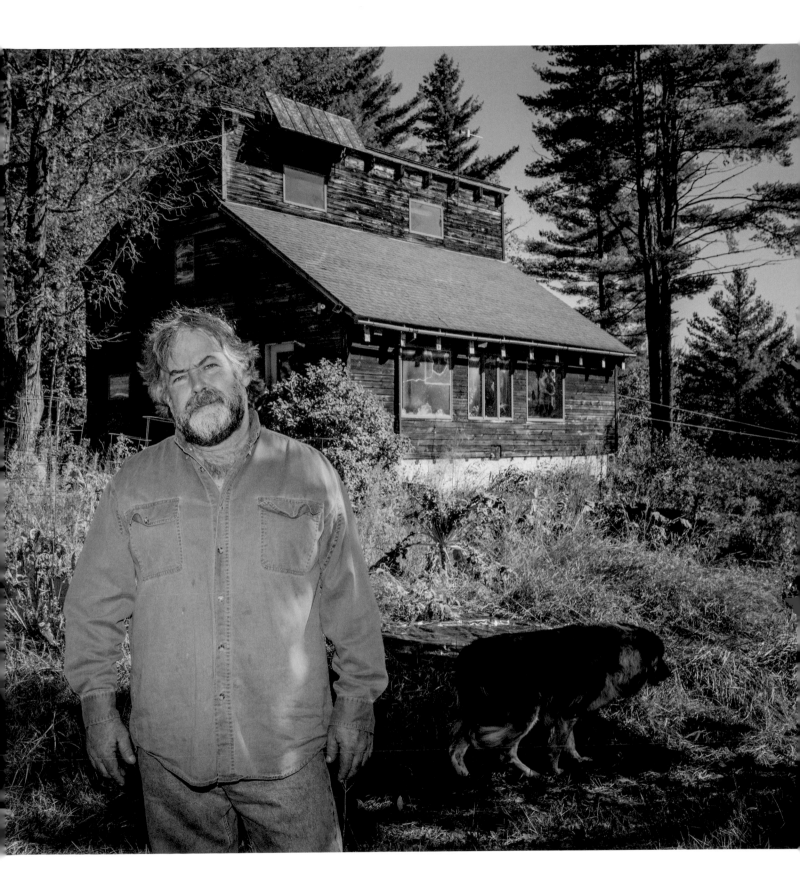

Our "American Dream" is to utilize our
gifts and opportunity to serve as
medical missionaries both here
and abroad, to this
end:

at home
• Ephesians 5:1-2 •

loving our neighbors
• John 13:34-35 •

(Make the love of
Jesus
Known)

in our professions
• Colossians 3:23 •

sacrificing for others
• John 15:13 •

and taking the good news of
the Gospel to the
unreached people groups of
the world.
• Matthew 28:19-20 •

Allison & Sam

44

Allison and Sam, *Blacksburg, Virginia, photographed in 2015*
Allison and Sam were photographed at Sam's mother's house.

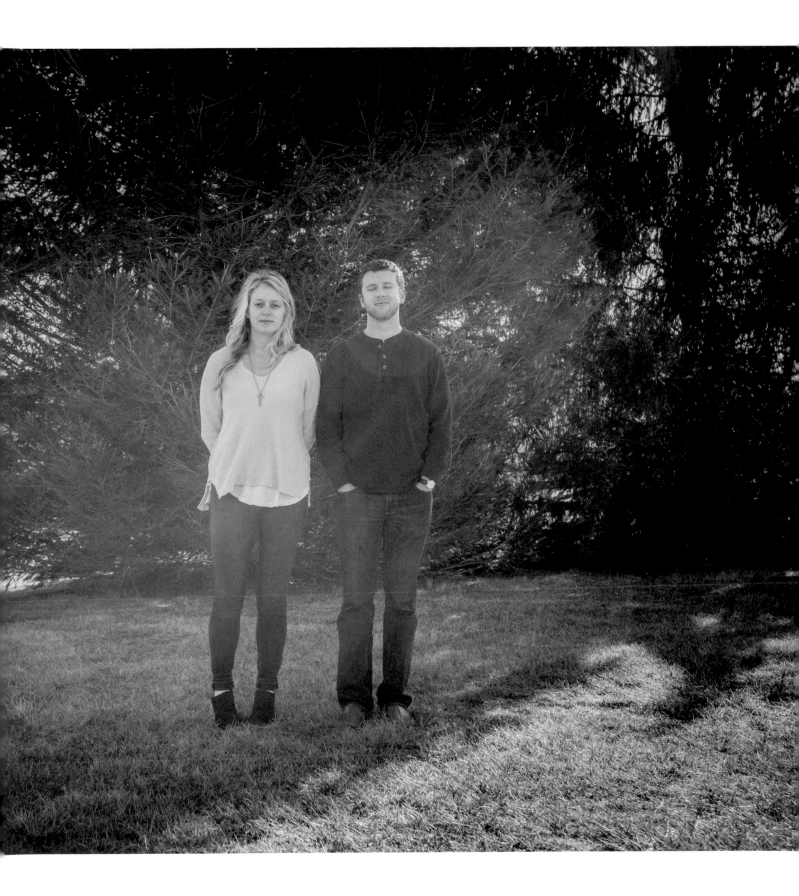

my Dream

To leave the world *safer and* a better place for my children and grandchildren;

Kim Tempo

46

Kim Tempo, *Kahului, Hawai'i, photographed in 2019*
Kim is a former member of the United States military. She was then
a candidate for West Point, but decided instead to focus on raising
her children. She now works as a legal aid counselor in Maui.

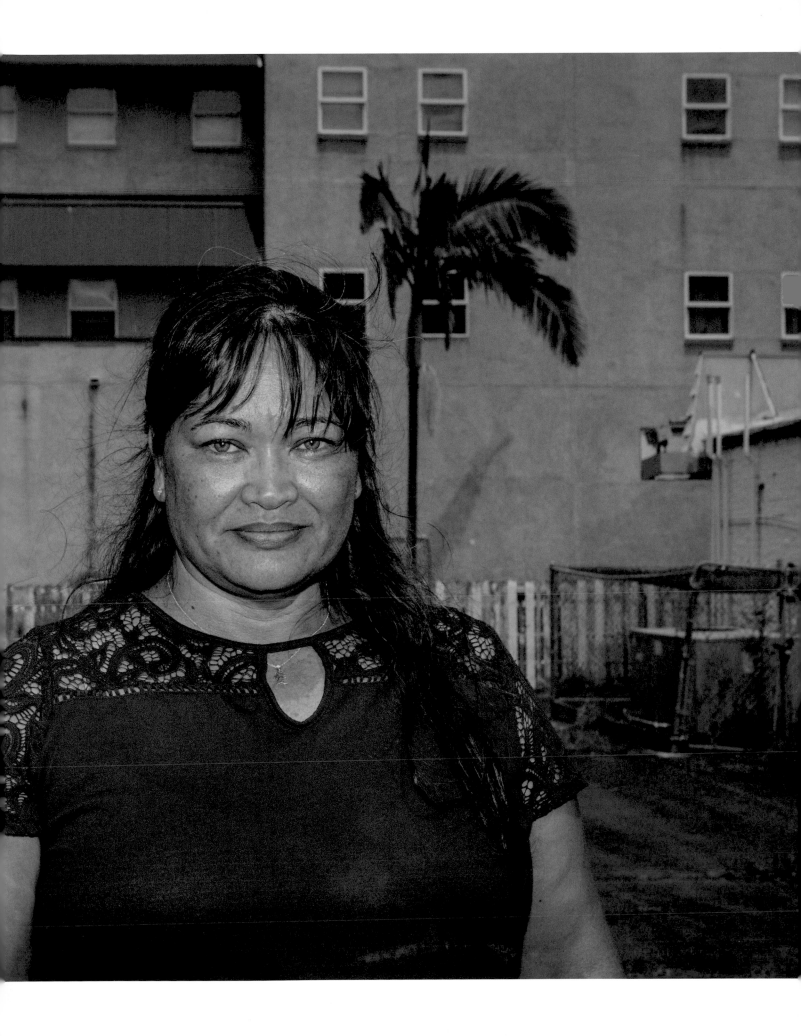

4/2015

As a young girl I dreamt of big things, I had high hopes of being rich, married, successful and **Happy**! I dreamt my life would be perfect! My dreams were realized when I married the love of my life, the perfect man for me! He was strong enough to hold me, brave enough to fight for our country and sensitive enough to do diaper duty. We built a future together, we made plans, a life filled of hopes and dreams. Military life was hard, but we made it work, I was living a dream!!

Reality hit hard when tragedy struck, my husband died. I lost hope in our goals, I lost sight of our dreams. Grief consumed me. At some point within that despair I realized, **I didn't die**, I had to keep living. I had to raise **our** baby! I had to keep our dreams alive, for the sake of sanity, LOVE, and LEGACY, **I had to push forward.**

Dreams change, the **best ones** are the ones you get to live out. I am rich! I am so rich in **love** and happiness! Personal success is in my grasp. My dreams are to be inspired, to stay motivated, to continue to persevere! That is my American Dream.

Yesi Bernal

Yesi Bernal, *Chicago, Illinois, photographed in 2015*
Yesi is pictured with her daughter.

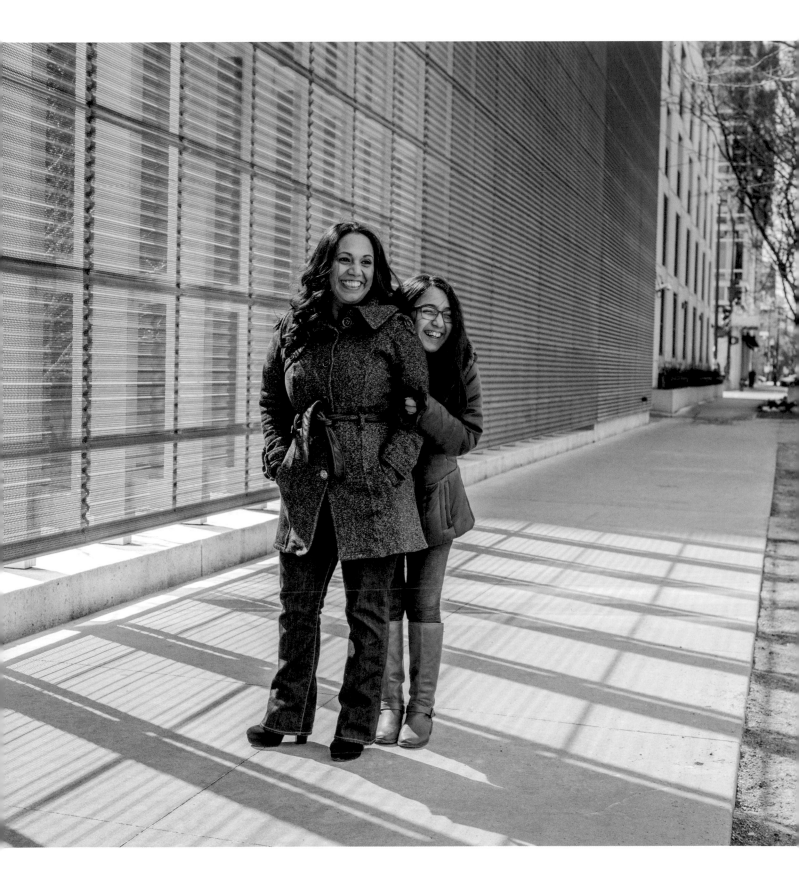

My American Dream is built on the backs of my immigrant parents. Growing up we didn't have much. What I knew of the American Dream was on the t.v.... The white faces with the white fences. It was so alien to me. But looking back my American Dream is filled with the smells of chemicals. You know, the chemicals they put on tomatoes to make them look nice. The chemicals that benefited the tomatoes, but irritated my mother's eyes and my father's hands. These chemicals that, not only me, but many children of farmworkers know. But while my parents were just simple farmworkers that worked below minimum wage and were looked at with disdain because of their tomatoe stained clothes, they showed me what the American Dream is. It's sacificing everything for a "better life." My American Dream isn't monatry. It isn't materialistic. My American Dream is a feeling. I want to feel true happiness. I want to look around one day and say "Yes, this is why my mom, my dad, and my grandparents crossed the Rio Grande."

Maria Castro, *Immokalee, Florida, photographed in 2017*
Maria was raised by immigrant parents in the second-poorest town
in Florida. She now lives and works in Naples, Florida, which is the
second-wealthiest community in the state.

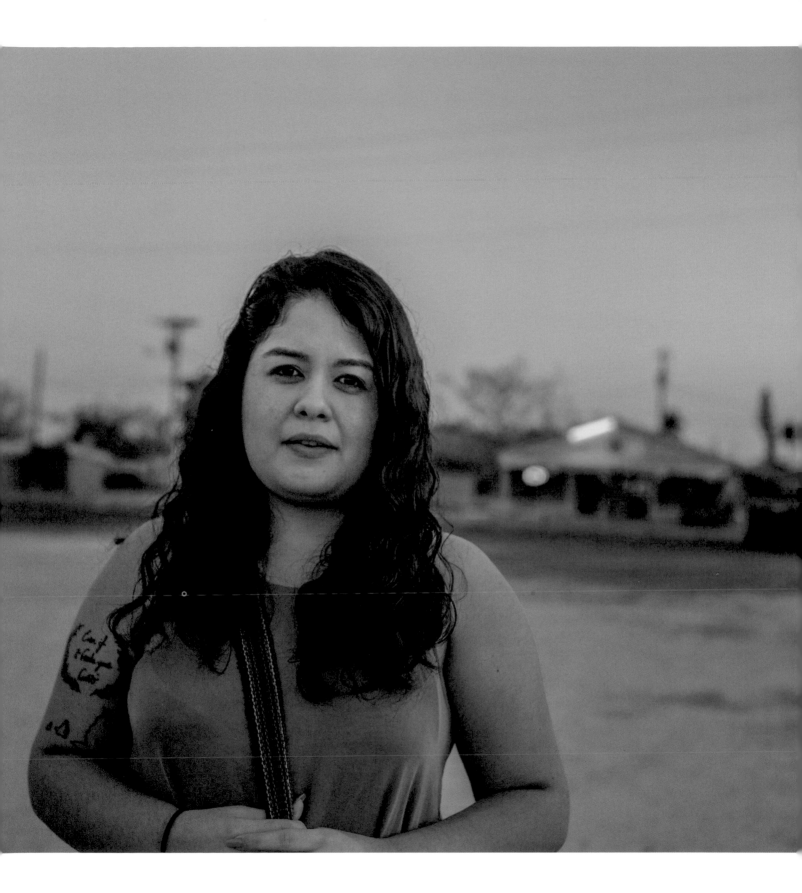

The Santek Family, *Pittsburgh, Pennsylvania, photographed in 2015*
Barb raised a family in Australia but moved to the United States to escape an abusive relationship once her children were grown. After settling in Pittsburgh, she became a foster parent to two infants from an abusive home. She adopted Shanyasia and Nyasia, then their newborn biological sister, Shaquala, several years later. Barb is known as the mom on the block with the funny accent.

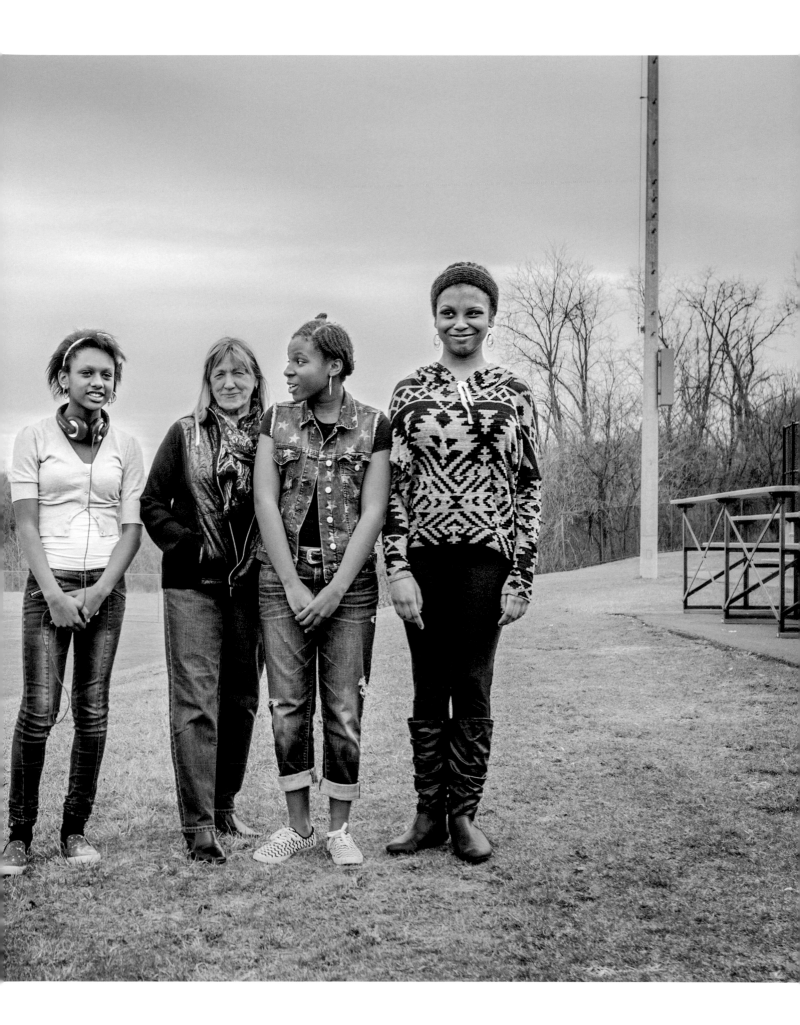

— My American Dream —

I know my children use both their hearts and brains in all they do, which should allow my dream of them having happy, independent and successful lives to come true.

My american dream is to live a happy and peaceful life.— Forever.

My American Dream is for everyone to enjoy and share our similarities but our differences too. I wish this for everyone. Differences make life interesting and fun. I love Asian, African and Middle Eastern foods, I love my African friends hair styles and my Mom's Australian customs.

I love my friends, not just for their foods, hair styles and customs but for their love and friendship.

Share the LOVE!

My American Dream

My American Dream is to be a lawyer / Defense Attorney to be able to defend wrongfully accused victims such as Tyrone Hood.

What is the American Dream? Success? A house to own? Freedom? Happiness? How About instead of an adverb or a Noun, A verb? TRY. The American Dream is TRY. TRY to be happy, TRY to be successful. TRY 2 buy a house & TRY to preserve freedom & TRY 2 do. TRY! is the American Dream. This Great Nation allows everyone the → 2 try. TRY A new food. TRY A book. TRY to change an unjust & oppressive system. TRY to keep the status Quo. TRY! TRY to convince sml. TRY to ride a bike & TRY to help someone in need. TRY to be there for HR kids & TRY to understand sml else. TRY to fly. TRY out a new mattress. TRY embodies effort, opportunity and even chance. The US is the #1 Nation in the world for immigration & People know they can TRY in the U.S. TRY meat. TRY vegan. TRY God. TRY Atheism. To TRY— be it as mundane as ordering something from the other side of the menu to as ambitious as running 4 president.— to try. That is the American Dream. Give it a TRY!

56

Ben Baker, *Ashburn, Georgia, photographed in 2015*
Ben is the publisher of the *Wiregrass Farmer*, a local newspaper in Ashburn. He volunteers
as a guide at the local Crime and Punishment Museum and as the TV announcer for the
local Christmas parade. He's also the former chairman of the local Fire Ant Festival.

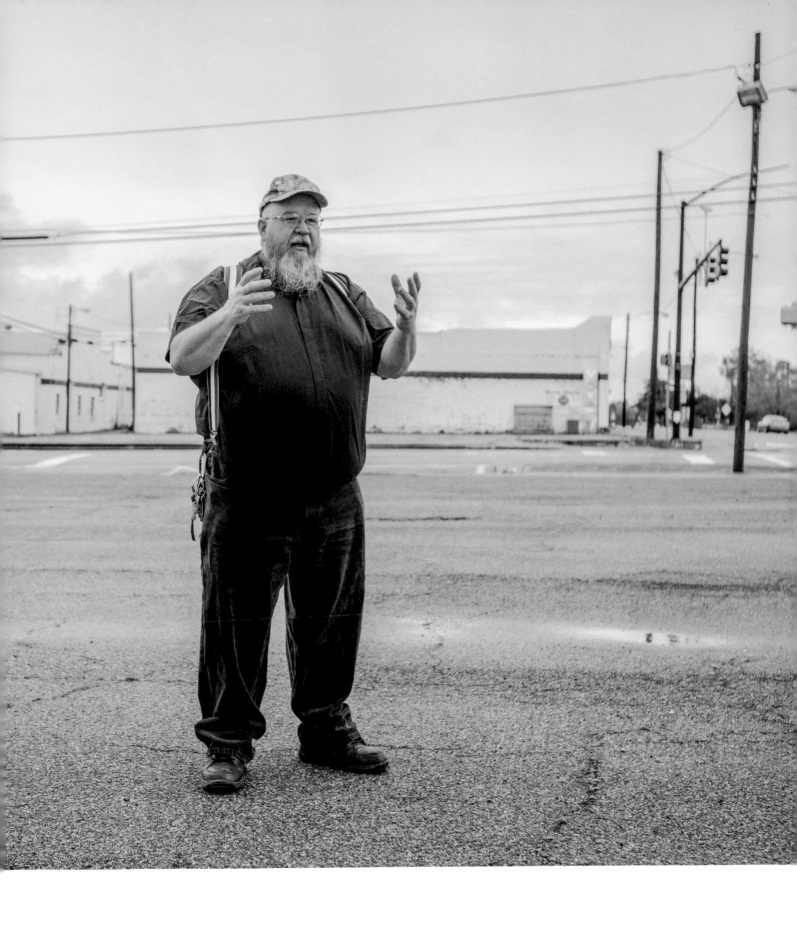

My American Dream...
Is believing in humanity! Is being an advocate for women and children and a voice to the voiceless. Through the work of Princess, Inc. and the manifestation of other untapped gifts, talents, ideas... I desire to curate a lifestyle of "Being the Change" I desire to see in the world... Starting with Atlantic City (my hood) first! And then doing the "ME" work it takes to be used by my Lord to impact true, authentic change. Dreaming and believing that I am living and modeling a life of integrity before my daughter's eyes as a servant leader. My Lord will Command the Universe to make room for me and Journey to experience new freedoms and cultures and people and to impact people with love; making room for me to charter the world unknown... places and philosophies! Combatting trauma with authenticity and empathy and community service... the reality of this moment!
My American Dream is manifesting... NOW!!!!
Indra L. Owens 8/2019

58

Indra Owens, *Atlantic City, New Jersey, photographed in 2019*
Indra is pictured with her daughter, Journey.

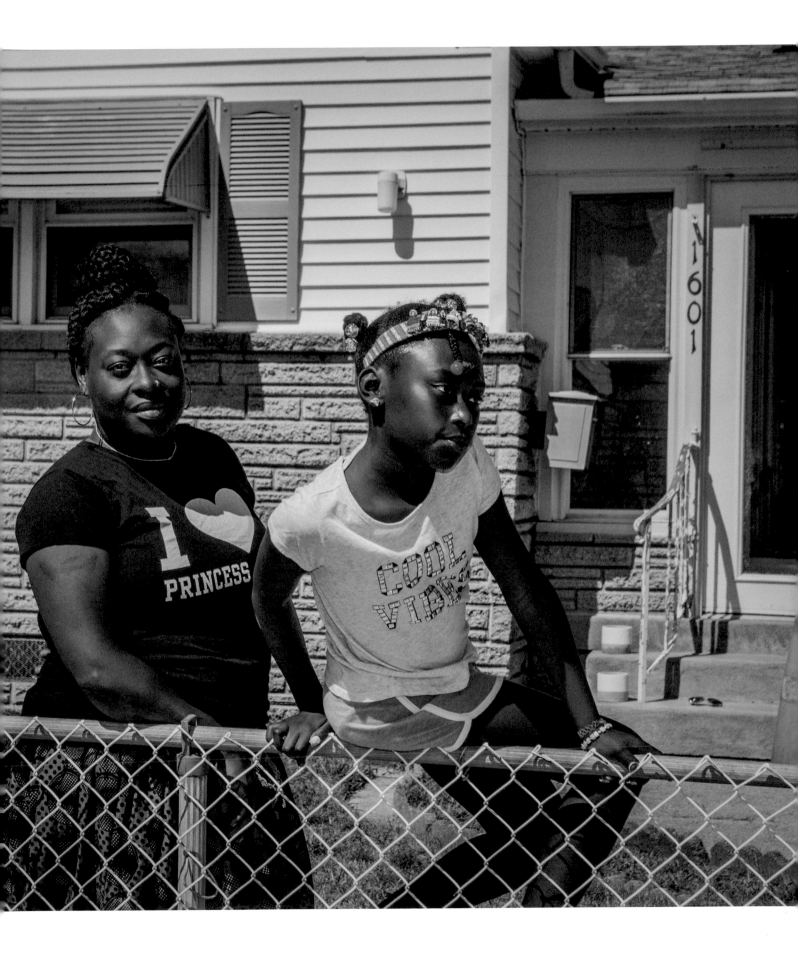

What is my American Dream? That we have the freedom to live our lives however we choose without government micromanaging, taxing, and regulating everything we do. It is my dream that we return to constitutional principles I took an oath to defend; that the freedoms I fought for overseas can be realized here at home.

The American Dream is being able to go about our lives without being harassed, assaulted, ~~the~~ threatened, or otherwise molested by government officials, provided we are allowing others to do the same. That is my American Dream!!

In Liberty,

C.J. Grisham

C.J. Grisham, *Belton, Texas, photographed in 2018*
C.J. is an advocate of open-carry gun rights. He is a former army master sergeant who was arrested for carrying an assault rifle while on a Boy Scouts hike with his son. He is currently in law school.

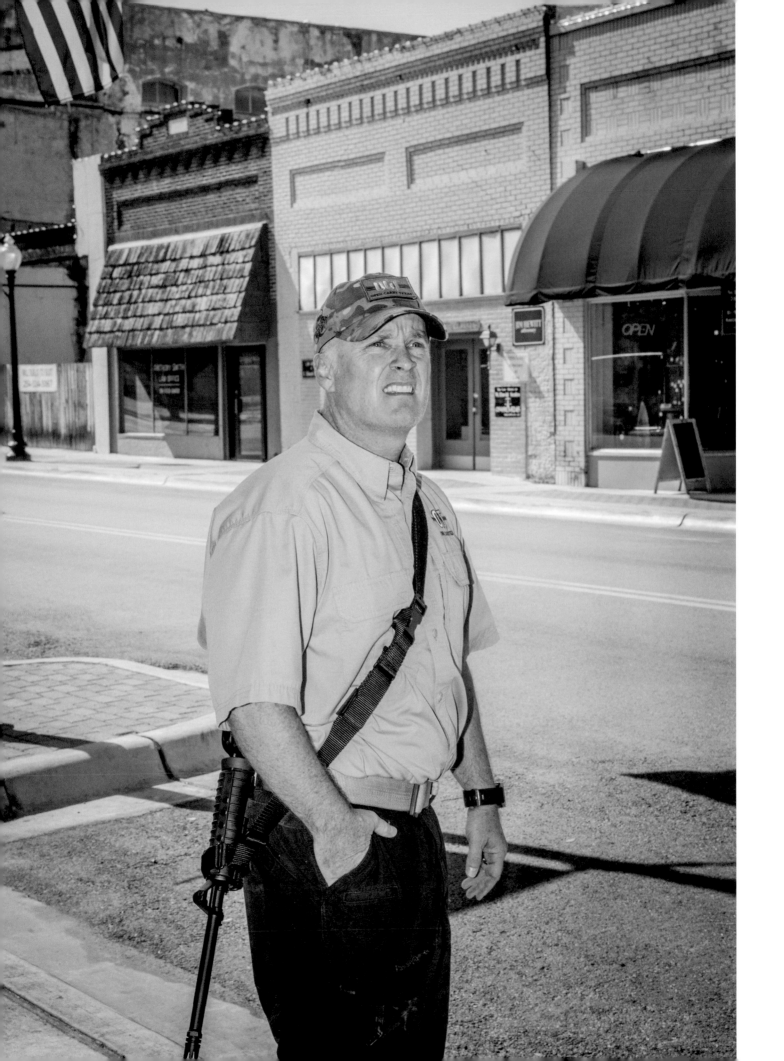

I live in a small Native American community in Lafourche Parish known as Grand Bois Louisiana, Growing up in a time that being Native American wasn't accepted by many other races. I lived a very hard life trying to be accepted, I was told by my grandmother to be myself and yes I was different and always would be different.

I have learned a lot about myself through the years, Starting a family of my own and then fighting an oilfield waste site in my community, and today my life long dream became a reality. I have always wanted to help tribal communities to become more sustainable through education and employment and today I was told that I'm officially a partner of a non-profit organization named Les femmes Rouge de la Bayou (The Red Women of the Bayou). this will allow me to apply for and get grants to assist my native people.

My mother was only allowed to attend school up to the 7th grade because she was native American, and now being able to see her daughter become an owner/partner of a non profit designed to assist Native American communities to achieve their dreams is my American Dream.

Clarice Molinere Friloup
tribal member of the United Houma Nation
2019

Clarice Friloux, *Grand Bois, Louisiana, photographed in 2017*
Clarice is a member of the United Houma Nation and lives in a small community in
southeastern Louisiana that is fighting the oil and gas industry for contaminating
the waters and surrounding lands. She wrote her dream in 2019.

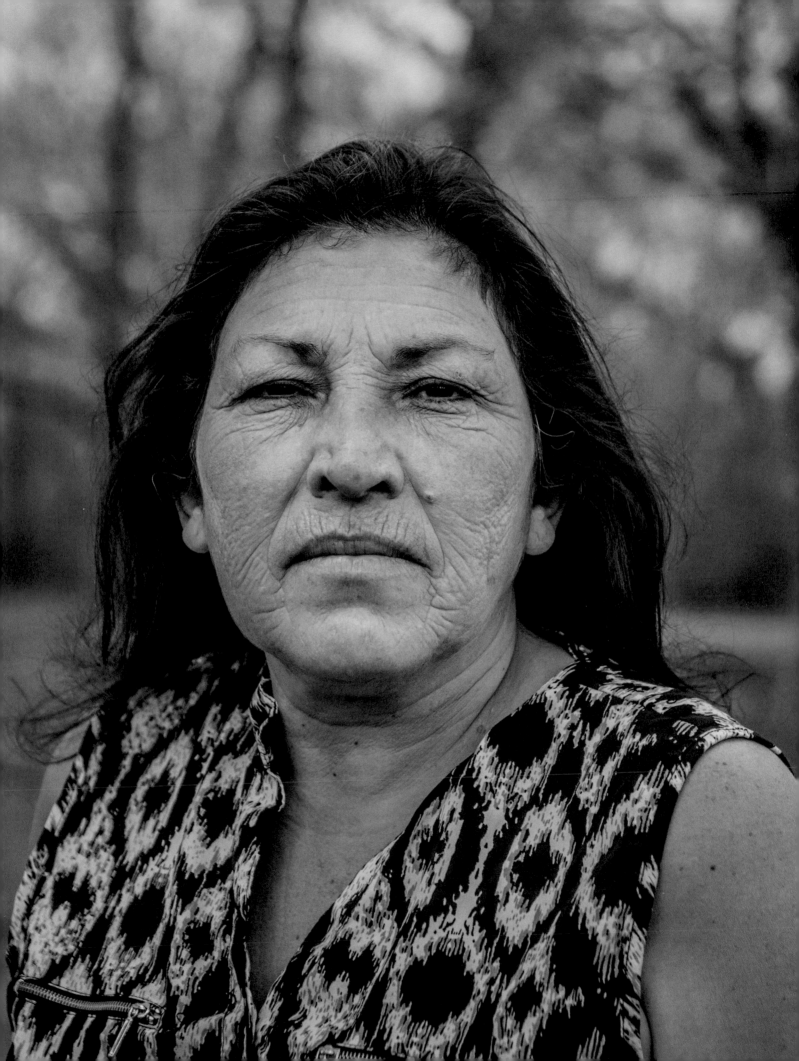

Dear America,

As of recently you've been a country of individuals not United States; completely contradicting our name. The worst part about it is you've been taking lives instead of saving them. Don't seem like you're trying to protect us to me. That's exactly why my dream revolves around unity. Using artistry, I plan to unite the globe with art because I believe art is a universal language that can be used to connect people of all backgrounds.

For example, you don't have to speak my language to understand the emotions I'm attempting to convey in a hand drawn portrait. That's just how I see it, we can all find a ground of understanding to communicate through. So, to achieve this goal I'm going to start with youth of all ages. By using multiple forms of media I plan on starting a career set for young artist to pursue their dreams, but more so to build a community of artist. I can go on forever on this topic, but I'm running out of paper

Dejohn Hardges, *Cleveland, Ohio, photographed in 2016*
Dejohn (center) is an aspiring writer. He is pictured with his
mentor, Daniel Gray-Kontar, and his friend Deija Vinson.

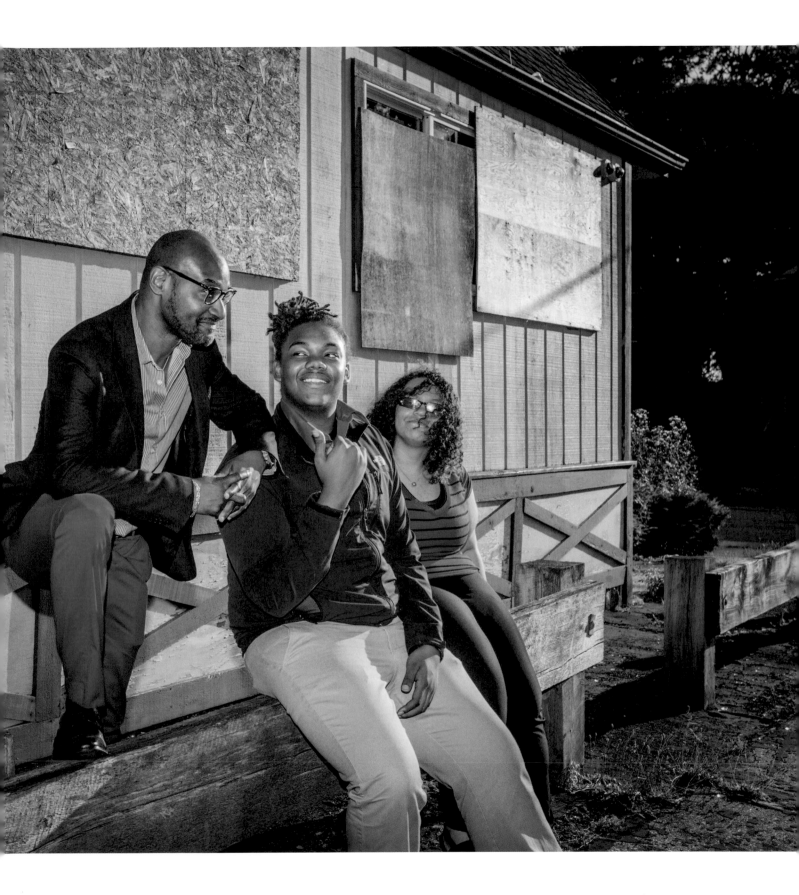

THE AMERICAN DREAM FOR ME IS A STRANGE CONCEPT. WHICH AMERICAN DREAM? THE ONE OF THE ENTIRE AMERICAS? BECAUSE I WAS BORN IN SOUTH AMERICA AND AS A CHILD I HEARD OF THE REPUBLIC OF COLOMBIA AND THE VISION OF SIMON BOLIVAR.

IS IT THE COLOR BLIND AMERICAN DREAM, BECAUS I AM STILL LOOKING FOR THAT ONE? WHEN I CAME HERE AS A CHILD, I SUFFERED A PERIOD OF ARRESTED DEVELOPMENT. ALL MY ANCHORS WERE TAKEN AWAY. THE FIRST LESSON I LEARNED LITERALLY WITHIN DAYS OF ARRIVING, WAS THAT PEOPLE WOULD NOT LIKE ME BECAUSE OF THE COLOR OF MY SKIN. UNTIL THAT MOMENT I WAS NOT EVEN AWARE OF BEING A COLOR.

IS IT THE AMERICAN DREAM OF YOU CAN BE ANYTHING YOU WANT IF YOU APPLY YOURSELF. THERE IS THE IMPLICATION IF ONE DOES NOT SUCCEED IT IS ONE'S FAULT. THERE ARE NO SYSTEMIC HINDRANCES. I THINK OF THAT EVERYTIME I SEE THE INEQUITIES THAT FULL THE SYSTEM. THERE ARE SO MANY TO POINT OUT THAT I AM CONSTANTLY AMAZED THAT SO MANY DENY THESE OBSTACLES. RACE, GENDER, AGE, SEXUAL ORIENTATION, RELIGION ARE EXCUSES FOR DENYING COMPLETE ACCESSIBILITY TO THE SYSTEM.

IS THE AMERICAN DREAM THE RIGHT TO FREE SPEECH AND THE RIGHT OF EVERY CITIZEN TO CRITICIZE THEIR GOVERNMENT AND THE ECONOMIC STRUCTURES THAT UNDERMINE THE IDEALS OF FREEDOM? IF SO WHY ARE SO MANY UPSET WHEN A MAN REFUSES TO STAND FOR THE NATIONAL ANTHEM AND KNEELS INSTEAD AS A FORM OF SPEECH TO PROTEST WHAT MANY OF US DO NOT EVEN WANT TO CONFRONT.

IS IT THE AMERICAN DREAM OF THE FIRST WORDS OF THE DECLARATION OF INDEPENDENCE THAT ALL MEN ARE CREATED EQUAL, OR IS IT THE IMPLIED HIEARCHIES OF WEALTH, PRIVILEGE AND ACCESS THAT ARE THE BARRIERS TO AN INHERENT EQUALITY?

OR IS IT THE AMERICAN DREAM THAT REMAINS EVER DISTANT FROM OUR GRASP FORCING EVERY GENERATION TO FIGHT FOR THE PROMISE IMPLICIT IN OUR DOCUMENTS OF INCORPORATION BUT SO FOREIGN FROM OUR DAILY LIVES?

José Faus, *Kansas City, Kansas, photographed in 2017*
José emigrated from Colombia to the United States
when he was nine years old.

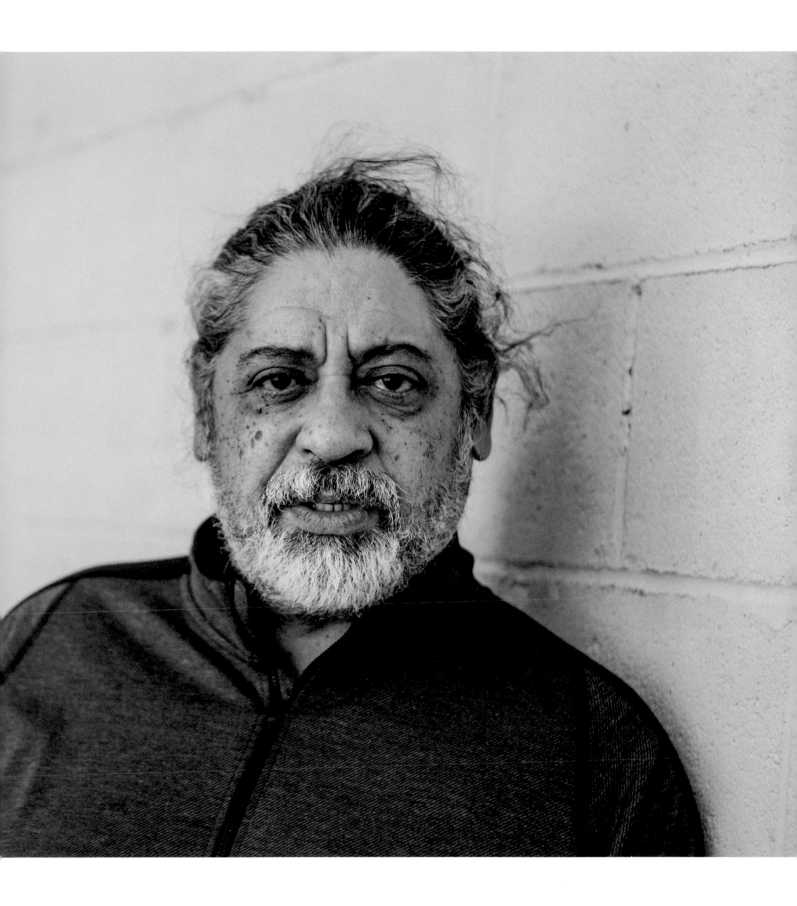

"What is the American Dream?" in my eyes... what a loaded question. I think, truly, my American Dream is simple: to be happy and to live with purpose. To not wander among many, not knowing who I am or where I'm headed. My American Dream is to be free, free from all the pain that this world has to offer. I spent 11 years trapped in my own head, a head full of despair and pain. I was unsure if I was ever going to make it out alive. I was unsure where I was going to land in life, and a year and a half ago - my life came to a screeching halt. I was broken. And I had no idea on how I would ever pick up the pieces - I had lost all of myself along the way. Slowly I built a foundation of love and trust, and I started to grow. I began to love myself, my delightful flaws and all. My purpose is is to carry a message of strength. My mission is to never feel trapped again. My goal is to always remember - it can always be worse. Everyday I live my American Dream.

Aubry Baker, *Des Moines, Iowa, photographed in 2015*
When this photograph was taken, Aubry was living at a halfway house after being convicted of drug offenses.

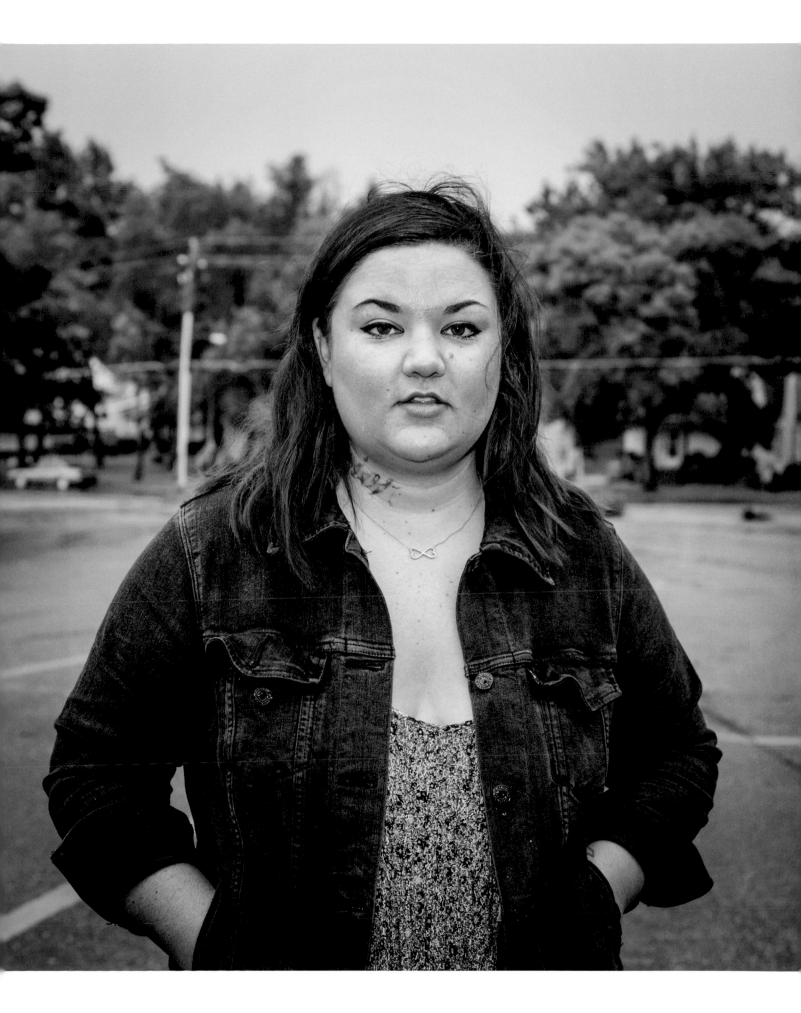

I'm a pastor on the West side of Buffalo, NY. I do what I do because the story, the teaching, and the spiritual power of Jesus. is still compelling to me, even when I get frustrated with the church. I do what I do because it is such a joy to tell people that they are loved, that they matter and they belong.

I don't believe in the "American Dream." The American dream hurts and excludes too many people. I like God's dream — loving your enemy, even to the point of death. If I have a dream for America, it's that some day we'll dare to try God's dream.

Drew Ludwig, *Buffalo, New York, photographed in 2014*
Drew is the pastor of the Lafayette Avenue Presbyterian
Church. He is pictured with his two daughters.

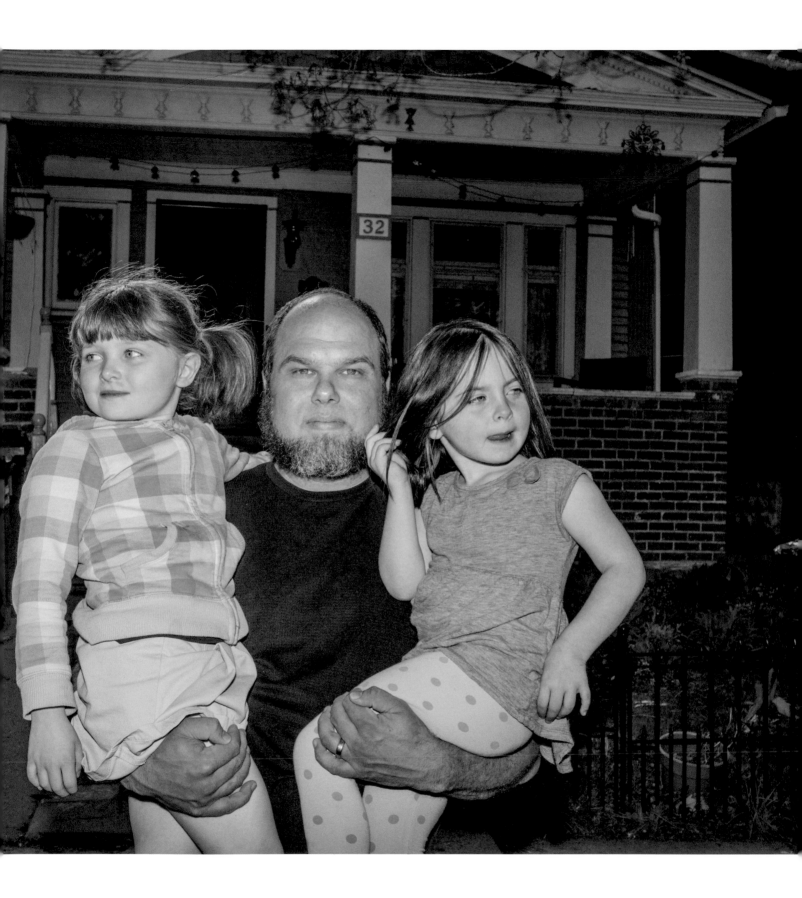

The American Dream belongs to its people—
specifically the future generations
who will inherit it. As stewards
of the Earth, we must ensure that
the prosperity of America is accessible
to all its citizens by certain inalianable
rights: healthcare, education, and
sustainable infrastructure. The dream
is about "waking up" so that we may
rise to meet the challenges of the present
day. God Bless America!
 — Leah Rose of the
 Alaska Sunrise Movm.

Leah Rose, *Chena, Alaska, photographed in 2019*
Leah lives in a "dry" cabin without running water. She
is a musician and is involved in environmental issues.

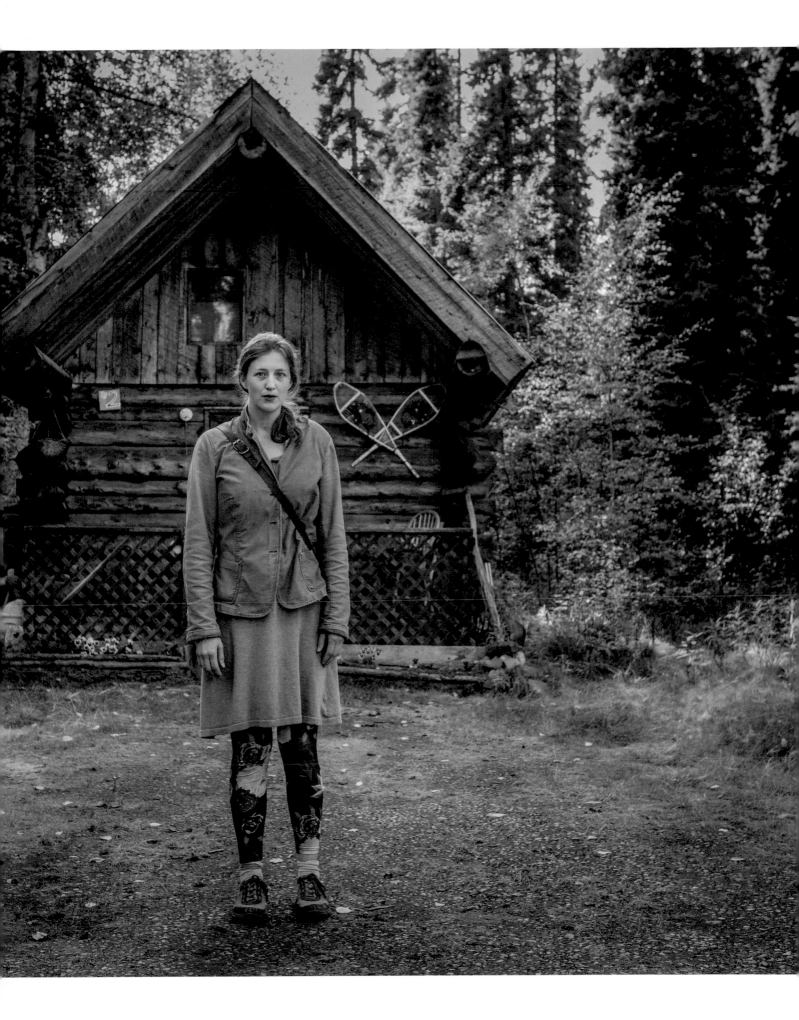

Hello, my name is Gracie Stover and I have reached the American Dream. I have made my home a true place of shelter for my family. They can take refuge from the wrath of Mother Nature and feel protected from harm with loving and secure arms wrapped around them. They know that they will always have a place to call home and in the end, isn't that what we all dream about?

Gracie Stover, *Mount Hope, West Virginia, photographed in 2015*
Gracie had a college scholarship but opted to instead remain in her childhood home—a small coal company house—to continue taking care of her ailing mom and her disabled brother. Thirty-eight percent of the population of Mount Hope lives below the poverty line.

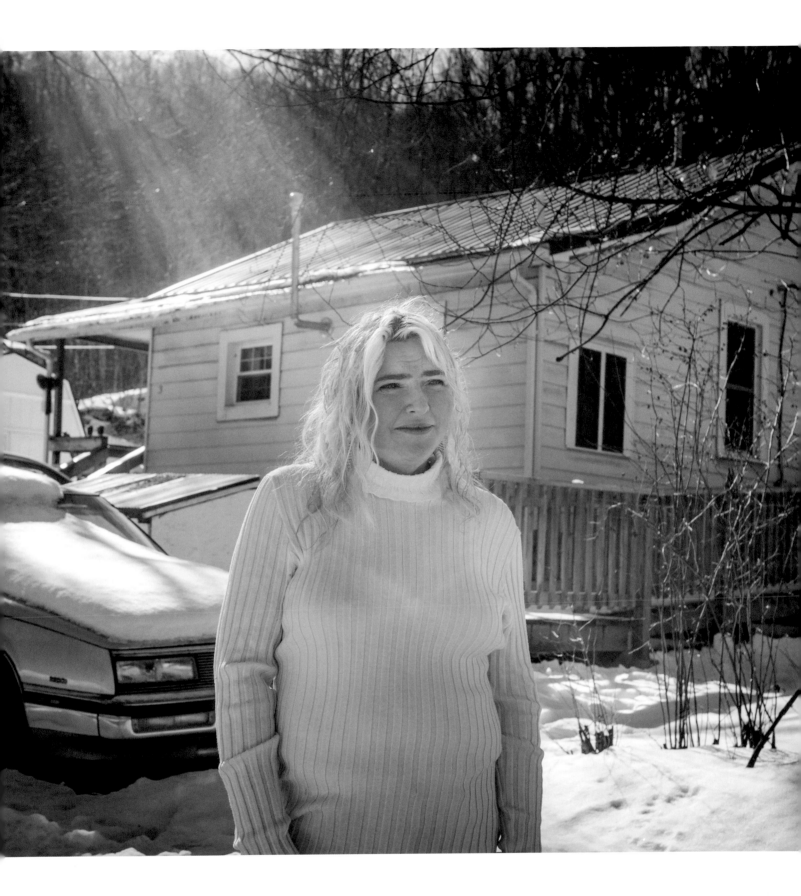

Call me strange But unlike many, My American Dream is that of Love, Compassion Empithy And peace. Which will Result in Happiness.

I want to one Day See a world without Hate. Hate of the Color of my Skin. I want The world to See we all are one Race The Human Race.

Black, whites, to get Along And stop The Hate, the Jealousy, thinking one is Better than The other God Created us All in his Image. to Be Like him. To walk in Love and Compassion.

I Am a woman That lives my life As A Believer of Jesus Christ. who Died so That we Can have Everlasting life. I Try so hard to Live accouring. Because This life is only A waiting Room For me And while I'm here. I will Spread Love Not Hate (1 John 4:20) Tells me That if Any one Says They Hate Their Brother whom They See Every day But Loves the lord whom They Have Not Seen is A Lier.

We have To live with Love, Compassion And peace in ouR Hearts That For me is my American Dream. To one Day Live in A world. without So much Hate Toward each other. Stop Chasing After Lust For Fame And Fortunate. And Live in A world of Peace.

Cecelny A M. Anderso Douglas

CeCe Douglas, *East Liverpool, Ohio, photographed in 2018*
CeCe (right) cares for her two uncles who have learning disabilities and a nephew who is bedridden as a result of a long-term illness. She formed a community group with a number of other local women to try to combat the opioid epidemic that has ravaged their community. She was photographed with her sister Glentonia.

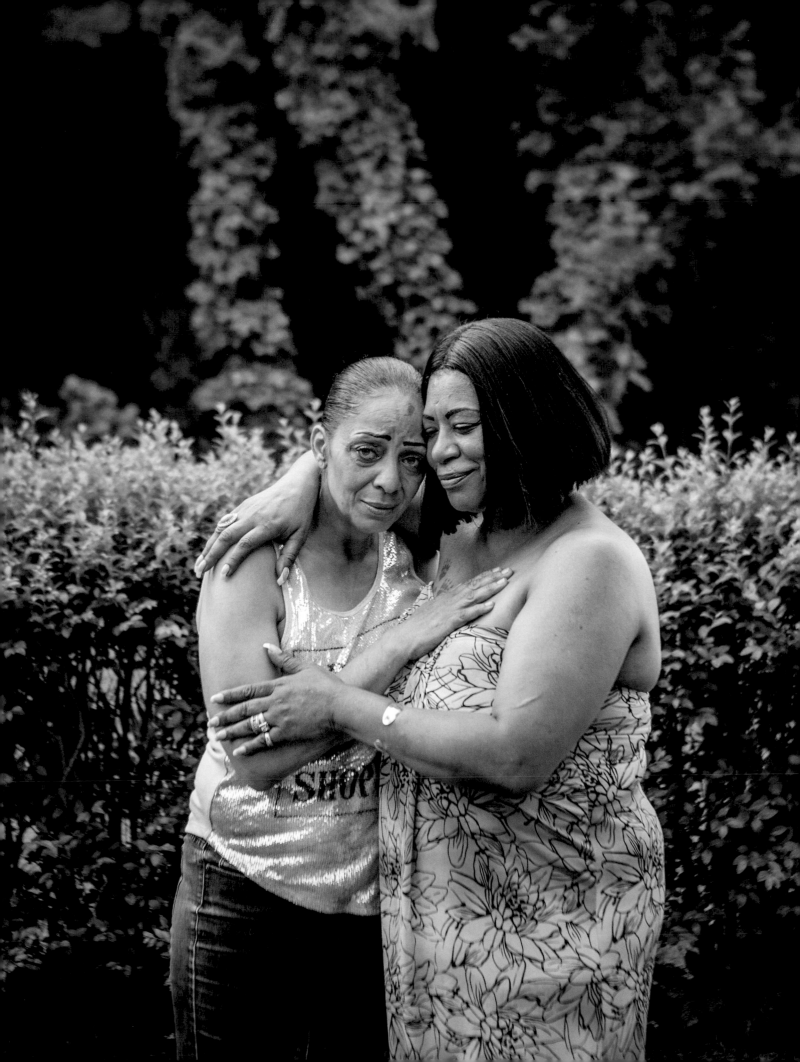

HAVING SPENT 10 YEAS IN
CORPORATE TECHNOLOGY SALES, I
HAD THE OPPURTUNITY TO MEET
MANY DRIVEN INDIVIDUALS

I HEARD THEIR SUCCESS STORIES,
AND TRIED TO UNDERSTAND WHAT
MADE THEM TICK.

IT ALSO TAUGHT ME ALOT
ABOUT WHO I AM, AND WHY
I DO WHAT I DO.

THE AMERICAN DREAM TO ME
IS THE FREEDOM TO DO WHAT
GIVES YOU PURPOSE, FREE FROM
ANY OPPRESSION OF ENVIRONMENT,
THOUGHT, DEBT-SLAVERY, NUTRITION
AND FEAR.

Nate Prenheim, *Freeman, South Dakota, photographed in 2015*
Nate and his wife, Jessica, decided to leave their jobs in Colorado and move to South Dakota
to pursue a simpler and more connected life. They now work forty acres of grassland, where
they raise buffalo and are dedicated to farming in a holistic and organic way.

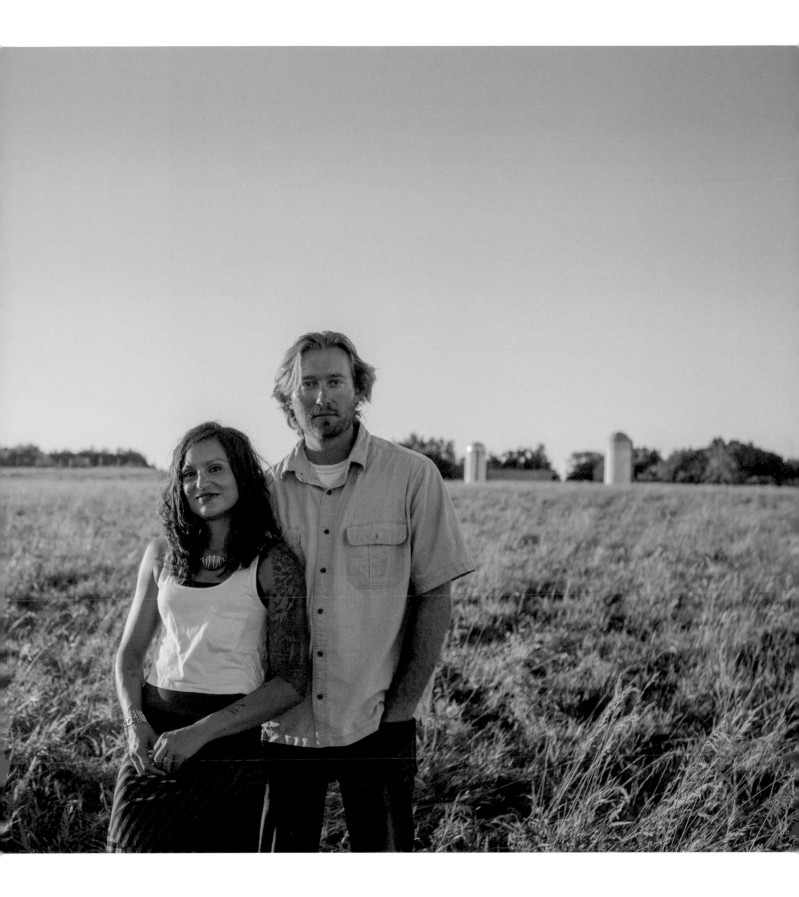

I came to the United States as a little boy after living in Spain and in Japan.

As a seven year old, America was the land of green grass you could run and sit on, the land of delicious milk that wasn't boiled and the land where you could go and play with your friends until the street lights came on, the universal American signal to go home for dinner.

Almost sixty years later, America is still all of that. A country where you can express what you think even when those around you have a different point of view and even when you disagree with your government. It is a land where if you are hard working and willing to make sacrifices, your family can get ahead and your children can go to school.

This America didn't just happen. It was and continues to be the determination of us, who live here, to make it so and to keep it so.

Even as some would embrace fear, put out Sweet Liberty's torch of freedom and hide behind rusted steel, other Americans are moving on, embracing a world of brotherhood, of possibility, and understanding. Tony Sedgewick July 2017

Tony Sedgewick, *Nogales, Arizona, photographed in 2017*
Tony is a lawyer and a rancher. The border fence that separates
Arizona and Mexico is pictured in the background.

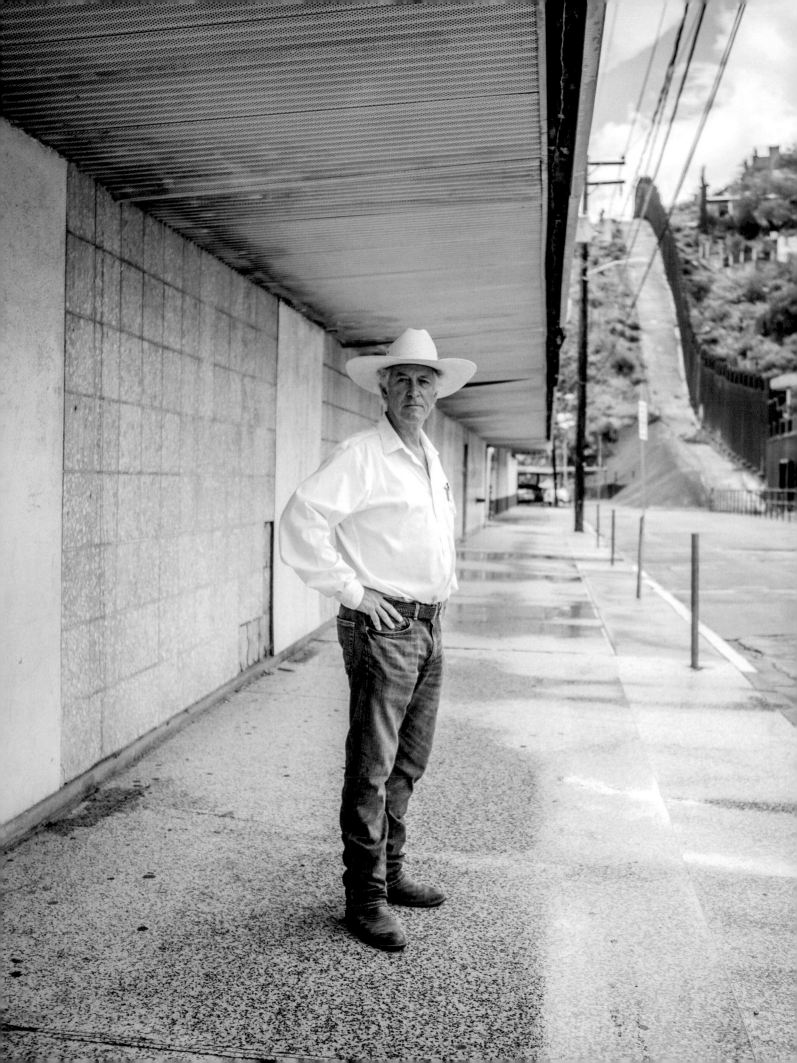

When I lived in Guatemala I used to think that the "American Dream" was having a lot of money and a big house, the way you see in novelas (soap-operas) — but that changed sixteen years ago when I actually moved to the U.S. As a daughter of hard-working immigrants, as a DREAMER, as a WOMAN, as an AMERICAN, who is just as American as someone born in the United States, my meaning for the American Dream has changed. It is no longer just about having money and a house with a "white-picket-fence..." My AMERICAN dream is to no longer live in fear of being sent back to a country that I no longer call "home." It is to give my parents the gift of watching me graduate college and finally see their endless years of hard work pay off. It is to be able to continue to educate black and brown children of immigrants and to continue to advocate for and promote restorative practices in schools so that we end the school-to-prison pipeline and preserve every students' right to a quality education. My American Dream is to see an America led by a female president for a change. An America who does not practice, support, or praise racism, discrimination, or hate. My American Dream is to see America reach its full potential. To see an America with actual "justice for ALL," including the Trayvon Martin's, Tamir Rice's, and Sandra Bland's. I hope to one day see an America who looks out for all of its people and provides equal access to healthcare for all. An America who would never stand and watch its people be deprived of a basic human right such as clean water. I hope to also see an America that can lead by example and take care of our Earth the same way it has taken care of us. My American Dream is a reflection and vision of Muhammad Ali looking into a crowd of students and delivering the shortest poem in the English language: "Me? WE!"

— L. Salazar

greenroom

Lesdin Salazar, *Providence, Rhode Island, photographed in 2019*
Lesdin is a youth development worker.

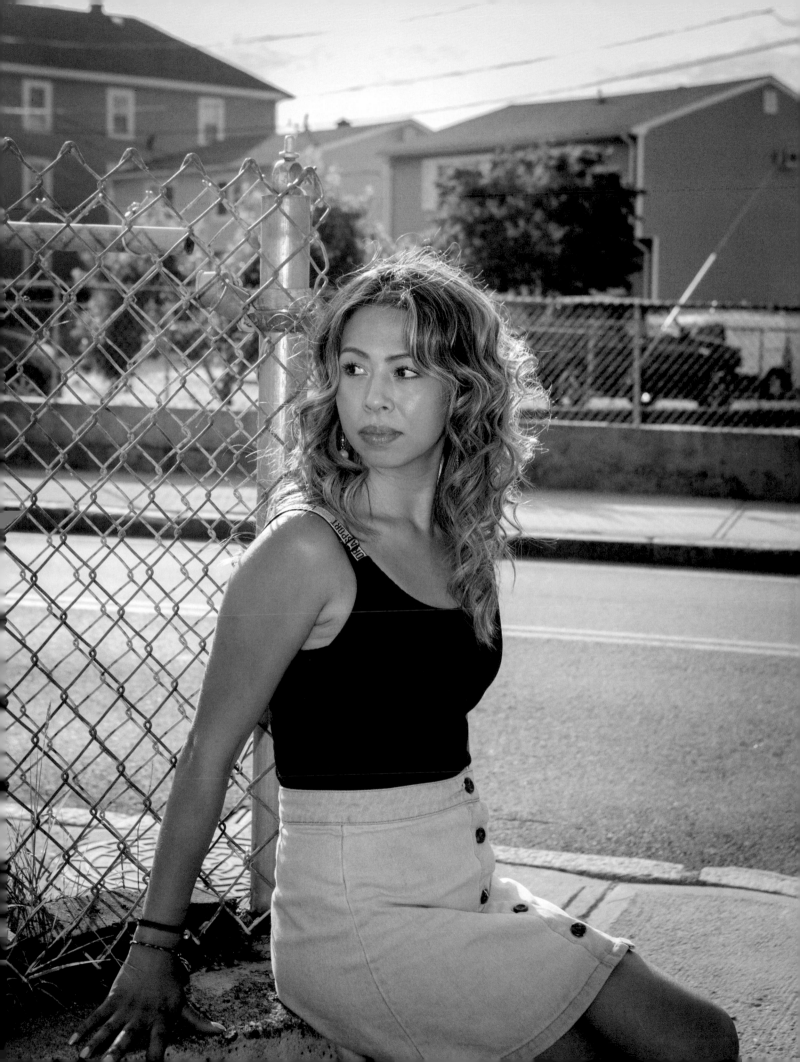

My name is Mary Cory. My husband, Tom, and I have been given stewardship over some of the richest soil in the world. The land that we farm has been in our family since the mid-1800's. Our ancestors were adventurous pioneers on the midwest prairie. We are located in central Iowa.

As we began to learn more about health, wellness, and nutrition for our own family, it made us desire to change the way that we farmed. Folks who are not able to raise their own food depend on people like us to produce it for them. When we look customers in the eye, we do not want to apologize for the methods we use.

Over the past twelve years, we have transitioned our land from conventional corn and soybean production to land that is grazed by animals.

Our tagline is, "It begins with the soil." To us, this means that if we do what we can to facilitate a healthy soil life, this will allow a variety of plants to convert sunshine and soil nutrients into a healthy product produced by our animals. The nutrient-dense grass fed beef, lamb, chicken, and eggs will nourish individuals. This is one tool to enhance wellness.

When individuals are physically, mentally, and spiritually healthy, they are then able to use their time and resources to think more clearly and to pursue their own dreams.

We derive immense satisfaction knowing that we have done our part to encourage this.

Mary Cory, *Elkhart, Iowa, photographed in 2015*
Mary and her husband, Tom, have six children together,
and Tom has four other children from a previous marriage.
They live in the heart of Iowa farming country.

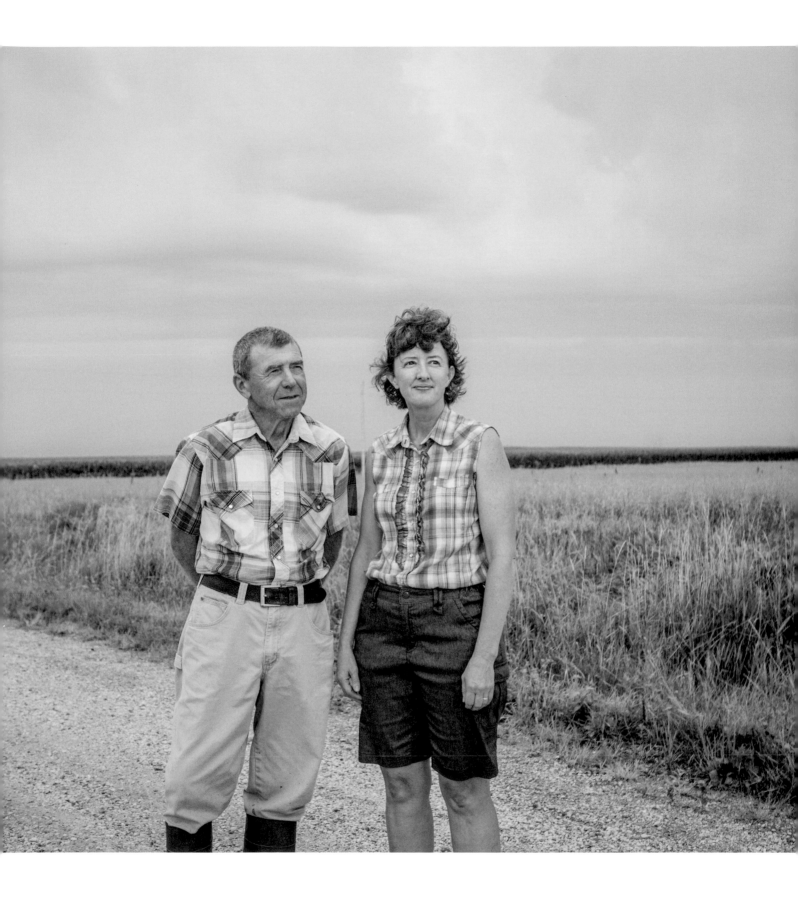

After living in England, I moved back to the U.S. so my sons could live the American Dream. Instead, less than 2 years later, they were both in school on 12/14/12 at Sandy Hook Elementary when a disturbed young man broke into the school and brutally murdered 26 innocents — including my beautiful baby boy Dylan — shot to death in his 1st grade classroom. Now, my dream for America, is to be a country where no child ever experiences the devastation of school shootings. My mission is to make that dream a Reality.

Nicole Hockley, *Newtown, Connecticut, photographed in 2019*
Nicole lost her six-year-old son, Dylan, in the shooting at Sandy Hook Elementary
School on December 14, 2012. After the tragedy, she began Sandy Hook Promise,
an organization that works to protect children from gun violence.

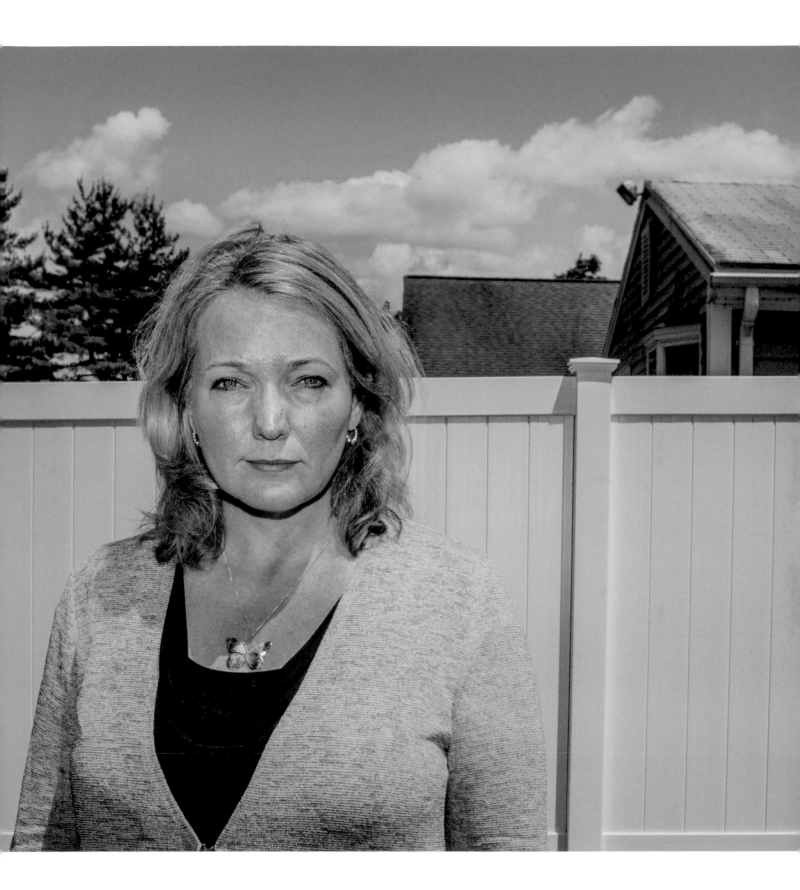

My American Dream

Hello My name is Kora L. Childers. My american dream is to follow my brothers footsteps into the future. He has accomplished going to military, becoming a meteoroligists, passing the most difficult tests, getting the highest score on the ASVAB test where people thought he was cheating!!! The point my brother brings to me is to never give up no matter what life throws at you, and my american dream is to be successful and not just to impress people, but for my own good.

Kora, *Goldfield, Nevada, photographed in 2017*
Kora is pictured with her grandmother Sharon.

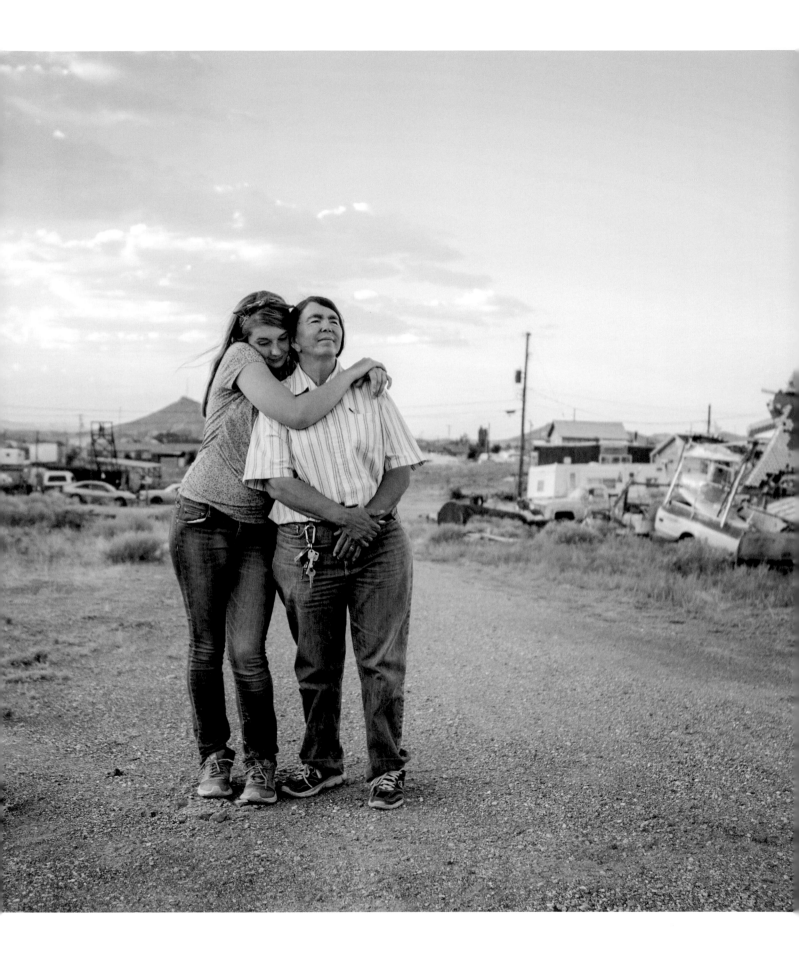

My American Dream

My Ancestors came to America in chains. When slavery was abolished, we were considered three-fifths, and segregated to an inferior societal status. So I dream the dream of a people who have come this far by faith. I dream of an America which embodies it's own declaration: that all people are created equal, that they are endowed by their Creator certain unalienable rights, that among these are life, liberty and the pursuit of happiness.

— Dr. Lisa M. Weah

Lisa Weah, *Baltimore, Maryland, photographed in 2015*
Lisa is the pastor of the New Bethlehem Baptist Church in Sandtown, the neighborhood in Baltimore where Freddie Gray died in police custody in 2015.

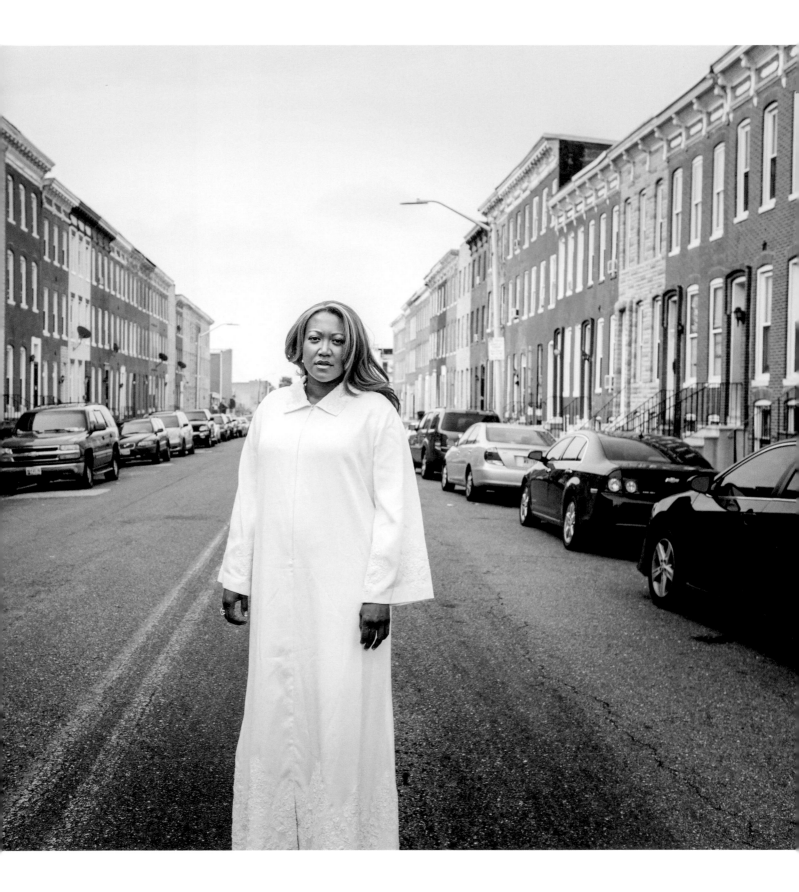

I Think I would have been good being born in 1850 and being part of The Westward expansion Exploring new and unsettled Land as a Hunter Trapper and prospector

I discovered the Wrangell Mts of Alaska as a young man and persued That dream looking for and finding Gold guiding hunters, and Trapping in The winter.

Building a home and living in Wilderness Areas has been my dream as long as I can remember

Now as these mts become more settled I use my bush plane to visit The more lonely Lands.

Gary Green, *McCarthy, Alaska, photographed in 2019*
Gary built his house over thirty years ago in one of the most remote communities in America, hauling and milling all the logs himself. He is a bush pilot by profession and bought his first plane more than forty years ago with gold he had prospected.

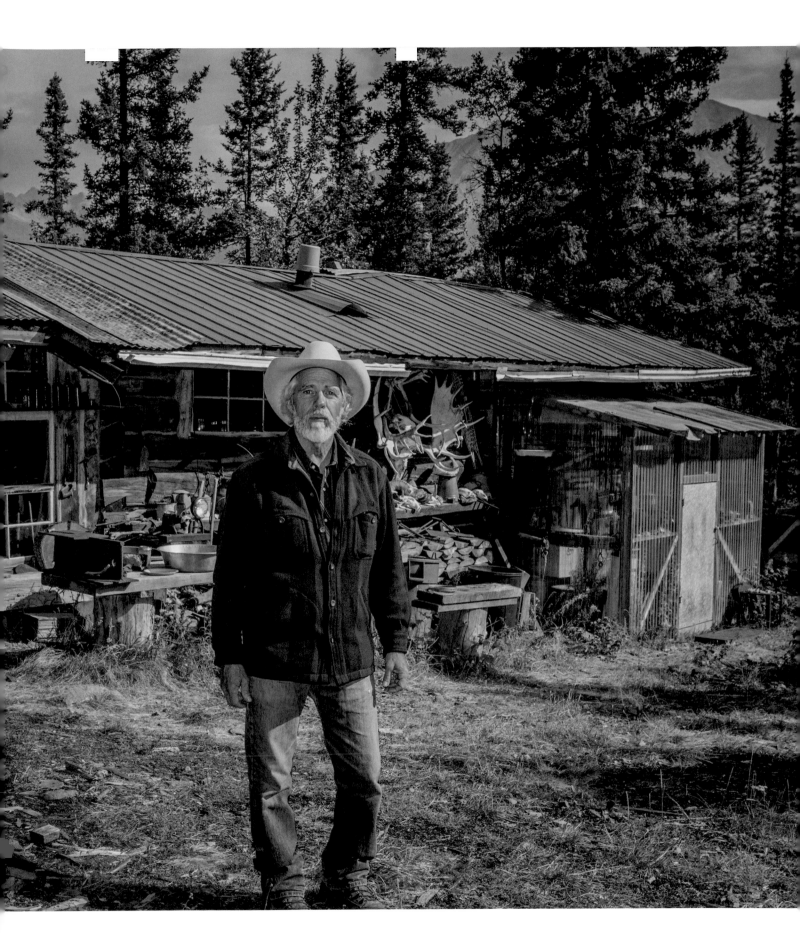

Michelle Jones, *Tampa, Florida, photographed in 2017*
Michelle and her husband, Brian, were photographed at Altair Training Solutions, a former
state prison facility they purchased and ran as a military training center. The property was
seized in a raid by multiple government agencies and foreclosed on in June 2018.

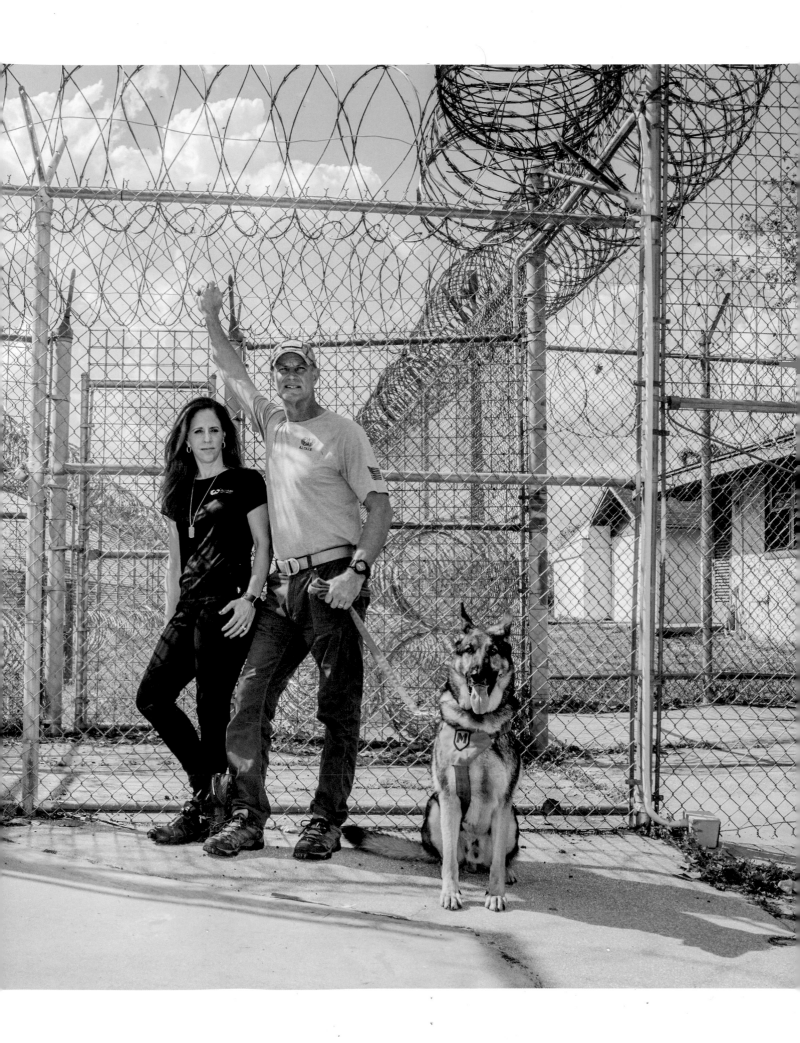

What does the American Dream mean to me?

I'm from Cape Cod, MA and come from a hard-working, blue-collar family w/strong roots. I started working when I was 13. I put myself through college at Master's Degree level; served in the military 13.5 yrs where I was a Company Commander in Iraq for a year and I've been a small business owner for 14 yrs. I've travelled to over 30 countries and I still absolutely believe that America is the greatest country on Earth. I believe that in America you can be anything you want to be. So, my answer to the question... The American Dream is FREEDOM.

The freedom to co-create with God, any life I want to create. The freedom to create wealth/prosperity/abundance in all areas of my life. The freedom to believe in what I want to and to be Conservative without being called a racist or bigot. The freedom to defend myself and legally carry a gun and safely train others to do the same. The freedom to build and run a business within the parameters of the law without excessive government intervention and regulations that impede success and progress.* Freedom for our military leadership and service men/women to do their job in combat without political agendas that get our people killed time after time.* The freedom to pray and honor God openly without persecution, because America needs it desperately.

A judicial system free from political corruption where justice is actually served rather than outcomes being determined by who has the most money and can hire the best lawyers. A country where politics and corruption are not the foundation; and promotion and success is based on merit and mindset; not gender, skin color, or how much money you're willing to pay.

Concluding, the American Dream to me is getting back to the basics... God first, Freedom, and Capitalism. That is what made America great in the first place and the only things that will keep her there. All the greed, corruption, political attempts to take away our rights and divide our country, impose Socialist ideas and punish the wealthy will only destroy America and everyone in it. The American dream is the Land of the FREE and the home of the BRAVE. God Bless America always.

Michelle (Gleskey) Jones
Army Veteran, Entrepreneur
Tampa, FL

What Is The American Dream

Much like a deep dream is frail when you begin to remember it, the American Dream is an ephemeral idea. A gossamer cloth. Wind in the branches high in a tree.

Certainly there are some constants:
Life, Liberty, and the pursuit of Happiness.
Give me Liberty or give me Death.
Architect of one's own life.
Ain't nobody can stand in your way.

The long view through World History and Anthropology confirms that whatever it is, it's unique.

For me, as an American Dreamer, I chose Life. I chose Liberty over a slow Death. I've experienced the pursuit of Happiness. I sacrificed the domestic path of family and home, the pressures of an imposed social identity and chose to create my own persona.

I gathered together all of my influences - The Road, literature, history, my Grandfather's 1950 Buick Roadmaster, Americana artifacts, travel, 20th century flotsam and jettsom,the idea of travel as a source of inspiration, Kerouac and Cassidy, Lewis and Clark, Thelma and Louise, the saving grace of Rock n Roll, my own Walden Pond, small town pool halls, 6:00 a.m. diners, Bluesman as shaman, Jazz as oracle, my voice coming back to me from deep in the Grand Canyon, Stagger Lee, Paul Bunyon, John Henry, Johnny Appleseed, Apache, Commanche, Sioux, cotton fields, wheat fields, leaves of grass, sea to shining sea.....
I took all these things and turned them into, or made them into, or rather more aptly I was made into, by some act of fate, a rolling business in the travel industry where I give tours exploring the physical and cultural landscape of America. I'm free to support my self financially, dream and create, and culturally influence this epoch called the American way of life. 30 years ago in an epiphany I named my tour business the American Dream Safari.

So....what is the American Dream?
I can only speak for myself.

Tad Pierson, *Memphis, Tennessee, photographed in 2014*
Tad lives in a warehouse with a collection of salvaged
Airstream trailers that he calls his "indoor trailer park."
He also gives unscripted driving tours of Memphis.

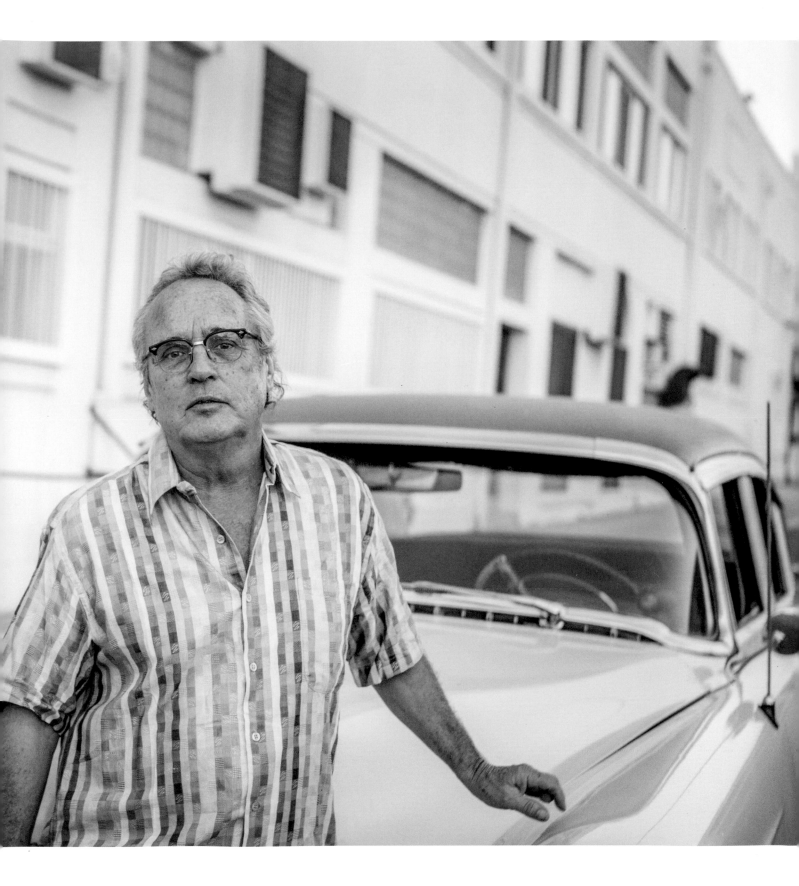

We are living our dream,
our American Dream!
We choose to be happy without
making our lives about how
much money we make. We
base our success on our
children and our relationship
with them. We care about
our Mother Earth. It is
important to us to leave the
smallest footprint behind in
all that we do. We don't know
if it is possible to leave this
world in better shape than
it was when we arrived
but we sure can try!

Freedom is the
American Dream!

Miss Kitty
&
THE IDAHO
Hillbilly

Kevin and Kitty, *Council, Idaho, photographed in 2019*
Kevin and Kitty run a salvage business, an eBay store,
and a YouTube channel. They also forage for mushrooms,
which they sell to wholesalers.

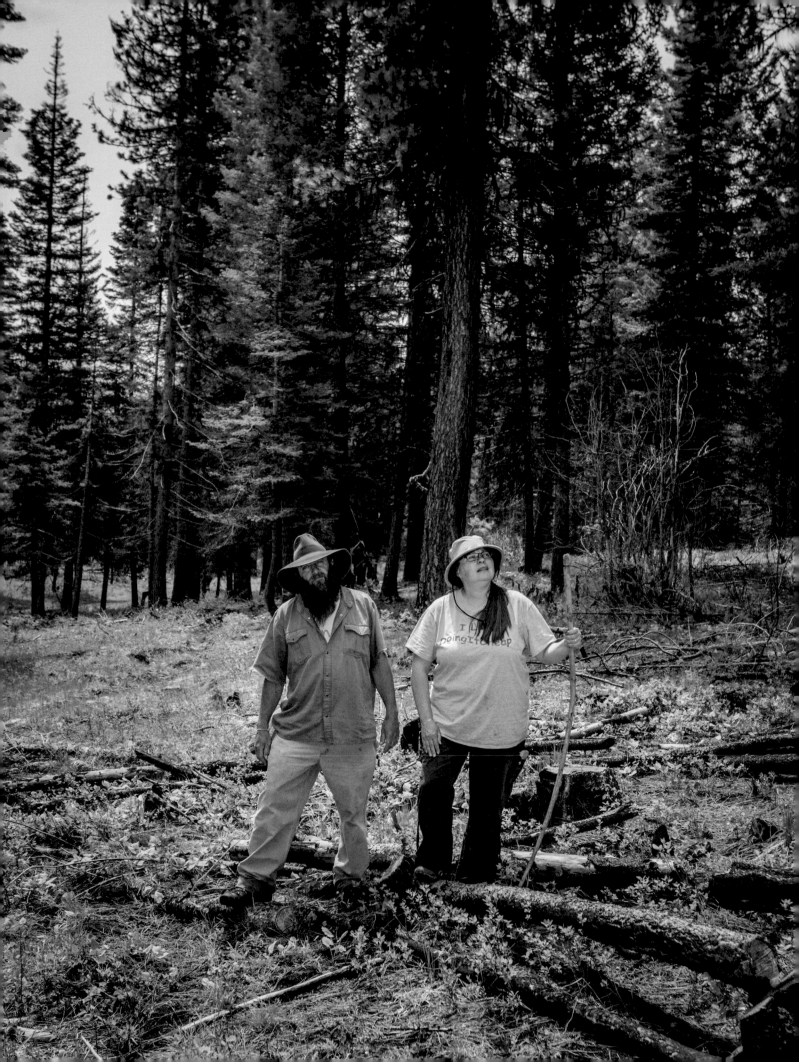

May 6, 2015 4pm

I think a dream is to improve oneself in many ways to better yourself and others around you. Create and engage with the neighbors, community, and society so we can establish and build a healthy, happy and peaceful environment to live in. So we can leave these foot prints for ours sons & daughters to follow. If everyone can reach one and touch one and pass on, the world will be a better place.

In America, I think I can put my dream into a reality much easily than when I was in Burma, a place I called home, where almost everything is restricted. To settle and start a life in a new place, culture & environment... it's not easy, ...a lot to learn. My American dream is to do the above as much as I can and explore and live life to the fullest. For me, to live a life that is not beneficial to others is in vain.

Faustina Sein

Faustina Sein, *Buffalo, New York, photographed in 2015*
Faustina is a refugee and is from the Karen people of Myanmar (Burma).

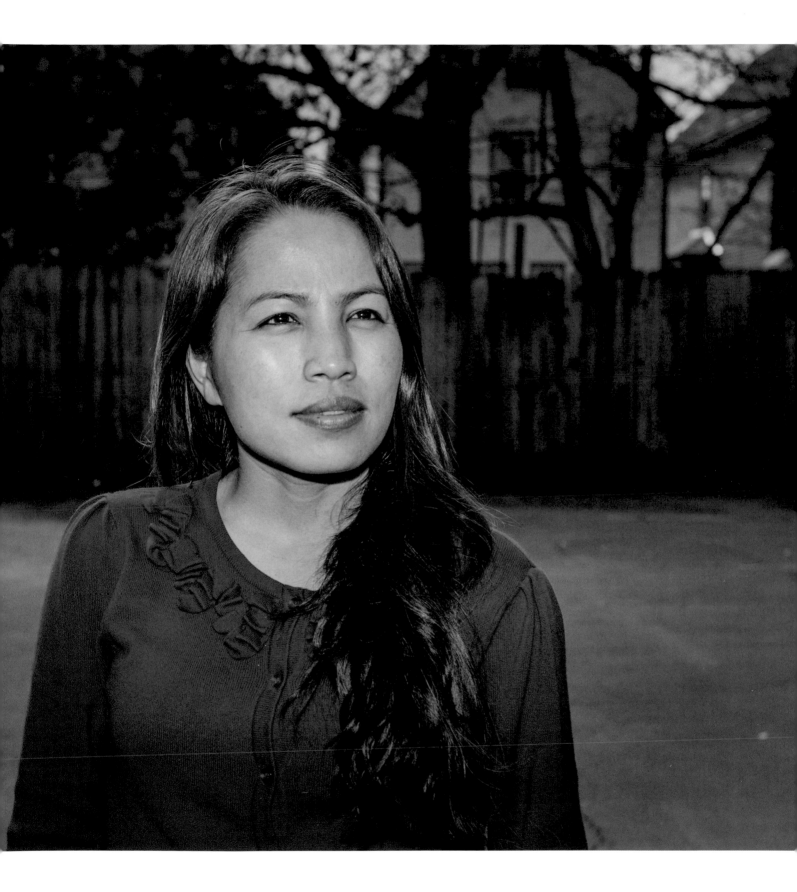

My American Dream

I wish to one day see a more simplistic society within our country as well as globally. Everyday people like you and I struggle to pay off bills that seem to be endless. Most of us work long days for next to nothing pay just to make ends meet. I wish for the concept of Money, Politics, and Society in general to change or disapear forever. Right now we are more distant and seperated than we have ever been!

What Does The Future Hold???

I feel a time is coming when people will come together to govern themselves. A system based on morals instead of man made laws designed to oppess. Communities will grow their own food, collect their own water, protect each other, ect... So if we come together life would be less stressful. The need to work for a chain store or corperation would disapear as people once again became involved with their communities. When survival can be simple with a little team work then why would you ever want to make it complicated and stressful. You can choose to live another way, a simpiler... You just have to take a leap of faith and step away from the reality everyone calls Normal...

"Peace Be The Journey"

Nick Smith, *Thurmond, West Virginia, photographed in 2014*
Nick was living in his car while waiting to begin work as a
river rafting guide for the spring season.

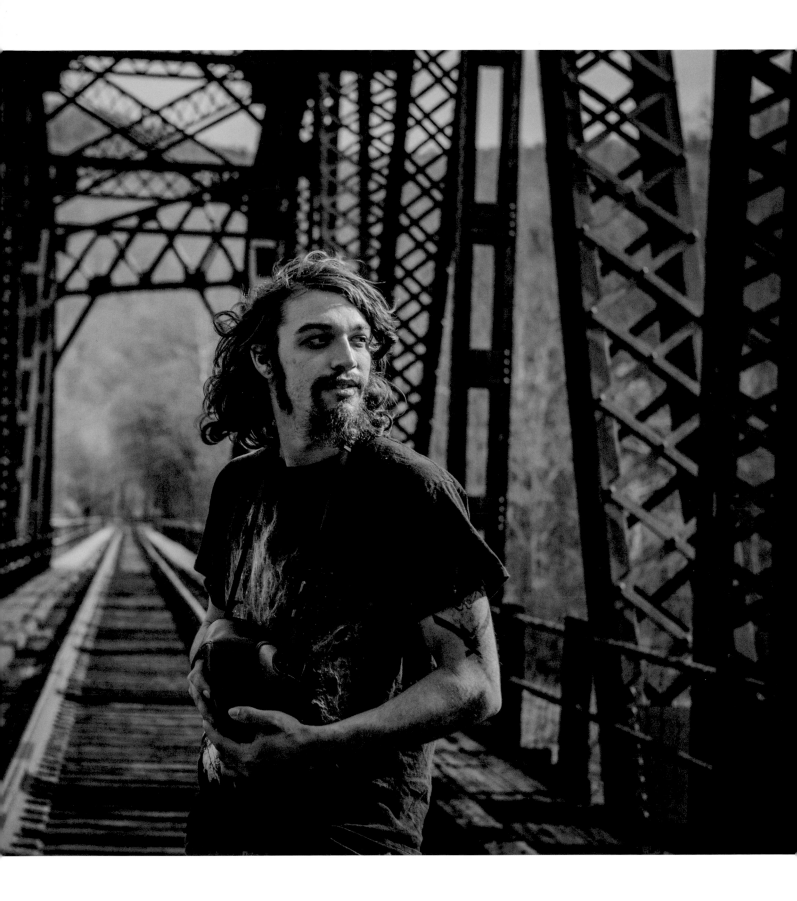

What does the American Dream mean to me?

"To some it means financial success, to others it means freedom of expression. While others dream to practice their religion without fear. The "American dream" is a complex concept providing Americans with the hope of better life. However, the American dream for any person and for any epoch has always been based on the following pillars: freedom, equality, control over one's destiny and an incessant pursuit of one's dream. The American Dream is based on the idea that any person, no matter what they are, can become successful in life by his or her hard work. The dream also embodies the idea of a self-sufficient person

I want my kids to live a better life than I did. The American Dream is still alive out there, and hard work will get you there. The ideal society for America is the society which different people can live together in harmony. Equality despite differences is a very desirable thing. History has shown that by accepting the differences and acknowledgement of others can lead to prosperity

Keandra, *Kentwood, Louisiana, photographed in 2018*
Keandra became paralyzed after her boyfriend at the time intentionally drove their car into a tree. She lives with her mom, sister, and two daughters (pictured).

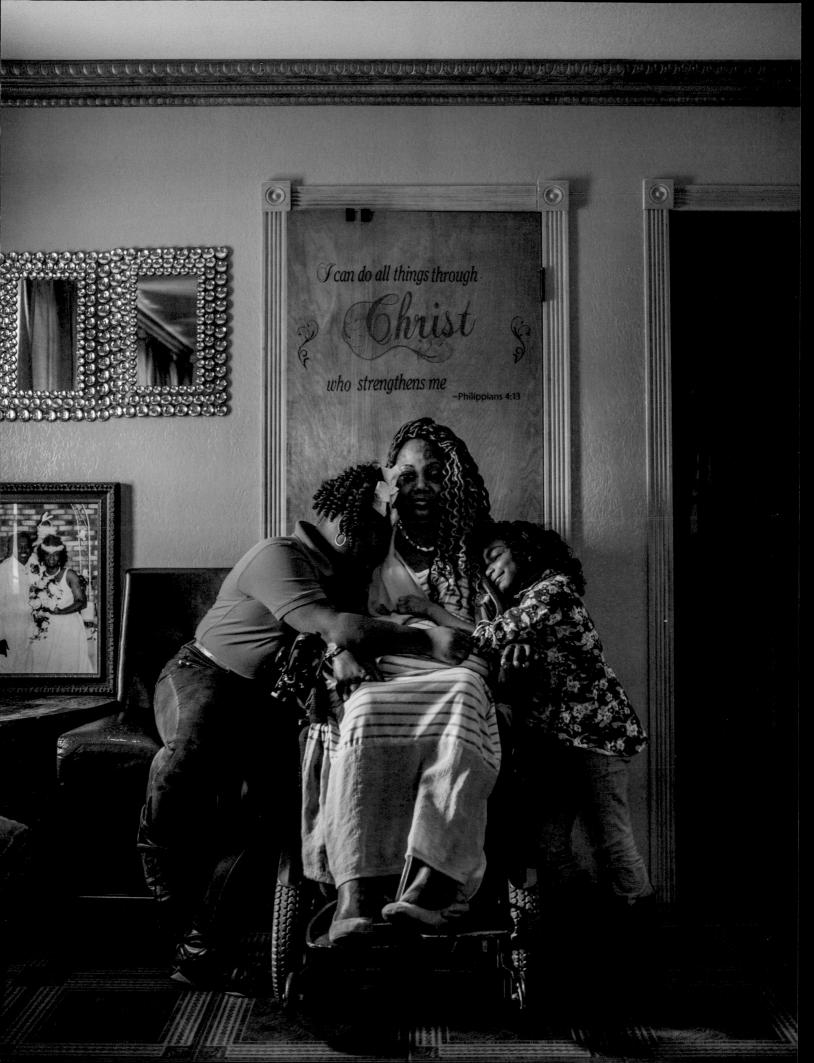

The American Dream

This differs with every individual and we must accept we all differ in ability, outlook, and result. It's in our DNA + free will. In our bitter political divide millions believe institutions (government, church etc) can engineer "happiness", a utopia, or "restore" a mythical "better time".

At 58 I live a life I never knew possible at 18. When I put aside the unrealistic and concentrated on what I could control life became easier even with personal adversity.

For America technology has changed everything We have students building robots in their basement, Skype with a friend in India I'd never known otherwise. We made huge gains against pollution, etc

Too many are fixated on external ideology political causes etc. instead of the reality; Your life within reason the control is in YOU! Achievement, adaptation, and learning is a choice, start doing it!

Lewis Loflin, *Bristol, Virginia, photographed in 2013*
Lewis works as a security guard and is an electronics hobbyist.

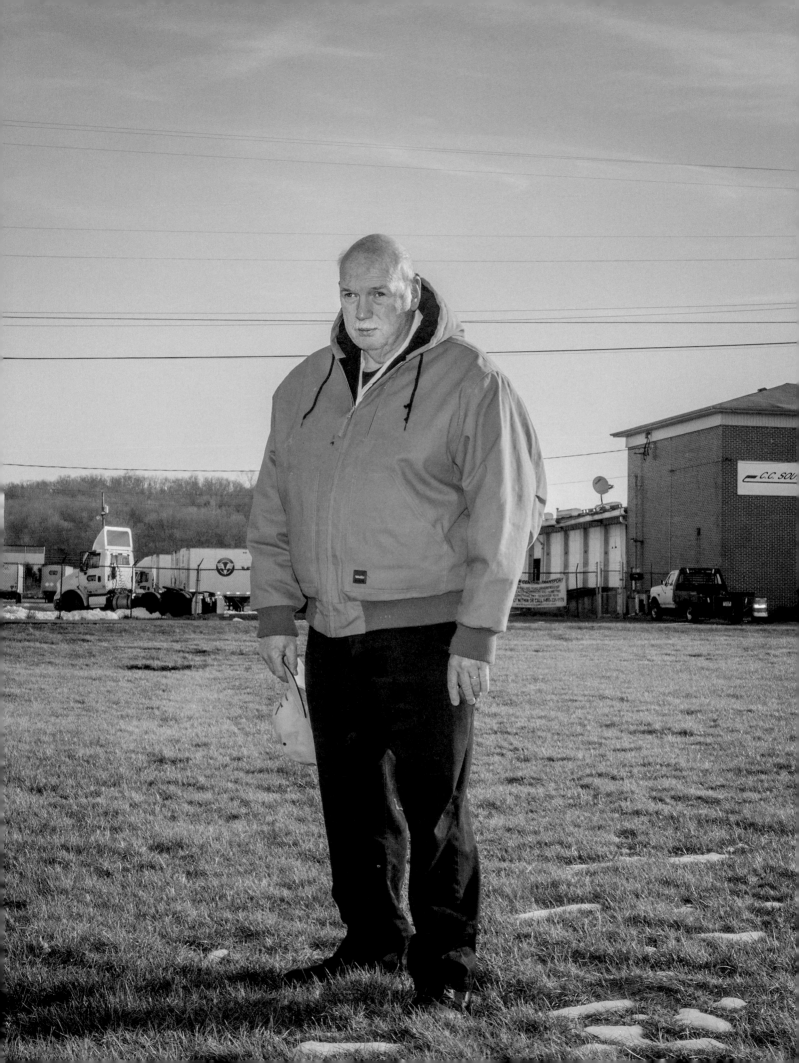

AMERICAN DREAM

TO LOVE MY WIFE AND LIVE
OUR LIVES IN FREEDOM AND
HAPPINESS
ALSO TO TRY AND BE THE
PERSON THAT I BELIEVE
MY DOG THINKS I AM

JUST AS MY ANCESTORS FLED THE NAZI'S FROM
GERMANY TO AUSTRIA TO AVOID HARD LABOR AND
DEATH AND FROM ITALY TO AMERICA TO LIVE THE
AMERICAN DREAM, I FOUND MYSELF STANDING AT
THE CROSSROADS CONTEMPLATING WHAT MY PURPOSE
IN LIFE WILL BE. . . . WHAT PATH AM I MEANT TO TAKE?
WHAT WILL BE MY FATE? WHERE WILL ALL THE
TWIST & TURNS OF MY CHOSEN PATH LEAD ME TO IN
THIS JOURNEY OF LIFE? THE MYSTERIES OF MY DESTINY
WILL UNFOLD AT EACH TURNING POINT?!!

LIFE IS TO BE LIVED WITH FREEDOM AND PASSION; TO
SHOW COMPASSION. I WILL NOT BE CONTENT TO TAKE MY
PLACE AT THE CURBSIDE AND SIMPLY LOOK ON AS
I SEE THE FALL OF HUMANITY ALL AROUND ME
THROUGH SOCIAL INJUSTICE. CURIOSITY WILL NEVER
ALLOW ME TO TURN MY BACK ON AN OPPORTUNITY
TO MAKE A DIFFERENCE OR TO BE THAT DIFFERENCE. . .

LIFE IS TO BE "LIVED", "TO STAND OUT." WE WERE ALL
MEANT TO BE A PART IN EACH OTHERS JOURNEY. LIFTING
ONE ANOTHER UP AND OUT OF THE GRIPS OF PAIN AND
SUFFERING. ONCE I STARTED LIVING LIFE, EVERYTHING
BEGAN TO CHANGE. MY ROSE COLORED LENSE FELL OFF
AS I REALIZED THAT LIFE FOR SOME CAN BE
UNFORGIVING. LIFE FOR ME FEELS GOOD AS MY LOVE
FOR THE UNIVERSE BEGAN TO FLOW THROUGH ME. . .

I WILL TRAVEL THE WORLD IN SEARCH OF WHAT
I NEED, AND I WILL RETURN HOME TO FIND IT. . .

WHAT I BELIEVE, I WILL ACHIEVE . . .
I AM THE POOR LITTLE RICH GIRL
Vicki Kobayashi

Chris and Vicki Kobayashi, *Makawao,*
Hawai'i, photographed in 2019
The couple was photographed
at their home with one of the many
dogs they have rescued.

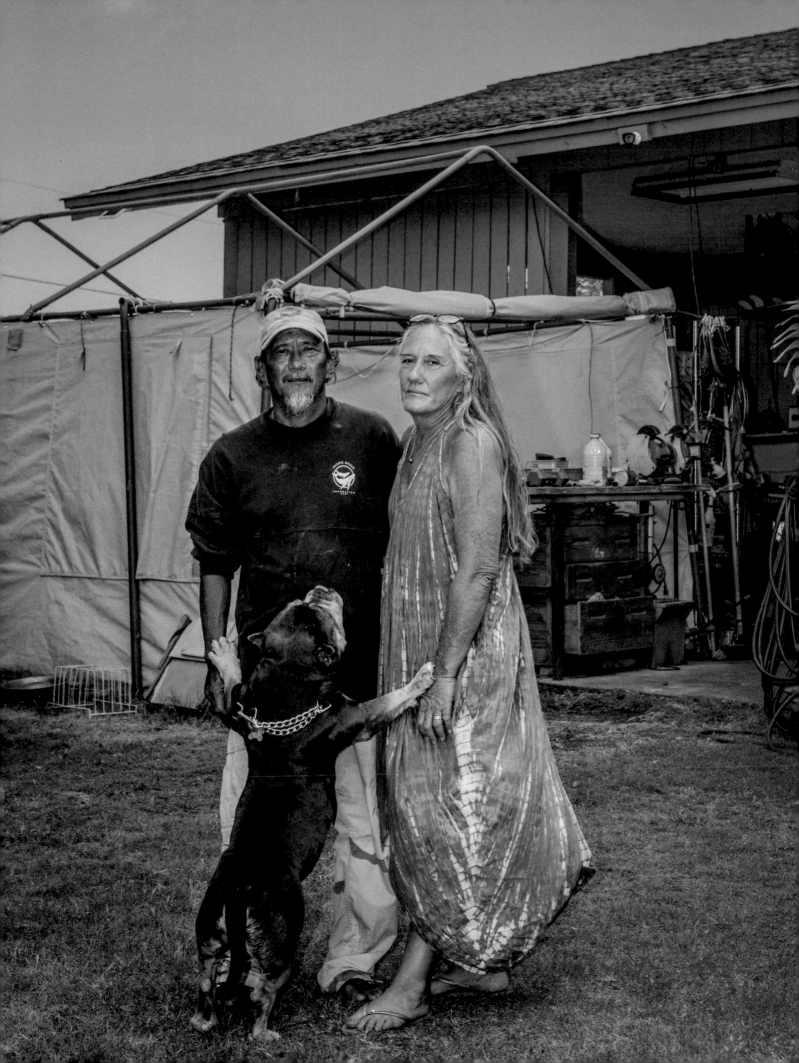

MAY 2019

WHEN I WAS IN MY 20's, I THOUGHT MY "AMERICAN DREAM" WAS TO FIND A WAY TO SUPPORT MYSELF WITH HOURS I COULD WORK AROUND MY DRINKING/HANGOVERS. I ~~OFFE~~ ACCEPTED THE OFFER TO GET HELP WHEN MY PARENTS PRESENTED IT. MY LAST DRINK WAS IN JUNE OF 1997 WHEN I ENTERED A REHAB FACILITY. FAST FORWARD 20+ YEARS (WITH THE HELP OF FRIENDS, TEACHERS, SONGS + SPIRITUAL GURUS) I'M MARRIED + LIVING IN THE ROCKY MOUNTAINS OF COLORADO WHERE MY HUSBAND (ALSO SOBER, SINCE 1999) AND I BOTH GET TO WORK AT A REHAB FACILITY IN BEAUTIFUL ESTES PARK, COLORADO.

"JUST ASK AND YOU'LL RECEIVE, BEYOND YOUR WILDEST DREAMS..."

LYRICS FROM HOW IT ENDS BY LOCAL DENVER, COLORADO BAND - DEVOTCHKA

Peter, *Allenspark, Colorado, photographed in 2019*
Peter (left) and his husband, Jim, both work at a recovery and treatment center close to Rocky Mountain National Park.

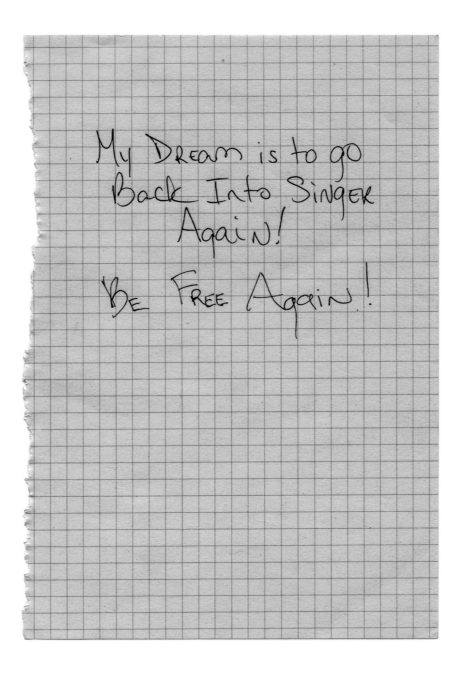

Leanette White, *Washington, DC, photographed in 2019*
Leanette says she is from Barbados and lived in eight homeless
shelters in 2018. She is planning on moving to San Francisco.

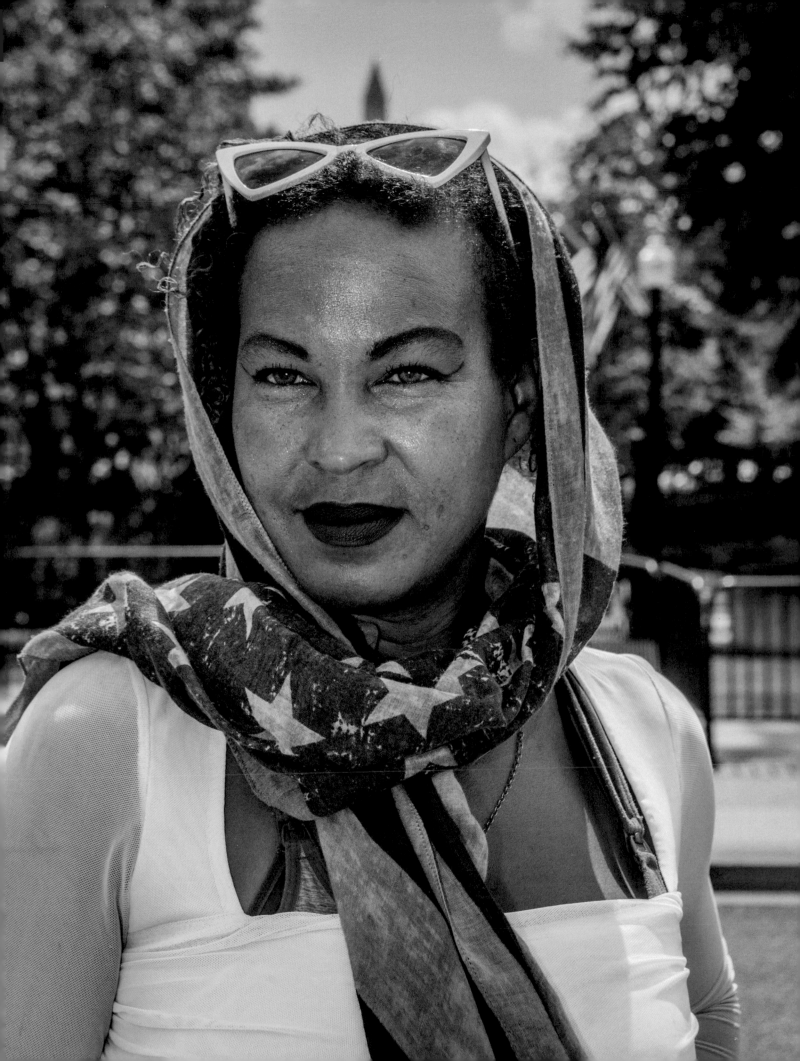

THE AMERICAN DREAM —

"LIFETIMES FILLED WITH HAPPINESS, PEACE, GOOD HEALTH, PROSPERITY, AND, MOST OF ALL, LOVE — THE GREATEST GIFT."

FOR MORE THAN TWO DECADES, I HAVE BEEN A VOLUNTEER ADVOCATE FOR MILLIONS OF CHILDREN WHO HAVE BEEN ABUSED, NEGLECTED, EXPLOITED, ABANDONED, HOMELESS, AND INSTITUTIONALIZED.

OFTEN, I SUPPORT AGENCIES AND ORGANIZATIONS THAT PROVIDE FOR THE HEALTH, SAFETY, AND WELFARE OF VULNERABLE CHILDREN IN DIRE STRAITS.

AND, I CONTACT STATE AND FEDERAL LEGISLATORS TO PERSUADE THEM TO DRAFT, SPONSOR, AND PASS LEGISLATION THAT IMPROVES OUR CHILDREN'S LIVES AND FUTURE.

I'M A CLERGYMAN AND MONK AND A FORMER COUNCILMAN ON THE CITY OF NORTH POLE IN ALASKA.

BLESSINGS,

SANTA C.

SANTA CLAUS
NORTH POLE - 2019

Santa Claus, *North Pole, Alaska, photographed in 2019*
Formerly known as Thomas O'Connor before he legally changed his name,
Santa moved to the small community of North Pole, Alaska. He was previously
elected to the town council, and, after a hiatus, is running for council again.

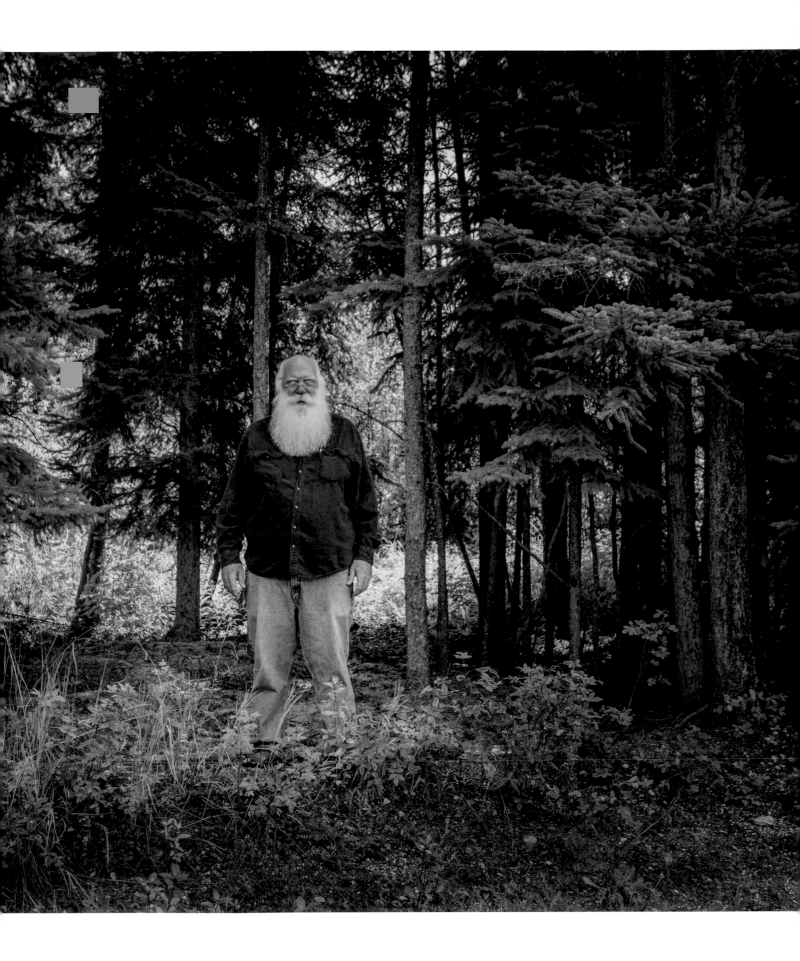

My American Dream is simply to be accepted as an American. After 25 yrs in this country, I'm still not considered an American here and abroad. Many still ask me, "what are you?" When I answer, "American," I usually get the response, "No, seriously, what are you?"

If you really want to know, I'm Vietnamese. I wasn't born in this country. I speak English with a slight Vietnamese accent, at least according to some "Americans." I eat rice and use fish sauce as a condiment. I celebrate the lunar New Year. But I don't think any of this makes me un-American.

I am American. When I first came to this country in the early 1980s from Vietnam, I have strived to be American by assimilating in every possible way without losing my Vietnamese heritage. I'm loyal to this nation and have taken an oath of allegiance. I speak fluent English. I respect diversity. I fulfill my civic duties. I believe in freedom and equal opportunity. I love hamburgers and hot dogs.

Yet, most people have only identified me by my skin color, ethnic background, and socio-economic status. These differences in race, beliefs, etc. have translated into discrimination and social inequalities. For this country to overcome them, it needs to embrace differences and diversity. After all this is what being American is about.

Mai Le Liberman, *Boston, Massachusetts, photographed in 2007*
Despite having grown up in Lawrence, Massachusetts, Mai has been told to "go back where you come from" many times.

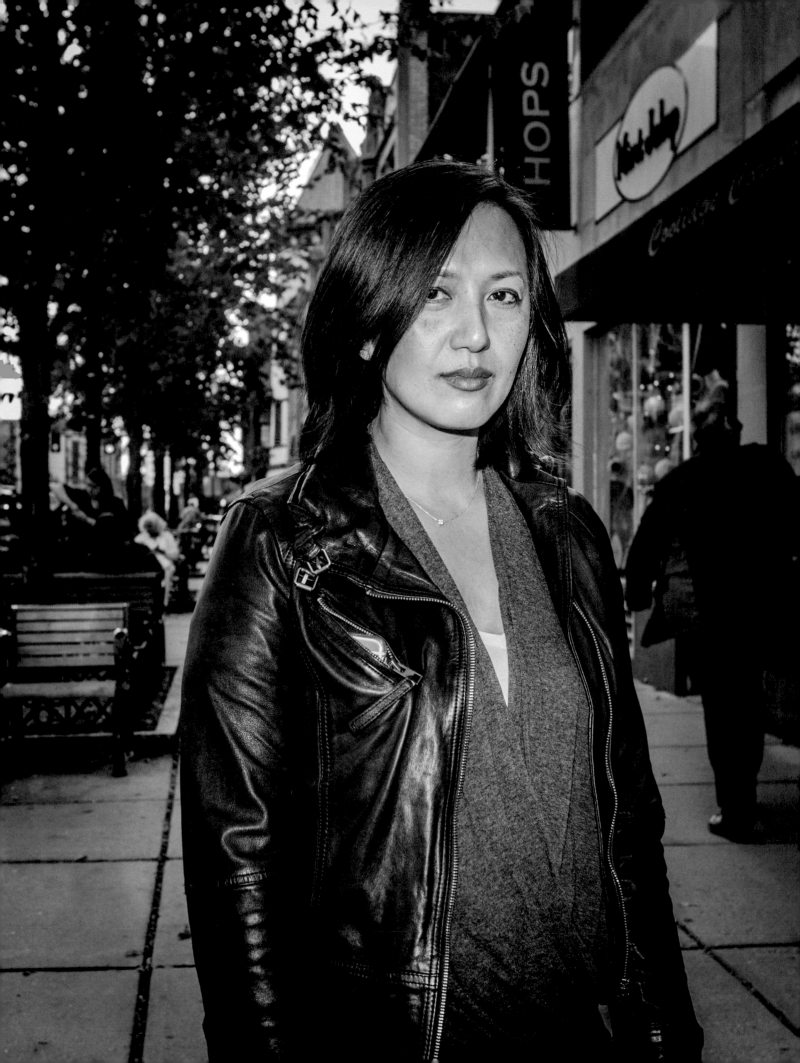

MY AMERICAN DREAM

AMERICAN WAS ESTABLISHED ON THE BASIS OF FREEDOM & EQUALITY. TODAY WE CANNOT SAY THE SAME.

MY AMERICAN DREAM IS TO WAKE UP & NOT WORRY!

KNOWING THAT IF I GET A 0.40c RAISE THEY WILL NOT CUT MY HEALTHCARE OFF. THEY SAY WE ARE FREE BUT IN REALITY WE ARE NOT! THEY CONSTANTLY CREATE LAWS TO KEEP ME FROM MOVING FORWARD. I CANNOT JUST GO TO THE REALTOR & SAY I WOULD LIKE TO BUY THIS HOUSE OR TO A DEALORSHIP AND PURCHASE A NEW CAR. IF I HAVE THE SAME RIGHTS AS WHITE AMERICANS, HOW COME MY CREDIT SCORE IS LOW?

FREEDOM, EQUAL RIGHTS FOR ALL, WHERE?

NOT HERE IN NORTH AMERICA!

Otibehia Allen, *Clarksdale, Mississippi, photographed in 2017*
A single mom to five kids, Otibehia works multiple jobs as a data entry clerk and as a transportation dispatcher to cover her bills. She lost her Medicaid coverage in 2017 because she received a forty-cent-per-hour raise.

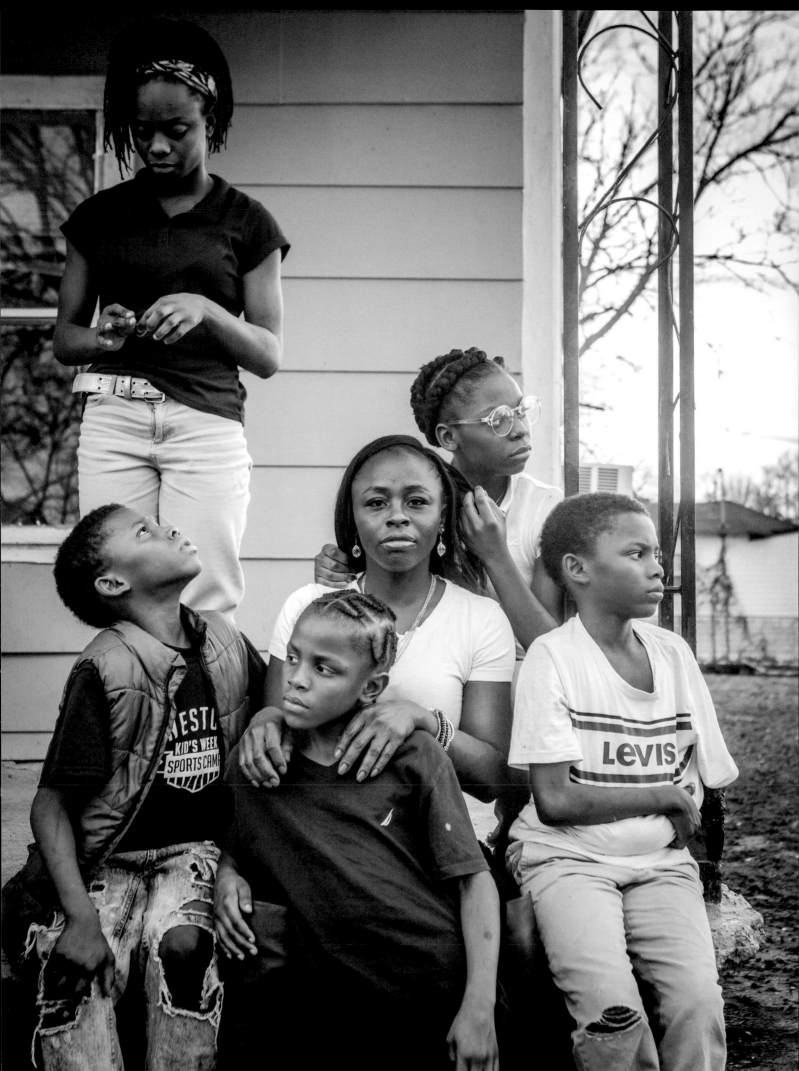

Growing up, the American Dream seemed quite simple: get a great education, work hard, raise a wonderful family, be productive, and make this country and earth a better place. Seems more like a fairy tale now.

Today's American Dream has so many questions. Why is there so much hate that we are destroying core values and democracy? Why is it so difficult to get an affordable, quality education? Why is the middle class falling into the abyss of poverty? Why do we refuse to provide the people with health care? Why do we allow corporate greed to run our government? Why do we allow foreign companies to use eminent domain to destroy our land and water? Why do we continue to destroy the environment instead of rapidly to renewable energy? Why do we refuse to grow sustainable food. What will our grandchildren's American Dream be?

In the time that I have left, my American Dream is to stand up to the forces that divide us, to empower the people, to save our clean water, and to protect the earth.

Art Tanderup

Art Tanderup, *Neligh, Nebraska, photographed in 2017*
The property owned by Art and his wife, Helen, is in the direct path of the proposed Keystone XL Pipeline. They have been pressured by various lobbying groups and corporations to allow the pipeline to run through their land.

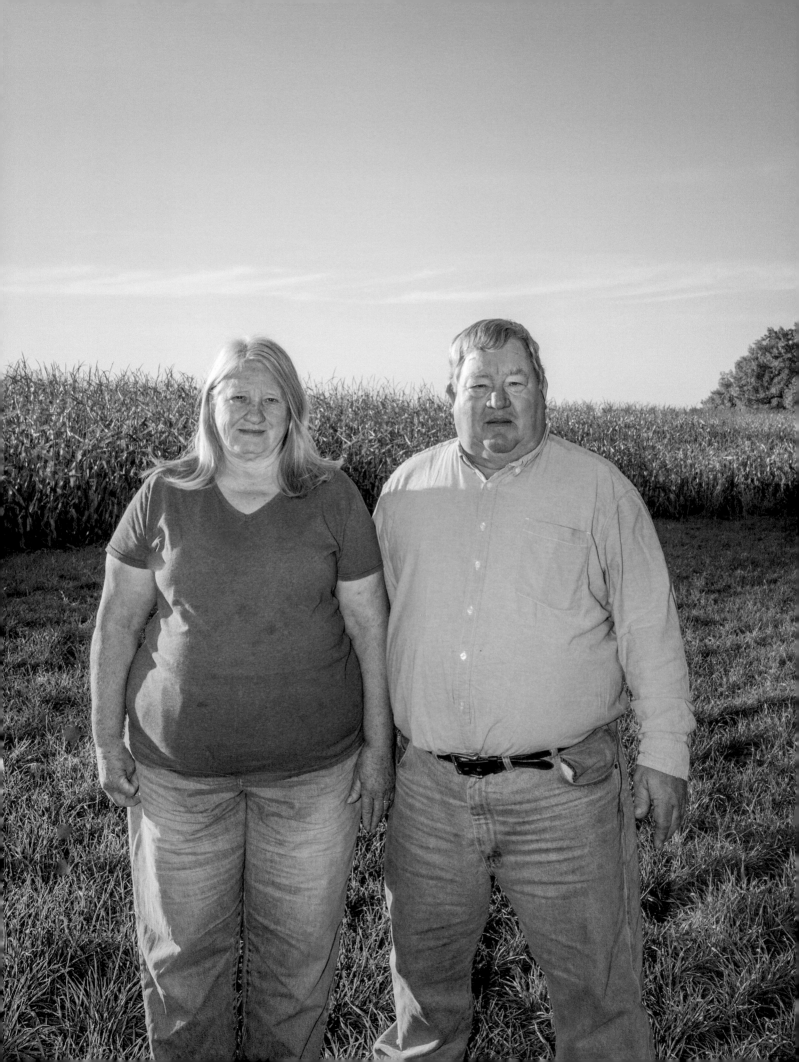

The American Dream is the freedom to have choices!
Ella M. Jones

Ella Jones, *Ferguson, Missouri, photographed in 2017*
Ella has lived in Ferguson for more than thirty-five years. She is a widow
with one daughter. In 2015, she quit her job with Mary Kay cosmetics to
run for city council and won with over 50 percent of the vote.

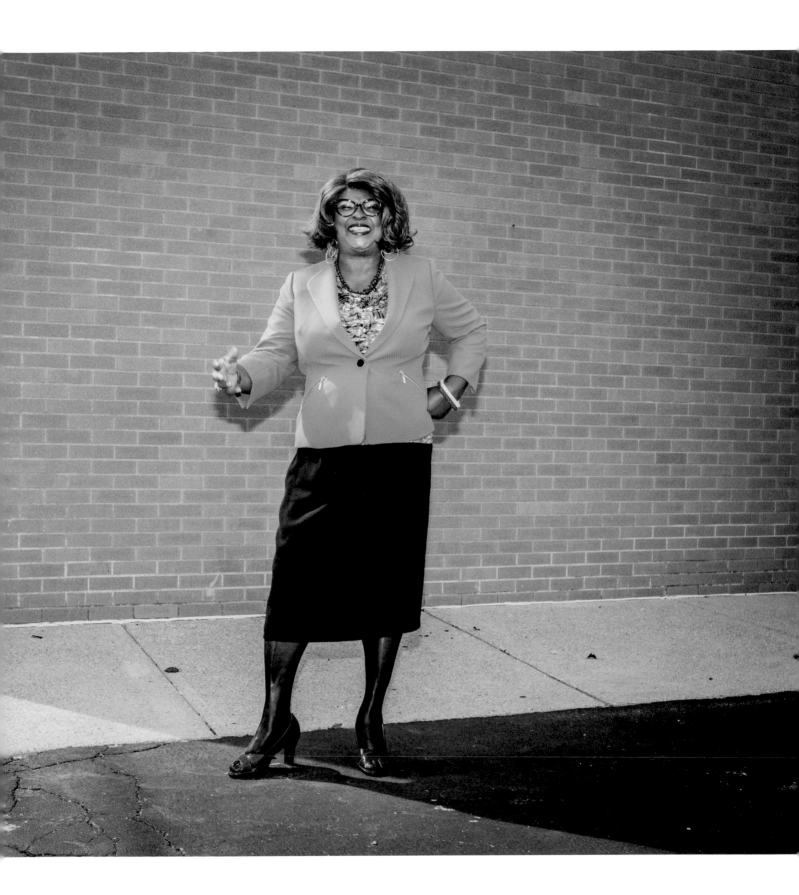

|T|he American Dream Is...
T|h|e American Dream Is...
Th|e| American Dream Is...

The |A|merican Dream Is...
The A|m|erican Dream Is...
The Am|e|rican Dream Is...
The Ame|r|ican Dream Is...
The Amer|i|can Dream Is
The Ameri|c|an Dream Is...
The Americ|a|n Dream Is...
The America|n| Dream Is...

The American |D|ream Is...
The American D|r|eam Is...
The American Dr|e|am Is...
The American Dre|a|m Is...
The American Drea|m| Is...

The American Dream |I|s...
The American Dream I|s|...

The American |D|ream Is...
The American Dr|e|am Is...
The American Dre|a|m Is...
The American |D|ream Is...

Danny Mowat, *Red Lodge, Montana, photographed in 2019*
Danny is a poet and chef/co-owner of a restaurant.

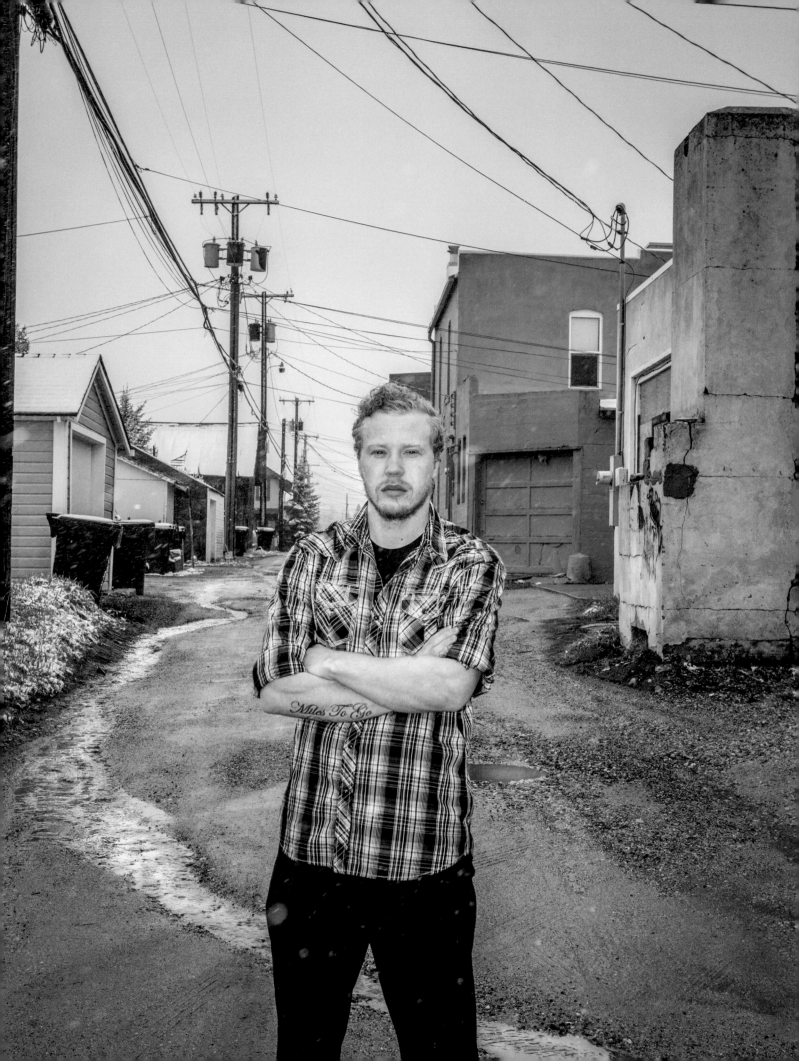

American Dream

My American Dream is where fighting to keep my rights isn't done at the capital. Where law abiding citizens aren't punished for the actions of those who aren't. Where law abiding citizens don't become felons by simply crossing state lines. Where I don't have to justify why I should be able to exercise my Second Amendment right. Where the land of the free is also the land of the open-minded. My American dream, as an all American teen will happen when we realize education is more powerful than legislation.

Dakota Overland

Dakota Overland, *Wyoming, Minnesota, photographed in 2018*
Dakota is an avid hunter and successfully competes in multiple tactical shooting disciplines.

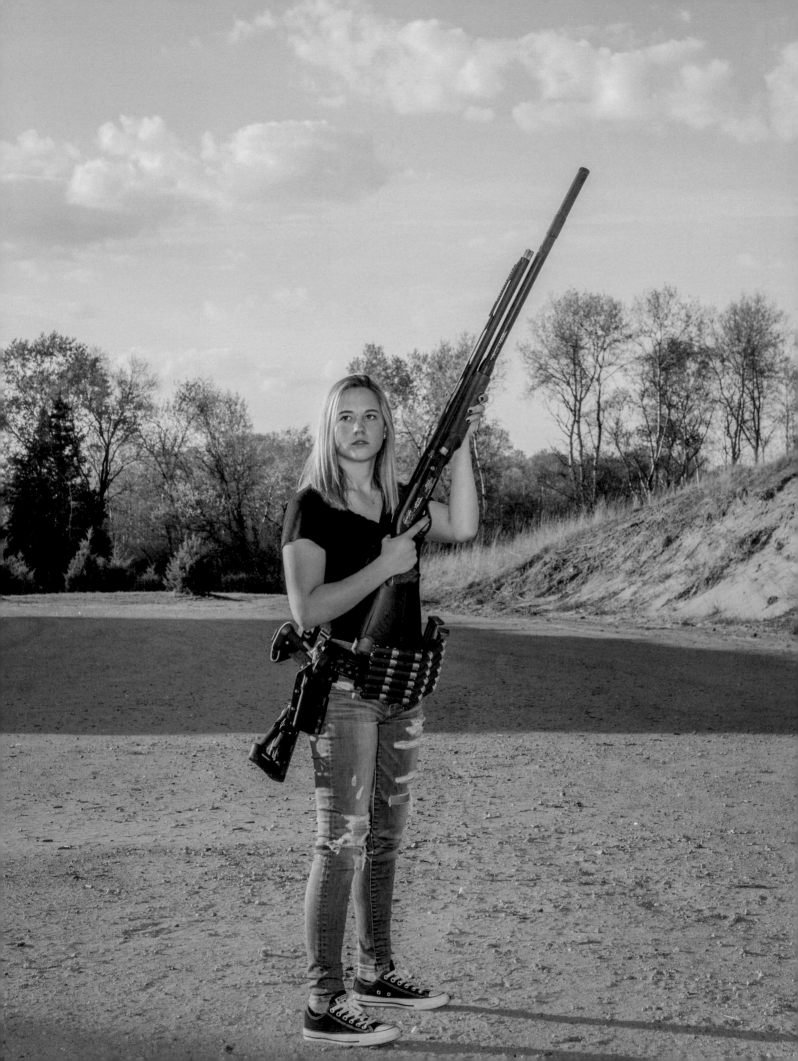

To LIVE IN A CITY WHERE PEOPLE CARE FOR ONE ANOTHER
SPEAK GOOD MORNING AND MEAN IT.

2016 RASCIM IS REAL KILLING REOPLE OF COLOR IS A SIN.
GOD PLEASE HELP CHANGE MINDSET FROM HATRED TO UNDERSTANDING

Ameena Matthews, *Chicago, Illinois, photographed in 2016*
Ameena is a former gang member and the daughter of one of Chicago's most notorious gang leaders.
She is the mother of four children and has worked as a "violence interrupter" and peace advocate in
one of the nation's most violent neighborhoods for the last decade. She is hoping to run for Congress.

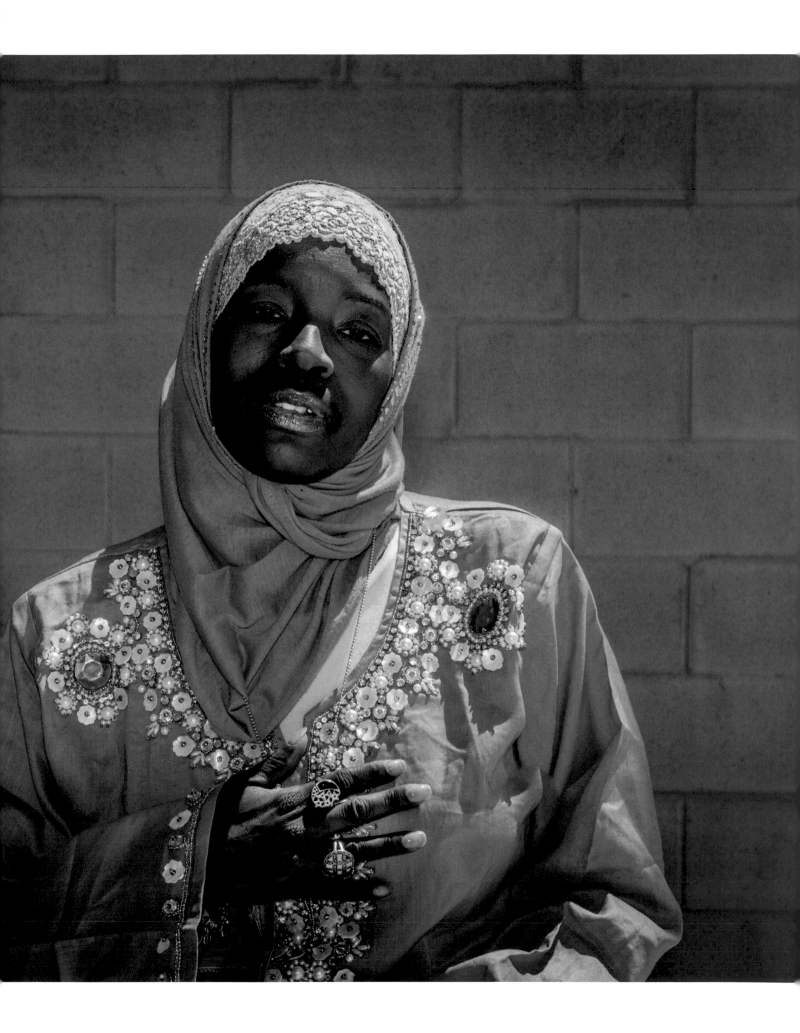

My American Dream

I want a livable future.

 We have been told by the IPCC that we have 12 (now 11 as of 2019) years before climate change is irreversable.

 I am 18. My generation should be planning our futures, not protests for climate action. As an Indigenous woman, it is hard for me to watch the land be so disrespected. Indigenous people know the land the best. We have taken care of it forever and in turn it cared for us. Now as we have been colonized, we have impending climate crisis. What was seen as progress was really only progressing us into our own doom. Indigenous voices have always been speaking and it's time those in power listen.

a hiki i ke aloha ʻāina hope loa

Punahele DeCosta

Punahele DeCosta, *Maui, Hawaiʻi, photographed in 2019*
Punahele is a graduate student and works part time at a restaurant.

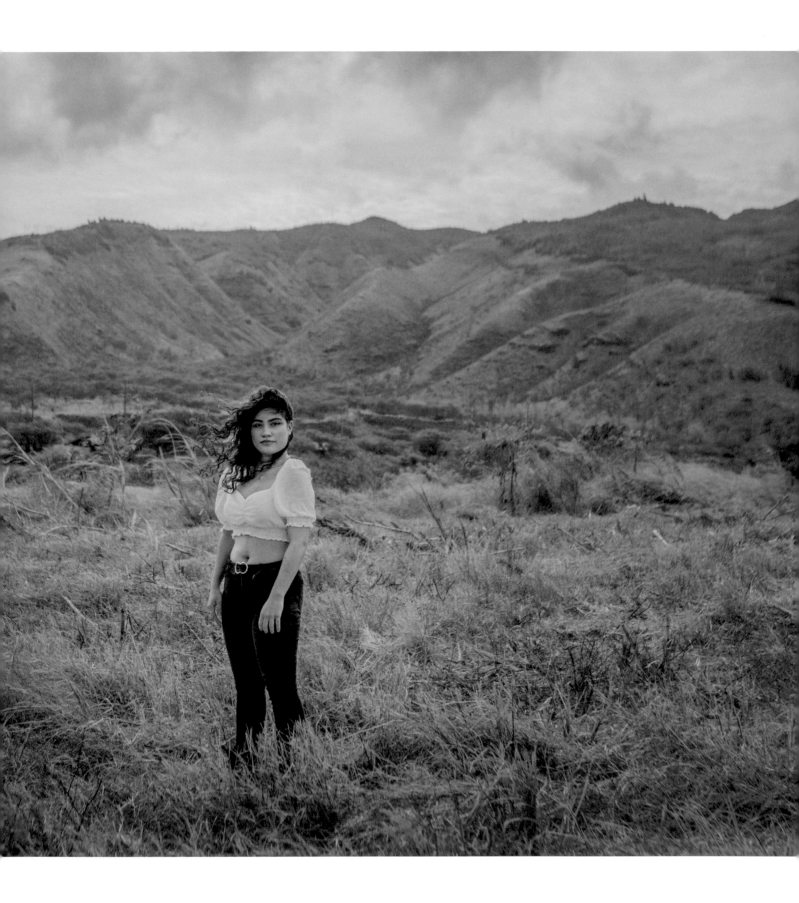

IN 2010 I HAD A GUN in my mouth and wanted to die. and Begged For my Life For my two girls. I SAid SAVE me please For my Kids, and At that moment I Put it DOWN. I SAid save me and I'll SAVE LIFE's TENFOLD. and Today I am alive to Share With you my story. I AM A Proud grandfather. and I SAVE 50 to 100 LIFE's a month, I AM The Founder of Heroin is Killing my TOWN. a grassroots outReach Heroin AWAReNess. Reaching 1 million a week world wide and I INSPIRE The world With my messages

NEVER GIVE UP!
JESS, GABby DADDy Love's you XO

Billy InkSlinger 2015

Billy Pfaff, *Medford, Massachusetts, photographed in 2015*
Billy began a grassroots campaign and a crisis line to assist
addicts after his best friend died of a heroin overdose in 2014.

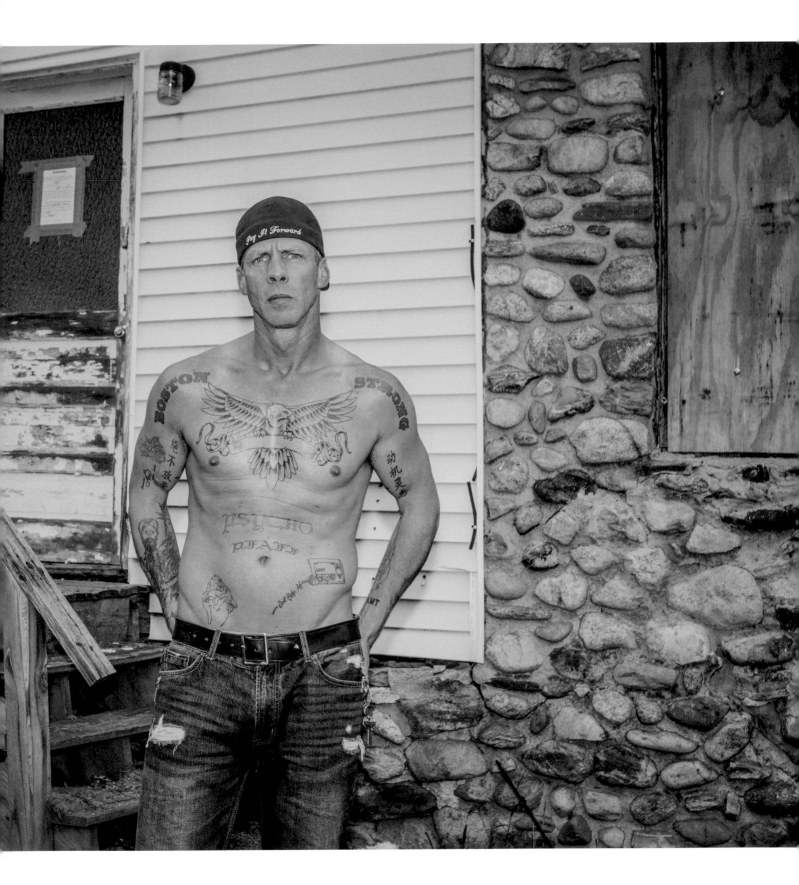

AIN'T NOTHIN' I CAN'T DO AND DAMN LITTLE I WON'T TRY.

Ethan Forester, *Bozeman, Montana, photographed in 2019*
Ethan works as a horse wrangler; his job is to round up and
capture wild mustangs in the American Southwest, then
transport them to Montana and "break" them.

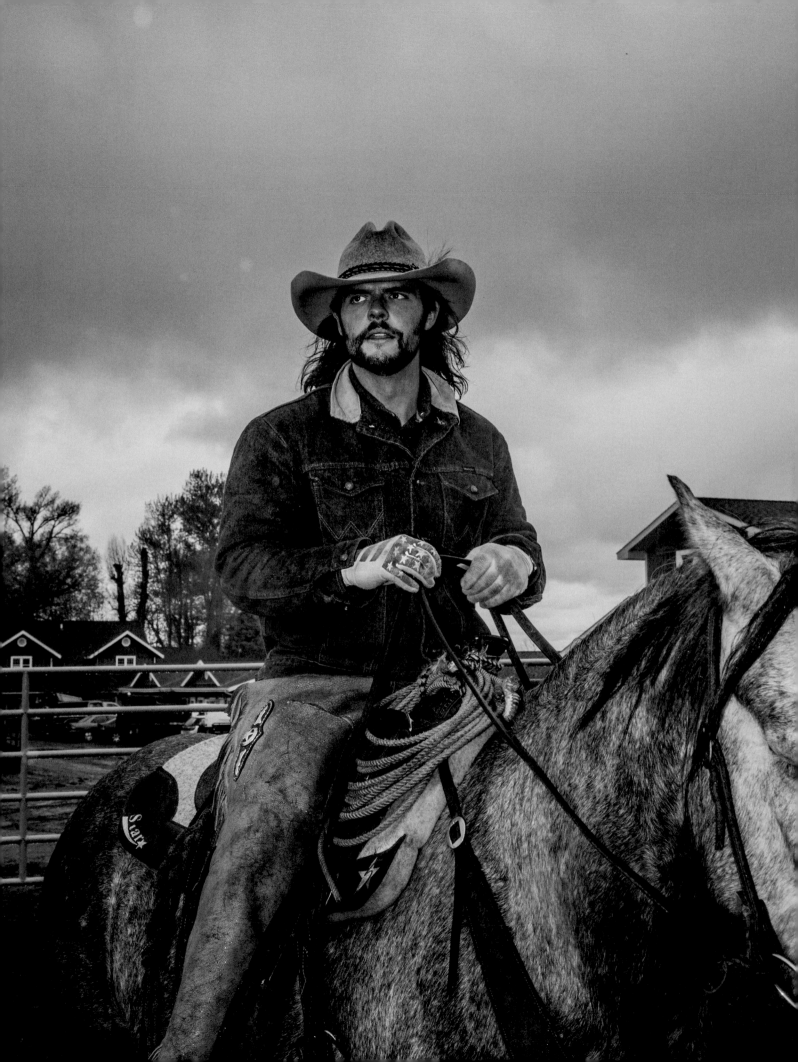

My dream is to never stop growing,
changing, or becoming — my
transition from female to male
was only the beginning — I want
to feel whole in my skin and
loved alongside others whom I love.
I ask a whole lot of questions,
my dream is to be okay without
knowing all of the answers.

Skylar Kergil

Skylar Kergil, *Cambridge, Massachusetts, photographed in 2014*
Skylar is transgender. He was born Katherine Elizabeth, but by the
age of three, he wanted to be treated as a boy and asked his parents
to call him Mike. He began gender and hormone therapy at fifteen.

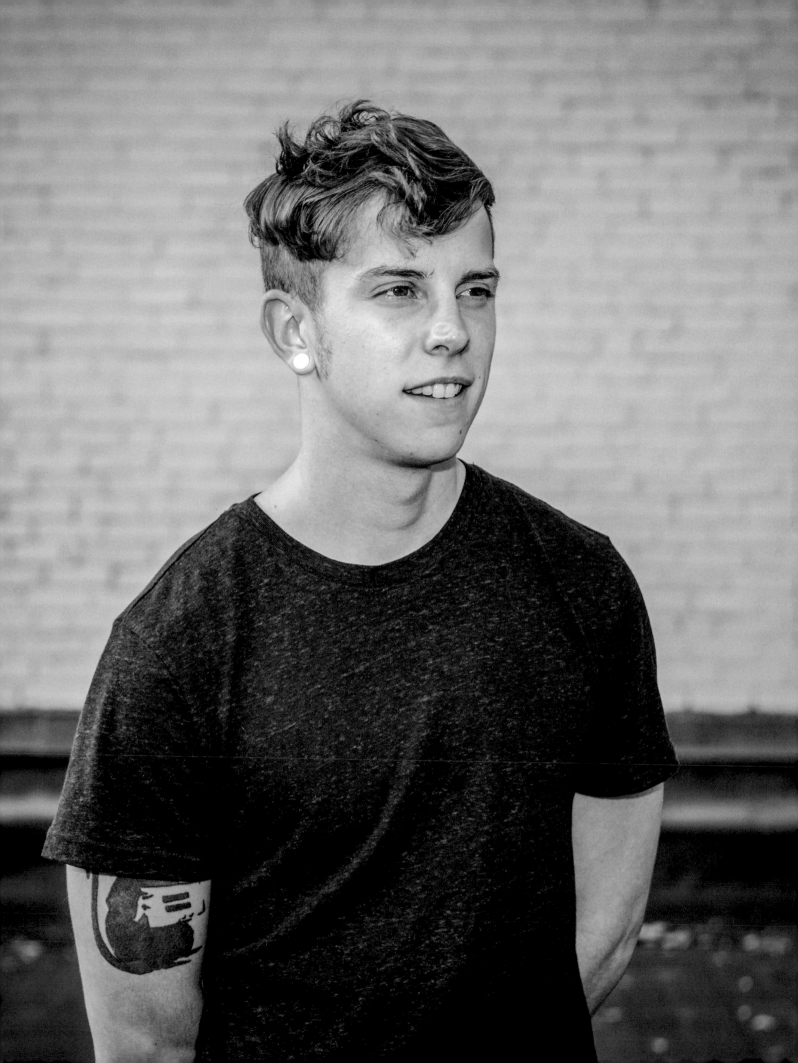

My American Dream...

I've searched my whole life trying to discover the meaning of being American. I've always dreamed of a better American life — this idea changing with time.

I emigrated to the US when I was two, with my non-English speaking, factory-working, welfare-receiving, traditional Korean parents. I have vivid memories of my broken home — tantrums by my alcoholic father & the sadness of my mother & baby sister. I wanted so very much to be like TV families such as the Seavers & Tanners. As a child, it was my dream to be American — to escape from a world of pain & poverty.

Education was a way to escape from my childhood; it was a true & wonderful key. Grateful for the opportunities given to me, I felt the need to give back to society. I joined Peace Corps & went to Africa, then pursued a graduate degree in Public Policy. I spent my early 20's dreaming of changing the world by helping people have the chance to escape their dismal worlds as did I.

Just shy of turning 30 years, with 2 degrees from top US universities under my belt, I sometimes feel I've lost & become disconnected with those dreams of my past. Yet, my American dream is only clearer to me now. Rooted in feelings of unsettledness & unhappiness that stems from a broken home & instability, my dream is to be happy. I'd like to build a happy, stable & healthy home; a haven of love & security for the children I may have one day. It's my American Dream to build the home I never had.

—Soo

Soo Chung, *Manhattan, New York, photographed in 2008*
Soo was photographed on Manhattan's Upper East Side.

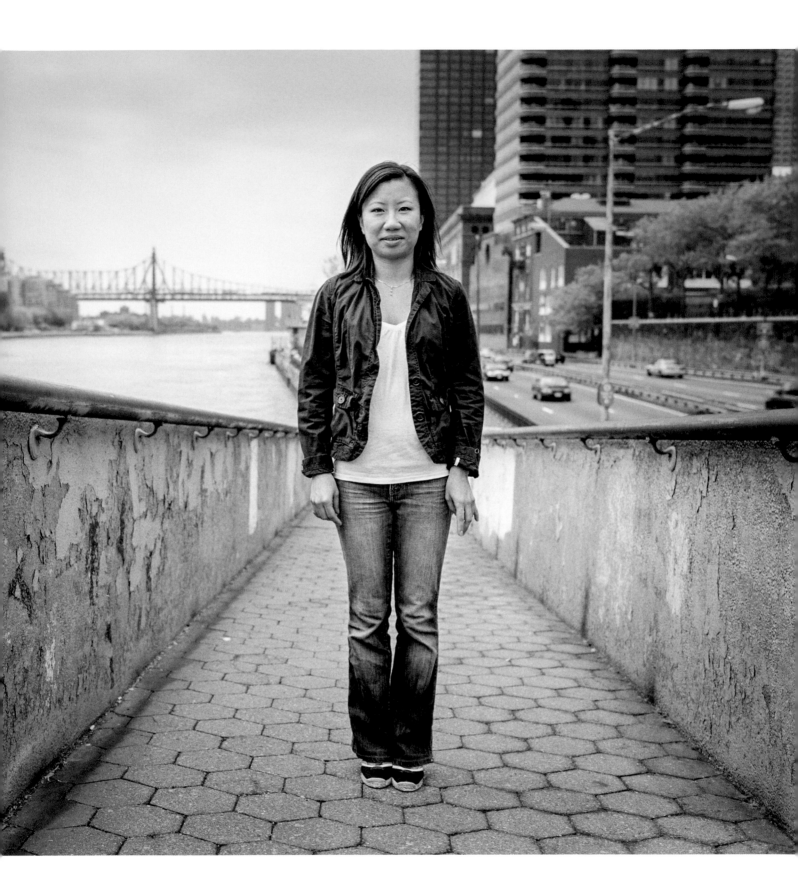

John Potter, *Luther, Montana,*
photographed in 2019
John is an illustrator and painter
whose work focuses on the
landscape of the American West.

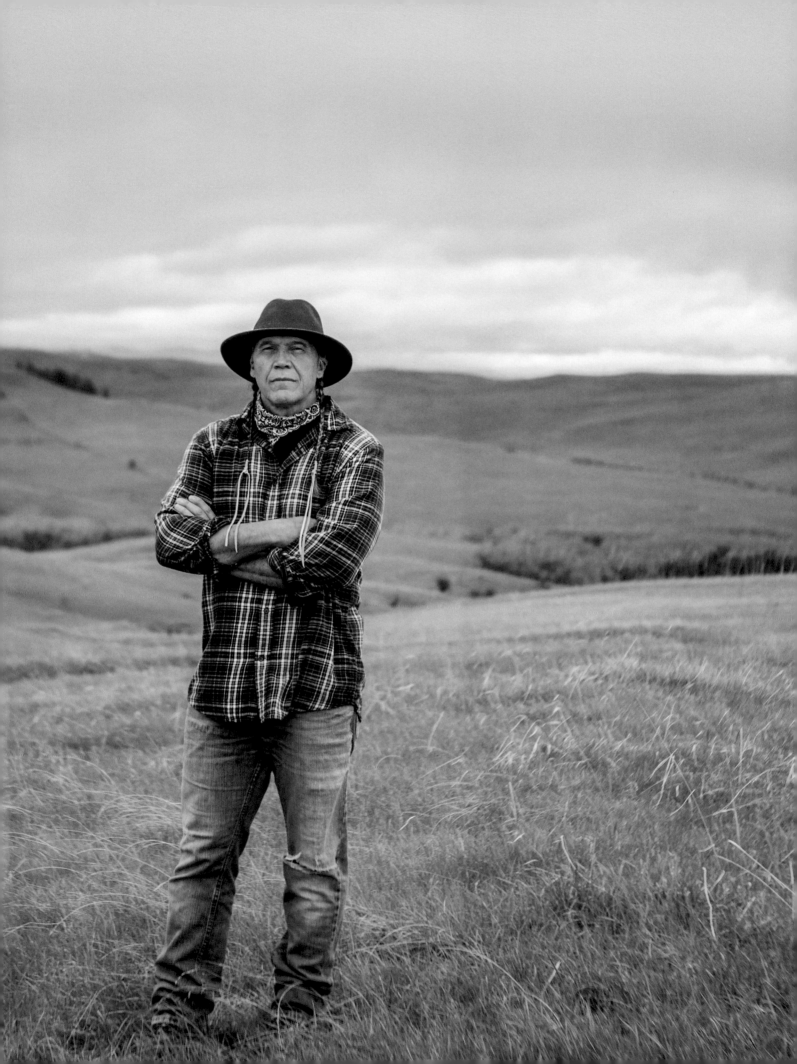

The American Dream has had many meanings since our land became "America," and it still has a lot of different meanings to a lot of different people. The most widely held and romanticized version, I believe, was first offered in the early 20TH century by historian James Truslow Adams: "... a dream of a land in which life would be better and richer and fuller for everyone, with opportunity for each" individual.

But before it was even a "thing," the American Dream, and the relentless, heartless and selfish pursuit of it by this country's colonizers, quickly became a nightmare for Indigenous Peoples, wild lands, and wildlife.

Ironically, the values that inspire the American Dream — liberty, equality, the pursuit of happiness and opportunity through risk, hard work and sacrifice — originated with Native People. The DIFFERENCE is that Traditional Native culture would dictate that these values be implemented toward the betterment and advancement of the WHOLE (the village, band, tribe — community), not the SELF (above others).

"Service before Self."

Adherance to this belief system made it extremely difficult, if not impossible, for 19TH & 20TH century Indians to "buy into" the American Dream. In short, the American Dream was for Americans, and other immigrants — not for the "first Americans."

To further complicate things for Indians, Native People were not "granted" citizenship in America until 1924. How can one pursue the American Dream if he or she cannot even VOTE for a political candidate who might be able to help you in your quest?

As the decades turned and churned toward the 21ST century, and society has become increasingly divided by economic gain and racial oppression, the American Dream, for a vast majority of Americans, went from something very attainable, to a dim and distant hope, to an exercise in futility. Even more so for those segments of society already disenfranchised by an America that would prefer that we simply didn't exist.

So, here's MY American Dream.

I dream of an America that apologizes — sincerely — for its centuries of dishonorable, dishonest, brutal and often atrocious treatment and behavior towards its Native Peoples. I dream of a Nation that remembers, respects, and honors its word (TREATIES) with the First Nations. A Nation which holds the land and its resources and wildlife as sacred beings, has reverance for the Natural World, and gives back for what it so greedily takes. A Nation that stops banging down our door while it steals from our garden.

My American Dream is of a Nation in which the very NOTION of missing and murdered Indigenous People is abhorrent to ALL people. A Nation in which NO ONE need fear for their lives while attending school or church, or while going to a movie OR a concert. I dream of an America in which leaders LEAD — with integrity, honesty, strength, compassion, dignity, intelligence and bravery — not bluster and boorishness.

My American Dream is for the betterment and advancement of the WHOLE — for the COMMUNITY of Turtle Island — for America.

Growing up in the 50's and 60's I don't remember having big dreams for my life. I went to work as a dental assistant my senior year of high school and that gave me an instant career. Before I knew it, I was married with 2 kids and house. Because I came from a broken home, I meant to stay married forever. I wanted the 50th wedding anniversary. I didn't quite manage the 50th, instead I made 19 years, 3 months and 21 days. I was back to re-planning my life as a single mom of two kids ages 9 & 15.

Besides family the two constants in my life have been my art and my activism. I started selling my artwork at 17 and still sell some today. As for the activism, I was more of a closet activist when I was younger. I didn't get out and protest but lobbied behind the scenes with the Commissioner of Education and several senators on changing some of the education laws that were hurting our children.

When I realized that a restraining order was not worth the paper it was written on, I became most vocal about introducing a stalking law. I worked with senators and several committees to ensure it would be passed as well as volunteering to fly in to testify.

My last activist role has been fighting the war on coal and flyash. I remember the first meeting I attended that was promoting the 2nd coal power plant next to our existing one. I filled out the paperwork for mom, Evelyn and me. When it came to the line about volunteering both mom and Evelyn said yes, which meant I was volunteering too. My first thought was how can the people in Bokoshe, OK fight a mega power like AES. It wasn't simple and it wasn't easy but we still chipping away and fighting the fight.

As I sit here today, I realize that each generation has left a legacy for future generations to clean up. From asbestos, coal combustion waste, electronics, plastic water bottles and the list goes on. My dream is to see future generations to not only think outside the box but throw the box away. Find new ways to enrich our earth instead of destroying it.

Susan Holmes, *Bokoshe, Oklahoma, photographed in 2016*
Susan lives alone in a small house on the outskirts of Bokoshe, a rural town in Oklahoma where 33 percent of the population lives below the poverty line.

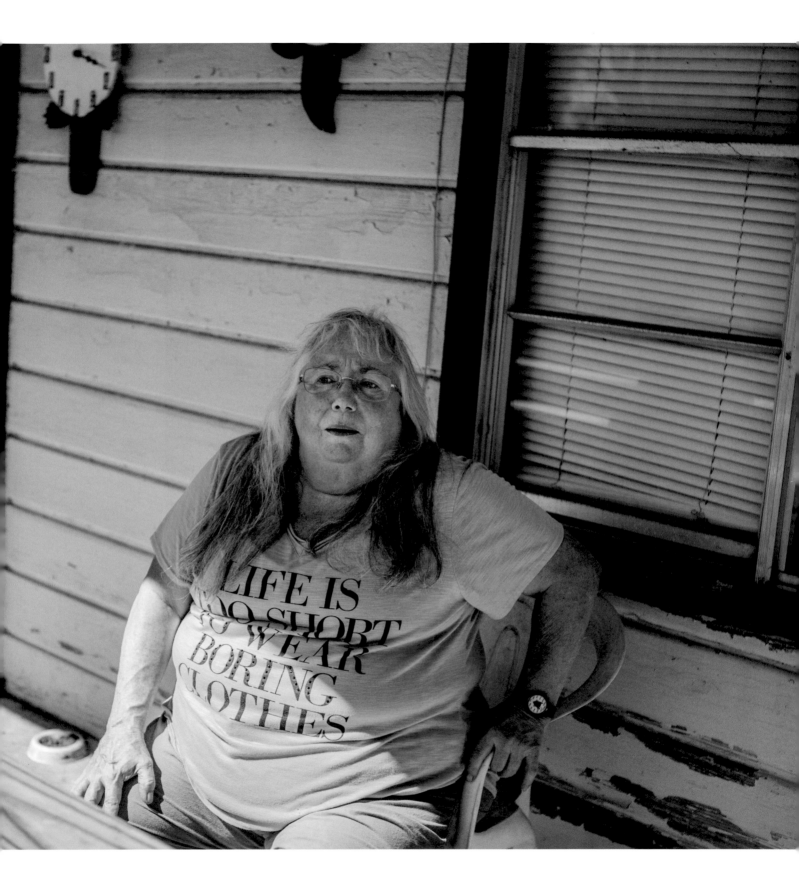

OUR AMERICAN DREAM IS SIMPLE.
THE REWARDS ARE NOT THINGS. THEY ARE
FEELINGS - PRIDE, AWE, LOVE, PAIN,
ACCOMPLISHMENT, EXHAUSTION.
IN OUR AMERICAN DREAM ECOLOGICAL
AND PERSONAL HEALTH ARE A RIGHT.
COMMUNITIES, RURAL AND URBAN, ARE
SAFE, STRONG, RESILIENT.
OUR AMERICAN DREAM IS SIMPLE.
THE REWARDS ARE NOT THINGS, THEY
ARE EXPERIENCES - A MEAL,
A CONVERSATION, A WALK, A HUG.
OUR AMERICAN DREAM IS NOT
EASY. IT REQUIRES GRIT, PERSISTANCE,
AND DRIVE. OUR AMERICAN DREAM
IS NOT EXCLUSIVE. IT GIVES. IN
OUR AMERICAN DREAM NO ONE IS
LEFT BEHIND. DIG IN.

— Chris Johnson
TAMARA JOHNSON

Tamara and Chris Johnson, *Centuria, Wisconsin, photographed in 2018*
Tamara and Chris decided to become farmers in rural Wisconsin after
studying environmental science.

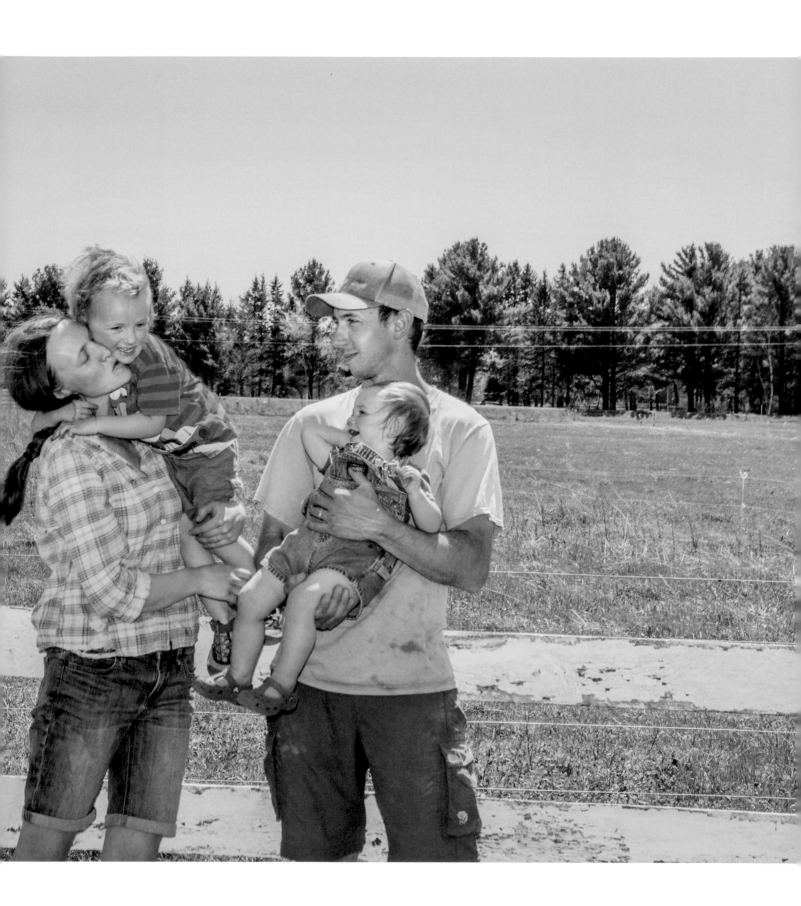

Our american dream is:
- to create a simple and beautiful masterpiece with our lives while we are here on this planet for this short and bittersweet moment in eternity.
- to make an impression
- to reclaim the pieces of the past that should endure
- to carry on, and leave behind the legacy of our grandfathers

- and to inspire our generation to reconsider what the "american dream" really is.

Matt Hobbs and Ben Hobbs, *Watkinsville, Georgia, photographed in 2015*
The Hobbs brothers began making furniture out of desperation. Ben (right) had endured a bad knee injury, and Matt was broke from a failed business and had considered suicide. To make money, they began selling farm tables on Craigslist. After a few years, their business, Sons of Sawdust, is thriving and has multiple employees.

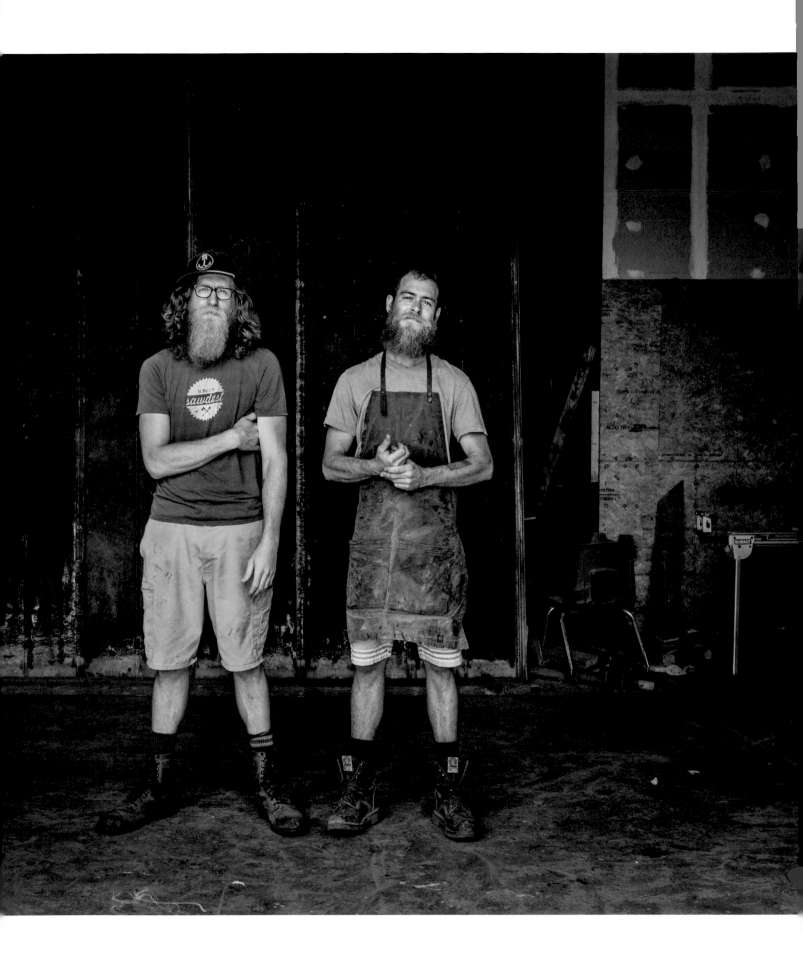

American Dream

Oppurtinity

This country is based on chances for the better. We all relate in one form or another. And thats struggle, but this country gives us chances to reach the highest levels of success. From the prisons, to the families striving and sacrificing for there kids.

Guy Lucero, Jr., *Sterling Correctional Facility, Sterling, Colorado, photographed in 2018*
Guy is one of the more than 2.2 million people incarcerated in the United States.
Now in his thirties, he has been in prison since the age of fifteen.

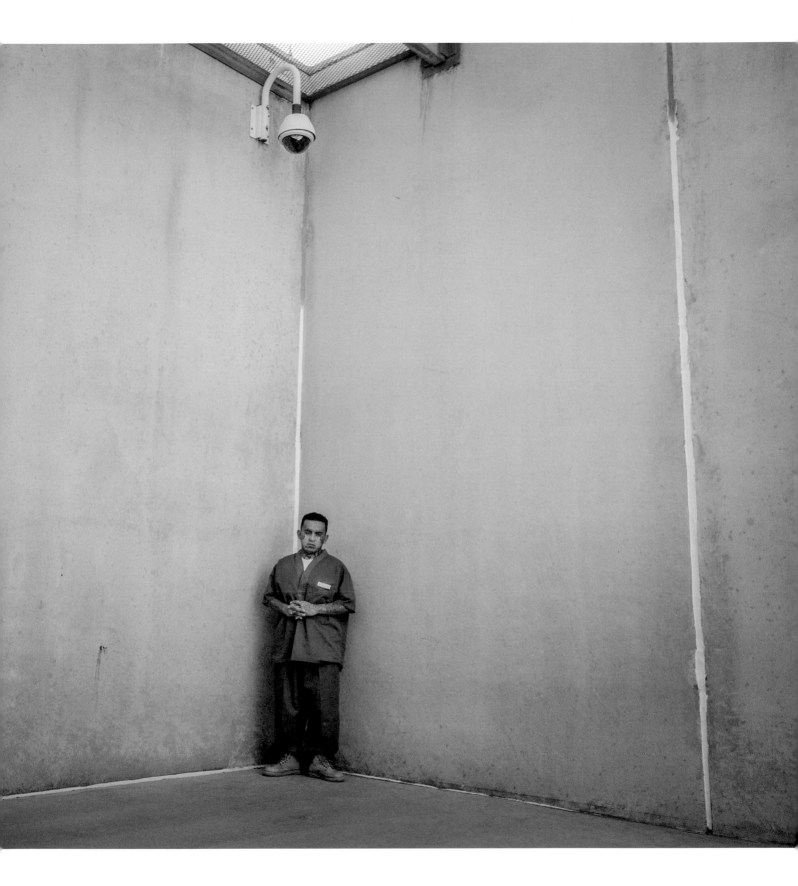

The American Dream

In a country never constructed to uphold the life, liberty, and pursuit of happiness for the slave, the lense from which I see an American Dream is blurry. However, my guiding force in this space and time is by all means necessary, pushing more of the warriors closest to the pain onto the threshold of power and decision-making, while never forgetting from whence they came.

-Branden Fletcher

Branden Fletcher, *Wilmington, Delaware, photographed in 2019*
Branden is a college student pursuing a double major in urban development and African American studies. He also volunteers at his church and for community development projects.

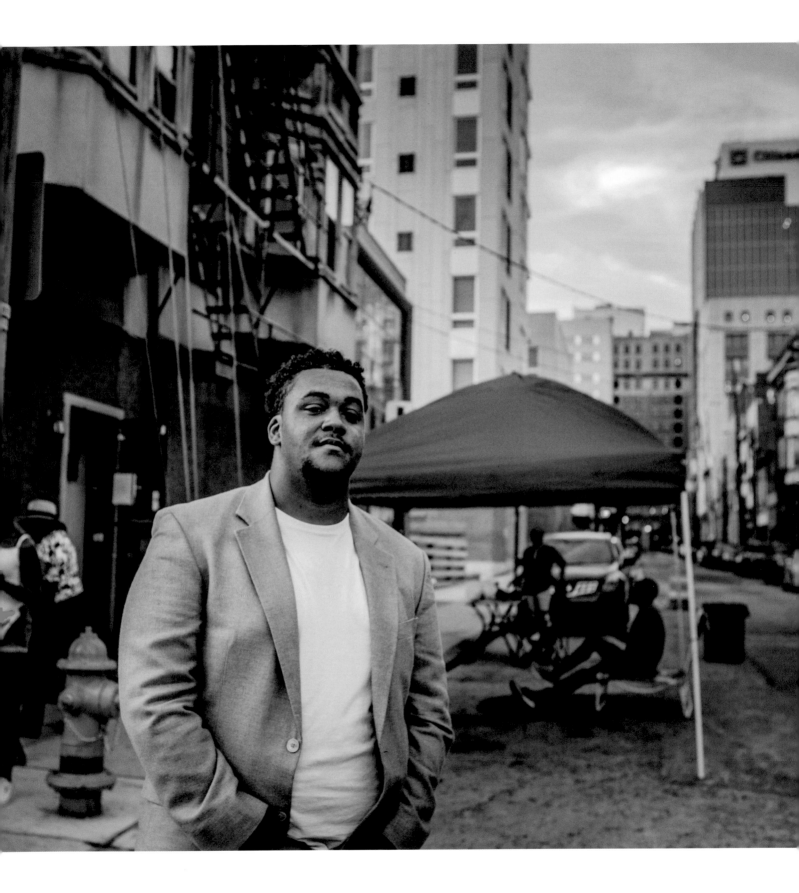

I've been diagnosed schizoaffective Bipolar subtype for 5 years. My life changed dramatically after the diagnosis, for better and for worse. Through all my hardships, My friends & family have constantly been by my side. My dream is for everyone like me (or unlike me) to have the same access to health care, resources, and support! that helped me, and for everyone struggling with mental illness to know they are Loved, supported, and heard!

Diana, *Fairbanks, Alaska, photographed in 2019*
Diana is currently in school and works part time
in a marijuana dispensary.

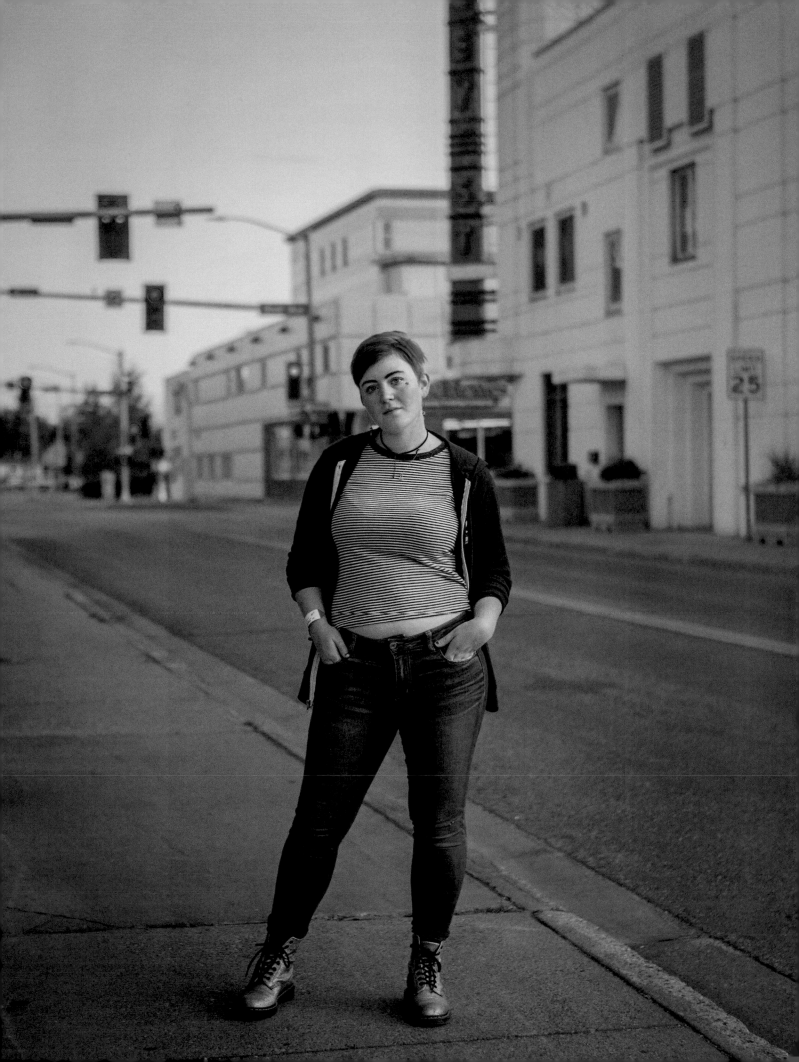

My family immigrated to the United States from China over 25 years ago. They left everyone and everything they knew, so that they could give me a better life. That was their American Dream.

They did just that — I went to college, got a job, got married, bought a house, and a few years ago, my husband and I started our own business — an ice cream shop in Cleveland, OH called Mason's Creamery.

My mom said to me, "We're so proud of you, you have your own business. You're living the American Dream!"

So my American Dream is the same as my parents. I want my future children, everyone's children, to grow up in a country where they have opportunities to create a better life.

Helen Qin, *Cleveland, Ohio, photographed in 2016*
Helen and her husband, Jesse, started an ice cream business,
Mason's Creamery, which has become a community hub in
their neighborhood of Ohio City.

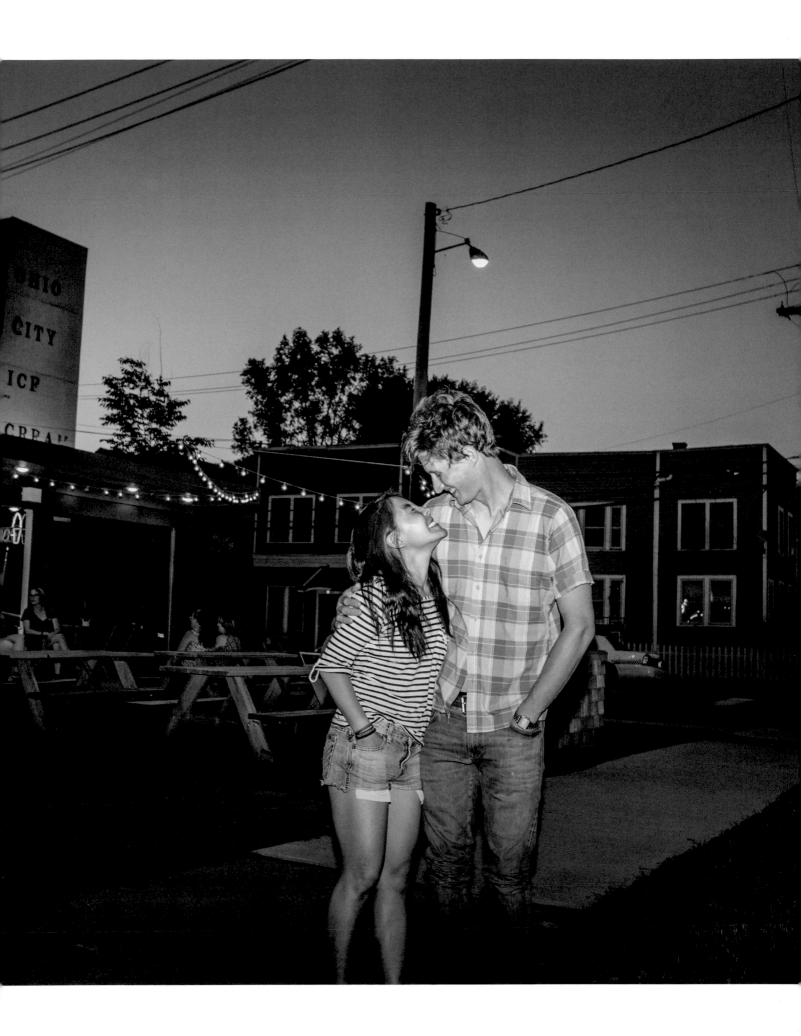

MY AMERICAN DREAM

My Name is Vicky Chávez. I am from Honduras.
I came to the United states in 2014, when
my daughter was 2 years old.
I Left Honduras to scape the terrible Violence.
Honduras is considered one of the most dangerous
countries in the world for women.
In Honduras, one women is murdered every 16 hours.

My american dream is for my daughters to
live in a country where they are safe from
Violence and abuse.
My American dream is to be able to demonstrate
to my daughters that they can have a future
of opportunity.
They Can Create and Persue their dreams
without Fearing for their lives.
They can go to University, study to work, and
Contribute to the American comunity that
supports them.
My american dream is to be able to finish my studies
at university, graduate and see my daughters graduate.

My American dream is to be able to stay toother with
all my family, the members of the church and all the
comonunity that support us so far.

Vicky Chávez, *Salt Lake City, Utah, photographed in 2019*
Vicky and her two kids live in sanctuary inside a church in Salt Lake City. She applied for asylum
in the United States after her boyfriend tried to kill her in Honduras. Under a policy revised by the
Trump administration, cases of domestic violence are no longer considered grounds for asylum.

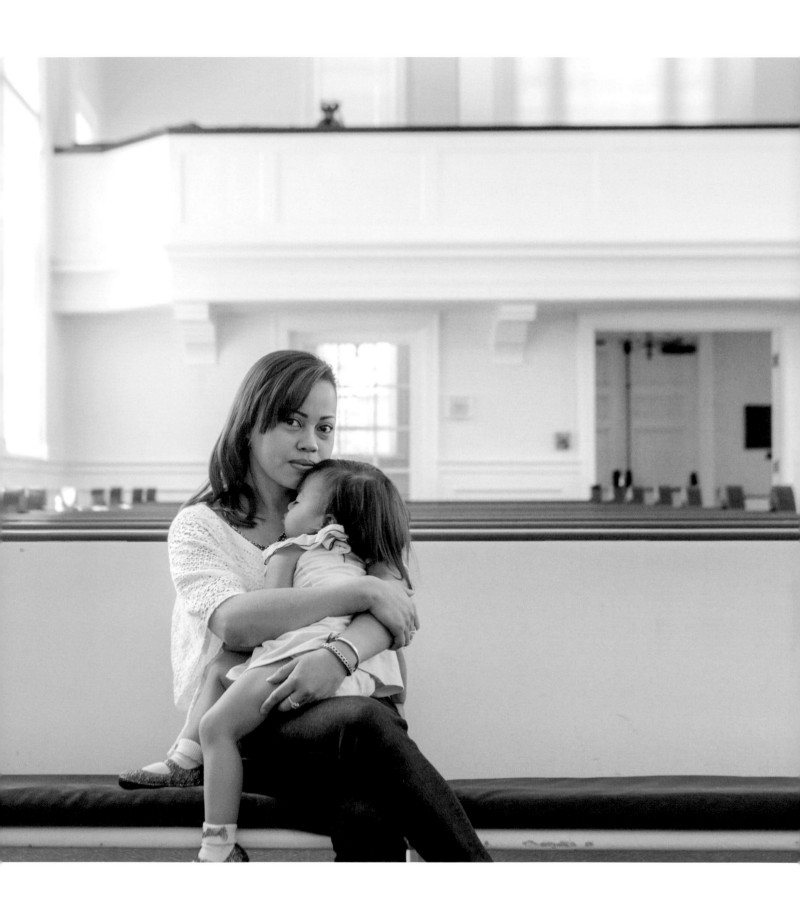

For Zach & Me, the American dream has always centered around one thing: community roots. We both grew up in northern Michigan, children of the working poor. Zach & his mother moved frequently; I transferred schools every 1-3 years. We found each other for the first time in Flint, and when we discovered that home ownership was a mutual dream, it made sense to look for a home here, so we could put down roots. After our absentee landlord finally agreed to sell us the little bungalow we'd been renting, we thought we were close to our goal.

When we found out they'd switched our water, we were horrified, but trusted that they had figured out a way to purify the river water. We drank it, bathed & brushed our teeth in it, gave it to our cats, & put it in our humidifier. By the time they finally told us about the contamination, our cats had lost half their fur. Zach had been hospitalized for double pneumonia, cause unknown. I'd lost 60 lbs due to intense stomach pains & nausea, my hair had been falling out for months, and my anxiety disorder became so severe I had to go on medication for the 1st time in 15 years. We had both been plagued by rashes & burning skin. They gave us poison, & lied to us about it.

The effect on us has been permanent. I still have frequent nausea & stomach pain. Zach's kidney function was compromised, & he's not even 30 yet. It's affected our American dream, too. We still dream of buying a house here in Flint. But now, we dream of taking a bath in our new home without being fully cognizant of the fact that we're bathing in poison. We dream of a cool drink straight from the tap. But our sense of trust in tap water, a basic human right, has been shattered. A half-empty water bottle triggers my panic response. How sick is that?

Like I said, my dream has evolved. Flint's water crisis isn't just Flint. Towns across the country have been dealing with the same contamination issues for years. The Western reservations have been dealing with it for decades. Clean tap water is a human right, & I will continue to fight until everyone has access to it. For now, though, the fight starts at home. Flint is my home, & I'm not going anywhere.

Megan Crane
Flint, MI March 2016

Megan Crane, *Flint, Michigan, photographed in 2016*
Megan and her then-boyfriend, Zach, both tested positive
for lead poisoning after drinking contaminated water.

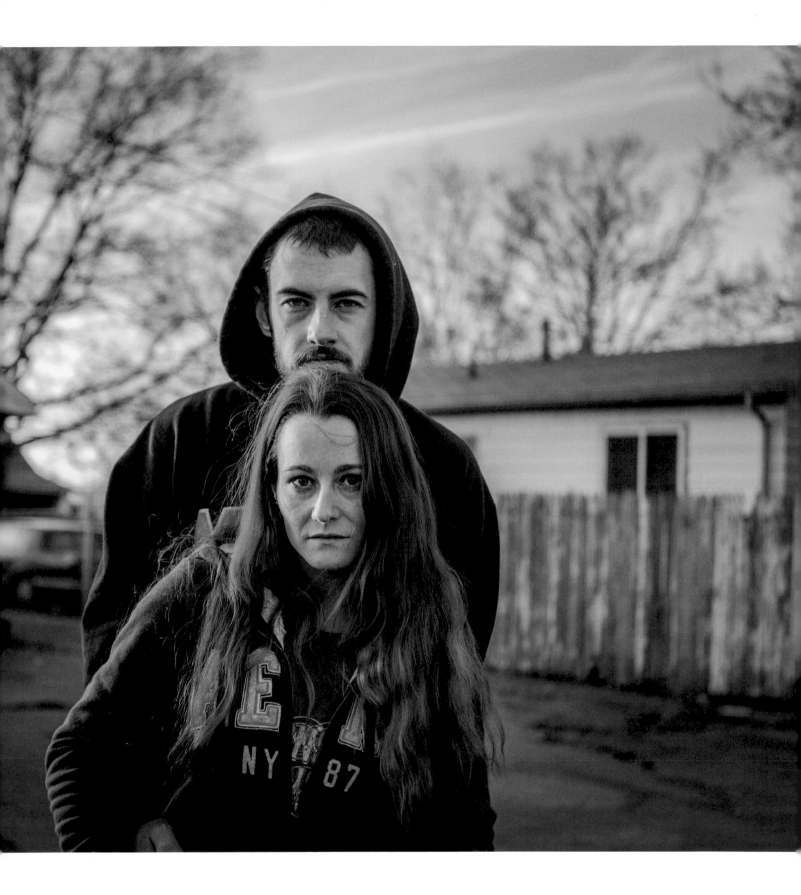

The American Dream
To help those who
are not able to help
thenselks, God willing

—Vance

Vance Edwards, *Cleveland, Ohio, photographed in 2016*
Vance has two college degrees. Despite this, he hasn't been
able to hold steady work. He was photographed panhandling
on a freeway entrance ramp in downtown Cleveland.

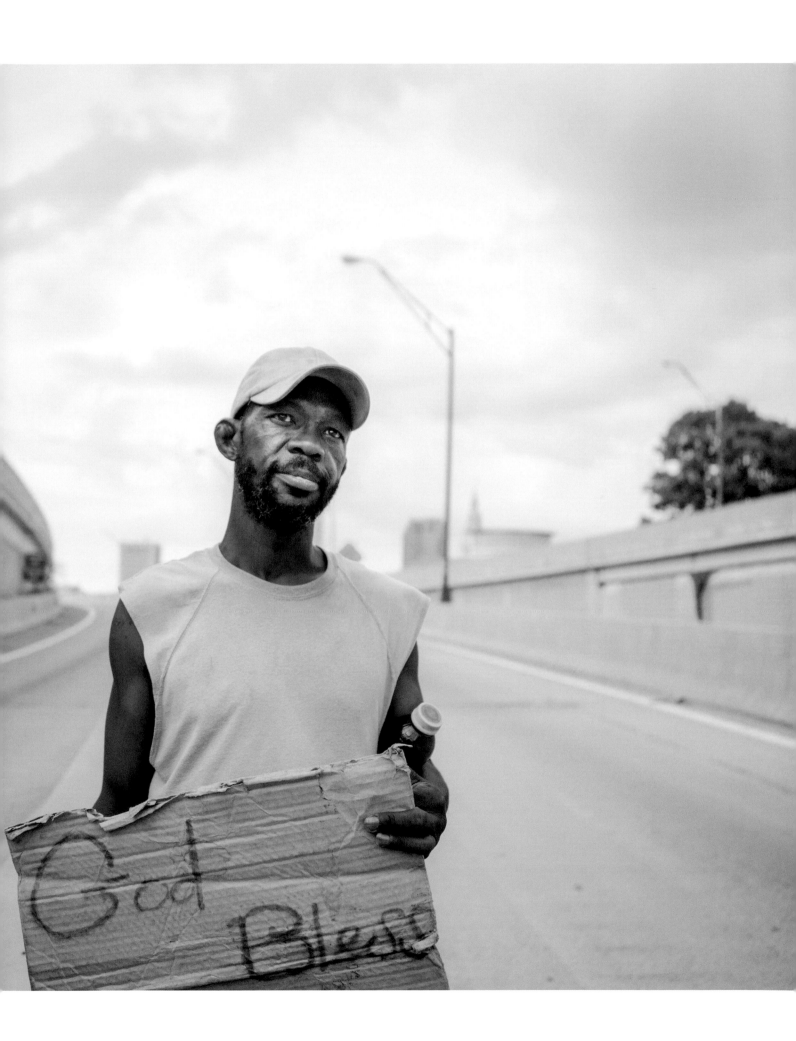

I don't want to change the world.

My American Dream is simply to find the balance between being content with what I have and always working toward something better. It is easy to focus on the goal and neglect the path to it.

I don't want to win the lottery. I want to wipe away the dirt and sweat at the end of every day and see some small good thing I have accomplished. So much of what I do does not endure. One season later, the acres of crops I agonized over are nothing but numbers on paper. I live a blessed life. I am thankful for what I have and where I am, but I am compelled to do more. I am a farmer. I depend on the same soil my Great-Great-Grandfather did. I can not destroy what he built. I hope my children will feel the same dependence and devotion that I do.

I don't want to be remembered for some great thing. I want my children to be my greatest accomplishment. I want them to cling to what they have, to what I leave them, but I hope and pray they reach for more.

1 Thessalonians 4 Adam Dean Stratton
 August 2016

Adam Stratton, *Golden City, Missouri, photographed in 2016*
Adam is a third-generation farmer in central Missouri.
He is pictured with his family.

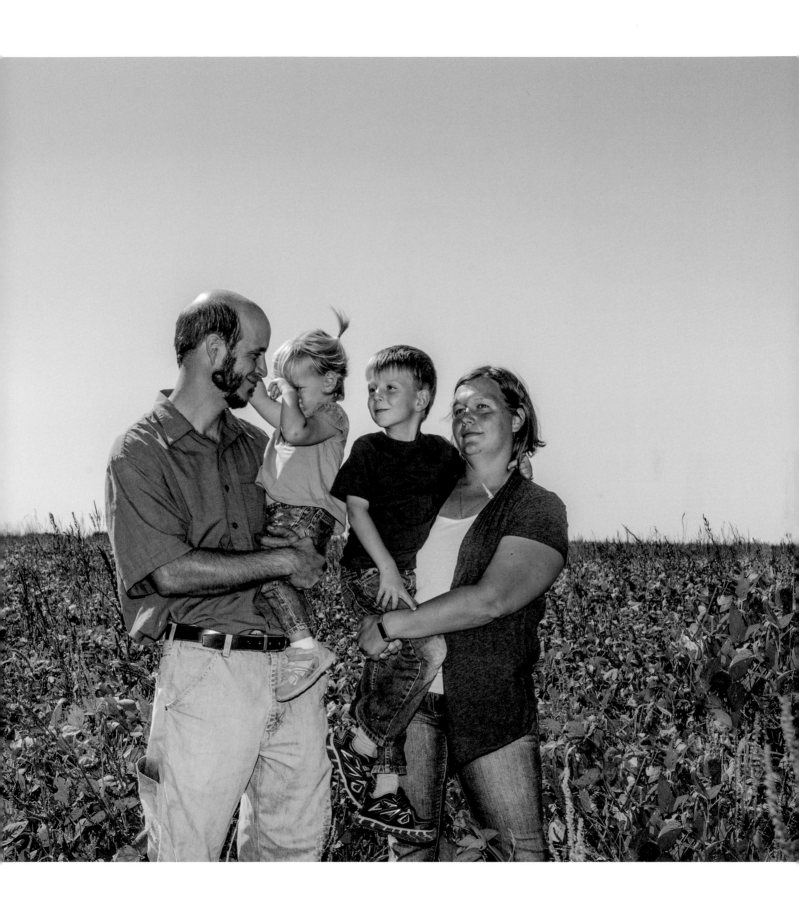

My American Dream.

To each his own huh! As a very little boy in San Francisco, California I just wanted to be a cowboy and of course knew really nothing about it as there ain't no ranches in the city of San Francisco. We moved east of there when it was 4 or 5 right after World War Two and now there were ranches, cows, and horses. But I still had to get a little older then five and that happened and things developed. I slowly got around the agriculture folks and began to live my dream.

It took time yet I got along well with people and if like they say, "You can be riding a three legged donkey and have your hat on backwards but if you got truth there are those that'll help you." And I damn sure got try!

I lived my dream since very young I guess and I'll be 80 this Sept 2019. Broke at times, flush at times, but alway had sources for cash if the right deal came along. Thats because my word was my bound. I stayed away from alcohol just about completly. Chewed tobacco for awhile. Always ate P, B and J sandwiches I made. Drove old vehicles that were dependible. Image ain't nearly as important as the quality of the person. If ya got respect everywhere you go you can go wherever you want, and doing that while being a cowboy has allowed me to live my American Dream.

Serving my country as an Airborne Infantry Soldier was very important to me and through that I also have family wherever I go.
God Bless America.

VAL

Val Geissler, *Cody, Wyoming, photographed in 2019*
Val lives and ranches on property at the edge of
Yellowstone National Park.

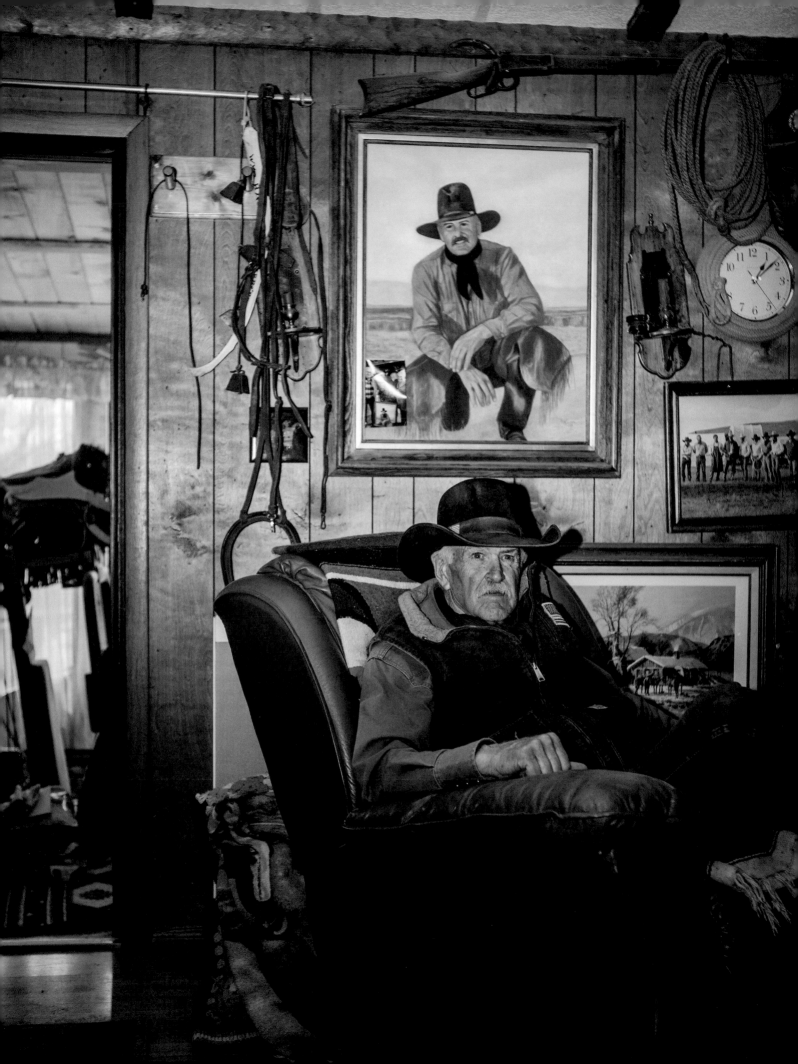

My American dream is more real, than lady liberty
wrapped in a floral-pink-hijabi, stealing history from the ghost of
your ancestors. My Americanness, can never be colonized.

My American dream is more scarier, than christopher columbus
still awake in his grave, chanting "I am sorry" in multiple
languages. My americanness, is your fare-father's nightmare.

My american dream is more deathless than a virus, still standing strong
In the face of your constant mass-incarcerating, white-washing or
gentifying. My americanness, is thriving without whiteness.

My Americans dream is more titanic than the refugees filling your
schools, The dreamers, now your doctors. The queer activist redefining your
love. The indigeous scientists charting your climate rape. & The women
healing your mental diseases. My Americanness, is fed by a radical
indegious ancestors.

My American dream is multilingual, multicultural, unapologetically
pansexual, and no need for a translator, coz 2045 is coming.
My americanness is thriving without whiteness.

My american dream is radical like Malcolm X, Brave
like Harriet Tubman. Bold like Mary Brave Bird.
Futuristic like Octavia Butler. Fearless like James
Baldwin My americanness is sustain by timeless black
magic.

My American dream prays in two languages feeds
two families in two continents. If you let it. My
americanness can heal your broken humanity.

Ifrah Mansour, *Minneapolis, Minnesota, photographed in 2018*
Ifrah was born in Saudi Arabia but moved back to Somalia, where her family is from, in 1991. By age ten,
she had experienced famine, drought, civil war, and living in a refugee camp before coming to America.
Her family was resettled in Texas, where she didn't see another black person for a month after arriving.

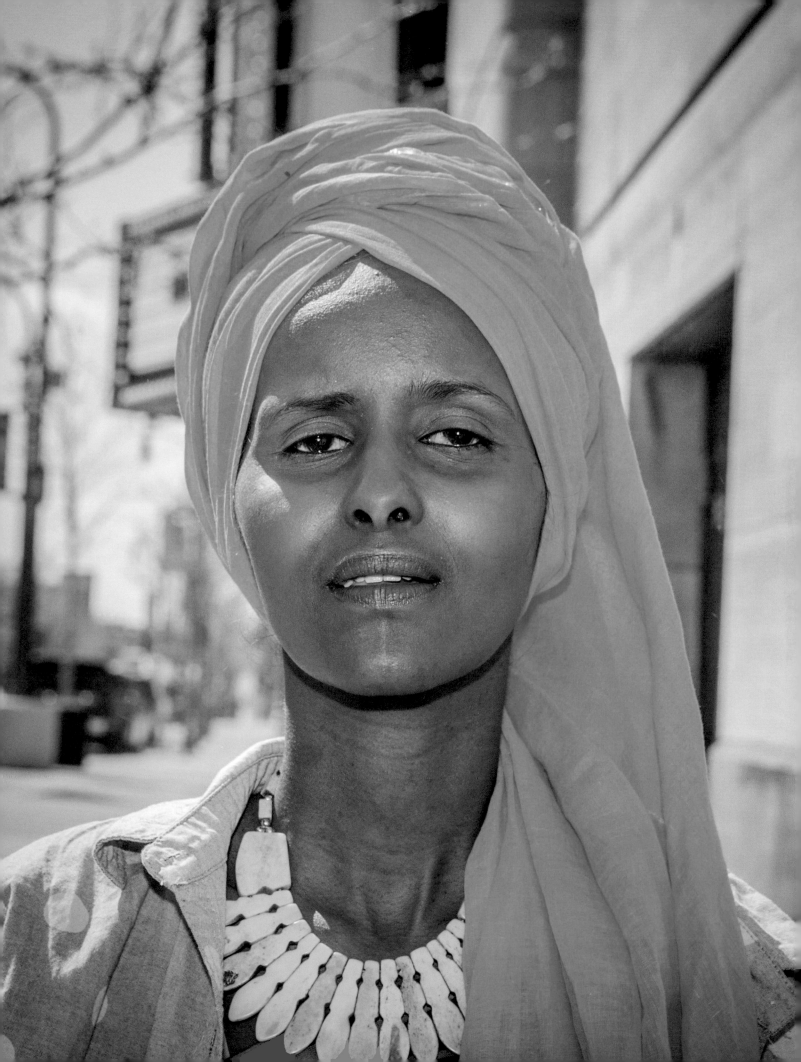

My American Dream

is to live in a country that cares for those with substance use disorders with love, compassion and effective, evidence-based treatment. My first husband, father, and only child died in active addiction. These men were among the most intelligent, open-hearted, creative people I have ever known.

My son, Halley, died of an accidental heroin overdose on 1/28/17 around 3:30 AM. Almost every morning since Halley's death, I wake up around 3:30 and wonder what I could have done differently so that he would still be alive. There is no denying that I did a lot and so did Halley. I always made sure that Halley had excellent health insurance and that he knew that no matter what he did or said I would always help him find treatment.

We knew that 9 out of 10 Americans suffering from substance use disorders do not seek treatment, in large part because of the dehumanizing stigma surrounding addiction and the misconception that substance use disorders are a moral failing. Halley and I understood that addiction is a chronic illness that deserves to be treated with the same urgency, skill, and compassion as any other potentially fatal illness. We knew that overdoses are the leading cause of accidental death in the U.S. I also understood that the National Institute of Health spent $5.6 billion on cancer research and only $1.6 billion on addiction disorders despite the fact that one-and-a-half more Americans suffer from addiction than all cancers combined.

I did not know that many treatment providers continued to hold tight to an abstinence-only model in treating all substance use disorders. Despite the fact that the research is clear — medication treatment reduces mortality from opioids by OVER 50%, this benefit is ONLY seen with the use of ongoing medication. I wish I had not known to advocate fiercely for Halley to receive this type of treatment. I wish the trained team of professionals we entrusted with Halley's care had listened when Halley told them He was terrified he would leave treatment, relapse, and die — That is exactly what happened. Halley's pleas for medication-assisted treatment were labeled as "drug-seeking behavior" by professionals clearly ignorant of evidence-based treatment.

I dream of creating a country where every citizen has an equal opportunity to survive and thrive, including those suffering from addiction.

—Charly Borenstein-Regueira

Charly Borenstein-Regueira,
New Orleans, Louisiana,
photographed in 2017
Charly's son died of an
opioid overdose.

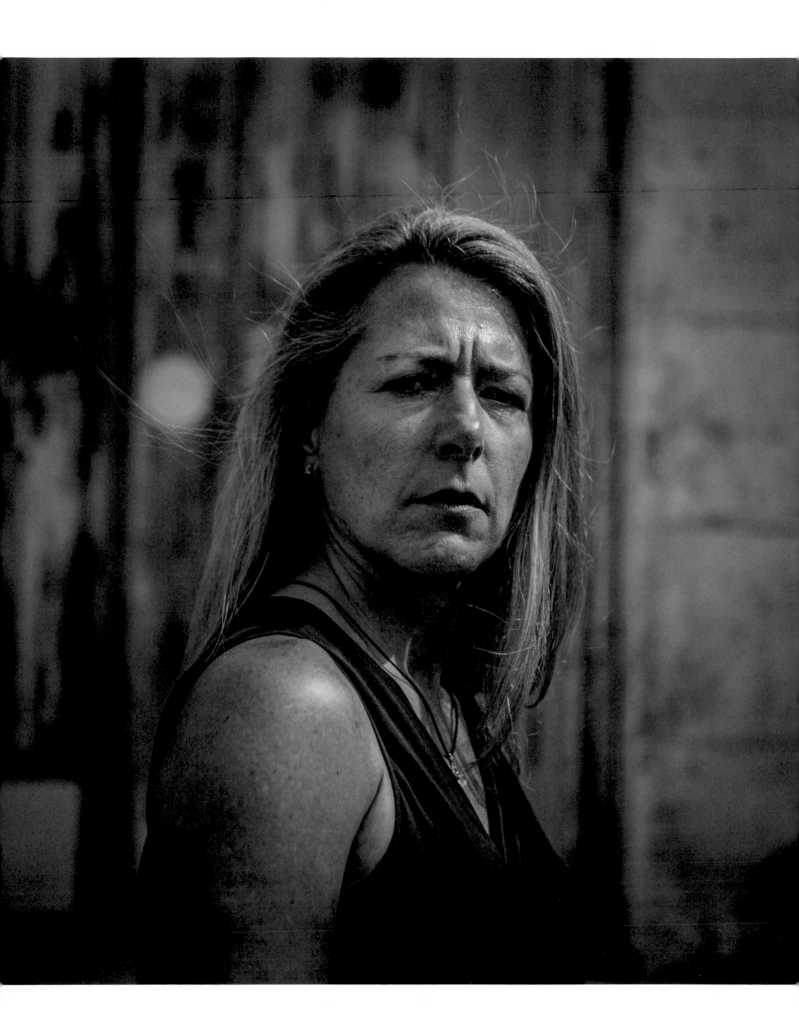

THE AMERICAN DREAM IS AN ADVERTISING SLOGAN; IT PROMISES MORE THAN IT CAN DELIVER, BUT ONCE YOU'VE BOUGHT IN, YOU'RE COMMITTED BECAUSE OTHERWISE YOU MUST ADMIT YOU'VE BEEN DUPED OR YOU WERE WRONG. BEING WRONG—BOTH ~~xxxxxx~~ INTELLECTUALY OR MORALLY— IS NOT ALLOWED IN THE AMERICAN DREAM. I AM A JOURNALIST, A WRITER WHO BENEFITS FROM THE FIRST AMENDMENT MORE THAN MOST. I'M LUCKY TO HAVE BEEN BORN IN COUNTRY THAT ALLOWS SUCH FREEDOM. BUT I AM NOT A PROUD AMERICAN. I DIDN'T DO ANYTHING TO ACHIEVE THE STATUS OF BEING AMERICAN. I WAS JUST BORN HERE; LUCK OF THE DRAW AND NOTHING MORE. THE UNITED STATES IS A DEEPLY FLAWED NATION THAT BOTH TOUTS ITS ECONOMIC AND WORLD-DESTROYING PROWESS, YET PRETENDS TO BE A PLUCKY UNDERDOG. I AM REMINDED OF A FRANK ZAPPA LINE: "I'M NOT BLACK, BUT THERE ARE A LOT OF TIMES I WISH I WASN'T WHITE." I OFTEN WISH I WASN'T AMERICAN, NOT BECAUSE I'M FOOL ENOUGH TO BELIEVE OTHER NATIONS HAVE IT ALL FIGURED OUT, BUT BECAUSE THE AMERICAN DREAM PROMISES FAR MORE THAN IT EVER DELIVERS.

Daniel Finney, *Des Moines, Iowa,*
photographed in 2018
Daniel works as a local newspaper
reporter in Des Moines.

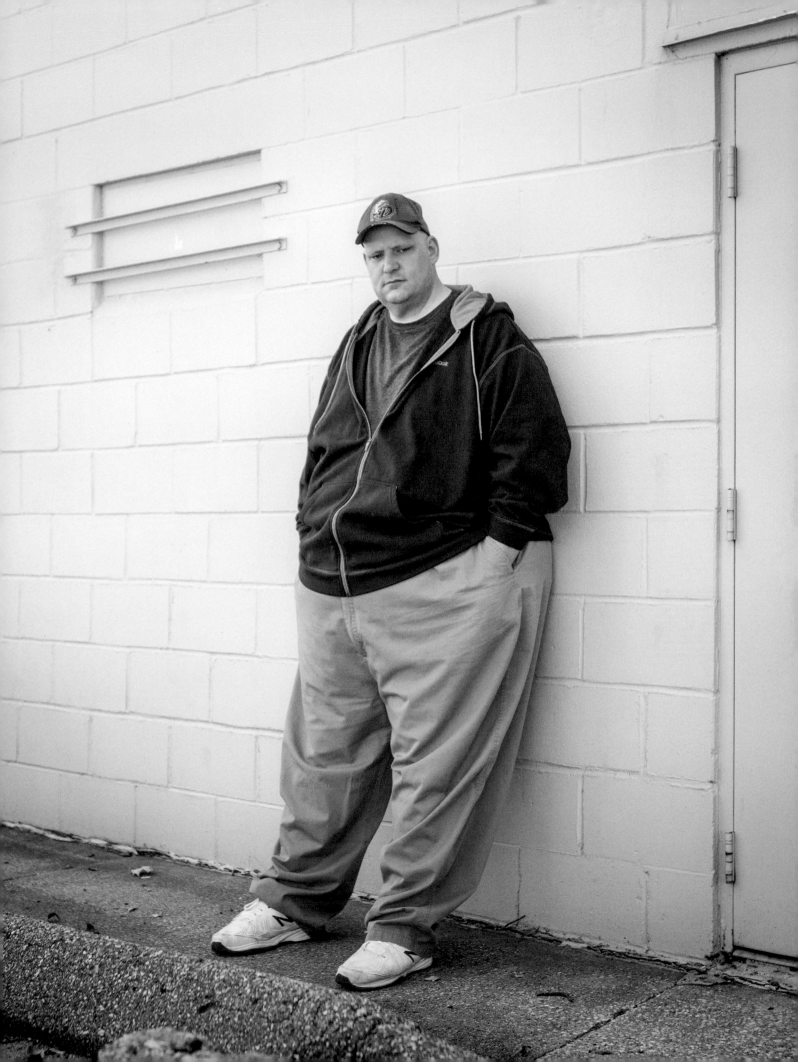

American Dream

In my opinion, as of right now there is _No_ American Dream and there won't be till something is done. Everybody wants to ignore the problems and not fix it. Once you accomplish fixing all the problems we have, then you can go for the American Dream.

It takes someone with a lot of intelligents, doesn't matter who they are to get this accomplished. That is what is called the American Dream.

This can't be done overnight, it will take years to do it.

Mark, _Tangipahoa Parish, Louisiana, photographed in 2018_
Mark has lived in the same house since he was born. He
started working when he was just fourteen years old.

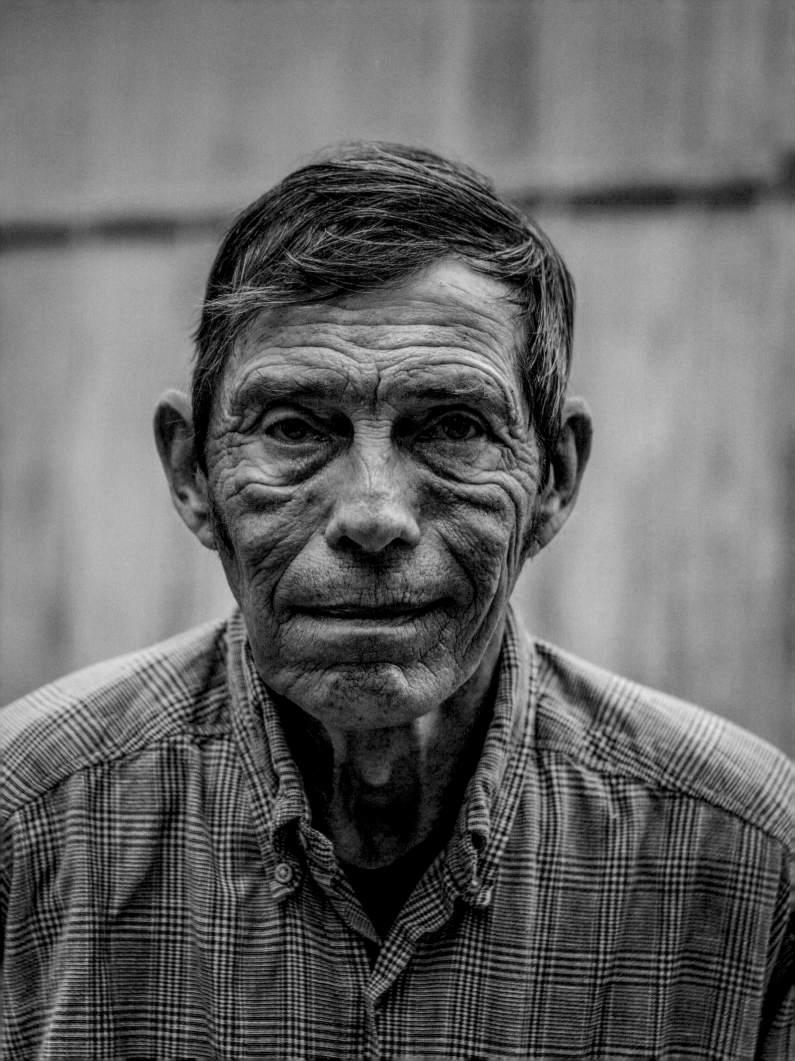

between Countries. Terror
is Not Conducive To Dreams.
Nightmares, yes. But My idea
Of The American Dream?
How about a Worldwide dream
Where all races & peoples can
feel secure in The World and
Know They have a place in
it!
 My American Dream is
To feel like My Country is
Working To Make The earth
a better place and Not out for
just our own Self interests.
That Would be an American
Dream Come True for Me.

PEARLS BEFORE SWINE STEPHAN PASTIS

Achieving your dreams is the key to a happy life. So write down a dream and go for it. And when you achieve it, CELEBRATE!

Be fat and lazy.

Larry, *Minneapolis, Minnesota, photographed in 2018*
Larry works as a janitor, and his girlfriend, Vicki, works at a copy
center. Both are involved in theater and regularly busk in parks
with their homemade bubble contraption.

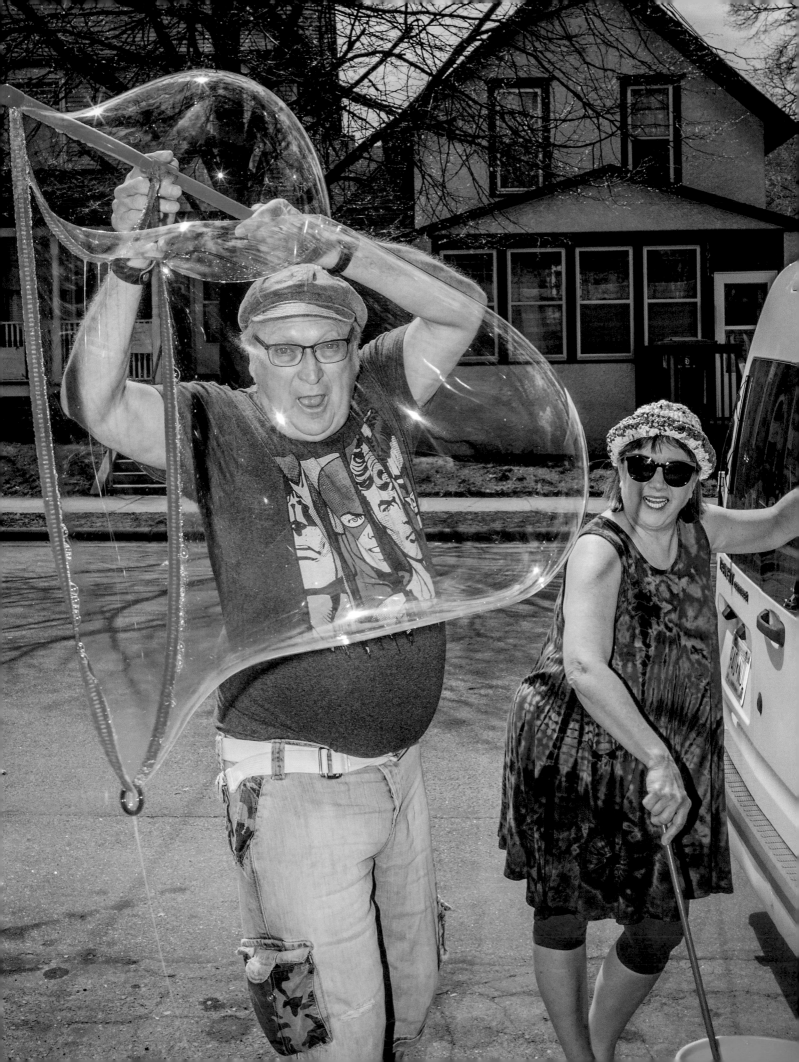

AMERICAN DREAMING

I've always been fascinated by the concept of home. Always. It's family and friends and community - geography, culture, tradition, attitude and even time. Home is a marker in time.

I had to leave to truly learn about home. I've lived all over this country and spent years in other countries. I've existed as both majority and minority; lived beyond the margins and outside of my comfort zone. It was leaving and exploring the world that shaped my deep, deep appreciation for Home.

Home is family and honeysuckle, friendliness and greenery. Home is security and love and opportunity. Home is refuge and respite. Home is my wonderful silly dog smiling at me. Home is bare feet in October and flash summer storms and rope swings at the river. Home is crying until tears turn to laughter on a sunny deck with the very best of friends. Home is a hand in the dark that never retracts.

My entire career is rooted in working with those displaced from their homes. I'm of my family, I'm of the South, I'm of the United States, I'm of the world. The longer I live, the more precious these gifts. My dream is for all to find such solid footing, for all to find or build the safety of Home.

Shea Post, *Athens, Georgia, photographed in 2013*
Shea has worked throughout the United States and abroad for various NGOs and nonprofits.

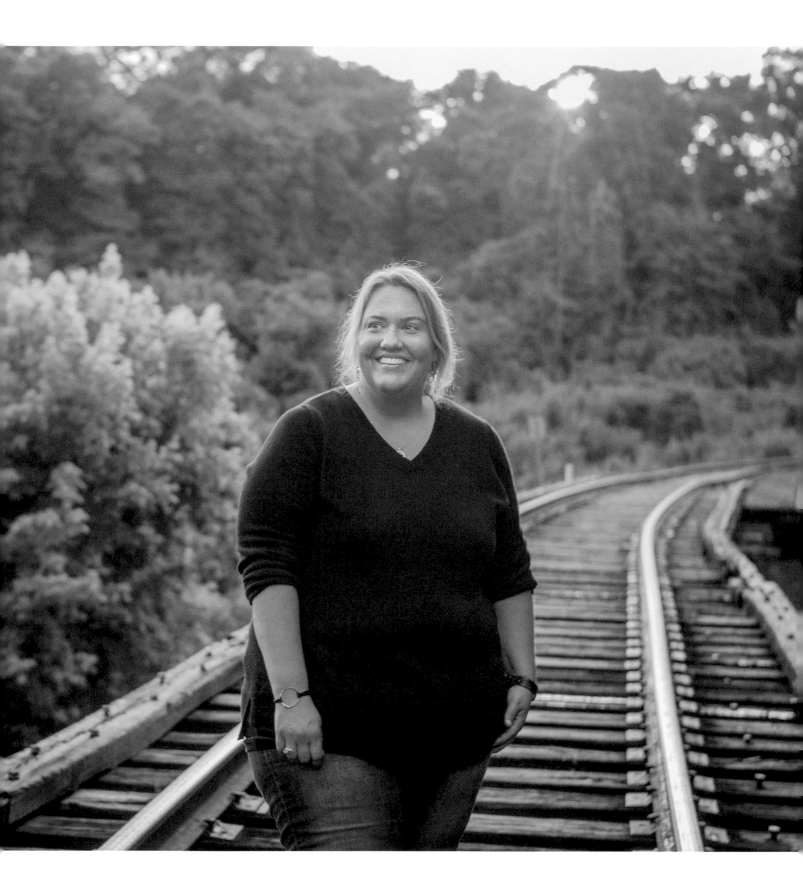

MY AMERICAN DREAM
TRACY ROSEN

SMALL PICTURE: I hope at
the END OF MY DAYS that
WHAT I HAVE given is greater
than what I have received.

BIG PICTURE: The WORLD IS NOT
a ZERO-SUM GAME NOR IS IT
PURELY TRANSACTIONAL. THE USA
has the opportunity to LEAD by
EXAMPLE to build a working
model where the FOUR Freedoms
(SEE FDR) ARE MADE REAL.
MY AMERICAN DREAM IS the
POWER OF TOGETHER RISES TO
THE TOP AND OVERWHELMS the
GRASP OF ALONE.

Tracy Rosen, *Richmond, Vermont, photographed in 2019*
Tracy and his wife, Lotta, live on a rural property along the Huntington Gorge.

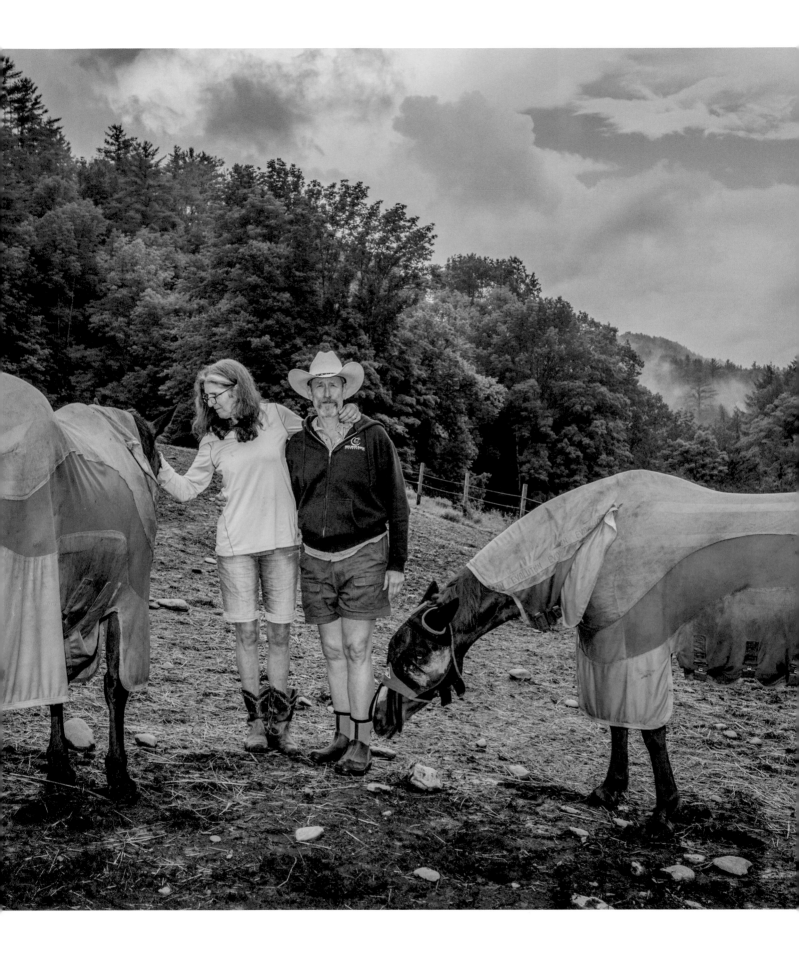

I started Patriot Prayer after I witnessed families getting attacked while leaving a Trump rally in San Jose in 2016. I believed that mayors in far-left cities were politically giving the police stand down orders so that Antifa could freely attack Americans who were preaching about freedom. During 2017 and 2018 I focused on going into the cities that gave stand down orders such as Berkeley and Portland sometimes bringing thousands into the streets for free-speech. I believed this would help expose Antifa and the politicians who support them.

I believed it was very important to remain positive and contrary to how mainstream media painted me, I always preached love. Mainstream media constantly accused me of spreading hate. In response, I put up a $2,000 bounty for any evidence of hate speech. For almost 3 years no one has been able to offer any evidence. 2019 I changed the direction of Patriot Prayer and started going into the smaller cities that believe in Freedom and God. I pushed for cities and counties to begin to pass constitutional ordinances that would protect their freedom at a local level. My speeches contained a mixture of the constitution and the spiritual aspect of fighting for freedom.

I believe that Jesus was the ultimate freedom fighter and is to be used as a guide in the fight for freedom in America.

Joey Gibson, *Battle Ground, Washington, photographed in 2019*
Joey is the founder of the far-right political advocacy group Patriot Prayer.

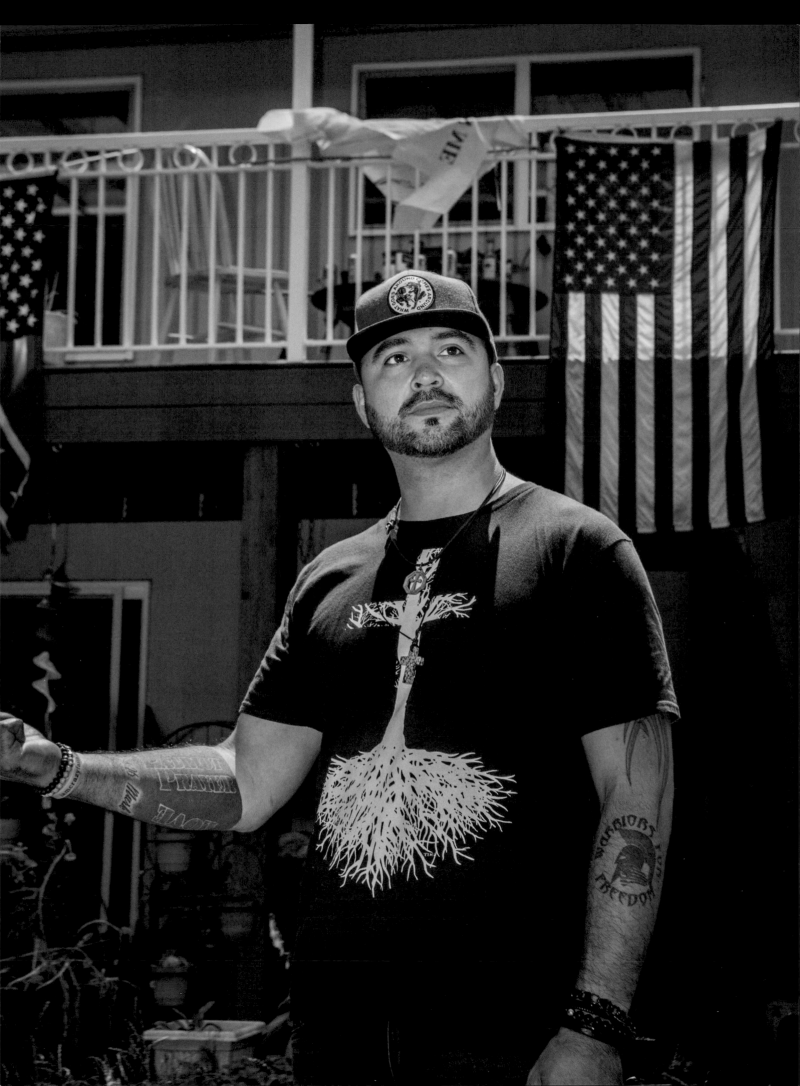

Albert P. NAQUIN's "American Dream"

As I went through life and got to where I am today, I seen many changes, some for better and some for worse.

I seen discriminatory, acts actually I was discriminated against because I am an Indian. There are too many homeless, too much drug users, too many alcoholics, too much much unemployment, too many laws. Too many Americans have more money than they will ever use in their life time, but they will never lend a hand to the unfortunates. Their statement is let them get a job.

My American dream is to wipe out all of the above and become one community of people/family and help everyone along our journey of life. One Nation Under God let us live by it every day.

Albert P. Naquin

Albert Naquin, *Isle de Jean Charles, Louisiana, photographed in 2017*
Albert is the chief of the Isle de Jean Charles Biloxi-Chitimacha-Choctaw tribe. Isle de Jean Charles is a small strip of land in southeastern Louisiana that has lost 98 percent of its land since 1955 due to levee construction, coastal erosion, rising seas, and hurricanes. The island's community is being moved to a new location a hundred miles north, making them America's first climate refugees.

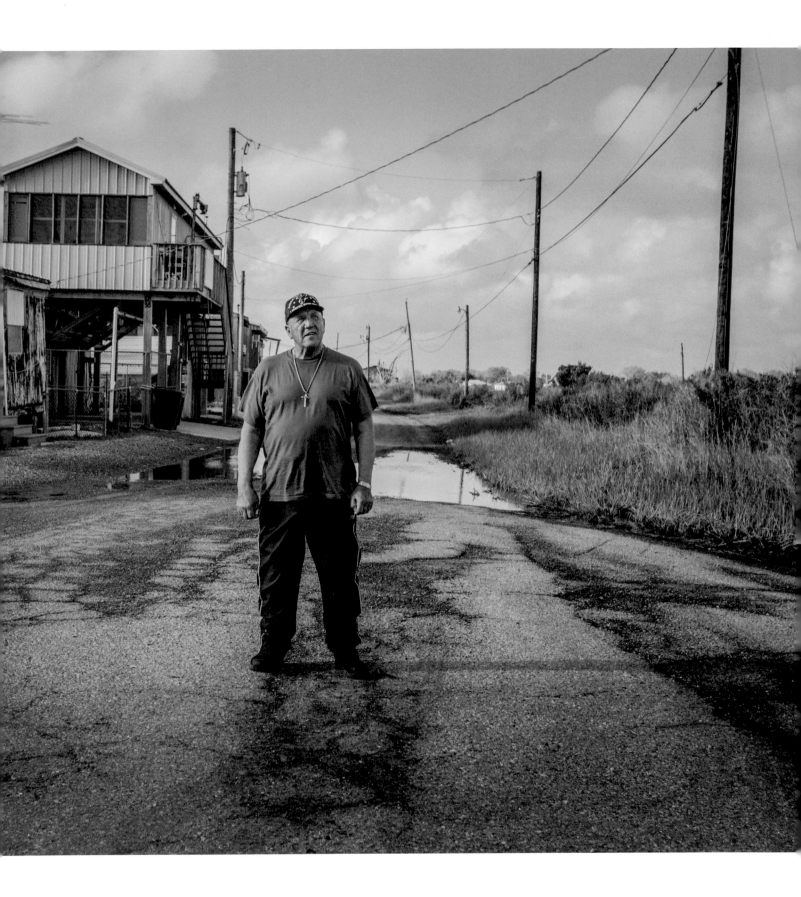

American Dream

My American Dream is to own
a Beauitful house
luxury

My American Dream is to own
a Beauitful luxury house and
still be working until im 65 year old.
See all my children have a Success
in life and watch my grandBaby
grown up to be a Beatiful young
lady.

My American Dream is to finish School own
a ~~big~~ luxury house have a ~~beautiful beautiful beautiful~~
happy family with enough money to ~~satisfy my~~
take care of my family and I ~~want~~ want to
be able to ~~take care~~ give back to my community.

Michael Singleton and Toya Graham, *Baltimore, Maryland, photographed in 2015*
Toya came to national attention when she saw her son Michael on television during the riots that followed the funeral
of Freddie Gray, who died in police custody in Baltimore. She ran from her home to where the riots were, found Michael,
and—on live TV—dragged him out of the melee. They both stated that their relationship has grown stronger as a result.

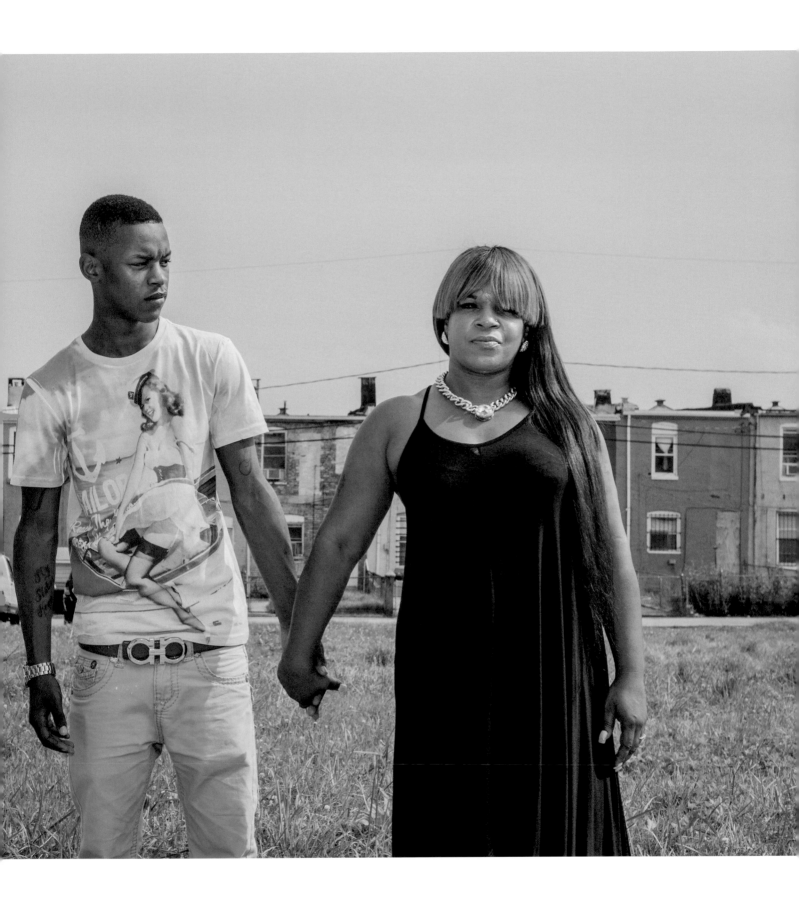

American Dream

My name is Bennett (Tim) Tanksley and I live, farm, and ranch on land that has been in my family for three generations. I also live in the shadow of a coal fired power plant which has been dumping their CCW (fly ash) out on the ground in this area since the plant started operation. I believe this social injustice is allowed to be inflicted on our community because we live in a rural, sparsely populated, economically depressed area where our voices don't count. As a veteran, when I recite the pledge of allegiance, the last words "Liberty and Justice for all," does not seem to ring true for me. My American Dream would be that my family, future generations of my family, and everyone could live in a society where "Liberty and Justice for all" is a statement of fact and not just the last words in the Pledge of Allegiance.

Tim Tanksley, *Le Flore County, Oklahoma, photographed in 2016*
Tim is a US Army veteran.

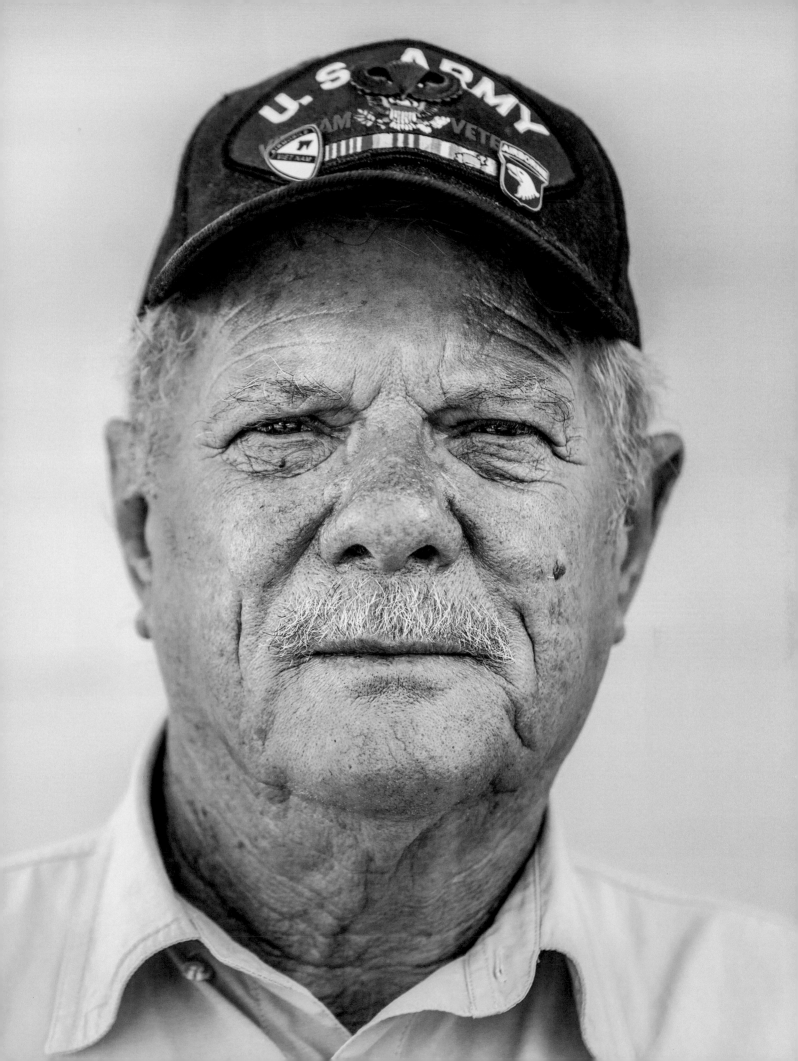

My American dream is that everyone has the gift of advocacy in their life ... that no one waits for a world, a community, or someone to give them permission to stand up for others.

I work for an organization that in a time of great fear had the courage to stand up for others — for people living with HIV/AIDS. Almost 30 yrs ago, those founders didn't wait and that provides me daily inspiration professionally and personally. I also feel blessed I get to pass that gift onto my kids. They are already pretty amazing kids, and I know because of advocacy they will grow into pretty amazing adults too.

Olivia

Olivia Chelko, *Monroe, Georgia, photographed in 2014*
Olivia, a single mom, is pictured with her adopted kids, Odessa and
Hamilton. She is the vice president of development for a health center.

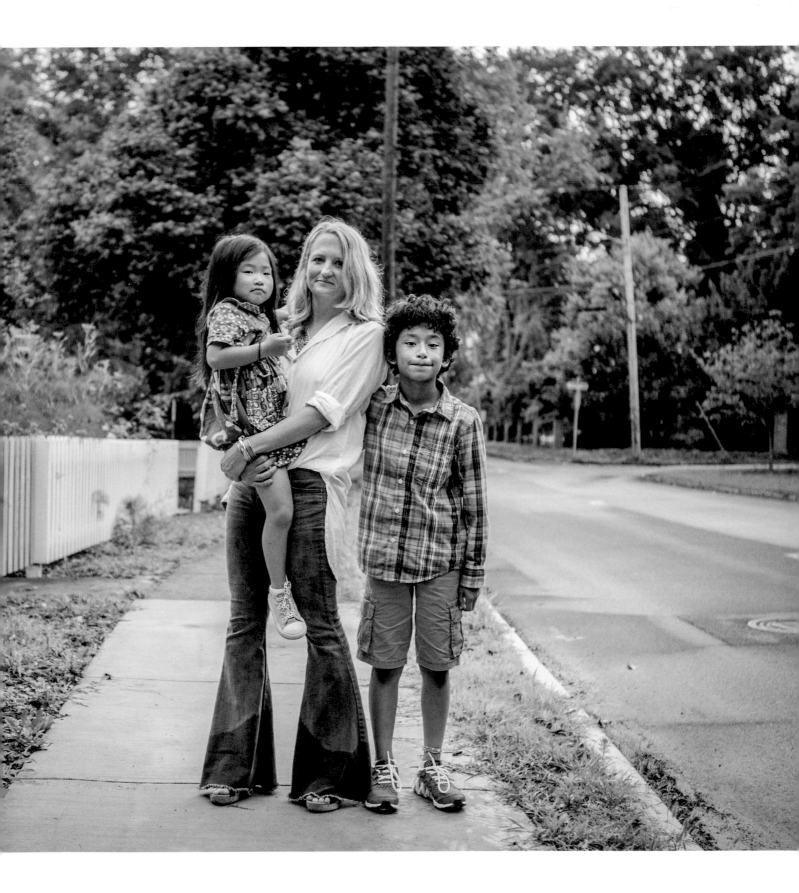

MAY 7 2019 EddIE POWERS

My AMERicaN DREAM

I'm WRiTiNG YoU to LeT YoU KNoW
What I BeLieve to be the "AmericaN DREAM"
OR Should I Say My AmericaN DREAM!! I had been
FoLLowiNG ELViS PResLeY'S Life and music Since I WAS
ABOUT 4 yearS old, I WAS quite INteRESTED in HiS
RAgS to RicheS STORY. So once I becameaN
AdULT and Wanted to be a PROfessional SingeR and
PeRFoRmeR OR Should I Say a ELViS PERFORmeR which
We aR called "ETA" which STANDS FoR ELViS TribUte
ARTiST. I STARTED MY ELViS CaR-eeR in San Diego
CALiFORNiA, and PERFORMED aS ELViS FoR 12 years.
BefoRemoviNG tO LAS VegAS, NV in 1995. Since then
I've been in many movieS and TV showS, and have
PERFORMed foR PeOple aLL oVeR the woRLd
IncLudiNG PERFoRmceS in Hong Kong ChiNA, malaysia,
United Kingdom. I am Living My AMERicaN DReAm,
to be able to PeRFoRM aS ELViS and bring such Joy,
and happiness to the milLioNS of ELViS PResLeY FaNS
WoRLd Wide. IT DoeS not even Seem Like a Job atell!
I AM so very happy to be able to perform to the FaN'S
of ELViS PResLeY! I know that he would be PRoud of
My tribUte to him. I have been PERFORMing aS ELViS
FoR oveR 35 yearS now, and I am HeaVily Booked
with My BeautifuL 1956 Pink Caddy in LAS VegAS, NV
So yeS I am TRUly LivingMy

 "AMERican DReAm"

Eddie Powers, *Las Vegas, Nevada, photographed in 2017*
Eddie has worked as an Elvis Presley tribute artist for more
than thirty-five years. He wrote his dream in 2019.

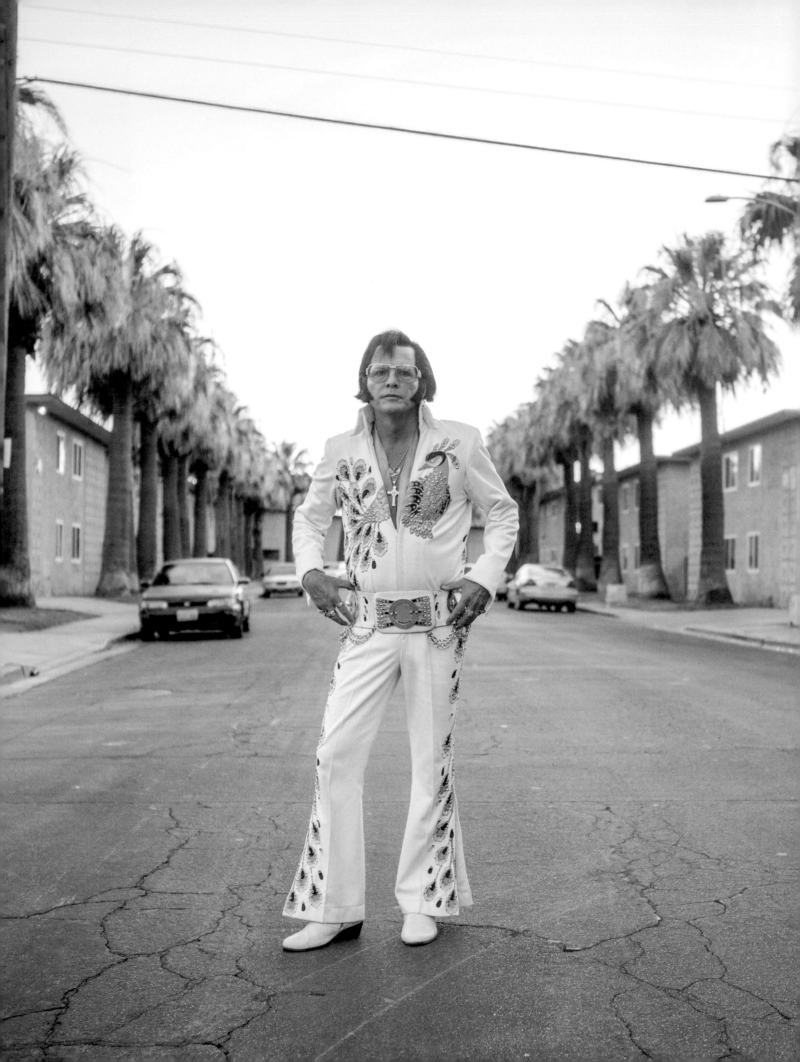

> MY American dream is to see all poor people, and all exploited people band together to create an existance that's a little less miserable than what we're living now.

Junior Walk, *Rock Creek, West Virginia, photographed in 2014*
Junior grew up with drinking water that was brown from coal runoff. He became outspoken against mountaintop coal removal after working for a coal company and learning about its devastating impact on the environment. As a result of his advocacy, he has faced death threats at gunpoint and had his car's brake line cut.

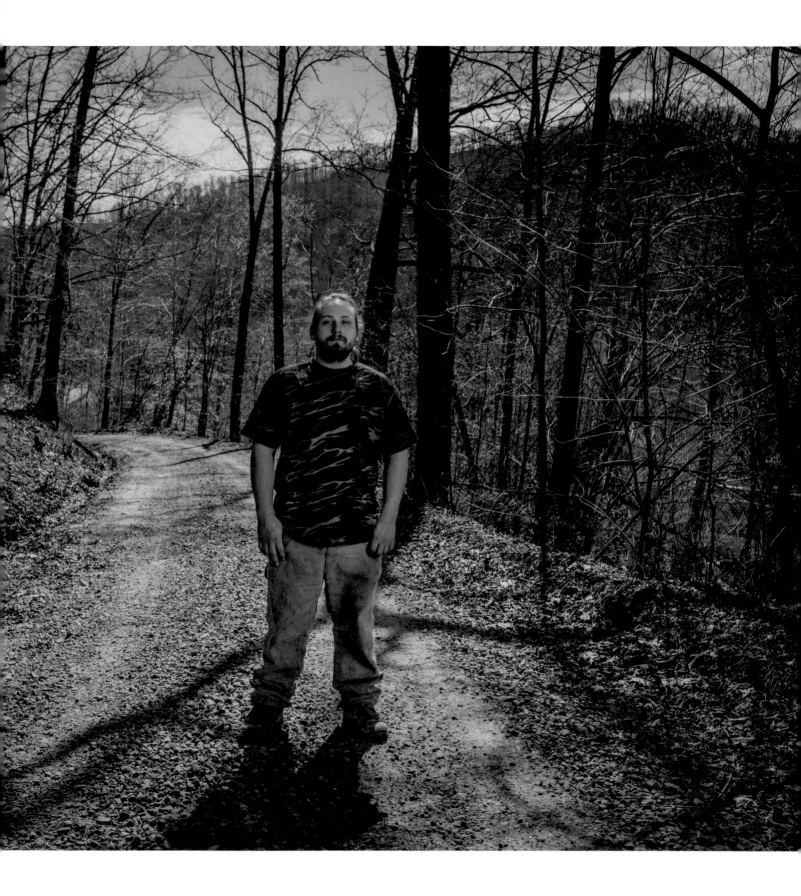

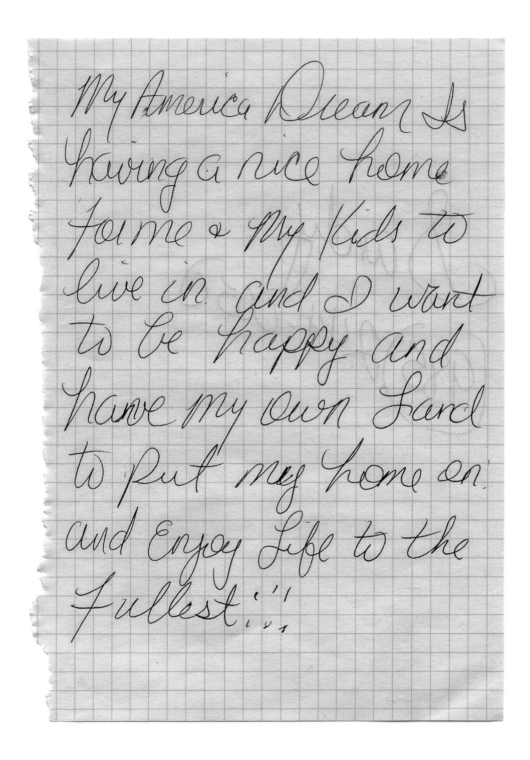

My America Dream Is having a nice home for me & my kids to live in and I want to be happy and have my own Land to put my home on and Enjoy Life to the fullest."

Sandy, *Fluker, Louisiana, photographed in 2017*
Sandy (center) is pictured with two of her daughters
and one of her granddaughters.

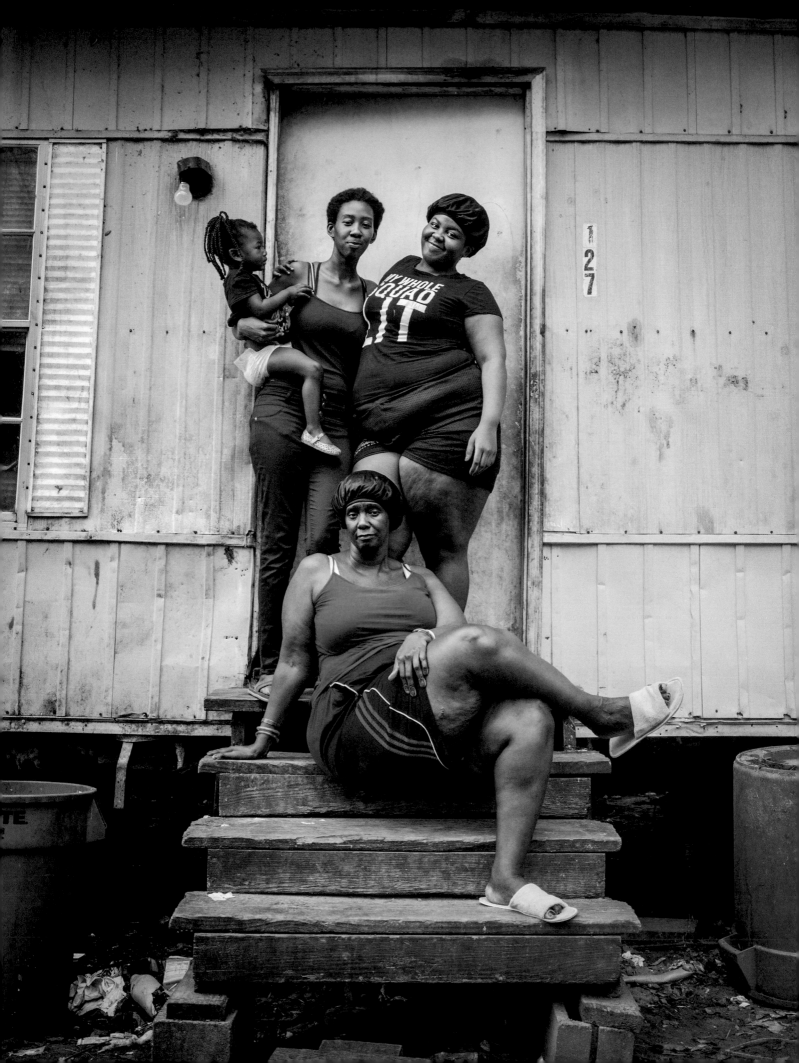

At first, I would snort at the idea of the "american dream". Back in history & past marketing that used to mean having it made: a house, a nice car, all the latest gadgets, and being married and stuff. It always seemed so materialistic and too picture perfect. to me. But if we were to change this idea, then for me, my "american dream" is to help make an impact on someone's life and to never let fear hold me back ever again... Fear of the unknown, fear/worry of what people think... I just wanna be done with it. And Lord-willing, I will pursue my passion to help people and help tell their story. I love nonprofit work and I was a Photojournalism major and it's what I set out to do in this world.

Makayla Eastman

Makayla Eastman, *Fargo, North Dakota, photographed in 2018*
Makalya is an aspiring photographer and works at a homeless
shelter in Fargo.

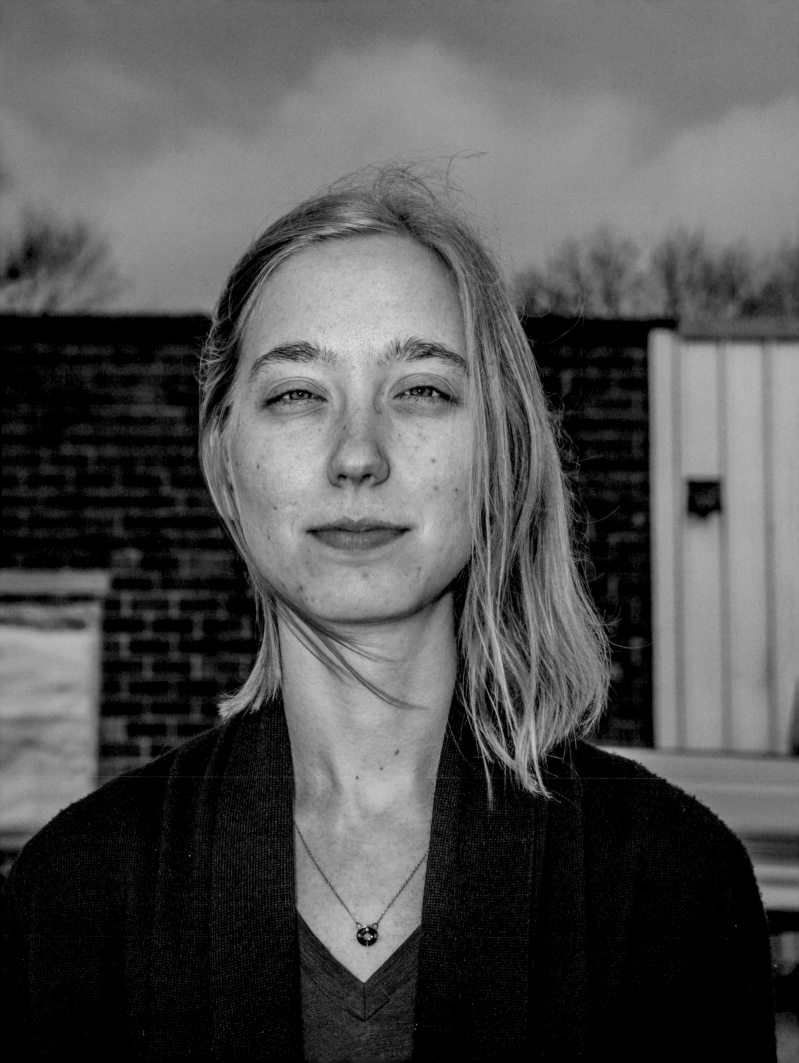

A mber waves of grain and spacious skies.

M ythic or myopic -- this vision, this dream, this

E veryman's and Woman's hope for freedom, abundance, bliss?

R ags to riches. According to Horatian Algebra, that's the way

I t works, right? And yet.....

C ity on a Hill or Castle in the Air? My own ragged yet determined

A ncestors, impelled by faith and that thing with feathers, left the land of
the Roisin Dubh and

N ever once looked back.

D reamy-eyed, still they come, and come. And let them. There is

R oom, and to spare. Mother of

E xiles, lamp ever lifted,

A waits and welcomes,

M aternal and bounteous.

Sharlee Glen, *Pleasant Grove, Utah, photographed in 2019*
Sharlee writes children's books and is an active member of
the group Mormon Women for Ethical Government. She is
pictured with her grandson.

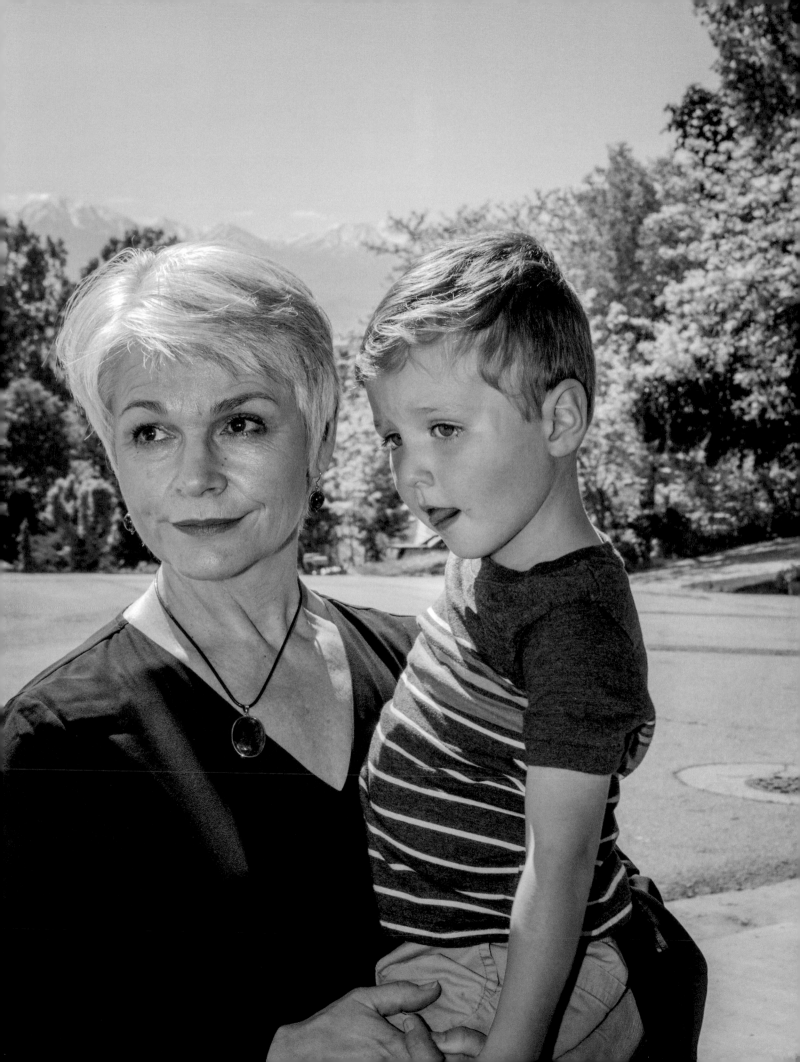

7/4/15 When I was in 4th grade, I read the Declaration of Independence every day. By 6th grade, I refused to recite the Pledge of Allegience. Every year for ten years, I read Frederick Douglass' Fourth of July speech on this day. My American Dream includes reparations for the descendents of African slaves, prison abolition, universal health care, and more tax money spent on education, public transportation, libraries and renewable energy than on "defense". More and more, America makes me want to flee — to Canada, to Mars, anywhere where my family and friends might be safer than they are here, today.

1.

"There is not a nation on earth guilty of practices more shocking and bloody than are the people of the United States at this very hour." — Frederick Douglass, 1852

Let me know when I'm actually allowed to dream, America, because my hope is consistently gobsmacked by this perpetual violence.
 Let me wake up and know my life is a possible, valid, protected right.

Casey Rocheteau

Casey Rocheteau, *Detroit, Michigan, photographed in 2015*
Casey was photographed in her backyard on the Fourth of July.

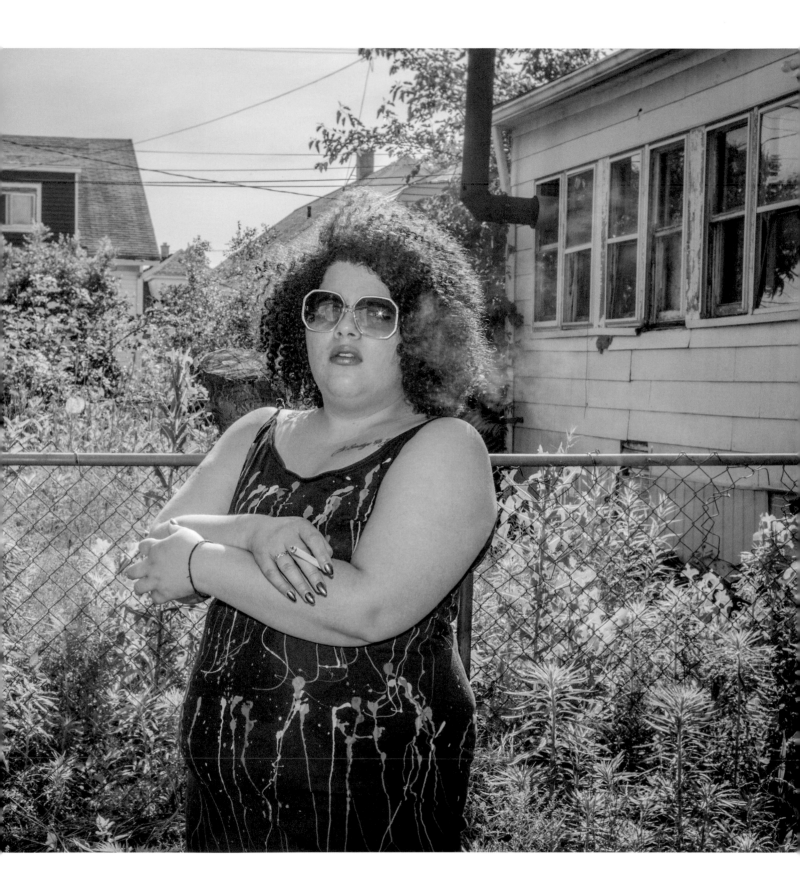

My American Dream would~~~~ Be to Find Love again (a meeningful relathonship with a Female)

Byron Seeley, *Jeffrey City, Wyoming, photographed in 2019*
Byron is a potter and artist who lives in an abandoned uranium
mining town in central Wyoming.

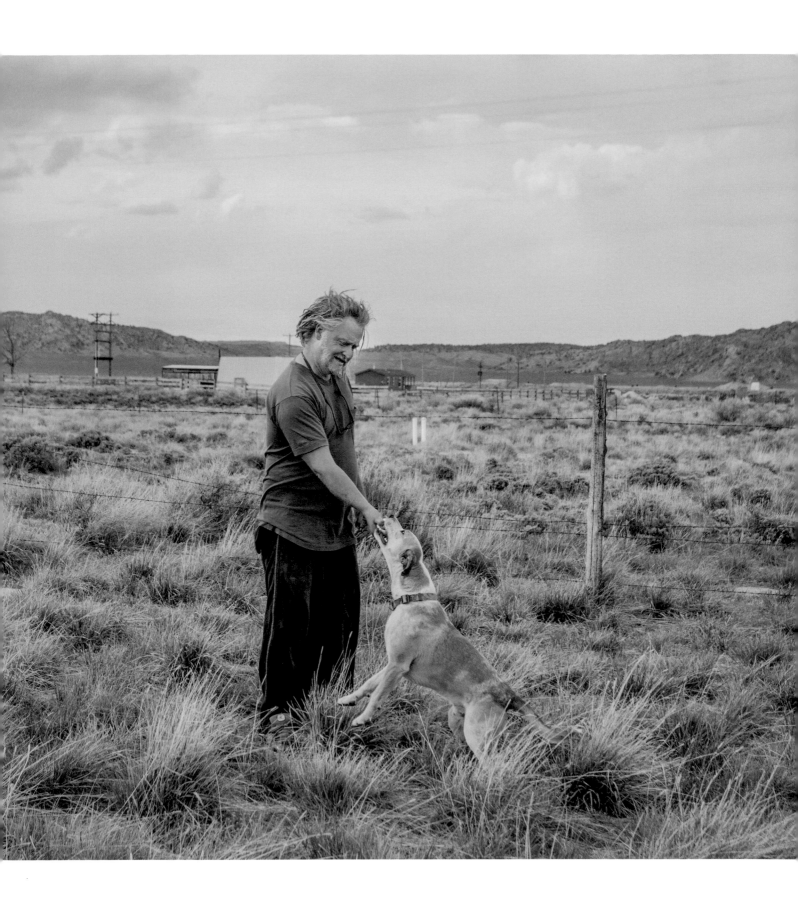

The American Dream ~~pursuit~~ is the pursuit of inner peace, harmony and beauty that manifest itself by those who cross your path.

The American Dream is watching a young girl suffer in silence wondering if she would escape the cycle of poverty. But ~~because~~ the American Dream gives hope and inspires the young girl to overcome the odds to pursue a college education, serve her country, endure the indignities of war, to ~~one day~~ return heal, only to serve her country in a different capacity; ~~counseling~~ the American Veteran who also suffers in silence. The American Dream offers us an opportunity to ~~do something~~ find a purpose on this earth larger than ourselves despite the odds.

Danielle Green, *South Bend, Indiana, photographed in 2015*
Danielle attended the University of Notre Dame on a sports scholarship before joining the US Army.
While serving in Iraq in 2004, she lost her arm in a rocket attack. Her husband died of a heart attack
in 2011. She now works as a counselor for veterans, and had her first child in 2014.

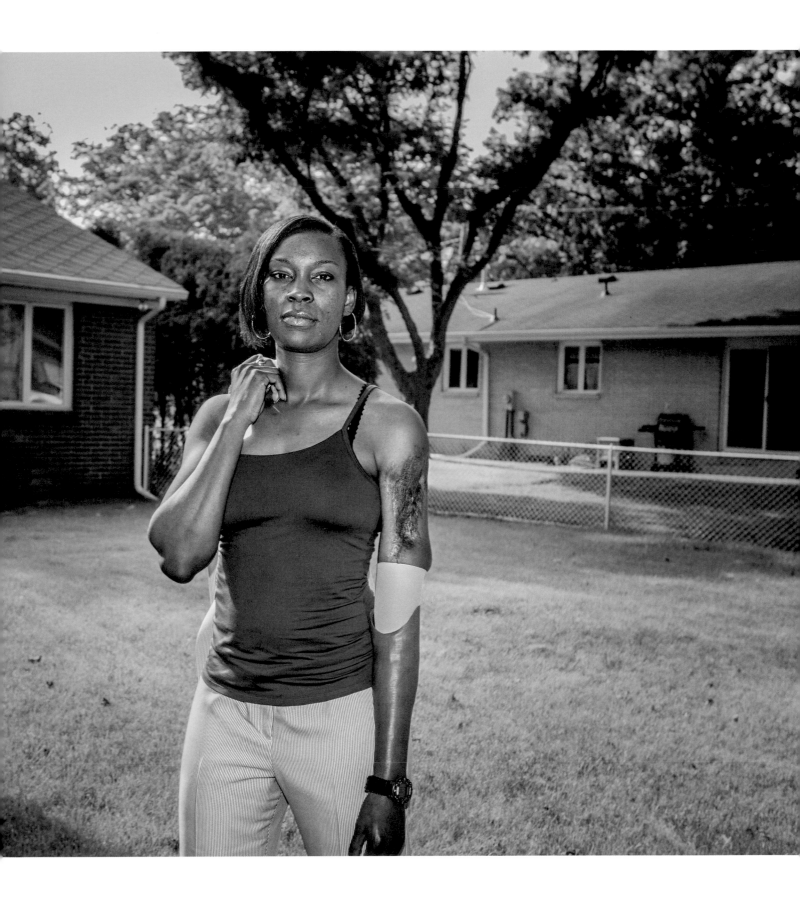

Our American Dream

To create (or at least plant a seed for) a resilient and regenerative culture. To create an alternative to mainstream hyper-consumerism through homesteading, community and permaculture. To help spur along the inevitable transition back to a society of producers rather than a society of consumers. To offer our children (and other families) a meaningful and sustainable existence as human beings. To be connected and help other people to be connected with what gives us life and what lets us truly live. To allow ourselves to truly feel. To help develop a local sustainable food economy in our northern climate. To hell with the concept of "leave-no-trace" or "net-zero"! If we can help it, we'll make a huge ecological footprint, but we want to have a "net-positive" effect on our community (human and other living things) and on the planet. To embrace fertility and life rather than a blind allegiance to comfort and convenience regardless of hidden costs to life. To seek interdependence on community, the land, water and all life in our quest for independence from sterile manufactured society. That someday America and the world will be back in the hands of caring people rather than the death-grip of faceless greedy corporations. To live every-day as if it could be our last. To always be thankful for what we have regardless of the circumstances. To recognize the pain and suffering of both humans and all living things that we are responsible for. To always be good enough, but also always have room for improvement. To be leaders with no masters yet be no master. To live truly free, but never free from responsibility and accountability. To give and to take, but always first give. To be a good partner and parent. To teach and to learn. To share the moments as evolutionary social animals. To recognize the great mystery that is life and to look upon it with awe but to always question. To dream big and take calculated risks. To always be honest and open in our communication with others. To instill our values in our children and try our damndest to show them a good example. To learn to stop blaming. To be imperfect. To be human. To be at peace with the fact that we have to kill so that we may live and eventually we too shall die. To live and let live when possible. To let our bones and flesh eventually rot into the earth without chemicals or preservatives so that through our deaths we will return life to the earth and complete the cycle. That all of humanity may live their dreams without stealing away the dreams of others.

Amelia and Steven Roach, *Finland, Minnesota, photographed in 2018*
Amelia and Steven live off the grid with their three children in a remote part of Minnesota.
Their home, which is two miles up a dirt track from the nearest paved road, is a two-room
cabin with an outhouse. They grow their own food and homeschool their kids.

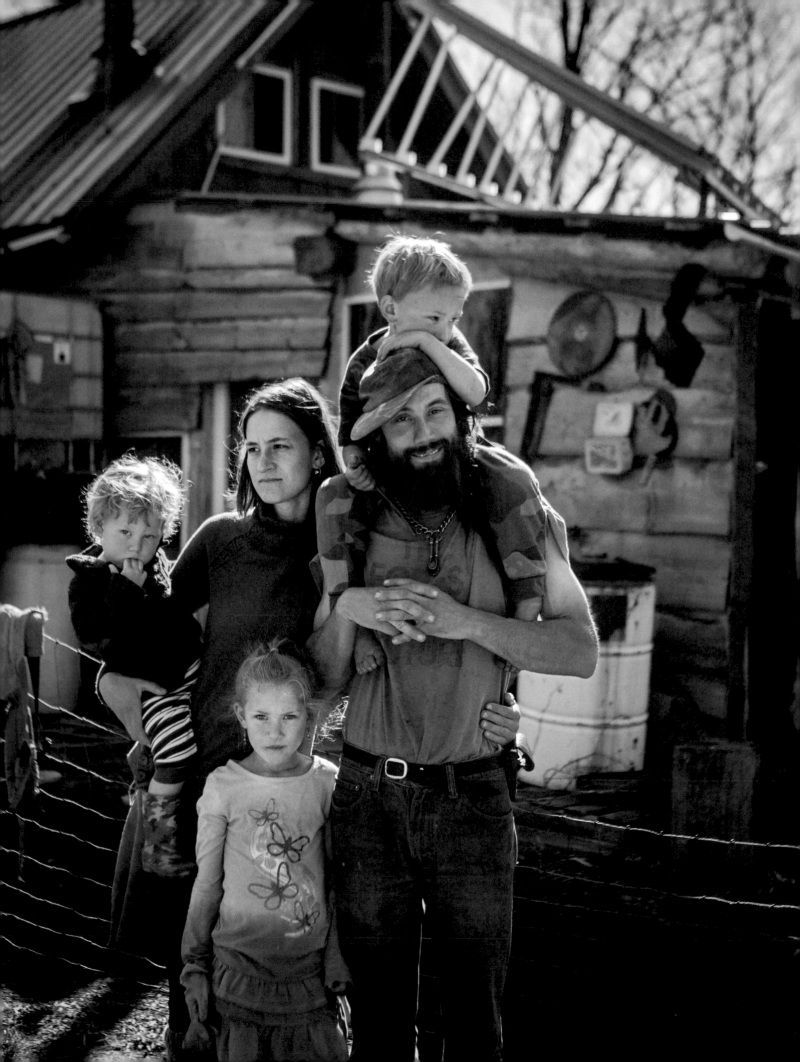

7/17/16

I want hands like these to express a heart like mine without pre-judgement. I want a life like mine to be on a platform like this without conclusions being jumped. An enviornment like this shouldn't tell my life before you know me. My ~~xxxxxxxxx~~ fatherlessness ~~xxxxxxxxx~~ shouldn't read you a future criminal record. In my country I'm often refered to as a statistic. Little did you know I wish to live in an America ~~xxxx~~ where a puerto rican, African American, and ~~xxxx~~ white young man can feel free and brave opposed to colored and enslaved. ~~xxxx~~ Little did you know my pigment doesn't represent my character. Little did you know I too have dreams not to just make it out of the hood but to better it. Little did you know I want myself and donald trump to have known the same America.

Sincerely, Robert Norton

Robert Norton, *Cleveland, Ohio, photographed in 2016*
Robert is an aspiring musician.

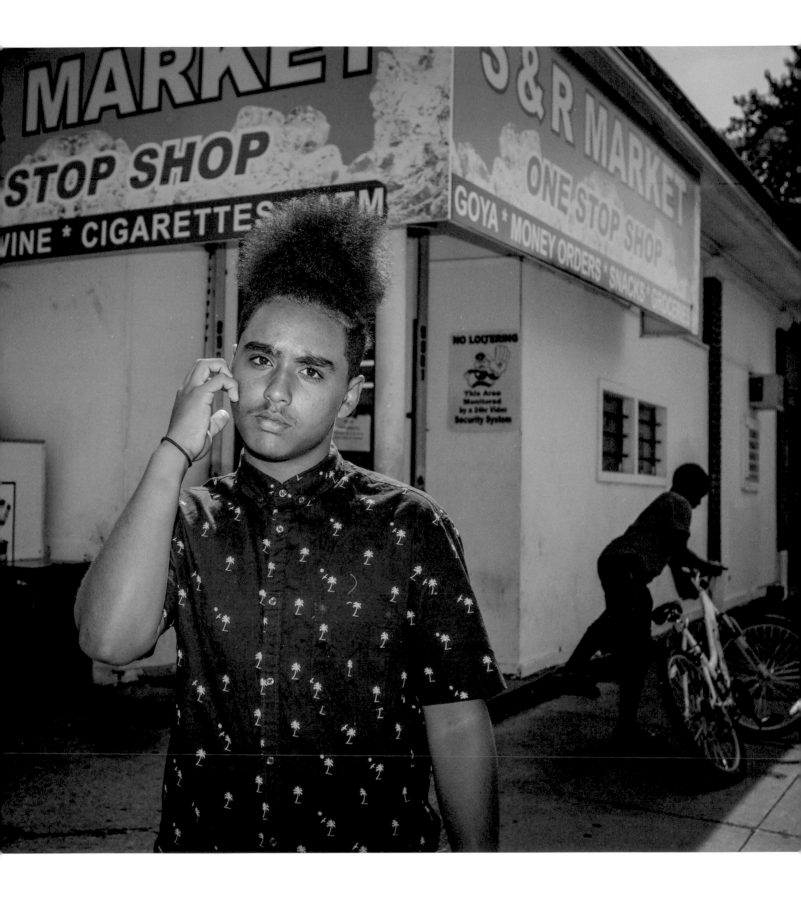

Someone once told me "The second that you accept what was good enough for you as good enough for your kids, you lose." We both believe that, so when we decided to start a family, buying a home was the first step. Neither of our parents ever purchased a home, so we started there. And that's our dream, and how we're working toward it. We want to give our children more than we had so that they can do the same, and leave the world better than we found it. That's our American Dream.

Justin and Audra, *Oak Hill, West Virginia, photographed in 2014*
The couple was photographed outside the house they had
just purchased.

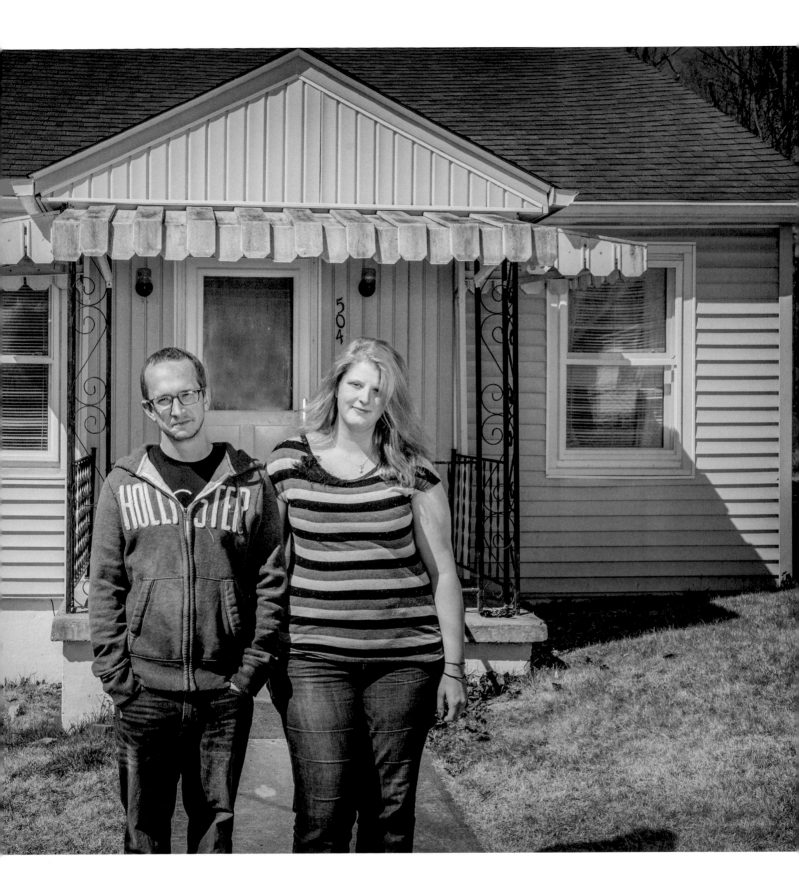

Our American Dream

is to keep it going: What we've found in each other. Other than being one pair of honkies, we don't have a lot in common. But we light each other up and, I like to think, light up our corner of the world a little.

Petey and Hardy, *Minneapolis, Minnesota, photographed in 2018*
Petey met Hardy when she got into his taxicab. He asked her to read a script for a play he was writing. She loved it, and they have been together ever since.

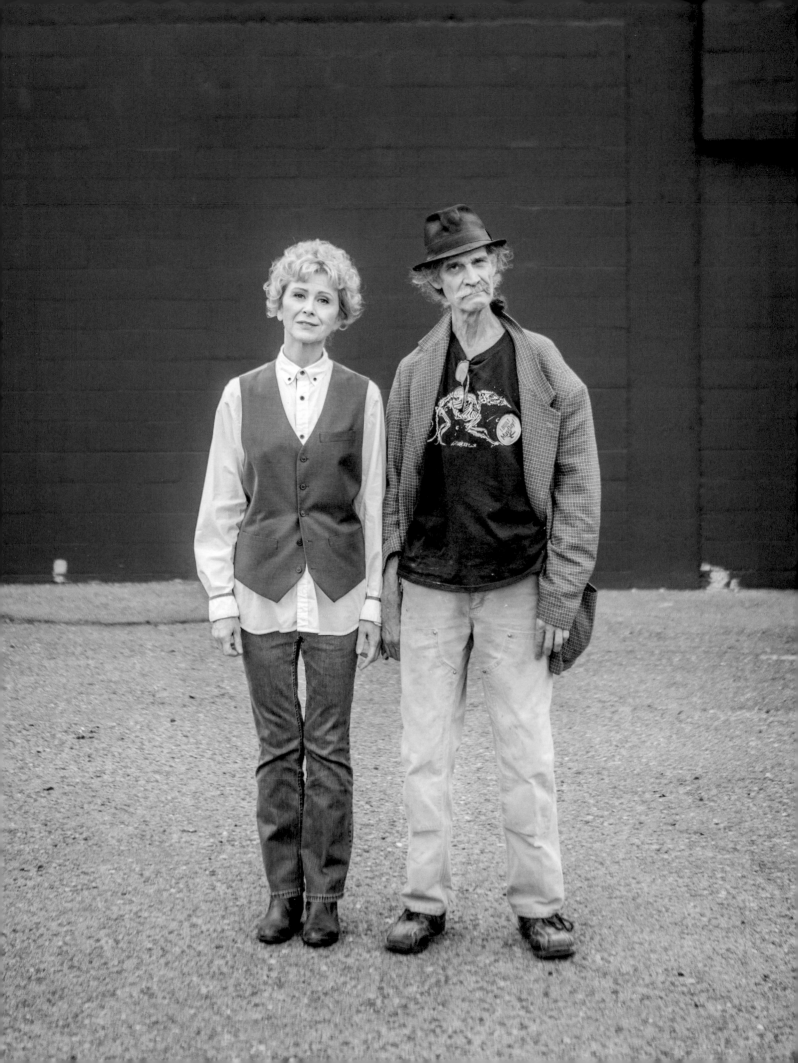

Toni Holt Kramer

Since Election Day I am happy, enthusiastic and more relaxed. I believe there are many people across the entire U.S.A. that feel the same way. My American Dream is to see our country thriving again and accomplishing all of the important issues that are very much in front of us.

The thing that matter to me, and still do, is a country like the one I grew up in where I felt safe going to a movie theatre or a mall. The incredible barbaric behavior of the past years without even labeling it correctly is not acceptable to me.

Consequently, the Trumpettes USA was born Sept 19, 2015 with three like minded best friends.

I became Founder and President. The goal was to have women

Toni Holt Kramer, *Palm Beach, Florida, photographed in 2017*
Toni is a member of the Mar-a-Lago Club and a cofounder
of the Trumpettes, a group of female Donald Trump supporters.

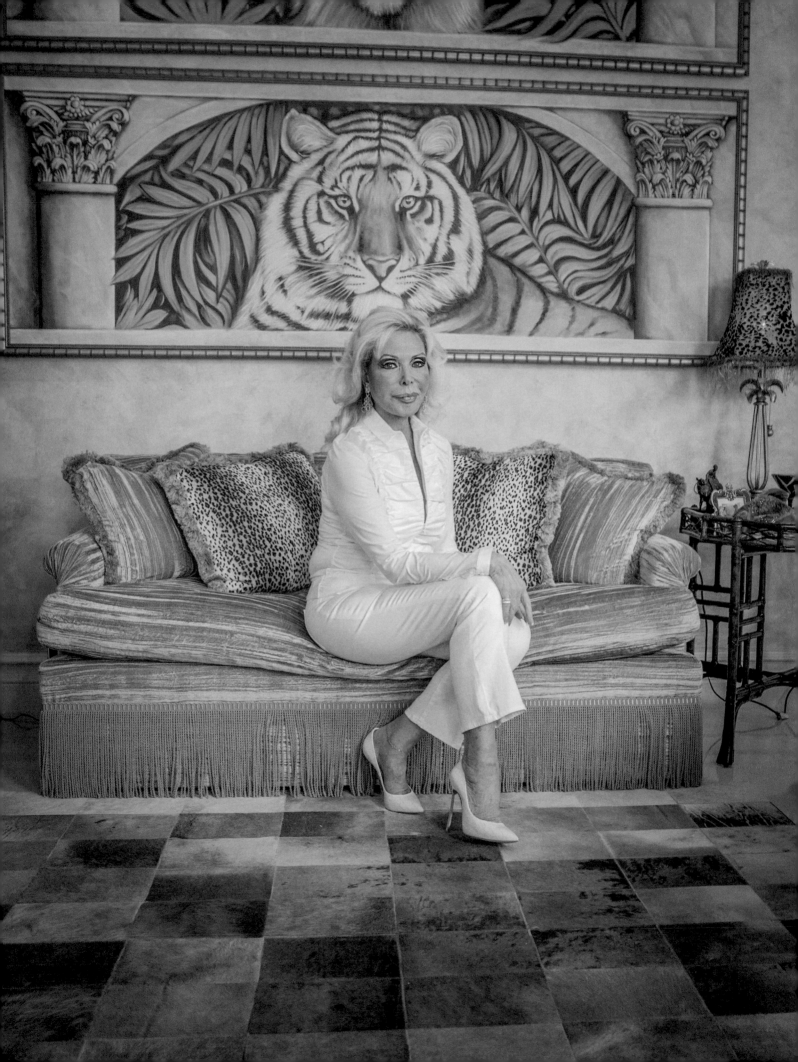

join us and give a platform to support Donald J. Trump. We were determined to get him behind the desk at the Oval Office.

Mission Accomplished!

Within 17 months we have grown by the thousands — followers of Trumpettes and Trumpsters.

We now have a new wave of young college students taking an interest.

The World took note of our mission, as the spokesperson for the group, I was at home. It came easily to me because of my 25 years experience on television. I am proud to say the Trumpettes USA has done one 55 television shows, newspaper and magazine interviews around the world. Some of these include "Sept Ah Huit" the sixty minutes of France, to America's "Nightline," to "Good Morning

Toni Holt Kramer

Great Britain as well as interviews for Japan, Denmark, Sweden, Germany, Unisex, Politics, as well as several documentaries just to name a very few.

The coup de gras was a double page center spread in the Presidents Inaugural Feb 2017 edition of "Vanity Fair" which has world wide distribution.

Now that President Trump is in office I feel my America coming back.

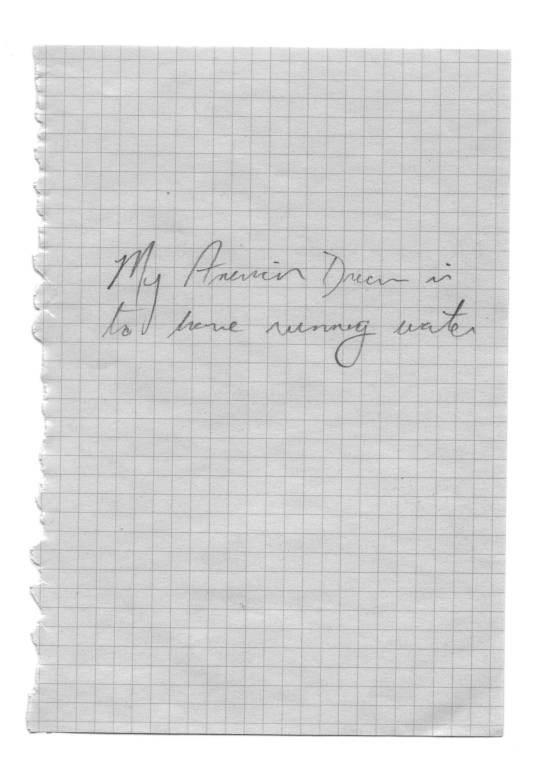

Clodite, *Roseland, Louisiana, photographed in 2017*
Clodite lives in an unincorporated community where more
than 40 percent of the population live below the poverty line.

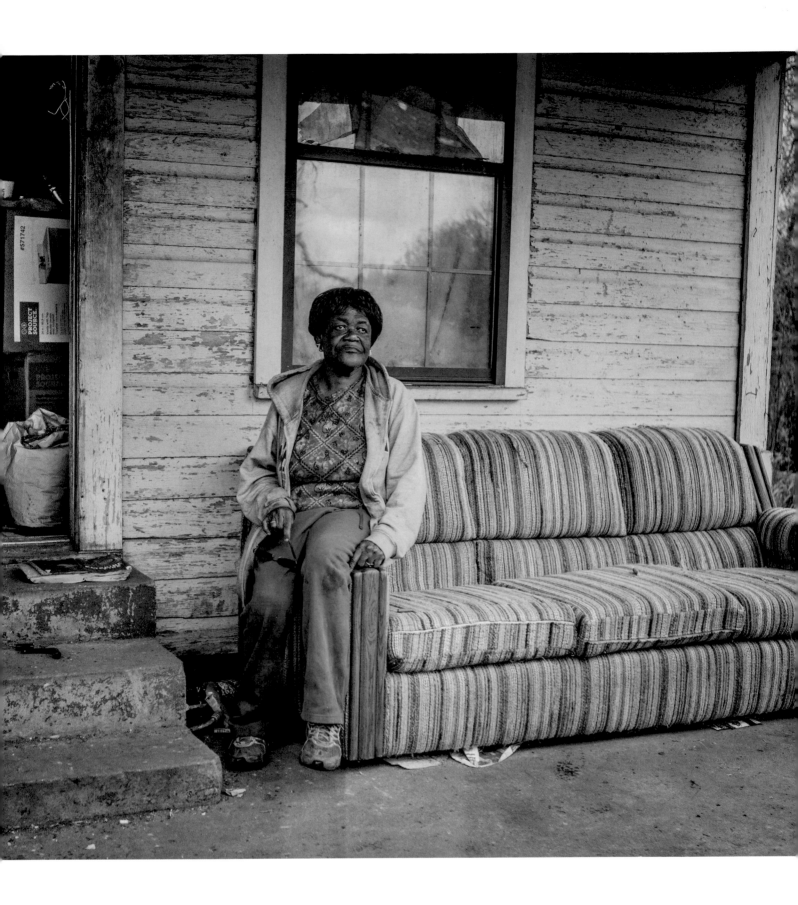

AMERICAN DREAM ♡

I'm a single mother of 5, police officer, Full time college student, A best friend, a sister and a girlfriend. My American dream is a ongoing journey. Supporting my family sometimes is a struggle with the long hours at work, the harsh reality of the city streets, followed by a packed full week of in class college courses, comming home to house work, kids school work and activities. My American dream has changed within the years. I say that life had much more in store for me than I thought, the let downs, the heart breaks, challenges and struggles, the hard times, the obstacles, I've overcome, the lessons I've learned, the strength I've had to dig deep and find not just for myself, but for my family... they all made me who I am today.

I want to show my children that against all odds, and no matter what life throws at you anything is possible. I value education, I do not want to be a statistic of an uneducation single mother. I push myself to finish my degree at University of Baltimore. In hope to attend law school within the next year. In my free time I participate with the police unity tour, polar bear plunge. My American dream is far from complete, what do I want at the end of it all? I want stability, I want all my hard work to pay off so I can own my house with land, a place where my kids can call home. I look forward for my Boyfriend Scott to return from deployment. He is my biggest fan and encourages me to reach my goals. I look forward to Sunday barbecue on the back deck after church. Even owning a pig. Every step along the way in my journey thus far has taught me to value everything I have in my life. How hard I've fought and how far I've come to make my American dream what it is has shaped the person I am today.

Although my definition of the American dream may seem far from most. But it's my story ♡. My journey is a long one and I'm enjoying it every step of the way, with the help of my children Jacob, Caleb, Isabella, Ethan and Colton you make my American dream.

♡ Mommy
(Karyn C.)

♡ ♡

Karyn Crisafulli, *Baltimore, Maryland, photographed in 2015*
Karyn is a single mom of five kids and a Baltimore police officer.

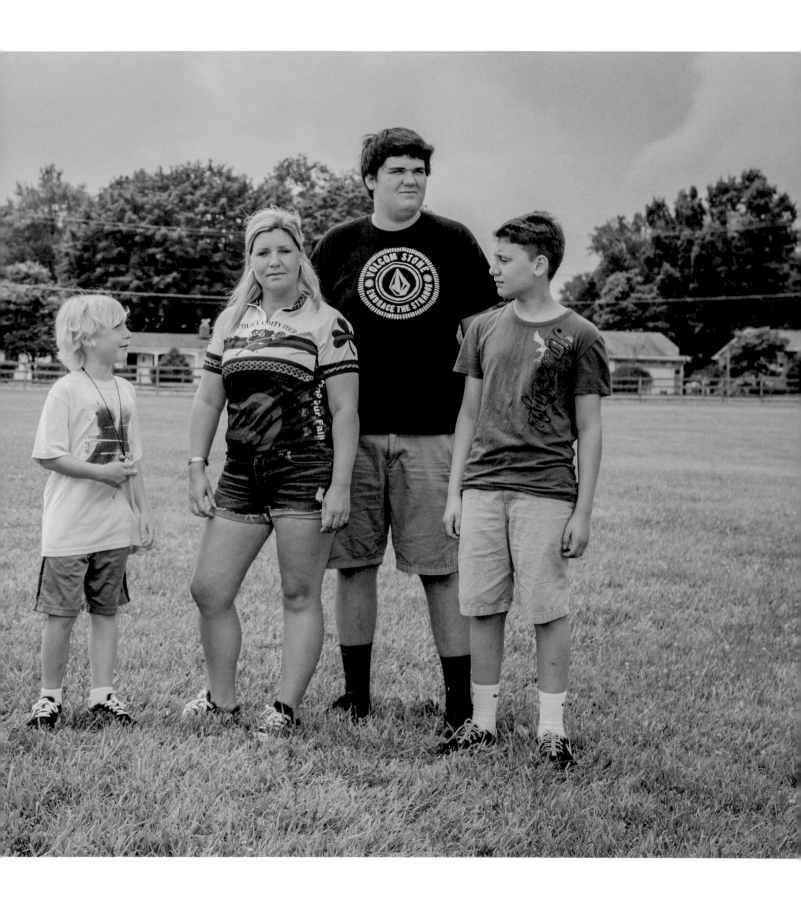

Would my "American" dream be the same as 'St. Julia's' dream? Because I've always dreamed kind of big, and part of that comes from my American roots, I imagine.

I grew up in a German-Protestant area in Lancaster County, PA. But my curiosity and love for reading led me to discover the Saints and the Catholic Church. Then I entered an Italian Religious Congregation whose mission is to spread the Good News through the media. What I wanted was always to share this great discovery of my youth and make others fall in love with it, too. Communicating a love for the True, the Good and the Beautiful. Helping people rediscover it. Like I said... dream big and don't stop there!

And how exactly does all of this tie in to being American? Well, it helps being part of an international Congregation of nuns. In our order, Americans kind of stick out as young, hopeful, extraordinarily idealistic, a little loud, too independent, very generous, brave and practical, willing to try, willing to get our hands dirty, convinced of the rightness of our cause and the help of God. I guess I'm some of all that... or at least I ascribe to it. In any case, I have German family roots, Italian ties via my Religious "Family", a love for Irish music, Greek food, Amish Farmers Markets, and anything Cajun (which means a party of some sort). In other words, I'm very, VERY American.

Sr. Julia Mary Darrenkamp

Sister Julia, *Boston, Massachusetts, photographed in 2014*
Sister Julia (left) is pictured with Sister Ann. Both are part of the Daughters of St. Paul, an order of Roman Catholic nuns.

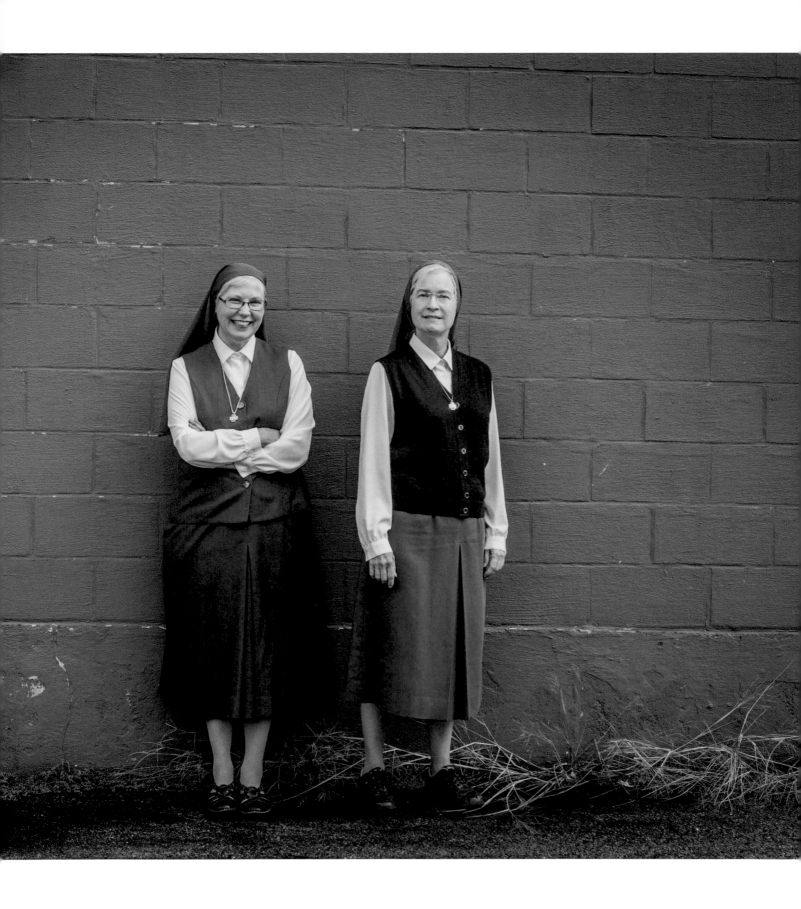

My American Dream Glen McMillin Jr.

The American Dream is defined as the ideal by which equality of opportunity is available to any American, allowing the highest aspirations and goals to be achieved.

My American Dream was born out of my own chaos and self distruction. Two years ago I had been found dead for the third and final time in a seventeen year struggle with addiction. Much like a large part of our nations youth, mine had also been stolen from Fentanyl and poor decisions.

My American Dream opened my eyes that we are here for reasons far greater then ourselves

My American Dream does not exclude God from schools or homosexuals from churches.

My American Dream doesn't turn a debate into a protest or a riot.

My American Dream isn't built on or fueled by the emotional or physical scaring of others.

My American Dream is a society that respects and looks up to its elders. It pulls from their experiences, rather then walking over-top of them.

My American Dream knows no prejudice, discrimination sexism, or bias.

My American Dream evolves yet always sticks to it's roots and fundamentals.

My American Dream is full of dilligence, love and compassion.

Glen McMillin, Jr., *Rogers, Ohio, photographed in 2017*
Glen has overdosed on opioids three times: once in his parents' bathroom, once in a church parking lot, and once in a ditch on a rural road (pictured) after he was dumped out of a car. He entered a treatment program and has been in rehab since.

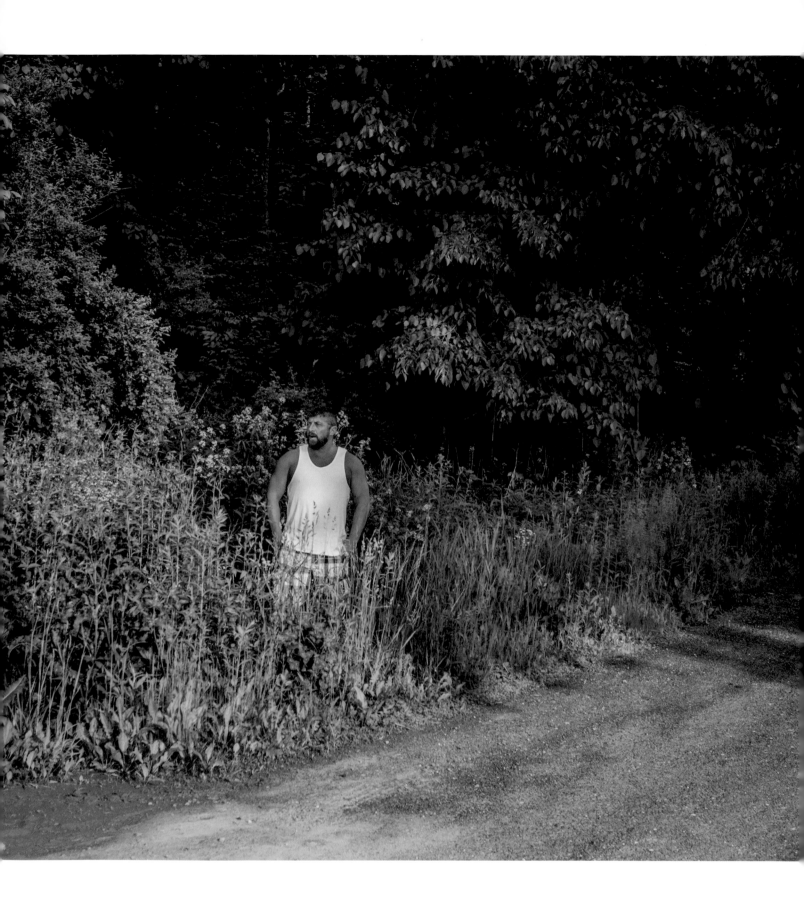

My American dream is a safe place for everyone. The poor, needy, sick, the helpless everyone. No more danger in the streets, or fear to walk down your own block at night. A sanctuary of sorts, where everyone can at least go to work and provide for their families and do what they love In peace. No fear of getting shot, robbed, kidnapped, only the wonder of what to eat for dinner or if you'll go out for a movie. Though it may be cliche, it's my American dream.

by Aveonte Willingham
Age 15

Aveonte Willingham, *Flint, Michigan, photographed in 2016*
Aveonte (right) is pictured with his cousins Samoura (top left) and Cassidy beside the site of the former Buick City auto plant, which was demolished in 2002. It is now one of the largest toxic brownfield sites in Michigan.

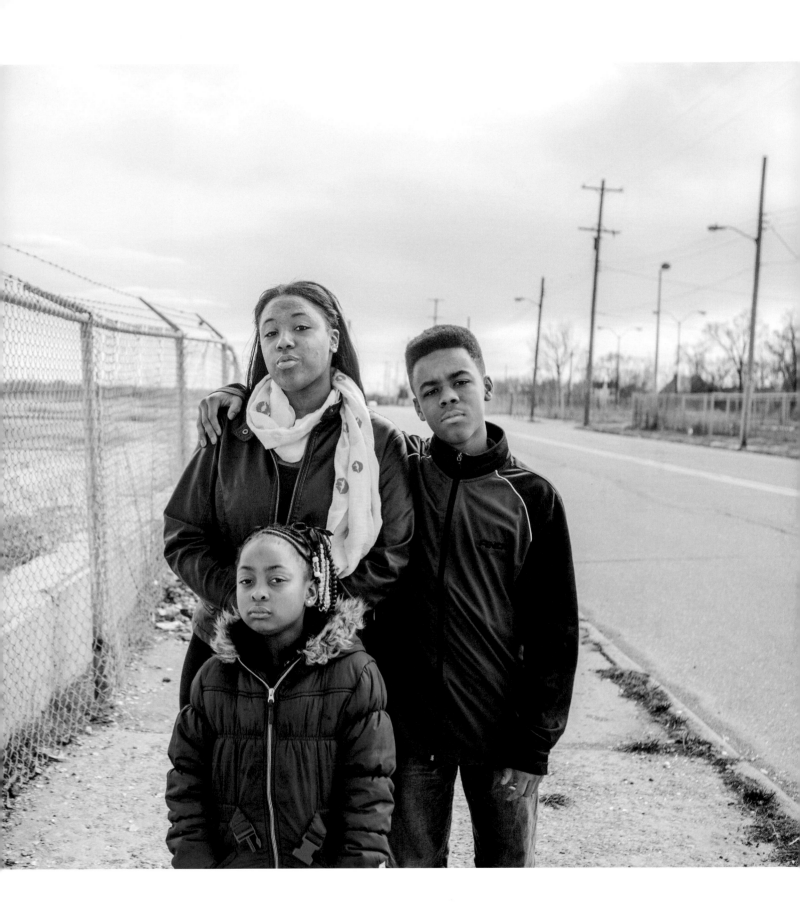

MY AMERICAN DREAM

I know this might sound ridiculous, and I swear I'm not even a huge sports fan, but the night the Cavs won the championship a couple weeks ago I realized HOLY CRAP- this is my dream come true!! Not necessarily because the Cavs won but because everyone in the entire city was sooo happy together - dancing + hugging + high fiving in the street!!! It was amazing. It didn't matter who you were or what you looked like — there was this shared feeling of joy and comradery. And that feeling — that is the feeling I want people to have everyday. That is my American Dream. I know the whole world can't be a giant party all the time, but if people could more often get that best feeling ever without having to worry about when they will get their next meal or if they will be able to pay their student loan debt or if their kids will be safe at school- and feel that spirit of friendship + community with people around them, I think we would all be better off. I know we can't completely erase all worry + fear from life, but I want people to have a great deal less of it so we can more often enjoy each other's company + the smaller moments + little surprises that are always popping up in life. Erin Guido

232

Erin Guido, *Cleveland, Ohio, photographed in 2016*
Erin is an artist and muralist.

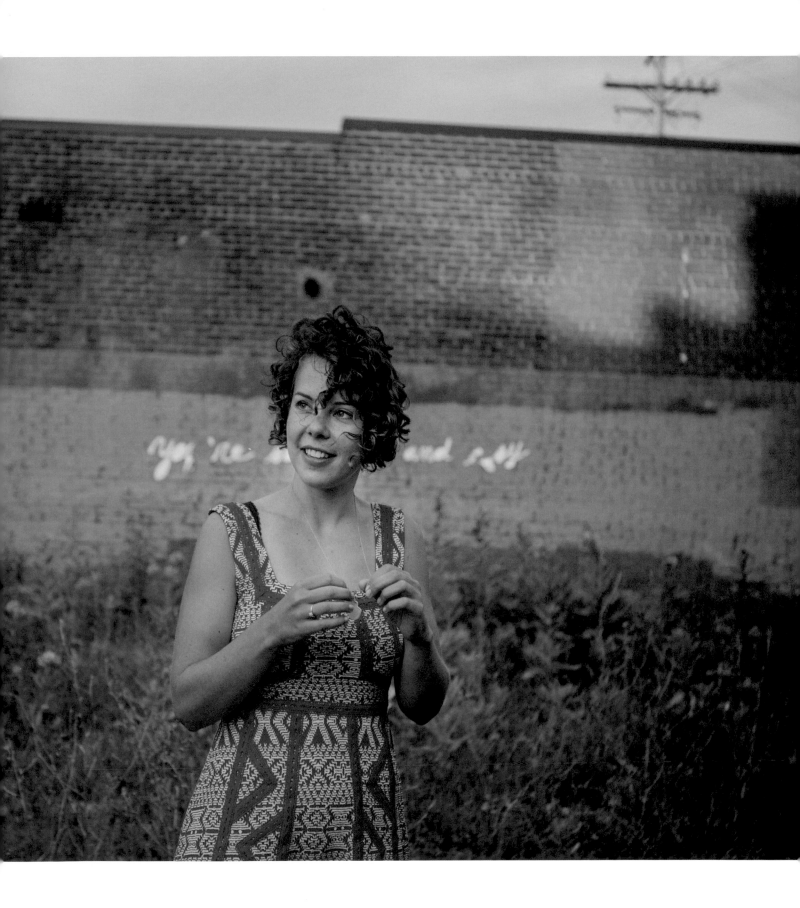

Joel, *South Bend, Indiana, photographed in 2015*
Joel (right) was a pastor in Illinois who attended conversion therapy after coming out to his family. After therapy, he resumed his church duties until deciding that he was not living truthfully. He was subsequently ostracized from his community, and left to begin a new life in Indiana. He met his husband, David, while working part time in a coffee shop.

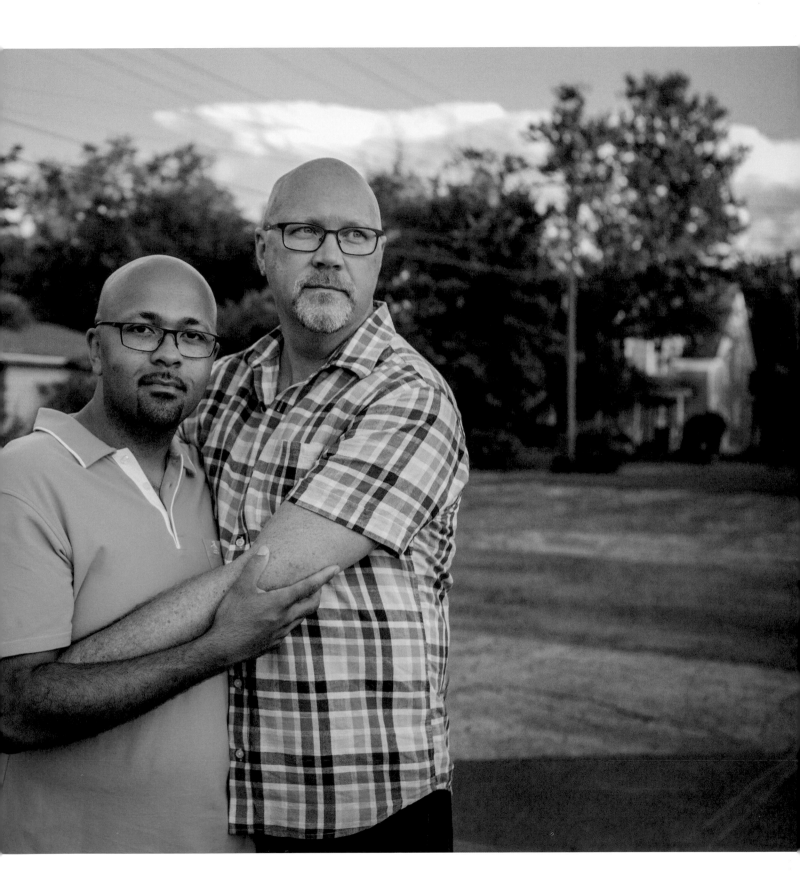

On August 12, 1977 I was an 11 year-old boy in Effingham, Illinois. I had no idea that 250 miles away in South Bend Indiana a baby was being born who would one day change my life.

It was 28 years before our paths would cross on a cool November day when David Seymour walked into The Daily Grind and ordered a hot Chocolate. I was managing the coffee shop while trying to piece life together after resigning as pastor of my fundamentalist Baptist church, thus ending my ministry career. When David met me I was still sweeping out the crumbs from the end of my 14 year heterosexual marriage while attempting to navigate the foreign territory of raising my 3 kids as a single gay dad.

David seemed too good to be true. When we began dating I called him my BOFA (BREATH OF FRESH AIR). He breathed new life into me. While our life journeys were completely different from one another, he took time to listen to me and to try to understand the damaging world I had come from and the scars it left on me. I had only recently ended nearly three years of

ex-gay therapy. Needless to say, I came with baggage, but he was willing to be with me while I sorted it out. It wasn't an easy time to be in my life. I'm not sure why he was interested in a struggling father of three, living in a tiny apartment, driving a dilapidated car, but he didn't let that stop us. Together we worked through every challenge that came our way.

In 2013 we went to New York City and were pronounced husband and husband. As an LGBTQ writer, speaker and advocate, many would assume that my American Dream would be marrying David, but it was not. Neither of us had romantic notions about marriage, however we are passionate about EQUALITY.

My American Dream is to live freely, openly and authentically with my husband and family. Together we live that dream every day.

We love deeply. We live openly. We dance passionately. We laugh freely. We speak honestly.

But more than anything, we live. WE REALLY LIVE!

My American Dream
by
John Rosenow

I am a big, healthy, American Male. I grew up in rural America and have been middle class my whole life. I married at 21 to a pretty girl. We are still married 48 years later. I work at Farming and am my own boss. I started 3 businesses that succeeded and one that failed.

I write daily. I play golf. I have a great dog, Pepin. I have never had a day where I went hungry. I have Never been a victim of violence. I know great people who are my Friends.

I have had every advantage a person in this world could want. I have lived the American Dream

John Rosenow, *Cochrane, Wisconsin, photographed in 2018*
John owns a dairy farm in Wisconsin and runs a side business selling manure.

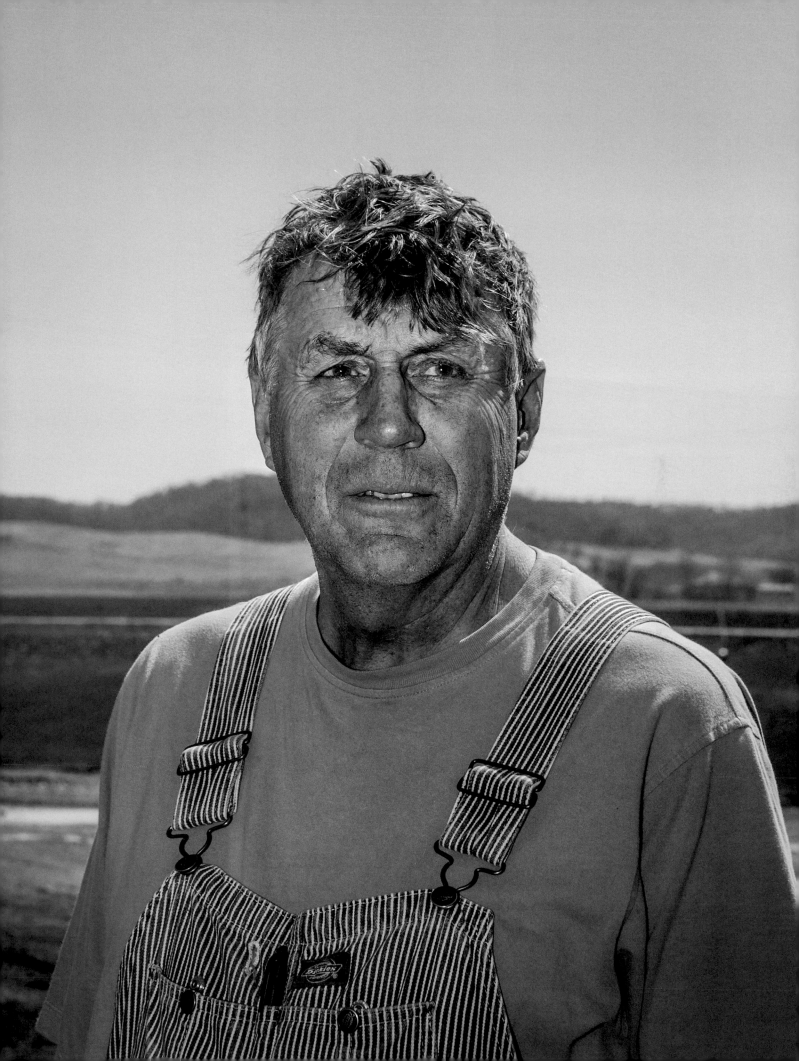

My dreams as an American are that schools are safe and provide children the opportunity to focus on learning and finding a passion that inspires them to be their best selves. I pray and dream that the water and food we intake are healthy for us.

My husbands' and my parents moved here from Italy to live the American Dream. To us that meant having benefits and resources they went without. That by working hard you can earn a living to raise a family comfortably. My Mom + Mother in law blindly left their family and friends to provide a better life for their kids. I know I could never do what they did But I greatly appreciate the amazing life they gave us. My biggest dream is to give my son, Vincenzo the same opportunities. Teach him all the amazing traditions, values and unconditional love we had growing up and dream when is not in our safe, healthy enviorment he is free and safe to be his best self.

Rosi Propato, *Ringoes, New Jersey, photographed in 2019*
Rosi is pictured with her husband, Ralph, their son,
Vincenzo, and the family dog, Vito.

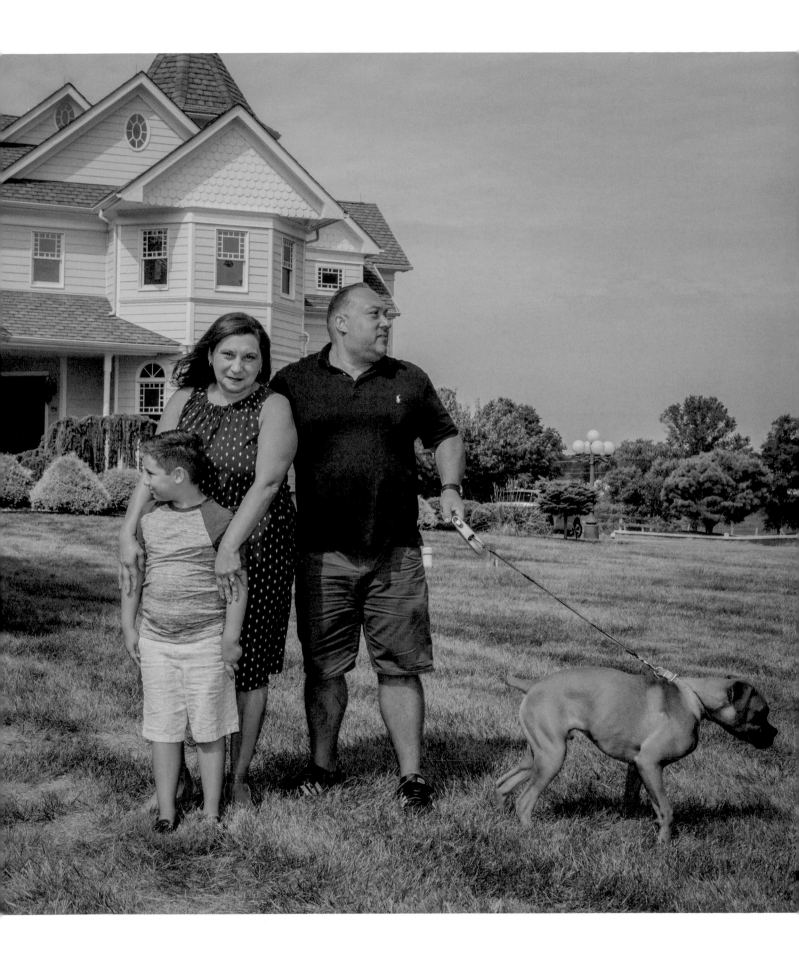

For as long as I can remember my dream was always just to be a mom. I wanted that to be my career! Through every pregnancy, I did everything I could to be the best mom, make the best and safest decisions. But what I didn't know was that I bought a house next to one of the most dangerous Superfund sites in the Nation! Legally, nobody had to disclose that to us! And we didn't know what Superfund sites were! We didn't know that radioactive waste from the Manhattan Project was sitting on the surface of a landfill less than two miles from the house we were raising our children in. We had to discover for ourselves that there was a fire burning next to the site, moving towards and threatening to hit the radioactive waste.

Since the moment I found out, I vowed I would go to the ends of the Earth to keep my children safe! And so the hours I had planned to spend with my children and husband were replaced with phone calls to agencies and elected officials, public meetings, and hours pouring over documents and learning to read and understand the science! I have met with local elected officials, clergy, Mayors, Attorney Generals, Congressmen, Senators, all in the hopes that someone will step up and protect my children. I have had to leave my family and travel to meet with the head administrator of the Environmental Protection Agency, the White House, and even the United Nations!

Needless to say, my dream has changed forever. Now I dream of raising my children in a safe environment. I dream of a day when I don't send my kids on the school bus with fears that a catastrophic event happens at this dangerous, burning, radioactive Superfund site and I'm not able to get to them. Most of all, I dream of a day when all of our children are protected and their health and well being is made a priority and placed above profit and politics!

Dawn M. Chapman
- Just a Mom

242

Dawn Chapman, *St. Louis, Missouri, photographed in 2016*
Dawn is the mother of three children in suburban St. Louis.

I am Broderick Flanigan community activist, entrepreneur, and visual artist from Athens GA. I specialize in bringing people's personal narratives to life in my paintings and drawings. I was born into humble beginnings because of my parents struggles with drug addiction. Over the years my idea or perception of the "American Dream" has shifted many times. Growing up I wanted to be an architect. This dream quickly fizzled once I realized that you have to be proficient in Math. By this time I was in high school and my parents were recovering from their illness. My "American Dream" then shifted to becoming a professional basketball player. I was only mediocre at best and being undersized didn't help. After high school my hoop dreams deflated when I didn't receive any scholarship offers. After working at a factory for a couple of years a good friend and a childhood mentor convinced me to go to college. At the time it was one of the best decisions I made. I was still on a mission to get a piece of the ever elusive "American Dream." College was fun to say the least. I had convinced that if I just kept taking classes, something would fall into place. I soon realized that things were not that simple. After I graduated I was determined to use my degree so I applied to numerous jobs within the arena of Athletic Training and Sports Medicine. When I wasn't able to find a decent job I went back to the drawing board literally! While working on a second bachelors degree I met a professor that sparked a flame that became my life's passion. In her art appreciation class I learned about various artists from different time periods. From hearing their stories I thought to myself, they are no different than me. This was a major point in my spiritual evolution. Over the past few years my entire perception of the "American Dream" changed. My perception of resources changed. I stopped buying into the illusion that there is a scarcity of resources that our society sometimes creates. I began to believe in my ability to change my reality through positive affirmations and focused intent. This coupled with a consistent work ethic and you have a powerful tool. My "American Dream" is for everyone to realize they are more than they have been conditioned to believe. Figure out want you want, ask the universe, and believe that it can happen. #SpreddLove

Broderick Flanigan, *Athens, Georgia, photographed in 2014*
Broderick opened a small arts studio in a dilapidated strip
mall with the hopes of it becoming a hub of creativity and
a community gathering place for local young people.

My American Dream is to put God first and for most and I believe that Donald J. Trump will put God in America again. I believe that Our future president will put America back the way it should be.

When I was a kid we didn't have to worry about someone being kidnapped. There was not all the drugs back then as there is in today's society or all the hate with terrorist attacks. The red, white, and blue stood for something. That is what this country was built on.

Now you fear everywhere you go unless you have God then you fear nothing. It is all about making America great again for our Children, Grandchildren, and great-grandchildren. That is all any American wants for everyone to come together and unite as one nation under God.

Chris J. Wright

Chris Wright, *Liberal, Missouri, photographed in 2016*
Chris was photographed with his wife prior to the
2016 presidential election.

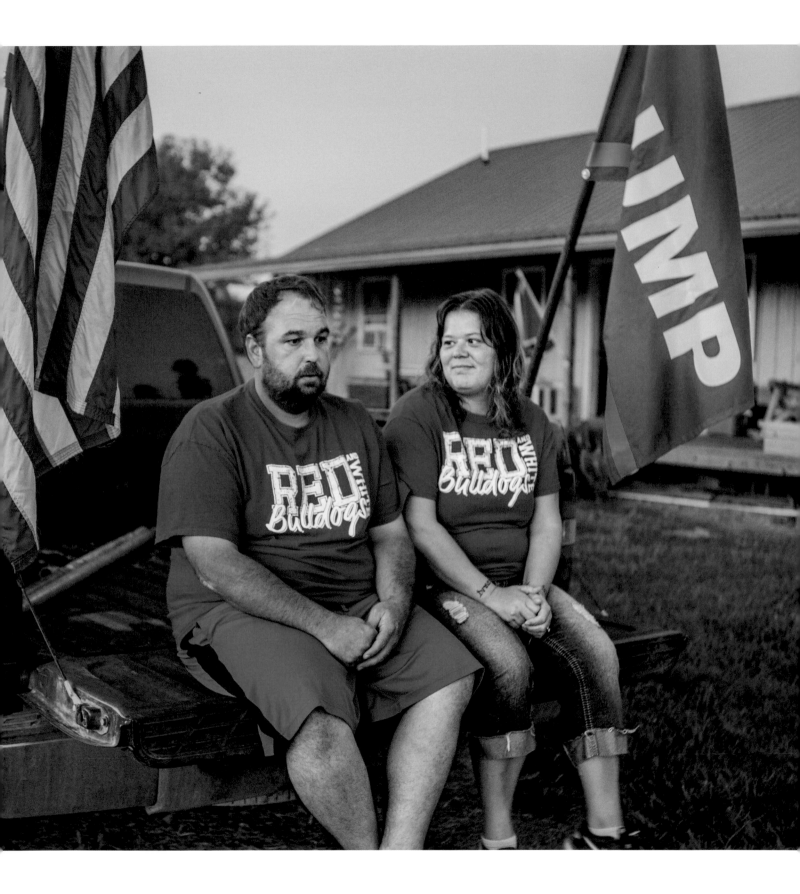

My American Dream
by Rachel Edwards

Equal Rights: the Equal Rights Amendment would pass and people of all genders would have equal rights and protections under the constitution (including transgender and non-binary people).

No Racism: people of color would not be disproportionatley imprisioned or brutalized and killed by police.

Housing and Food: everyone would have access to having a roof over their head and something to eat. No more people living under freeway overpasses and begging on street corners.

Healthcare: everyone would have access to healthcare (a human right).

Abortion: a woman would have complete control of her own body. NO governmental interference.

Guns: we would have common sense gun laws and no automatic, assault type of weapons.

Military: we would have a minimal military, just enough to defend ourselves. No huge military, war machine. Absolutely no Nukes!

Freedom From Religion: religious organizations would have no influence over governmental institutions at all. The Religious Right would no be able to impose their ideas on other people. The Mormon Church would not control the State of Utah.

Wealth: a more equal distribution of wealth. 1% of the population would not have the majority of the wealth.

Kindness: people would show, kindness, respect, compassion, and love to all other people even if those people are different than themselves. Even if they don't understand those people.

Hate Groups: there wouldn't be hate groups. See above.

Love
Rachel

May 16, 2019

Rachel Edwards, *Salt Lake City, Utah, photographed in 2019*
Rachel came out as transgender at sixty-two years old. She has multiple sclerosis (MS) and no medical insurance, so she can't afford the $7,000 monthly cost of her medication. She owns a home but won't sell it to pay for the medication because she wants to leave it to her children. Her MS makes writing by hand difficult, so she typed her dream.

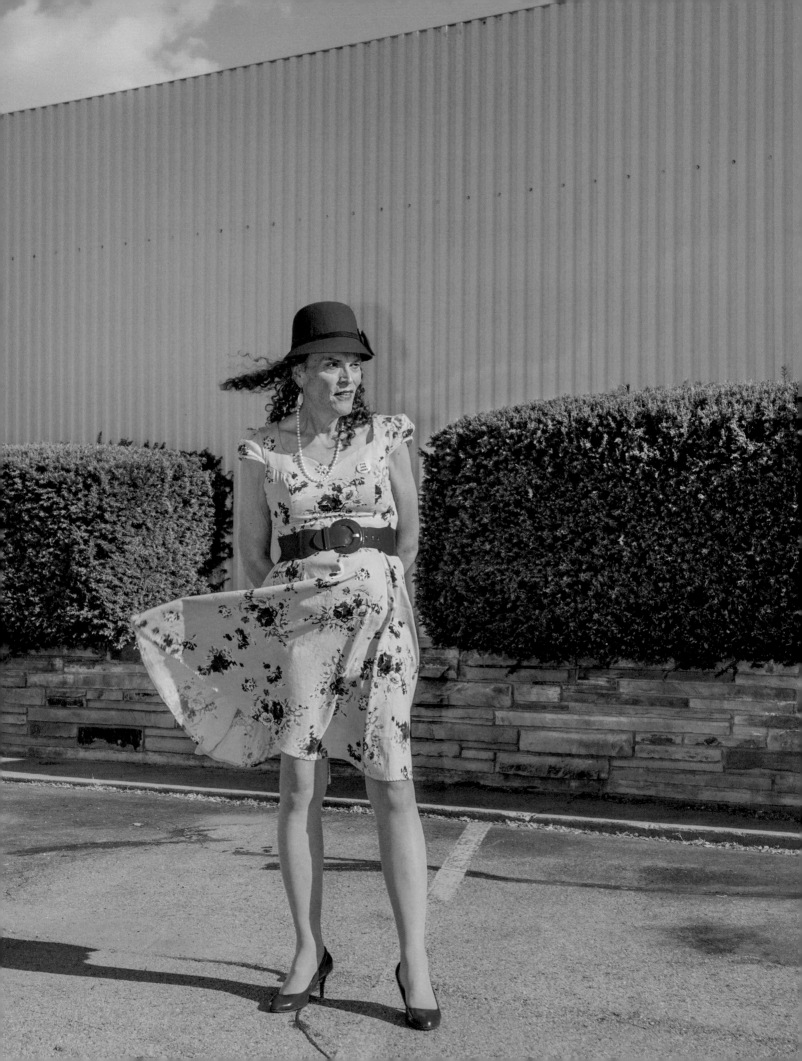

When I was a young girl in Haiti, I found out that I was going to the United States. I was ecstatic; I thought to myself "finally, I get to go to the land of the free, where life would be easier than what we were used to". I thought the American dream was having a big house, being rich and having nice cars. the American dream was suppose to be this grand magical outcome for people who decide to travel away from their homes to "Etazini" the USA. I am now 24 years old, and 13 years have passed since my plane landed. My reasons and beliefs have since changed. There is no real american dream, and there is no particular life that an American lives. In the words of George Carlin, " it's called American Dream because you have to be asleep to believe it". There's no American dream, only denial. it is the land of opportunity, the least I can say about America. An individual spend their whole life working to pay bills, where you can't live in peace, where you're drowning in debt for only wanting a better education, where you get crucified for stating your opinion. For a land called "United States" we are inevitably divided. So forgive me if my take on this is pretty negative, but the American dream is no longer a dream but a slight night mare.

Lynda

250

Lynda Sebastian, *Pahokee, Florida, photographed in 2017*
Lynda moved to Florida from Haiti. She is a student and works
with a local church in Pahokee, which is one of the poorest
communities in Florida.

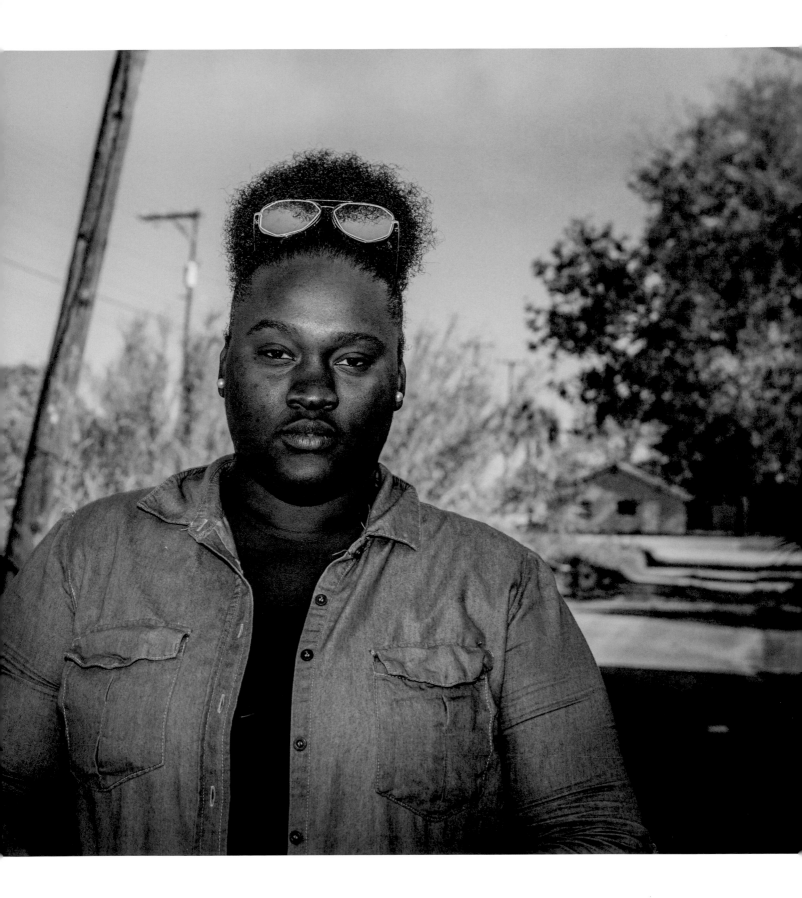

⭐ **"My American Dream"** ⭐

As any other young girl in my generation, a large part of my *American Dream* was; graduate High School, meet Prince Charming, big diamond ring, enormous white wedding ♡ Happily Ever After ♡ **POOF!** Reality: I graduated, had two beautiful daughters NOT married (NO regrets!) got a high-falutin job in Denver and did well for myself until a health problem popped up in my late 20's. My gallbladder was so full of stones they were backed up into my bile duct and threatening to shut my ~~liver~~ down. Excruciating pain like no other. It took doctors over a year to diagnose me as it was a disease that generally affected the middle aged. Surgery corrected the problem but I had no idea after eating oxycodone for over a year what withdrawal syndrome was - I just felt better when I took a pill. By the time I figured out the mess I was in - it was too late. I progressed to IV opiate use within 2 years. 2 prison stints and 16 months of rehab later I discovered the drug Suboxone. It saved my life. Now, working for the University of Colorado I spread the word of **HOPE** to people suffering from opioid addiction or opiate use disorder. (OUD) from my own community to communities across North America & Beyond. ~~Melissa~~ 2017

Melissa Morris, *Sterling, Colorado, photographed in 2017*
Melissa's boyfriend, Shaun, is a former Navy SEAL. When this photograph
was taken, he was on day leave from the halfway house where he was
living while on probation for drug possession.

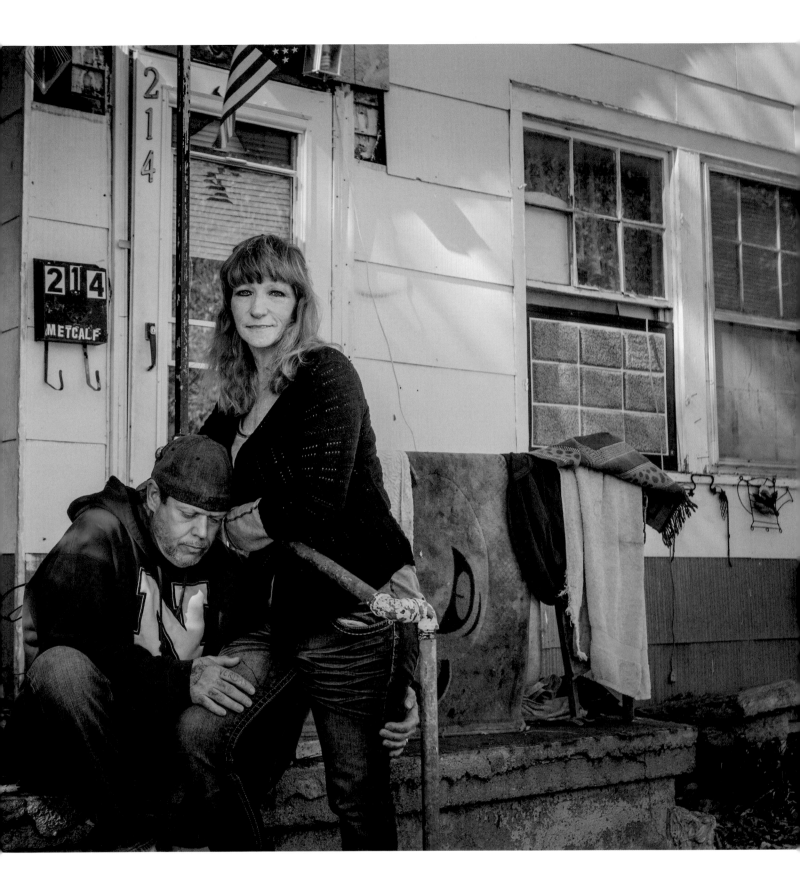

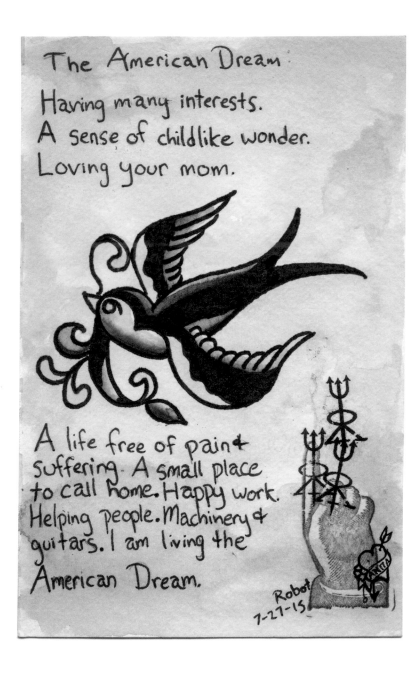

The American Dream:

Having many interests.
A sense of childlike wonder.
Loving your mom.

A life free of pain &
suffering. A small place
to call home. Happy work.
Helping people. Machinery &
guitars. I am living the
American Dream.

Robot
7-27-15

Ron Land, *Sioux Falls, South Dakota, photographed in 2015*
Ron is a tattoo artist and avid gun collector.

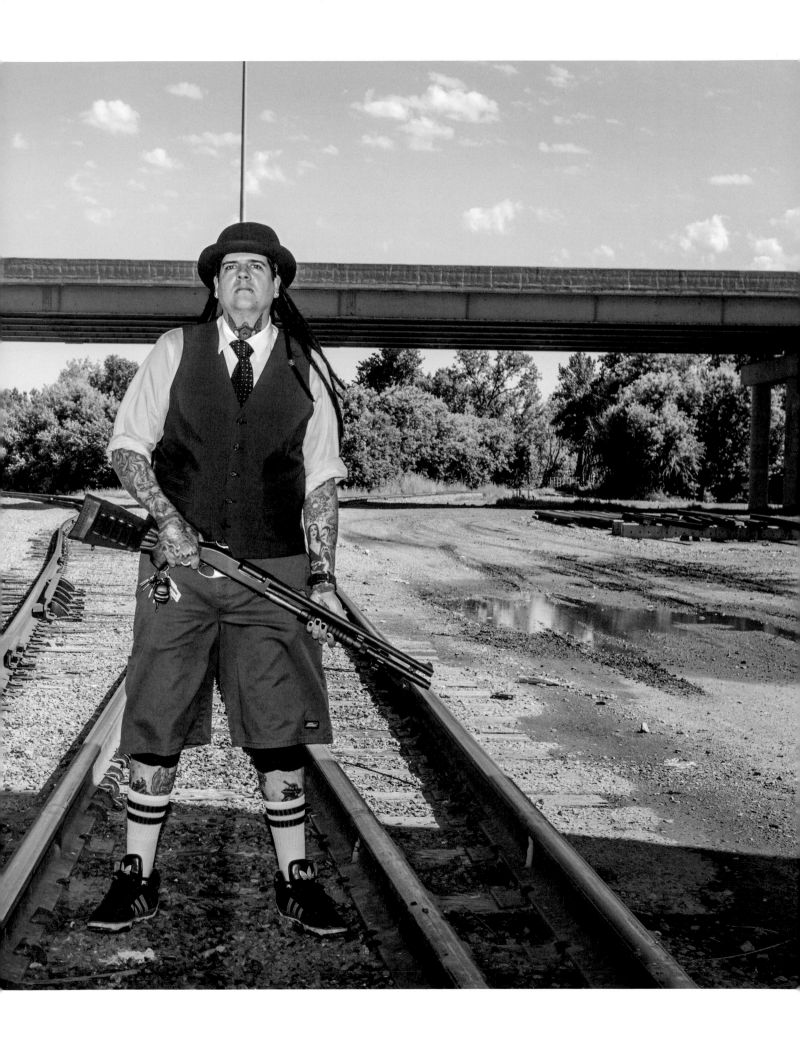

American Dream Assessment.

When I think about it, I realize that to me it has a different meaning at every given time in my life. We are the American Dream. Whatever we act on is the American Dream. The values that America was founded in are kind of Universal and Human, so I will shift the term into: Universal Human Dream; that we think can be achieved in U.S. In this sense my dream is of being an igniter of a <u>collective positive vision</u> into a society of authenticity and peace. Americans have been for so long lured into an illusionary dream of material meaning, and most of the time, putting aside finding meaning to their existence.

My Universal Human "American" Dream is to spark inner transformation through engagement, commitment, and authentic honesty for UNDERSTANDING among all habitants of this country and the world as key make up for a new society.

My Universal Human "American" Dream in this path is actually a transitioning state into a mindset of collective collaboration through real understanding and the sharing of our own humanity authentically. It translates into: Finding meaning to the "we" with purpose and at the same time; to enjoy our senses and those of our minds collectivelly to create out of kindness, a higher vision, and innovation. My "American" dream is to bring a spark of reflection into the American mindset and people from the world into the possibility of inner peace, commitment to grow and healing; and at the same time → to lead with social responsibility.

Erika Gutierrez, *New Castle County, Delaware, photographed in 2019*
Erika is a single mom and is involved in community development.

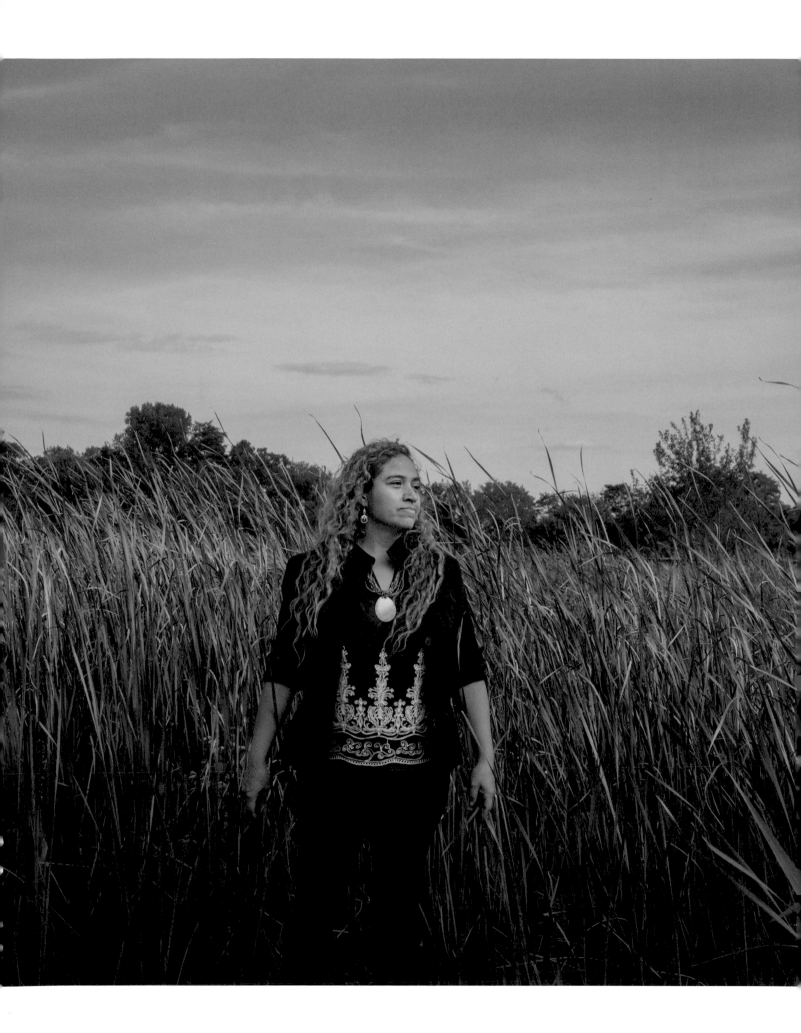

My American Dream

In my opinion, I think the American Dream is that all people should be equal. No matter if your black or white During slavery and Jim Crow whites controled African Americans. The whites had better schools, homes, and rights African American hated that whites controled and owned us as slaves African American people wanted to put a end to it. As a African American youngboy in America I see other African American males getting shot and killed by white polices. I just hope I can live to be a black man. Two main thing you should always have is freedom and liberty.

Chase LaCoste
Feb-18-18

Chase LaCoste, *Kentwood, Louisiana, photographed in 2018*
Chase (left) is pictured with his twin brother, Connor.

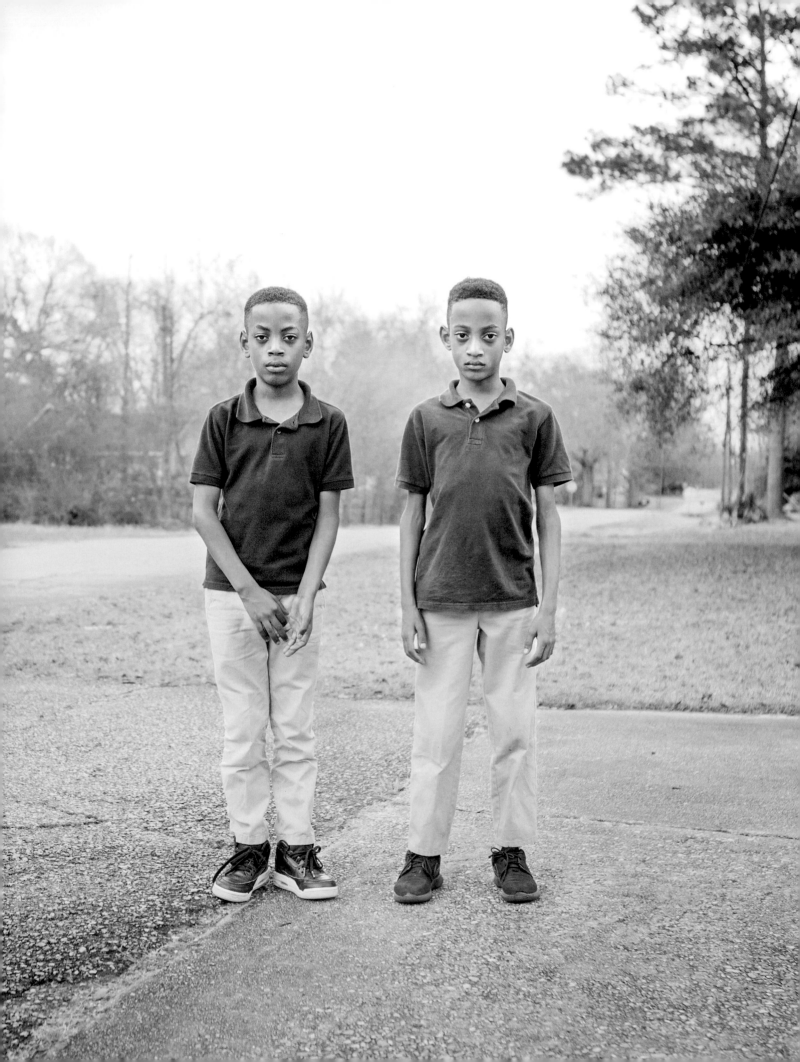

American Dream

I do not have an American dream if "America" means the U. S. However, I have a Southern dream. It is my desire that our Southern people learn of our history, culture and Southern heroes from our early settlement in the 1600s to present. It is important to learn that our Southern ancestors desired and fought for self-government, which included state sovereignty. Our Southern ancestors who strove to maintain self-government should be honored and looked upon with pride. Just one example of pride is the fact that our Confederate Constitution was a great improvement over the Constitution of 1787.

Because our Southern people have not been taught and have not learned their history, they have been indoctrinated with pseudo-history spewed forth by the electronic and print media of all genera.

Therefore, my Southern dream would be that our people would learn their history and thus be able to refute those who attack our flags, monuments and heroes as symbols of slavery and treason, because they were not and are not!

Robert B. Hayes

Robert Hayes, *Abbeville, South Carolina, photographed in 2015*
Robert is an advocate for the Confederate flag and a member of the League of the South, a white nationalist organization.

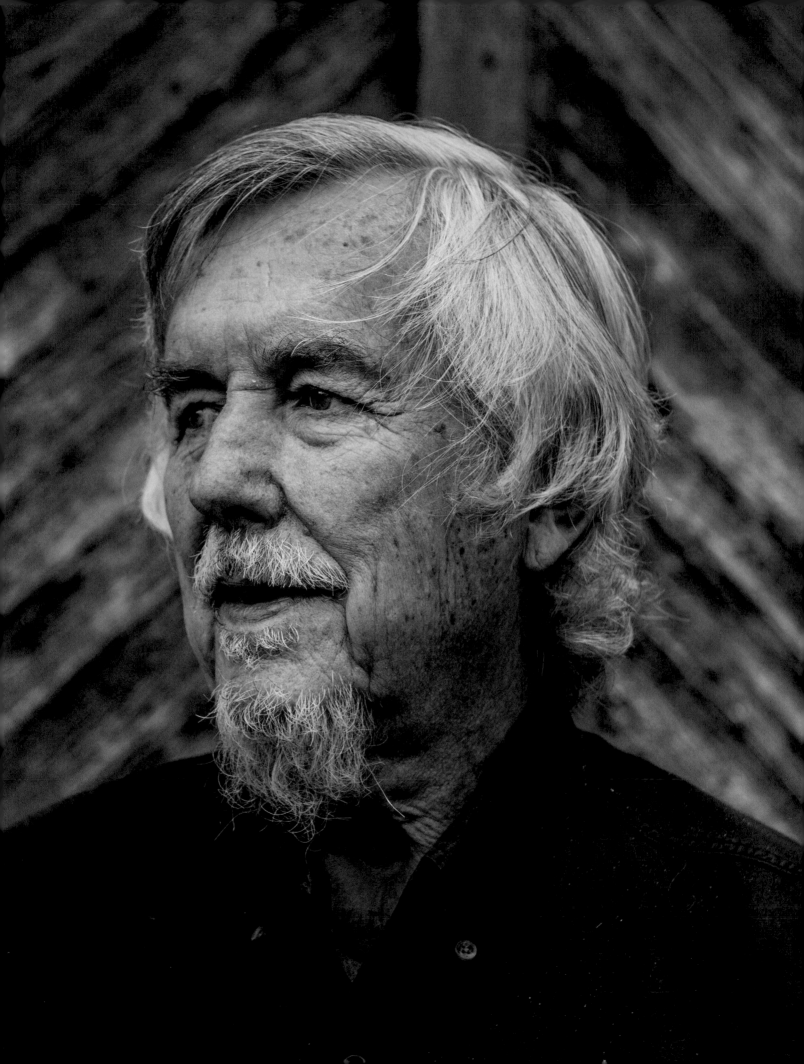

Gerald Nelson, *Bronx, New York,*
photographed in 2008
Gerald moved to New York
from Trinidad. He is retired
but continues to volunteer
at his church.

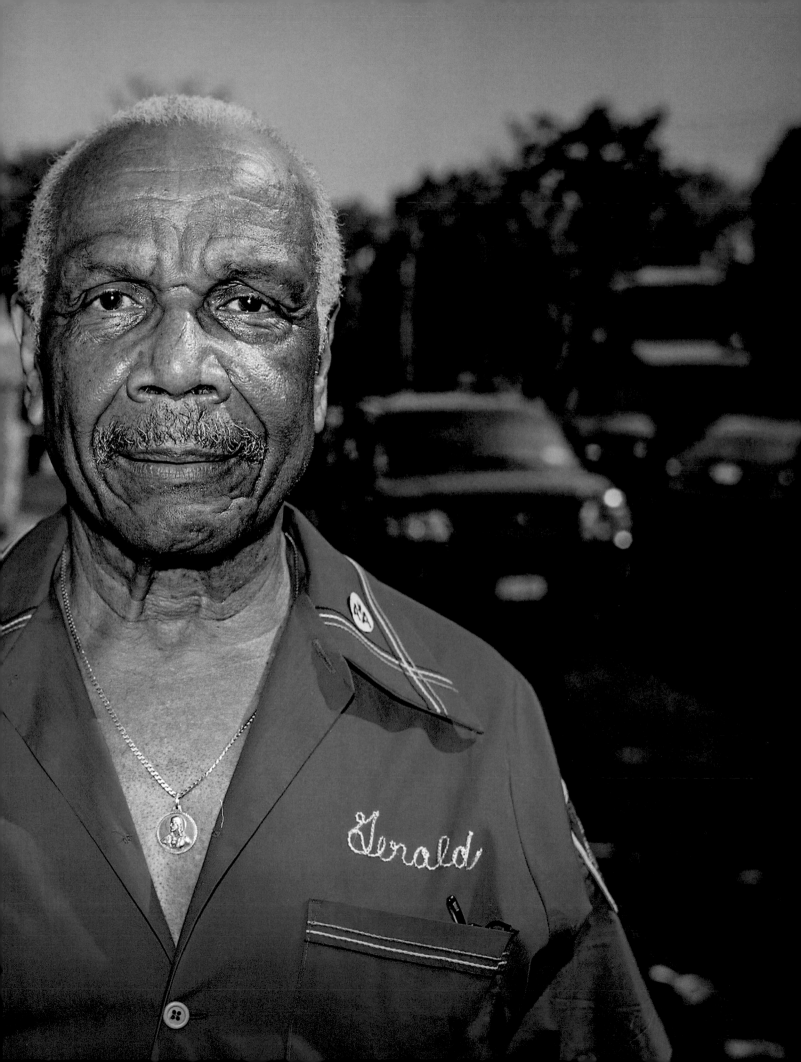

I CAME TO AMERICA FROM TRINIDAD IN 1969 LOOKING FOR
A BETTER LIFE FOR ME AND MY FAMILY. ON ARRIVING HERE, I WAS
MET BY A GOOD FRIEND OF MINE WHO RECOMMENDED ME TO HIS
COMPANY OF EMPLOYMENT, WHERE I WAS IMMEDIATELY HIRED. I
REMAINED WITH THE COMPANY FOR THIRTY FIVE YEARS UNTIL
RETIREMENT.

DURING MY FIRST SUMMER HERE I WAS ASKED TO PARTICIPATE
ON THE COMPANY'S BOWLING TEAM WHICH WAS PART OF THEIR
SPORTS AND SOCIAL ACTIVITIES, SINCE THERE WAS NO BOWLING
IN MY NATIVE COUNTRY AND THUS KNOWING NOTHING ABOUT
THE SPORT, I HESITATED, BUT WITH THE ENCOURAGEMENT OF
SOME OF MY CO-WORKERS, AND ALWAYS EAGER FOR A CHALLENGE
I DECIDED TO GIVE IT A TRY.

THE GAME WAS EXPLAINED TO ME. THE FIRST TIME I EVER
SAW A BOWLING ALLEY WAS AT MADISON SQUARE GARDEN.
I WAS AMAZED, I GOT TOGETHER WITH THE OTHERS BOWLERS
AND HAD A FEW ROLLS BEFORE THE GAME STARTED AND IMMED-
IATELY FELL IN LOVE WITH THE GAME. I WAS THE LEAD OF MAN
AND THE VERY FIRST BALL I THREW WAS A STRIKE. I WAS THEN
CALLED A WRINGER, AND HAD TO ASK WHAT THAT MEANT. NO
ONE WANTED TO BELIEVE THAT I HAD NEVER BOWLED BEFORE.
AT THE END OF THE SEASON I WAS SELECTED TO REPRESENT
THE COMPANY IN THE NEW YORK INSURANCE COMPANY LEAGUE.
DURING THAT VERY SEASON I ROLLED A GAME OF TWO HUND-
RED AND SEVENTY SIX WHICH WAS THE SECOND HIGHEST SCORE.
I WAS AWARDED A TROPHY I WAS TOLD BY MY TEAMMATES
THAT I WAS THE FIRST MEMBER FROM THE COMPANY TO HAVE
EVER ACHIEVED THAT HONOR AND I ALSO HAD THE OPPORTUNITY

To play against the great Johnny Petraglia who went on to become a PBA Champion, I was inspired to continue my bowling so I registered in a league where I lived in the Bronx. In 1976 I was selected and sent to Washington all expenses paid to represent the region in the Brunswick Bowling Internatonal. There I met the great Jesse Owens who had represented the United States in th Olympics. I also enjoyed the pleasure of competing on "Bowling for Dollars".

I am a proud father of four children, Kirk, Peter, David and Jennifer who are all successful in his/her own way. Kirk was a Captain in the United States Air Force. Jennifer (the only one born in the U.S.A.) was able to graduate from Boston University. I am a member of the Knights of Columbus with a fourth degree and an ex president of the Holy Namee Society for four terms. I joined the New York City Finest Auxiliary Police Department and retired as Captain in the 43rd Precinct in the Bronx. All this was accomplished in the great US of A. — This is MY American Dream.

My American Dream...... by Jan Morgan

Most people might describe the American Dream in terms of career success, monetary wealth, or accumulation of "things". For me, it is not that simple.

My American Dream is to wake up one day to discover I no longer have to fight. My dream is a victorious end to the constant attacks on our Constitution and Bill of Rights by our own citizens and an out of control government. Our Founders envisioned this internal war that many citizens today fail to see or refuse to fight. As he was leaving the Constitutional Convention, Benjamin Franklin was asked by a group of citizens what sort of government our delegates had created. His response was, "a Republic, if you can keep it." Though our Founders had succeeded in establishing a Constitutional Republic, Franklin knew, keeping it would be an ongoing challenge, dependent on active and informed involvement of the people.

Too many Americans are not active, informed, or involved in vigilant oversight of our government, which has become a cesspool of corruption. Our government is now our enemy's best weapon in the war against liberty, steadily trampling our Constitution and Bill of Rights, legislating away our liberty with laws upon laws, taxing the people into poverty, and enslaving the citizens with entitlements.

Our government has shifted in its role from protector to predator, dismantling the foundation of liberty to feed its increasing addiction for power and absolute control. This war has many battle fronts.

My battle zone is the 2nd Amendment.

I have devoted my time and energy to fighting the persistent attacks on the 2nd Amendment because without it, we have no means to defend the remaining Bill of Rights.

World history proves an armed citizenry is the best tool for keeping tyranny at bay. In the 20th century, over 170 million people have been annihilated by their own governments AFTER BEING DISARMED..... and the process was always the same: 1) REGISTRATION of firearms.... 2) CONFISCATION of firearms...... 3) ANNIHILATION of disarmed citizens. Gun control has never been about guns It was always about CONTROL. Right now, on the 2nd Amendment front, it is all we can do to hold our government at bay from further regulations on gun rights. My goal is to move beyond the holding line, and push forward, REPEALING the thousands of gun control laws on the books in America, until we reach our Founders original position on gun rights. The right to keep and bear arms is a RIGHT... not a PRIVILEGE. "A well regulated Militia, being necessary to the security of a free state, the right of the people to keep and bear arms, shall NOT BE INFRINGED."

My American dream may never become a reality, however, I will continue to fight for it the rest of my life because I would rather die on my feet fighting for liberty and live on my knees in reverence to tyranny. "Give me LIBERTY... or give me DEATH." The 2nd Amendment IS MY LINE IN THE SAND.

MOLON LABE

Jan Morgan, *Hot Springs, Arkansas, photographed in 2017*
Jan owns an indoor gun range that she declared a "Muslim-free zone" in 2014. She ran for governor of Arkansas in 2018 and received 30 percent of the vote. She was formerly a TV news anchor in Texas.

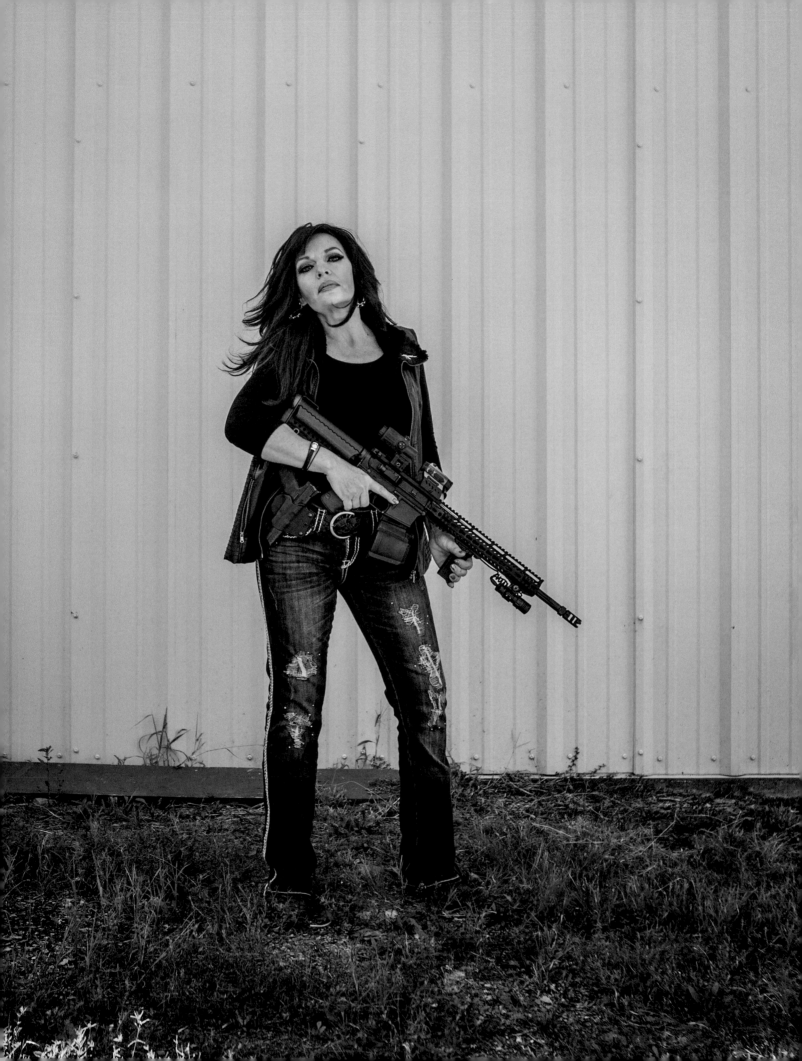

me: My dream is for forgiveness. I do wish for the common things, love, joy, peace, financial stability, etc. But, I know that true & complete forgiveness is the one thing that will bring me what I do not already have in my life; and I would so love to send again...

Zoey: My Dream is to be a Horse-Back rider with a Little Bit... I want to have Lots of horses and many other animals with a Big Farm and other things

愛 市場圈

幸福

愛

永 繁栄

安寧

愛

怒

Music

Leyla and Zoey, *Lodi, California, photographed in 2008*
When this photograph was taken, Leyla and her daughter, Zoey,
were living in a trailer on her parents' property outside Lodi.

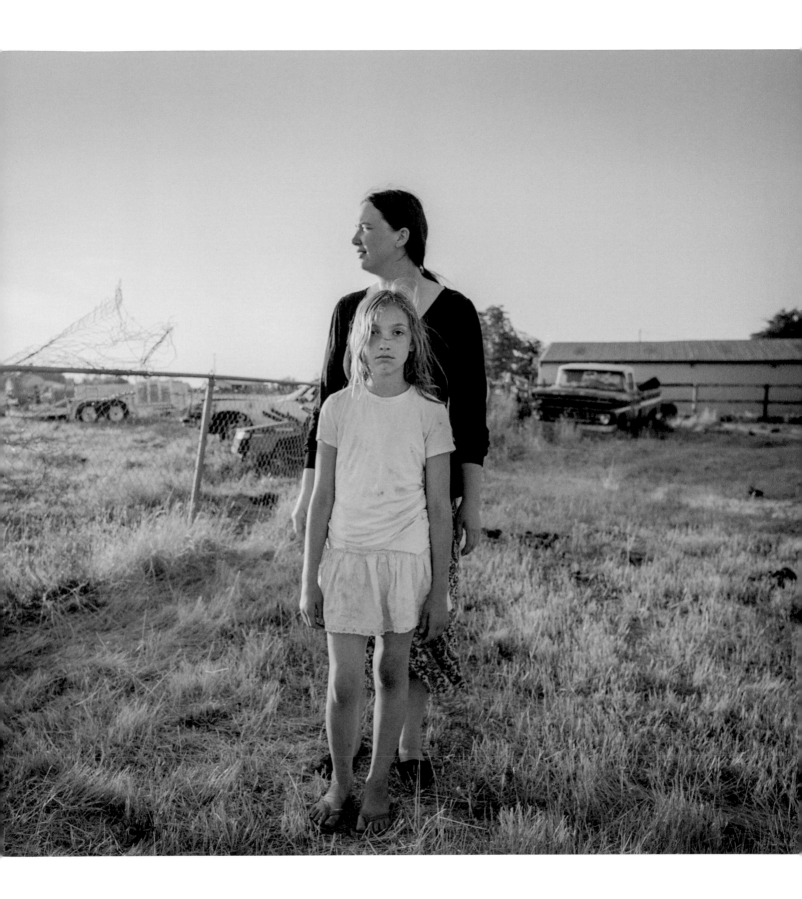

My American Dream is that we as a people would move away from the prejudices and bias' that is starting to define us as a nation of trite, ethnocentric, selfish know it alls. I pray that we will turn back to God and allow ourselves to accept one another and utilize intelligent discourse again rather than two second sound bytes and "ad hominem" attacks.

My Dream is that we would care about the needs of others more than our own desires. Maybe then our children can know joy and happiness in this great country of the future.

270

Frank Pomeroy, *Sutherland Springs, Texas, photographed in 2018*
Frank is a pastor of the First Baptist Church in Sutherland Springs. In November 2017,
the church was the site of the deadliest mass shooting in Texas history. Frank was
away the day of the shooting, but his fourteen-year-old daughter was killed.

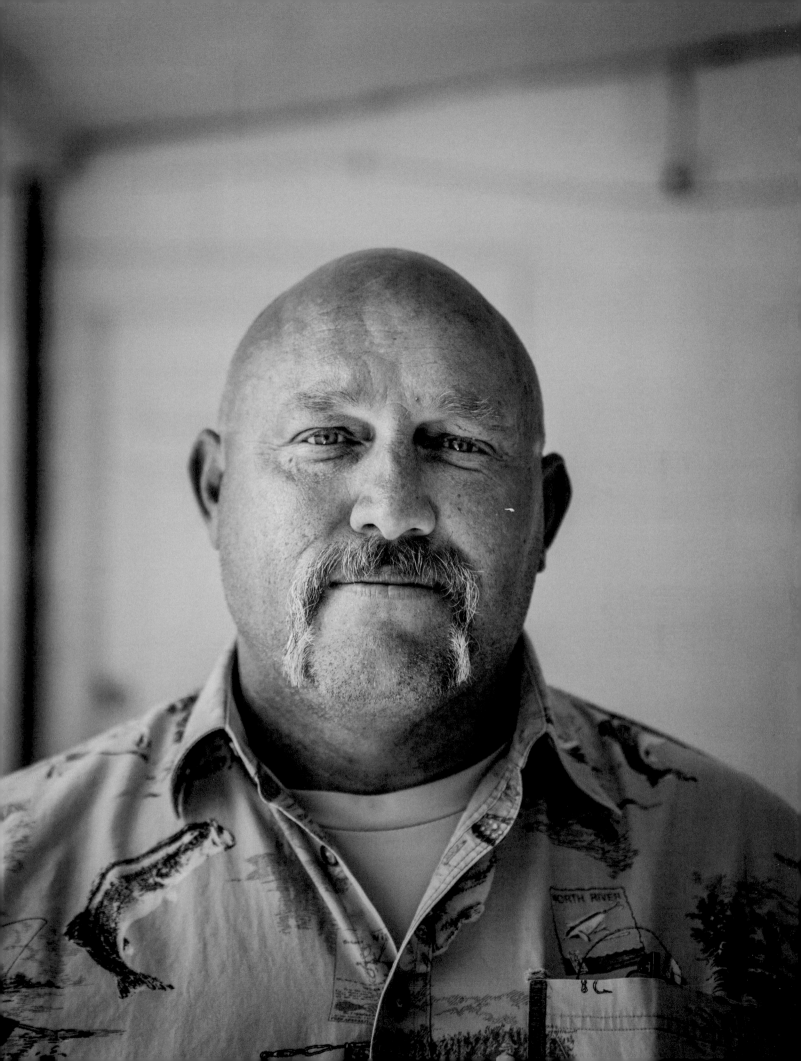

16/10/2015

I don't really have an American dream, because I don't live here, but I have a dream that follows me around wherever I am. That, is, to find the beauty in my surroundings, and to shape and share it. And that dream is very strong in Maine, where the 'sea' brings treasures right to my doorstep, and there is beauty all around me.

Irene Wanjiru

Irene Wanjiru, *Southport, Maine, photographed in 2015*
Irene is an artist and sculptor originally from Kenya.

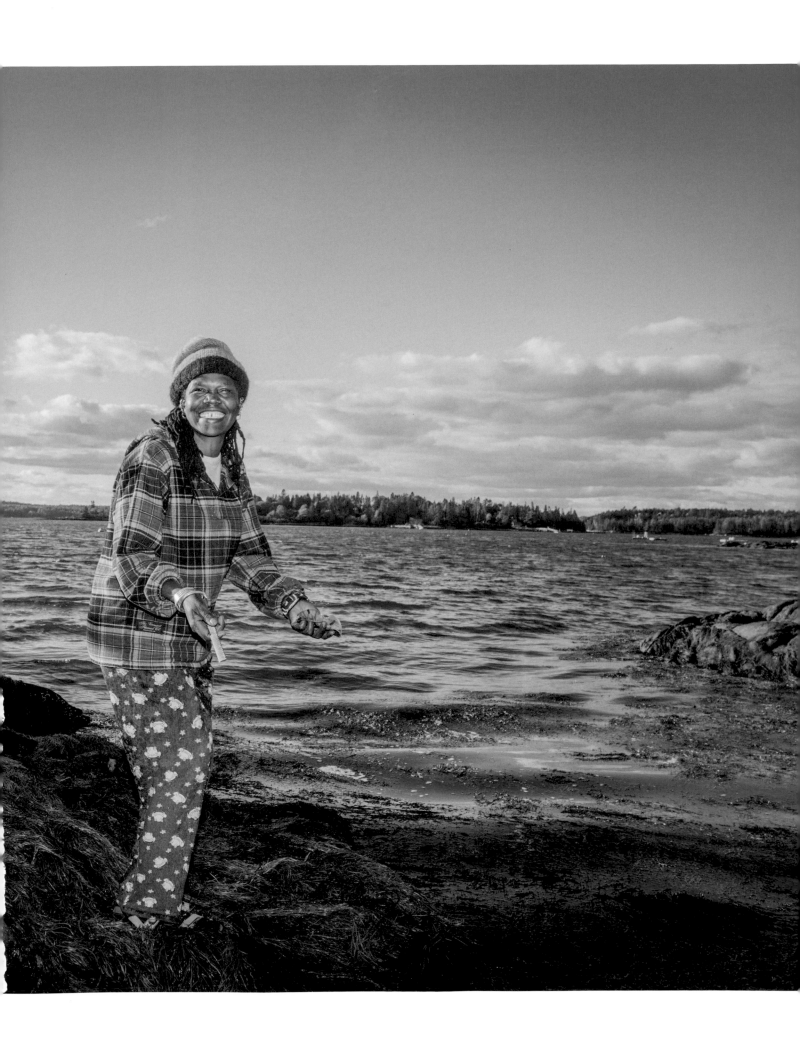

James K. Chilton, Jr. 7-31-17

 As a fifth generation cowboy and rancher, my dream is and has always been to succeed by contributing to a wonderful family, being the steward of a large cattle ranch and building a reputation of personal character and integrity. Beginning college at Arizona State University, after being raised in the ranching culture, I realized that finding an ideal spouse was my most important objective in life. Today, after fifty-four years of marital bliss, which includes two highly intelligent sons, and their respective wives, Jamie and Doris, and our five grandchildren, I could not be happier.

 My ranching dream included figuring out how I could raise the capital required to purchase a cattle ranch. My solution was to pursue a quality education so that I could enter a well-paid profession. After securing Master's degrees in both economics and political science, and carefully saving, my wife Sue and I purchased a ranch and enjoy a wonderful family while building a good reputation and being of servicing to my fellow ranchers and our industry. With opportunity provided by our Constitution and laws, I continue to pursue happiness and I have lived and continue to live the American Dream!

Jim Chilton

274

Jim Chilton, Jr., *Arivaca, Arizona, photographed in 2017*
Jim and his wife, Sue, live on a fifty-thousand-acre ranch that straddles the US–Mexico border. The Arizona Cattle Growers' Association named him Rancher of the Year in 2002 and awarded him the True Grit Award in 2005. He is in favor of building a border wall.

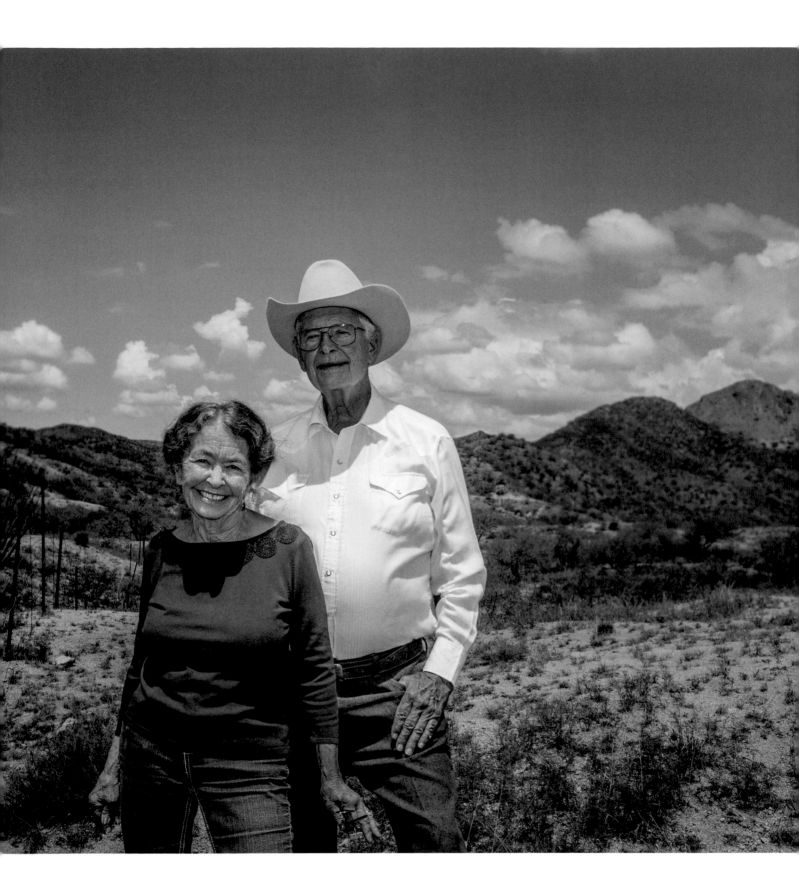

While to many the notion of the "American Dream" is one of success and endless material wealth, my personal experiences in this country have led me to the realization that this is an ideal that goes far deeper than just worldly success. I admit that when I first came to this country, I didn't know exactly what I was chasing but there was always a deep desire within me for a better life than what I had come to know at that point. Immigrating here by myself, at times I found myself in some really dark places as I had to deal with homelessness, poverty, loneliness and isolation. Yet, throughout those trying years, the dream of a better life always remained alive within me and gave me the strength to persevere through all these challenges. It's funny how life's seemingly worst moments, when you are stripped off of everything you know and are, presents you with the only questions that really matter in life. For me, I had to decide what will be the principles I will choose that shall guide me through the remainder of my life. Fortunately I made the choice to follow Love and life has blessed me beyond anything I could have ever imagined. Last year I married my beautiful wife Lucie and in March of this year, we welcomed our son Eli who brings so much joy to our life.

Coming to America has been a long and difficult journey for me. A journey that has presented me with many choices about who I am and who I wanna be. In the end, the "American Dream" is the freedom for every individual to make this choice for himself and therefore, be the captain of their own life by virtue of the choices one makes.

Many people are questioning if the "American Dream" is still alive today. I believe it is alive in many but at the same time, increasingly more people are giving away their own power by buying into the narrative of the media and political parties on both sides of the spectrum, that we are victims of life's circumstances and need those so called "leaders" to guide and protect us.

Simeon Platschkoc, *St. Louis, Missouri, photographed in 2015*
Simeon immigrated to America from Eastern Europe, and lived in
his car in Ferguson, Missouri, for a while. He now works in information
technology, and is pictured with his wife, Lucie, and their son.

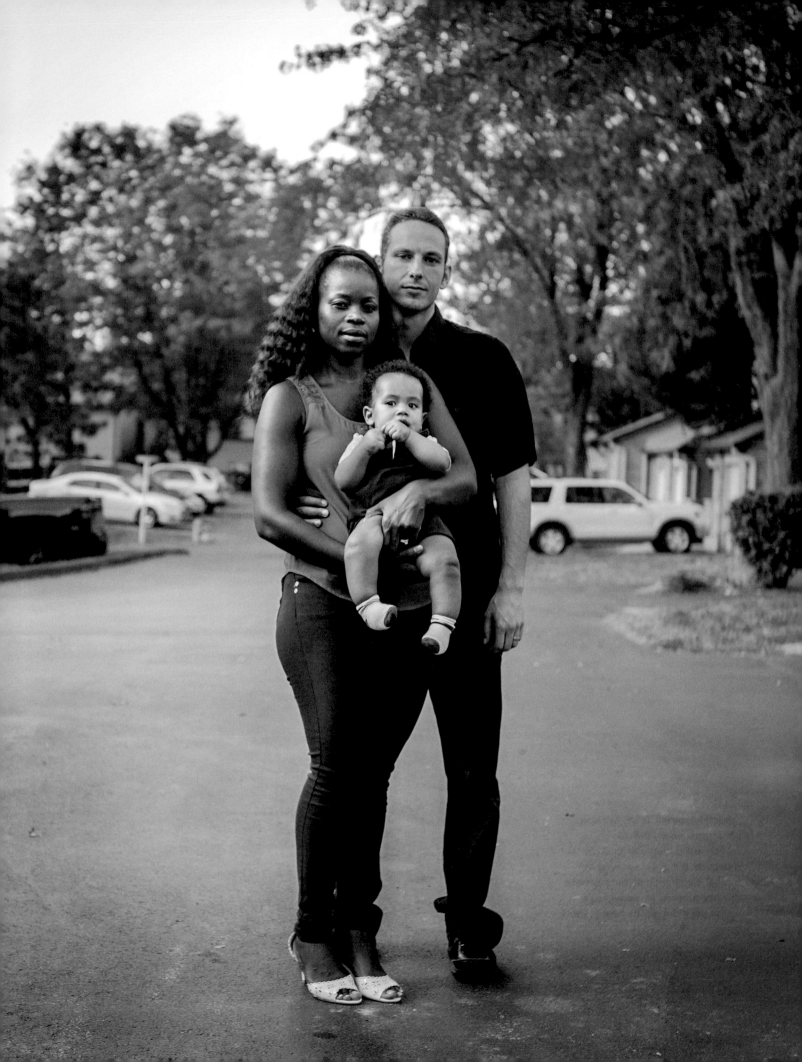

My American Dream ♡

My American Dream is very simple, more now so than ever. Thru my life I ran myself down a very bitter and angry road. I never cared to know what love and happiness truly was. I was never open to change or bettering who I was until one unfortunate day that fully changed my life. The death of my brother. Sure it crushed me, however I chose to use it for my strength and become a new person. Today I have a job I love and have pushed very hard thru several promotions to be where I am. I never gave up, which was a bad trait I used to have. I have found what true love and happiness are which has wiped all the bitterness and anger from me and now today can smile and laugh each new day Im blessed with. So my American Dream is to be fearless in the pursuit of what makes your heart happy. To be filled with love and happiness and give it to others as well. Never let a day pass

without bringing a smile to someone - a complete stranger or a loved one. To show my kids true manners and respect for others and most important to be a loving family and live our life to the fullest. I learned that when the world feels like an emotional roller coaster balance yourself with simple things in life. Too many people feel like money is the answer for their happiness when in reality its the ones you love

Jessica Kilpatrick, *Boaz, Alabama, photographed in 2018*
Jessica was a drug user for more than a decade, but got clean after her brother died from a heroin overdose. She has successfully worked as a restaurant manager for several years.

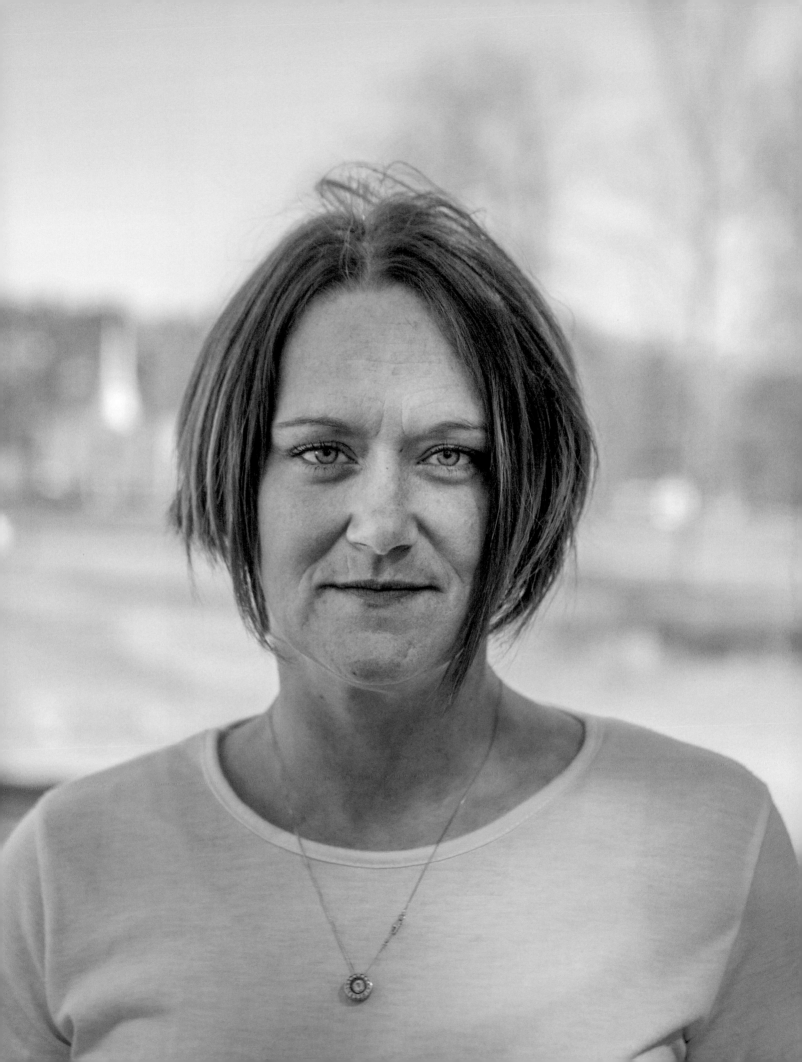

For me the American Dream is to have the chance to better yourself and be able to provide for your family. I feel that we have the ability to give our children more opportunities to succeed.

My parents came to the U.S. looking for the American Dream and with hard work and lots of sacrifice they were able to give me and my sisters a better life. I know that life in Mexico would have been so difficult.

My husband recently became a U.S. citizen and it was one of our happiest moments in our lifes. Even though I am going through some difficult times with immigration I keep fighting to stay here in the U.S. to be with my family to keep living the American Dream.

Silvia

Silvia, *Salt Lake City, Utah, photographed in 2019*
Silvia and her husband, Carlos, were photographed
with their children at Carlos's mom's house.

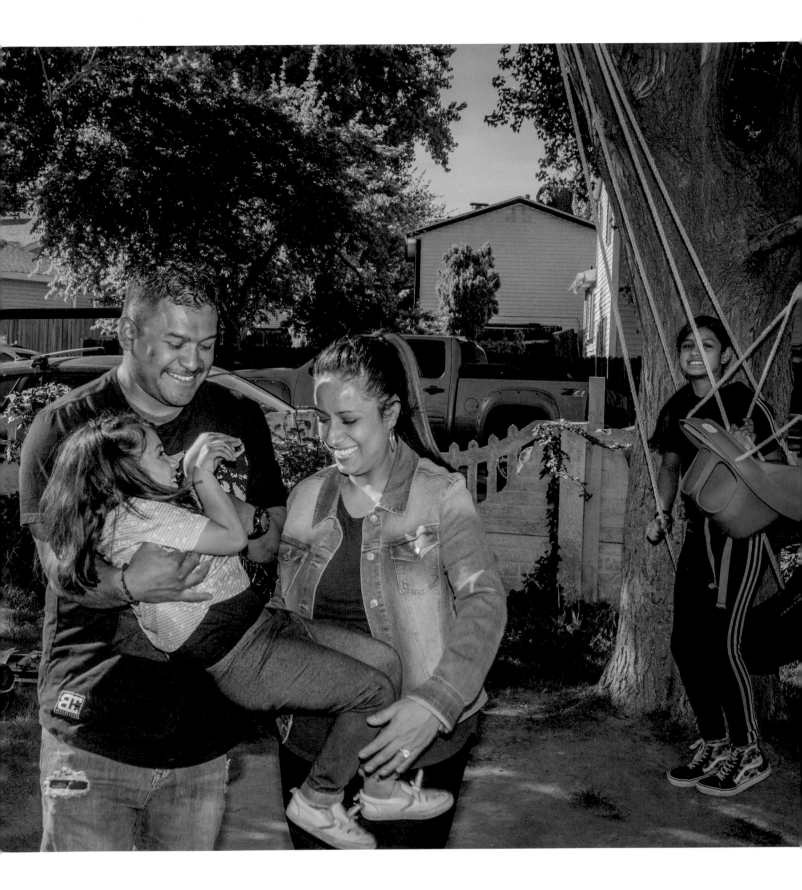

We dream of
a life filled with
adventures
[Big, small & daily]
We dream of
Building careers
out of our passions.
[and of seeing all
58 National parks!]

LP + KH
2015

282

Laura and Kevin, *Des Moines, Iowa, photographed in 2015*
Laura is a designer, and her husband, Kevin, works in fine clothing sales.

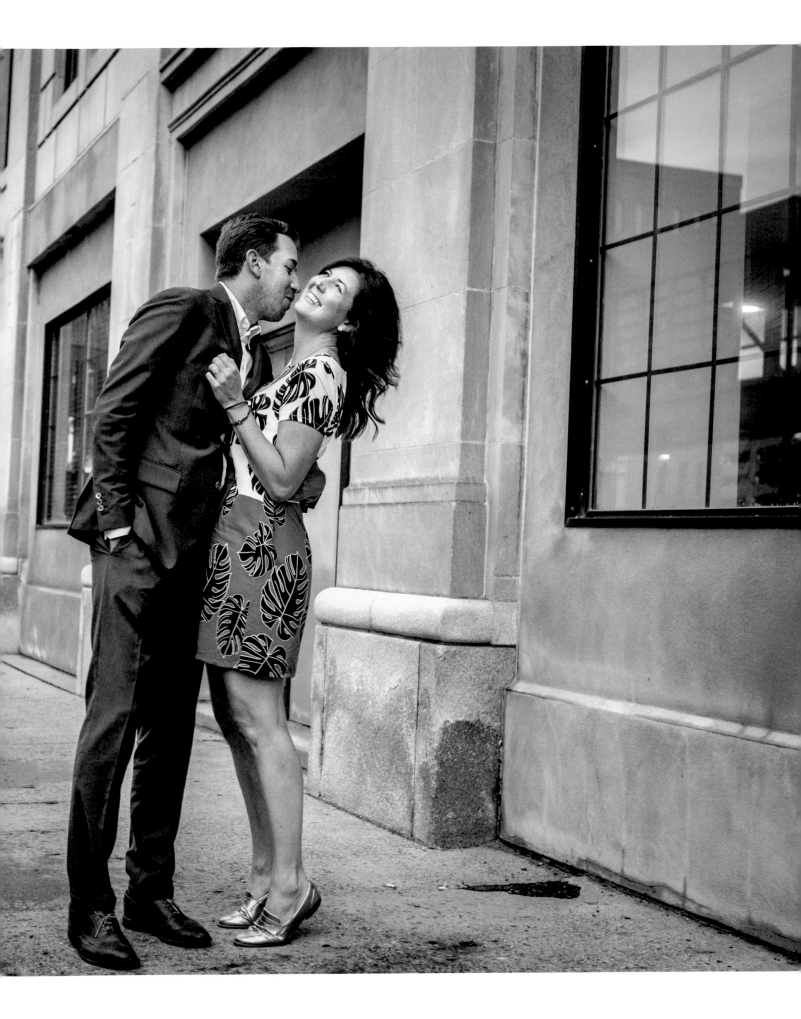

I AM MEXICAN, I AM AMERICAN, I AM
IMMIGRANT, I AM AMERICAN. I AM GAY,
I AM AMERICAN. I AM THE SON OF A SINGLE
MOTHER, A STRONG LATINA WOMAN, ONE THAT
SHOWED ME TO BE KIND TO OTHERS, ONE THAT
SHOWED ME I COULD GRADUATE HIGH SCHOOL,
GET A 4 YR DEGREE FROM A UNIVERSITY,
PRACTICE MY ART AND MAKE IT MY
CAREER. IN MOST WAYS I AM THE
AMERICAN DREAM. THOUGH GROWING UP
WE DIDN'T HAVE MUCH, WE LEARNED
TO ALWAYS GIVE TO OTHERS EVEN WHEN
YOU YOURSELF MAY BE STRUGGLING. MY
AMERICAN DREAM LIES WHERE COURAGE,
FREEDOM, JUSTICE, SERVICE, AND GRATITUDE
ARE CHERISHED AND PRACTICED. WHERE WE
ARE JUDGED BY HOW WE TREAT PEOPLE
BECAUSE THAT IS WHAT MATTERS. I DREAM
OF THAT AMERICA THAT FOUGHT FOR ME TO
BECOME WHO I AM TODAY. — AN AMERICA
WHERE ALL CHILDREN CAN HAVE THAT OPPORTUNITY
TO SUCCEED, TO DREAM, TO LAUGH, TO CHOOSE,
TO CREATE — EVEN IF THEY DID COME TO
THIS COUNTRY ILLEGALLY, LIKE ME.

Jairo Ontivarios, *Miami, Florida, photographed in 2017*
Jairo works as a director of community engagement at an arts center in Miami
that reaches communities that are typically underserved by arts programs.
He is part of the Deferred Action for Childhood Arrivals (DACA) program.

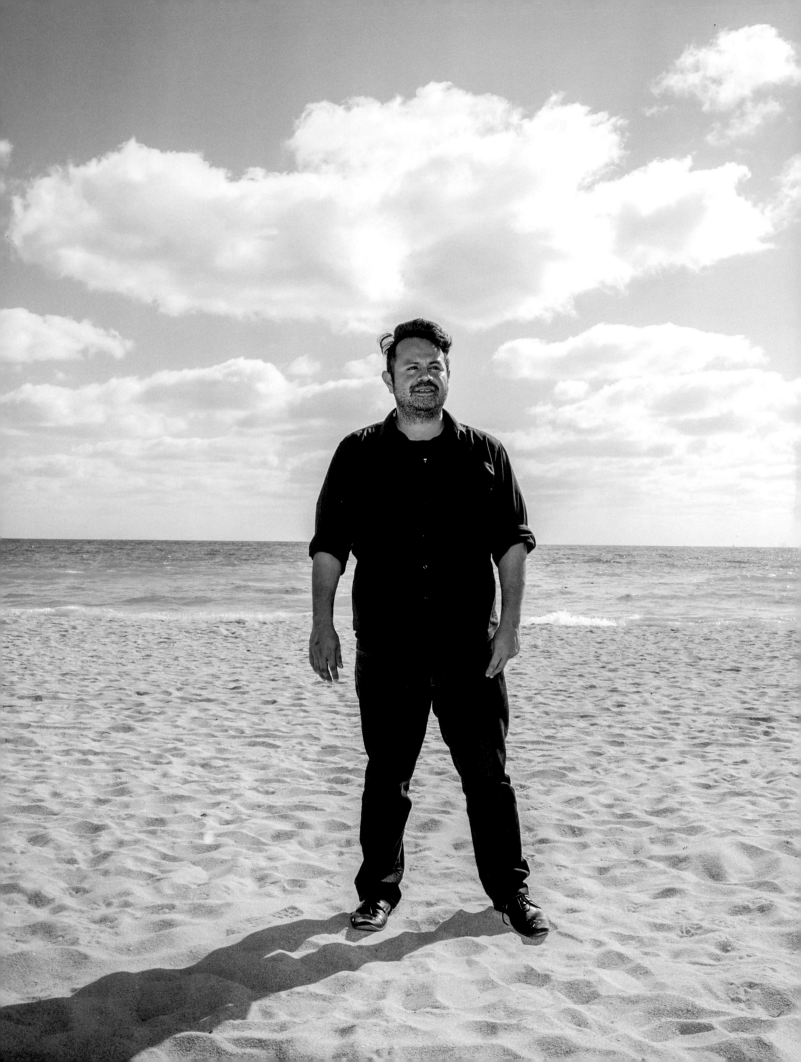

LIVE

FREE

ALWAYS

© 1999 Marian Nixon © 1999 Day Runner, Inc. 74397/Order No. 730-300

Ellen and Sam Freeman, *Gerton, North Carolina, photographed in 2015*
The Freemans live in a roadside shack that Sam's mom built more than
a hundred years ago. To buy beer and provisions, Ellen has to walk four
miles over a mountain.

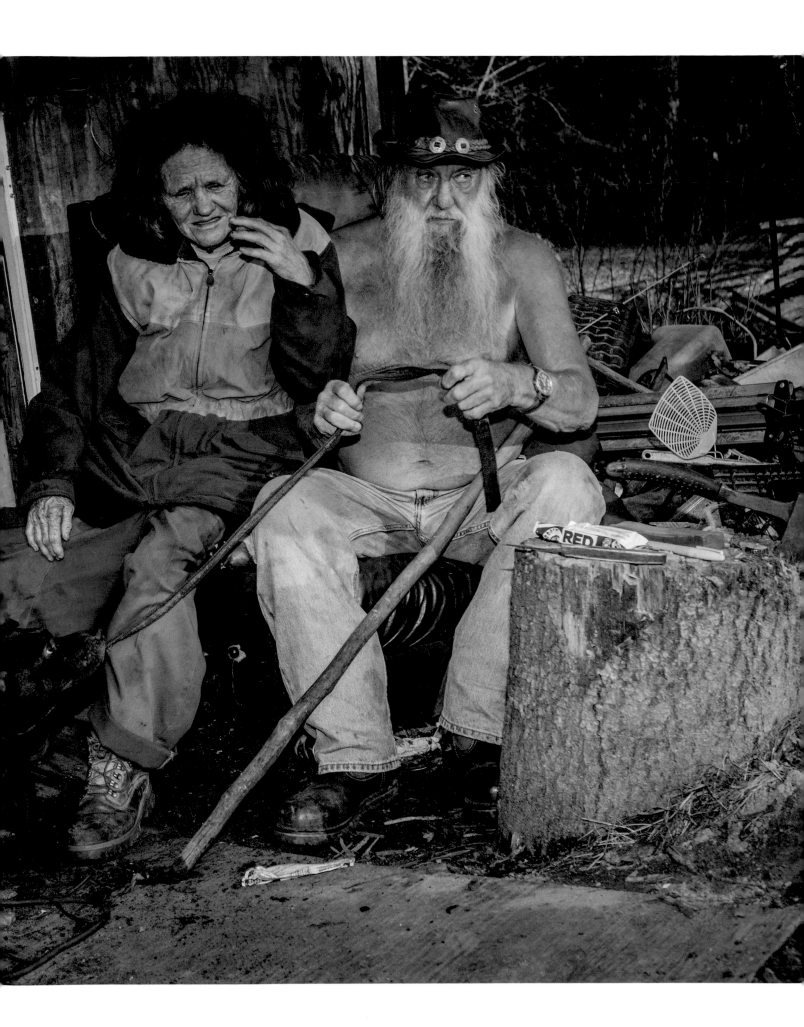

My American Dream

I am a person of African descent in America, and I've seen the many faces of injustice for people of color. My forefathers and foremothers were forced into the bondage of slavery in America for 400 years. I was born in the 1960s, and can recall the Jim Crow era in the South.

My maternal grandmother Josephine taught me about racism. I overheard conversations about lynchings, land grabbing, and other evil acts.

I heard Dr. King's speech "I HAVE A DREAM" in his speech he talked about equality for those that were oppressed. Today, in America we are still fighting for equality. What is the American Dream for me?

My American dream is to end poverty.
My American dream is end slavery in all forms.
My American dream is to end police brutality.
My American dream is to see my grandson grow up.
My American dream is bring the missing children home.
My American dream is to end homelessness.
My American dream is to end the pipeline to prison Dr. Antoinette Harrell

Antoinette Harrell, *Kentwood, Louisiana, photographed in 2017*
Antoinette lost her house and her possessions in New Orleans during Hurricane Katrina in 2005. In the aftermath of the storm, she moved to Kentwood, which is eighty-eight miles north of New Orleans. She does independent outreach and advocacy work on behalf of those less fortunate in the surrounding communities of Tangipahoa Parish. In 2015, she lost her leg to cancer.

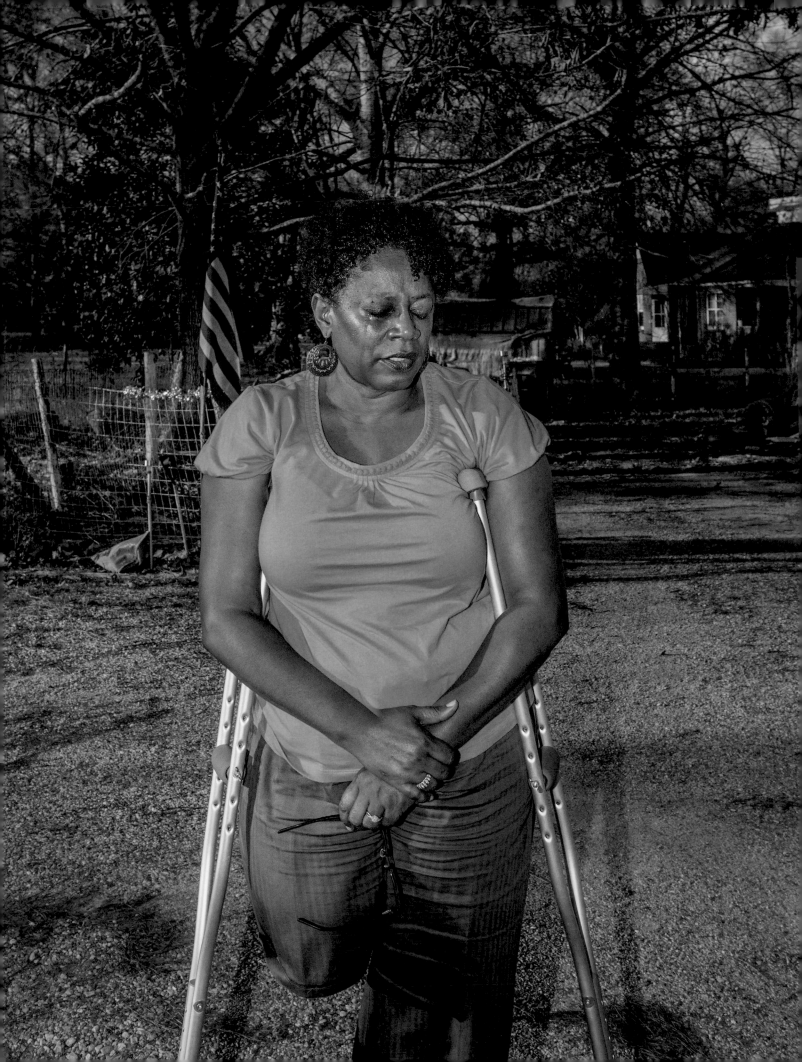

I'M GETTING READY TO TURN 65 YEARS OLD IN A FEW WEEKS AND I OFTEN THINK THAT I SHOULD BE DOING NOW THAT I AM GETTING CLOSE TO RETIRING AND I WONDER IF I WILL EVER REACH MY AMERICAN DREAM.

MY AMERICAN DREAM IS PROBABLY THE SAME AS OTHERS IN AMERICA. I'D LIKE TO BE FINANCIALLY INDEPENDENT. I'M NOT TALKING ABOUT BEING RICH AND HAVING ALL THE MONEY I COULD THINK OF. I'M TALKING ABOUT REACHING A TIME IN MY LIFE THAT WE DON'T HAVE TO WORK ANYMORE, ENOUGH MONEY TO PAY THE BILLS, TO SUPPORT MYSELF AND MY WIFE. WE LIKE TO TRAVEL AND I'D LIKE TO HAVE THE MONEY TO DO SOME TRAVELING. THERE'S A FEW MORE DESTINATIONS IN THE U.S. THAT I'VE BEEN TO AND WOULD LIKE TO SEE AGAIN BUT, THIS TIME WITH MY WIFE. SHE ENJOYS LISTENING TO ME WHEN I TELL HER ABOUT SOME OF THE PLACES I'VE BEEN TOO AND SOME OF THE THINGS I'VE SEEN. I TOOK HER TO SAN DIEGO AND SHOWED HER WHERE I WATCHED JOHN ELWAY AND MY DENVER BRONCOS PLAY AND WIN SUPERBOWL 32 AND HOW I FELT WHEN I WAS THERE TO WATCH THEM BEAT THE ATLANTA FALCONS IN SUPERBOWL 33. SO NOW, WHEN WE TRAVEL AROUND THIS GREAT COUNTRY SHE WANTS ME TO TAKE HER TO MAJOR LEAGUE FOOTBALL AND BASEBALL STADIUMS IN THE U.S. WE LIKE TO DRIVE WHEN WE TRAVEL AND WE'D LIKE TO DRIVE ALL OVER THE UNITED STATES IF POSSIBLE AND SEE THE BRONCOS PLAY A GAME IN EVERY NFL BALL PARK IN THE US.

MY WIFE'S FIRST COUNTRY WHERE SHE GREW UP AND STARTED HER LIFE IS MEXICO. MY WIFE IMMIGRATED LEGALLY TO THE UNITED STATES FROM MEXICO A YEAR AFTER WE WERE MARRIED. A YEAR AND A HALF AGO SHE BECAME A U.S. CITIZEN. HOWEVER, DRIVING HAS GOTTEN A BIT MORE CHALLENGING THROUGHOUT THE U.S... OUR ROADS AND BRIDGES ARE IN SUCH BAD SHAPE. I'M AFRAID WE'LL BE DRIVING ALONG AND HAVE AN ACCIDENT DUE TO THE POOR ROAD AND BRIDGE CONDITIONS WE HAVE HERE IN THE U.S...

I AM AN AVID SUPPORTER OF PRESIDENT DONALD TRUMP. I CAMPAIGNED FOR HIM AS A VETERAN FOR TRUMP AND OF COURSE I VOTED FOR HIM. MY WIFE BEING ORIGINALLY FROM MEXICO WOULD NOT SUPPORT OR VOTE FOR HIM. IT MADE THINGS VERY TENSE AROUND OUR HOUSE FOR A WHILE. HOWEVER, NOW THAT THE ELECTION IS OVER AND DONALD J. TRUMP IS THE PRESIDENT OF THE UNITED STATES. I THOUGHT THINGS WOULD BE BETTER. PRESIDENT TRUMP HAS SOME GREAT IDEAS TO PUT PEOPLE BACK TO WORK, AND HE WANTS TO STOP SENDING OUR HARD WORKING TAX MONEY ALL OVER THE WORLD. HE WANTS TO KEEP SOME OF IT RIGHT HERE IN THE U.S. AND HE WANTS TO PUT IT INTO REBUILDING OUR COUNTRIES ROADS, BRIDGES AND OTHER INFRASTRUCTURE. WHAT A CONCEPT, RIGHT! ...USING OUR OWN TAX MONEY TO REBUILD OUR OWN COUNTRY.

I TELL YOU, IF I WAS ABLE TO ADDRESS CONGRESS, I WOULD TELL THEM TO STOP ALL THE PETTY FIGHTING OVER IMAGINARY RUSSIAN PLOTS TO TAKE CONTROL OF OUR ELECTIONS AND LET PRESIDENT TRUMP DO WHAT HE WAS ELECTED TO DO. HELP THE PRESIDENT "MAKE AMERICA GREAT AGAIN." AND ONCE THIS IS DONE, I CAN GET BACK TO ENJOYING DRIVING AROUND THIS GREAT COUNTRY OF OURS, KNOWING THAT AMERICANS ARE WORKING AGAIN AND THAT AMERICANS HELPED MAKE THE ROADS AND BRIDGES SAFE TO DRIVE ON OUR COUNTRIES ROADWAYS AND MILLIONS OF AMERICANS CAN ALSO ENJOY A PIECE OF MY AMERICAN DREAM.

Anthony Seguro, *Albuquerque, New Mexico, photographed in 2017*
Anthony is a longtime NRA member and used to work in computer sales.

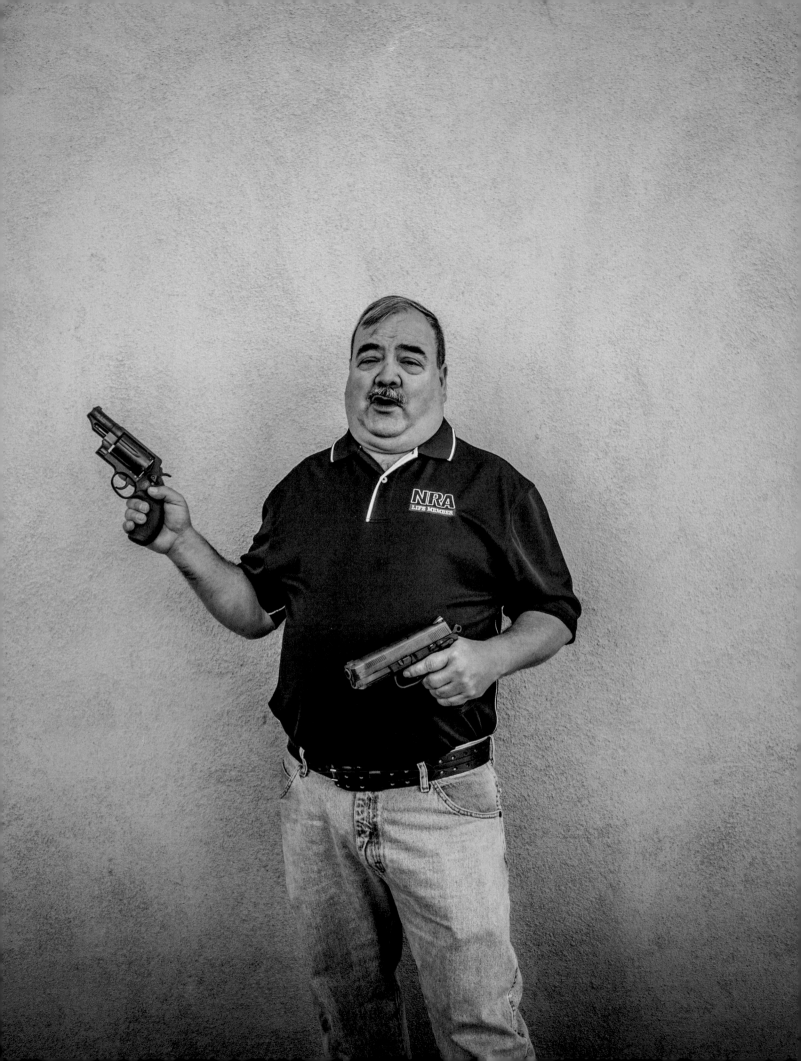

What is my American dream?
This is probably one of the easiest questions I have ever had to answer. I came across a quote from Confucius a few years ago where he had said find a job you love and you will never have to work a day in your life. Growing up here in southern West Virginia surrounded by such beauty I realized I wanted to do my part in protecting it and being able to show others how much these mountains have to offer everyone. I have been very lucky in finding a way to do this at such a young age. Twin Falls Resort State Park has been a blessing in my life. I wanted to find a job I loved that allowed me to give my wife and son the things I didn't have growing up. This job has done that and so much more for me. I take great pride in being the naturalist here and I couldn't of anything else I would rather be doing. I thank God every day for giving me the chance to live my American dream.

Coady Cochrane, *Twin Falls, West Virginia, photographed in 2015*
Coady was raised by a single mother in an impoverished area of West Virginia, and he enlisted in the US Army at nineteen to earn money to help her raise his siblings. After he left the army, he got a job at a state park instead of pursuing a career in coal mining, which is what most men in the region do.

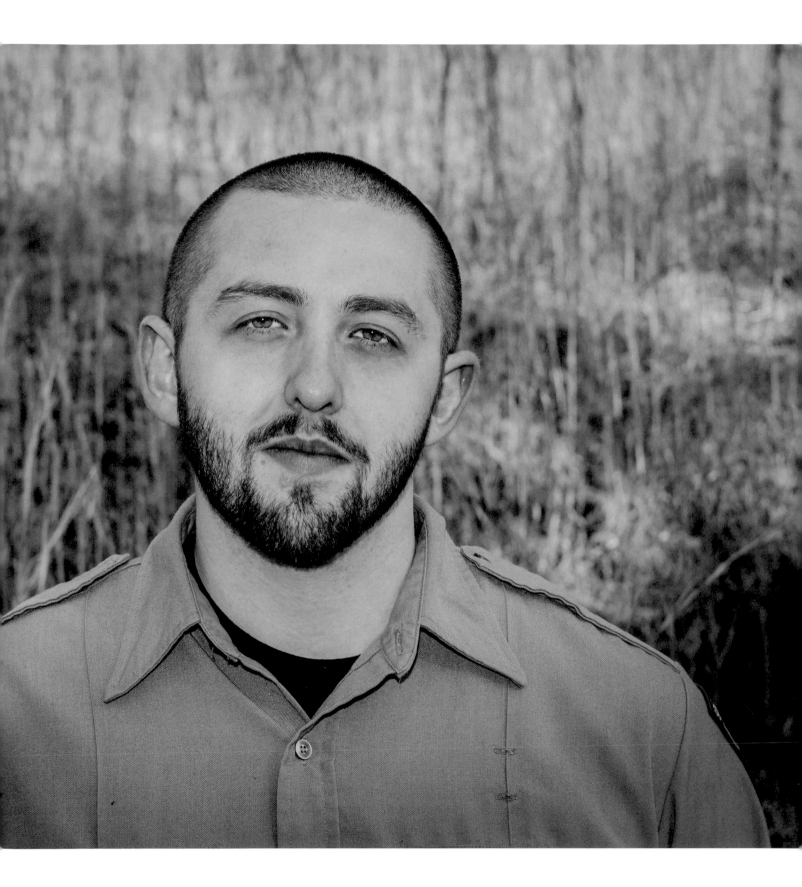

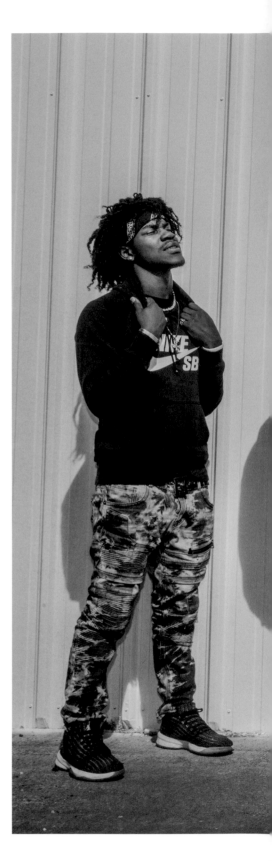

Our Dream is.....

To create a holistic housing system that makes achieving self sufficiency possible to all. Attacking this world's systems of oppression, addressing the lack of motivation, lack of determination, lack of self worth, lack of understanding, lack of knowledge, and lack of wisdom that is subtly destroying all that our forefathers fought so hard for us to obtain.

FREEDOM, LIBERTY, LOVE, and PROSPERITY!

Tearing down every stronghold, vain motive, and decieving heart despite our differences. In doing this we will build povertized communities creating strong support systems, educating the people spiritually, mentally, physically, and emotionally. Essentially eradicating the excuse of poverty!

"My people are destroyed and perish for a lack of knowledge."

Hosea 4:6 (NIV)

"When justice is denied, where poverty is enforced, where ignorance prevails, and where anyone class is made to feel that society is an organized conspiracy to oppress, rob, and degrade them, neither persons nor property will be safe."

Frederick Douglass.

Jessica Peterson, *Memphis, Tennessee, photographed in 2017*
Jessica and her family formerly lived in a dilapidated public housing complex that was rife with crime. She cofounded a tenants' association, reached out to local lawmakers, and, after years of advocacy, was able to get hundreds of residents of the complex moved to better housing. She and her family now live in a single-family home.

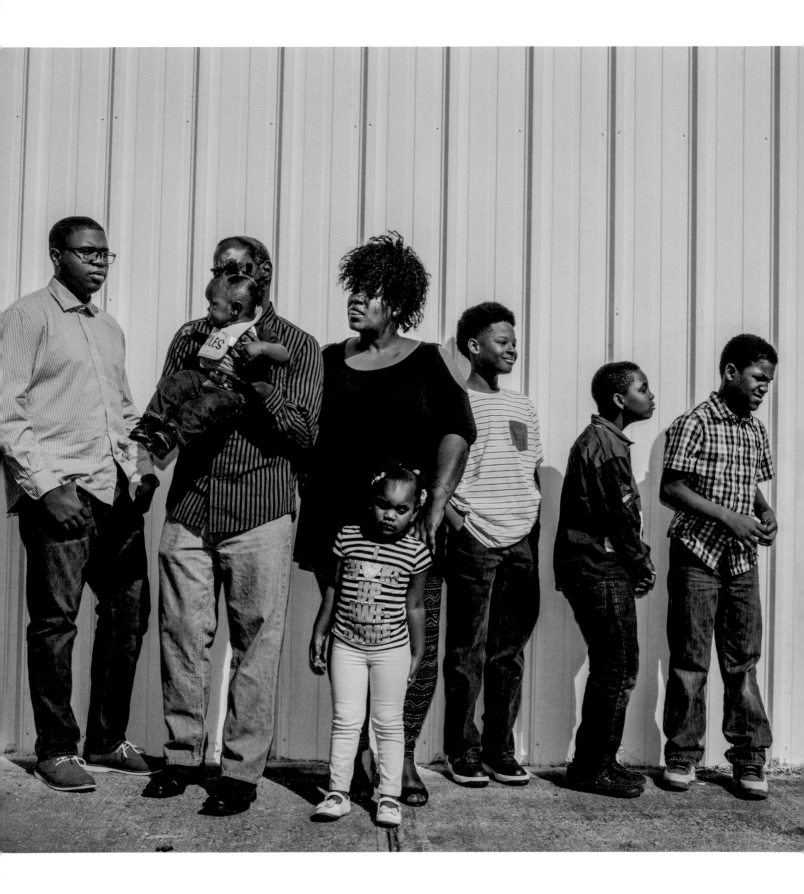

THE AMERICAN DREAM

MY NAME IS JUSTIN LANSFORD. I SERVED TWO TOURS OVERSEAS WITH THE U.S. ARMY'S 82ND AIRBORNE DIVISION. ON MY SECOND DEPLOYMENT I WAS SEVERELY INJURED IN COMBAT. I PROUDLY SERVED OUR COUNTRY, AND WILLINGLY POURED SWEAT AND BLOOD WHILE DEFENDING AND PROTECTING A SINGLE IDEA, "THE AMERICAN DREAM." ITS FUNNY, BECAUSE UNTIL NOW, I'VE NEVER ACTUALLY THOUGHT ABOUT WHAT EXACTLY THAT DREAM MEANS TO ME.

I'VE SEEN PLACES IN THIS WORLD WHERE PEOPLE DON'T HAVE THE LUXURY OF DREAMS. PLACES WHERE AN INDIVIDUAL'S SOLE PURPOSE IS TO STAY ALIVE, AND WHERE EVEN THAT IS DONE IN CONSTANT FEAR OF THOSE AROUND THEM.

HERE IN AMERICA, WE HAVE THE ABILITY TO LIVE FOR SOMETHING MUCH GREATER, AND THE BEST PART— WE CAN CHOOSE WHAT THAT SOMETHING IS. IN THE UNITED STATES, WE TRULY ARE FREE. FREE TO SET OUR OWN GOALS, FREE TO SUCCEED, FREE TO FAIL. THE OPPORTUNITY IN THIS COUNTRY IS SUCH THAT THE ONLY OBSTACLE BETWEEN US AND OUR GOALS IS OURSELVES.

WE HAVE THIS LUXURY BECAUSE OF THE THOUSANDS OF MEN AND WOMEN, MILITARY AND FIRST RESPONDERS, WHO PUT THEIR LIVES ON THE LINE EVERY DAY AND NIGHT, NOT ONLY TO KEEP US SAFE, BUT TO KEEP US FREE. FREE TO DREAM.

Justin Lansford, *Tampa, Florida, photographed in 2016*
Justin was serving as a machine gunner with the 82nd Airborne
Division in Afghanistan in early 2012 when an improvised explosive
device detonated under his truck and he lost his left leg.

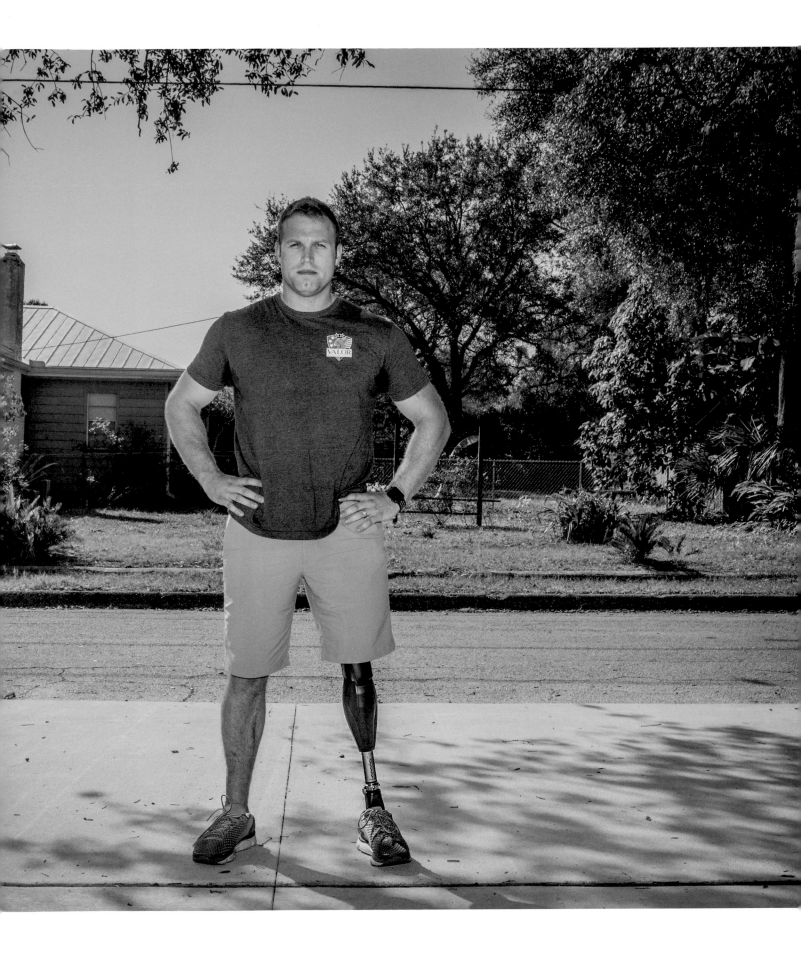

The American Dream

Things are seldom what they seem ~
Consider the famous American Dream,
A perfectly legal Ponzi scheme
That cons the gullible of all ages
And robs the poor of hope and wages,
Plundering land and sea and skies,
Poisoning all of our minds with lies
By con men promising boundless opportunity
While they rape and murder with impunity.

~ Carol Van Strum
July 13, 2019

Carol Van Strum, *Sisulaw National Forest, Oregon, photographed in 2019*
Carol (far right) is a writer and editor. A self-described "seasoned troublemaker," she was instrumental in bringing attention to the use of pesticides that harm the water sources in Western Oregon. She is pictured with some of the other environmental activists who are involved in the fight against the logging industry.

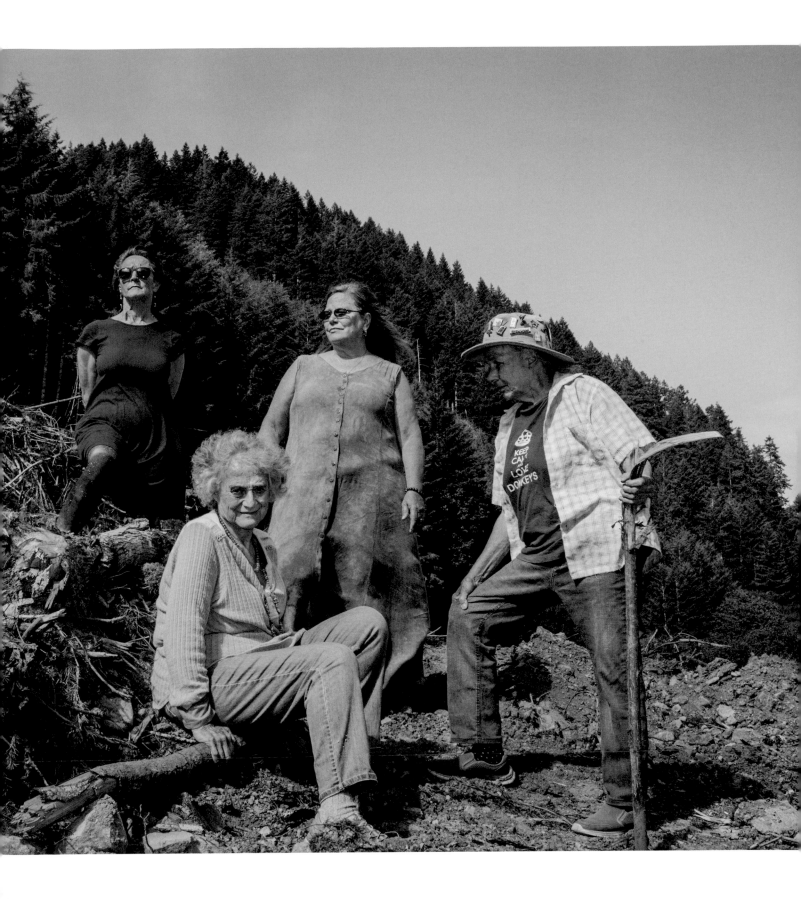

My American Dream is to run for Office &
help empower my community. Being undocumented
and with DACA hasn't stopped me from graduating
from my university with honors and being an
elected official would be the icing on the cake.

Hector Salamanca Arroyo, *Des Moines, Iowa, photographed in 2015*
Hector did not know that he was living in the United States without documentation
until he was in high school. He obtained Deferred Action for Childhood Arrivals
(DACA) status and continues his education and community work.

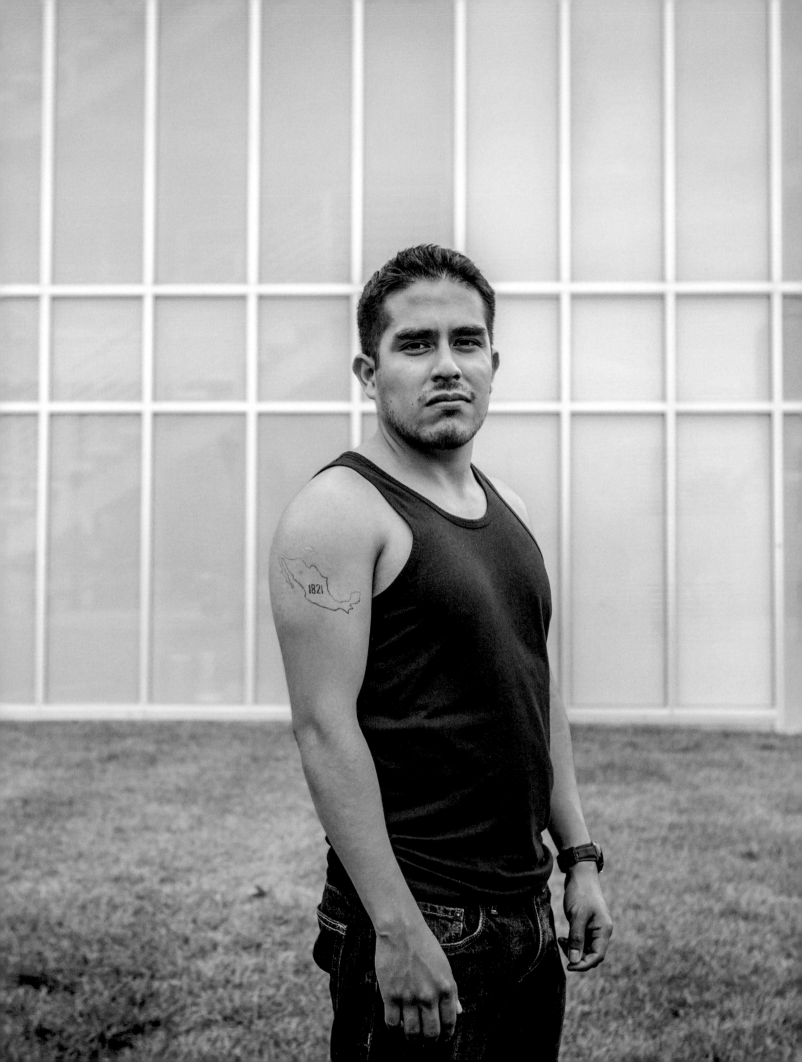

America Dreams:

My a, name are Apiel N Kuot, single mother
living with my 2 daughters, I arrive in
America in 2016, It's was not easy to cop
but I work throug it the work of case workers
and help with women of the world.

I gone to school for compter dipolma, and
learn to be self dependen in any condition
for everything I have pass through back
home Africa change to happionies,

my children go to school and are
also free from violace fightings,
now lean I can pay everything boy
own,

That is call America Dreams

I thank Everyone who stand
by my side to show right
way in life.

by Apiel N' Kuot

Apiel Kuot, *Salt Lake City, Utah, photographed in 2019*
Apiel grew up an orphan after her parents were killed in the civil war in South Sudan.
She fled the continuing conflict in Sudan and came to the United States in 2016 through
the United Nations refugee program. She is raising her two daughters as a single mom.

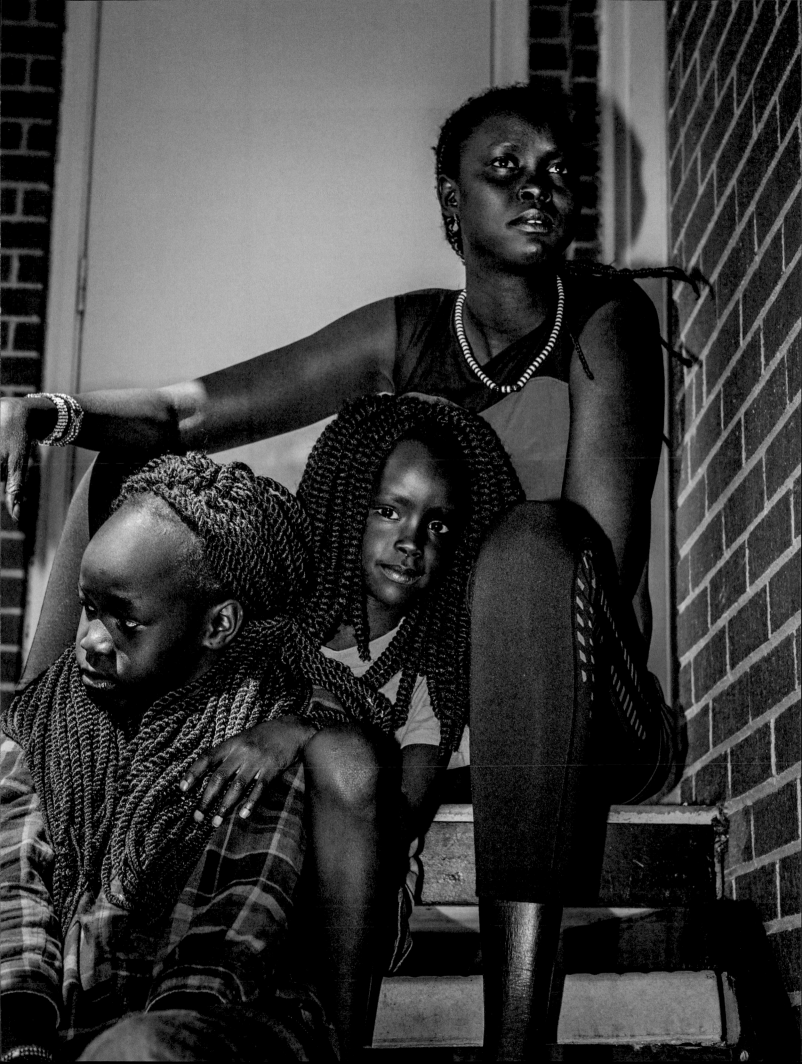

> **YESTERDAY IS HISTORY.**
> **TOMORROW IS MYSTERY. TODAY**
> **IS A GIFT.**
> ELEANOR ROOSEVELT

My American Dream is to honor my husband's life by living a full and satisfying life. To be free to enjoy good times with all the people I love. To be able to give back to the world for all I've received in my life.

I'm lucky, I'm living My American Dream.

by BEN'S GARDEN

Gabby Kubinyi, *Baltimore, Maryland, photographed in 2015*
Gabby is a Gold Star wife. The Gold Star Wives of America was cofounded by First Lady Eleanor Roosevelt and is an organization that supports spouses of fallen soldiers.

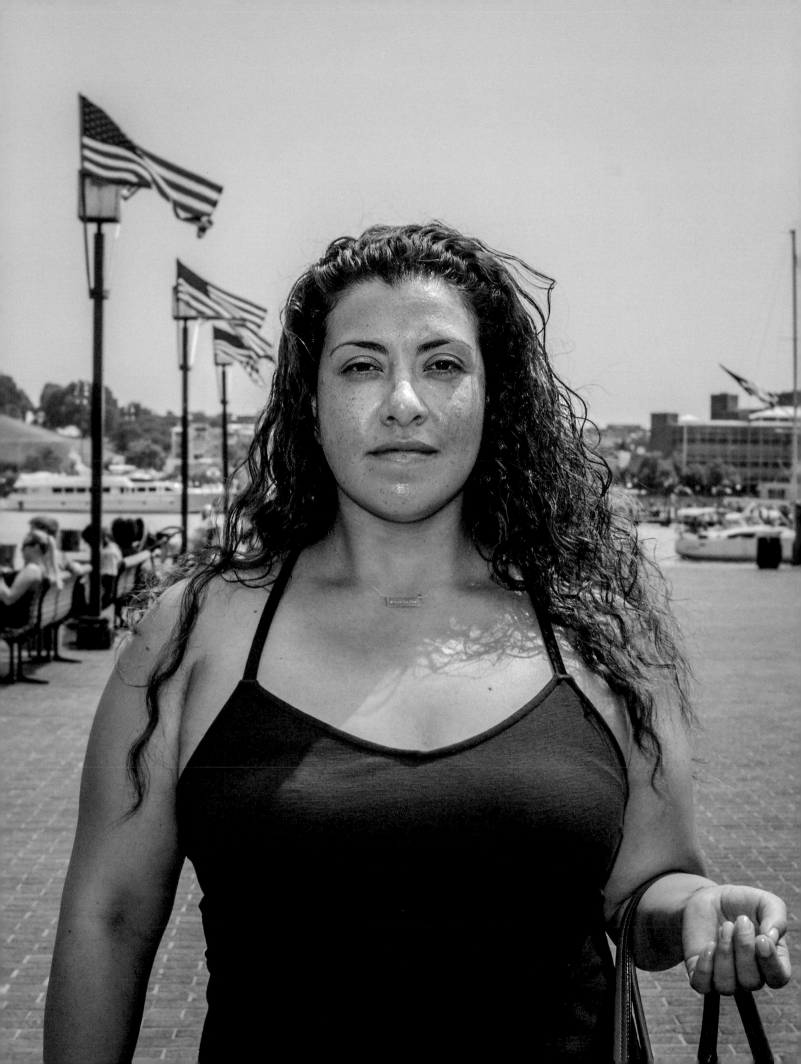

Denise Calhoun - 2/19/18

My idea of the American Dream is immensely different from that of James Adams in the early 1900's.

- The American Dream should be a land in which all people are created equally, where everyone has the same opportunities for prosperity, and where ethnicity and socioeconomic status has no weight or ~~no bearing~~ bearon on who you can become or what you can achieve.

- However, we now live the dream in a land where the person that is the symbol of all people can say as he chooses, do what he chooses and continue to act as if he is above the law.

- A land where we shouldn't have to create hashtags, like #blacklivesmatter to bring attention to police brutality against blacks.

- A land where we have black and brown people who continue to be victimized, marginalized, and excluded from opportunities, not by their neighbors, but their government.

- A land where students choose to take a stand with a call to action against those matters in which they feel are not being addressed by our government.

- I can only imagine but I do believe that since there has been an overwhelming amount of attention brought to these matters, America still has the ability and hope of making the American Dream of the 1900's a reality.

Denise Calhoun, *Webb, Mississippi, photographed in 2018*
Denise is a former teacher and works with her local school
district as an intervention coordinator and coach.

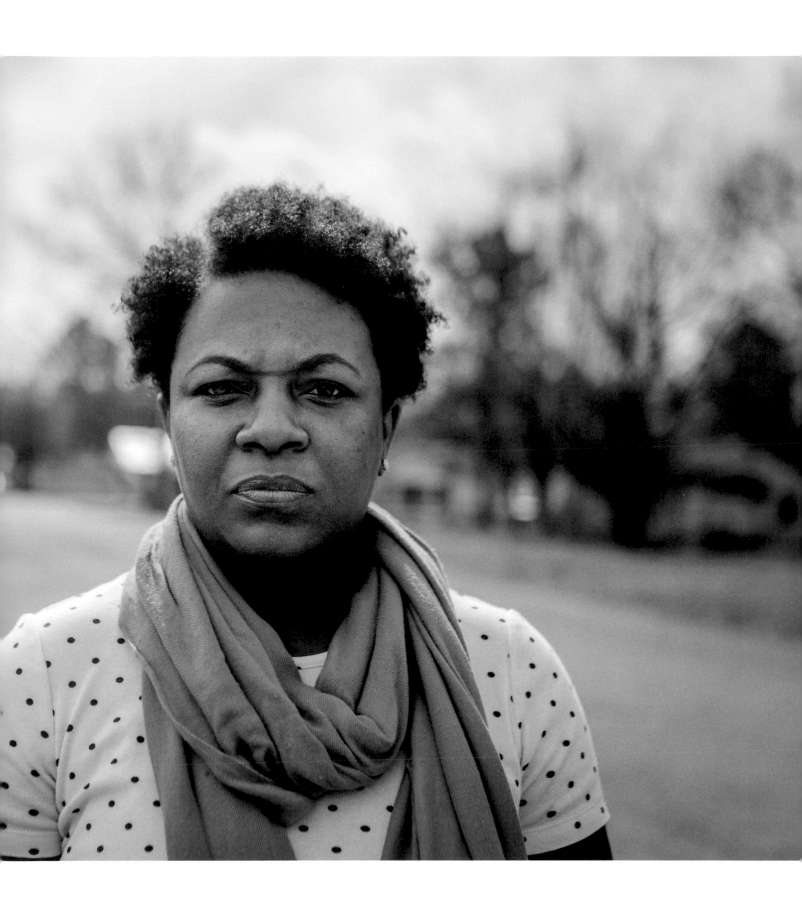

We been through such a brave time to American. We don't Know any of english. So American is like a dream, It like we have our own freedom, and so many education also we look forward in the future to be sucessful.

Thanks American for letting us when we have such a rough time.

Thanks a lot

Masan Ye, *West Buffalo, NY, photographed in 2015*
Masan (right) is a refugee from Myanmar (Burma). She works two jobs, attends night classes, and had just purchased her first car the week that this photograph was taken. She is pictured with her daughter.

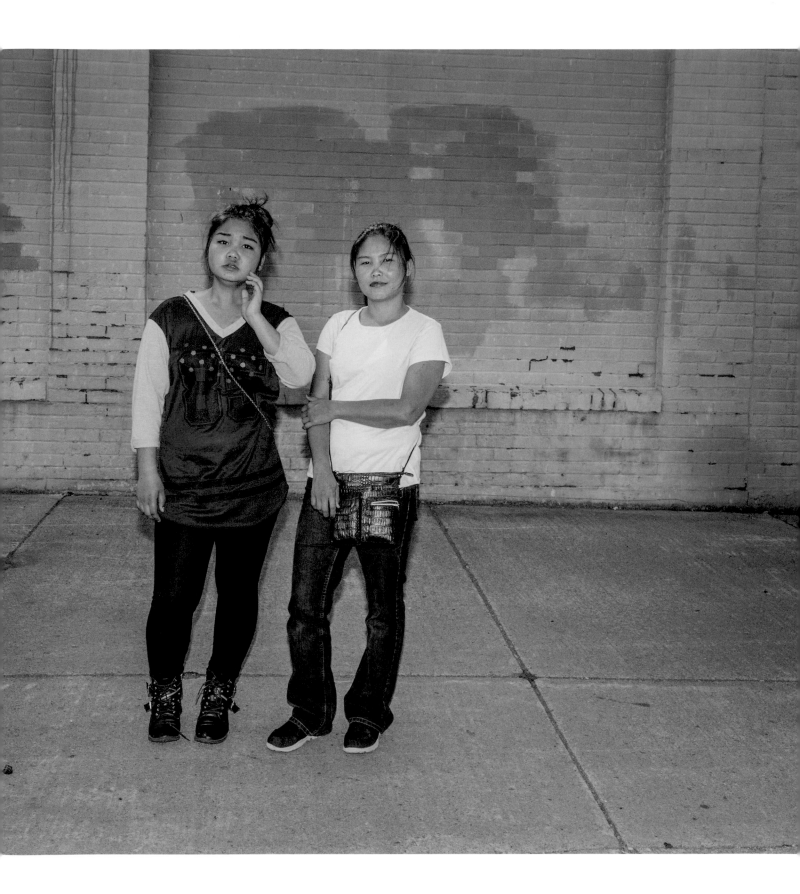

MY AMERICAN DREAM

After 9 years of study in India, I came to the USA as an ethnic Tutsi refugee from the D.R. CONGO.

I was amazed to see how people of various background live together in harmony. People are judged by their performance, not by their origin.

I created an NGO called 'New Day New Hope' to provide shelter to other immigrants who need a safe place to live.

My American Dream is to see the American capitalism grow and flourish with hope that the beneficiaries of that growth will use their wealth to alleviate the suffering of fellow human beings across the country and across the world.

John L. Sezikeye

John Sezikeye, _Baltimore, Maryland, photographed in 2014_
John was photographed with his infant daughter.

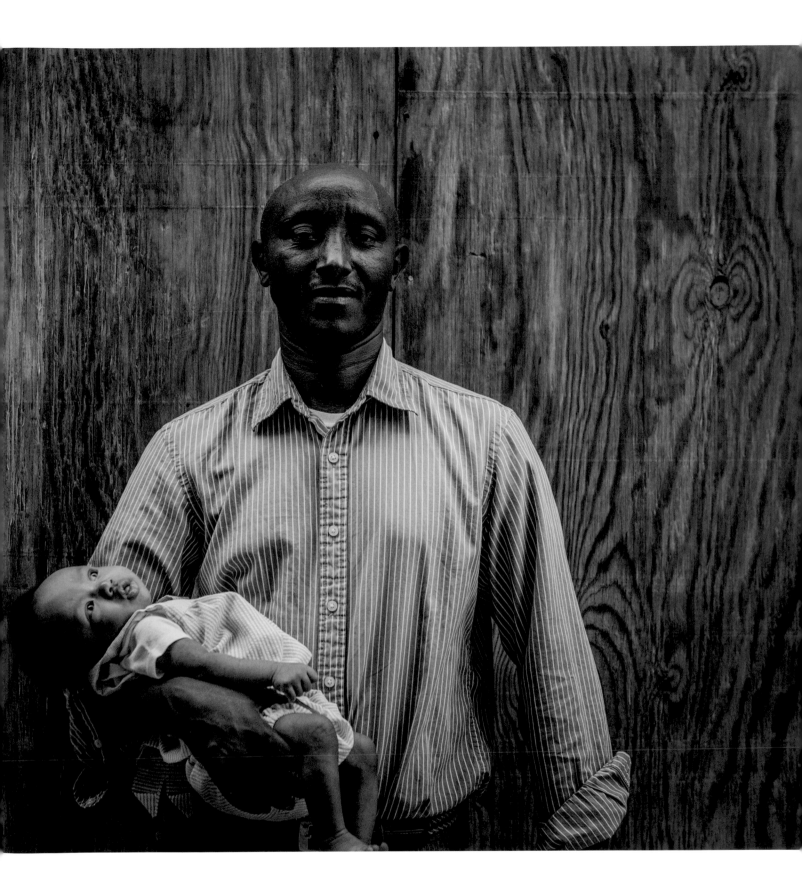

DoNald LongSoldier
Respect ··
wisdom ··
Generosity ✓
Courage ·

Use these in everything
every way of "this life"
without one you cannot
live "this life" in a good way

Never get mad
Refuse to feel sad

laughter is the greatest medicine..

we have no choice but to stay
"Strong!"

Donald Longsoldier, *Pine Ridge, South Dakota, photographed in 2017*
Donald is Lakota and was photographed on the Pine Ridge Reservation,
where the average life expectancy for men is just forty-seven years old.

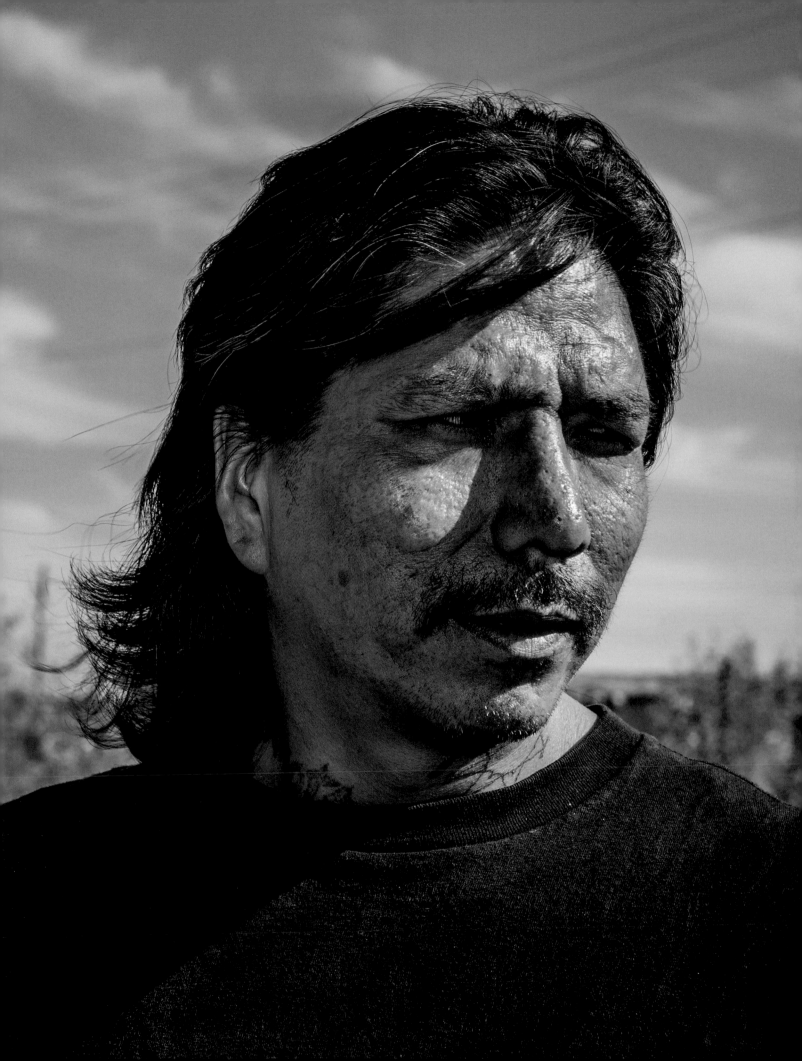

The American Dream

The American dream can be whatever you set your mind to. Here in America you have the opportunity to obtain whatever career your heart desire.

The American dream was designed for every immigrant to achieve their highest dream (Goal).

For me, someone else had their own dream for me. Their dream was for me to do time behind bars for a crime I didn't commit. (I was forced into a dream I never wanted to be part of as growing up.) I was convicted and giving a 75 year prison sentence, but only served 22 years. My sentence was commuted and I was released into a world that was different from anything I could imagine.

My American dream turned into the American nightmare. I realize that I have to work and do things 10 times harder and faster than a person who never been incarcerated.

My American dream now is to live a peaceful life. :)

T. Hood

Tyrone Hood, *Chicago, Illinois, photographed in 2015*
Tyrone spent twenty-two years in prison for a crime he didn't commit. After intervention through the Innocence Project, his case was reviewed and his sentence was commuted. He has received no compensation for the time he served.

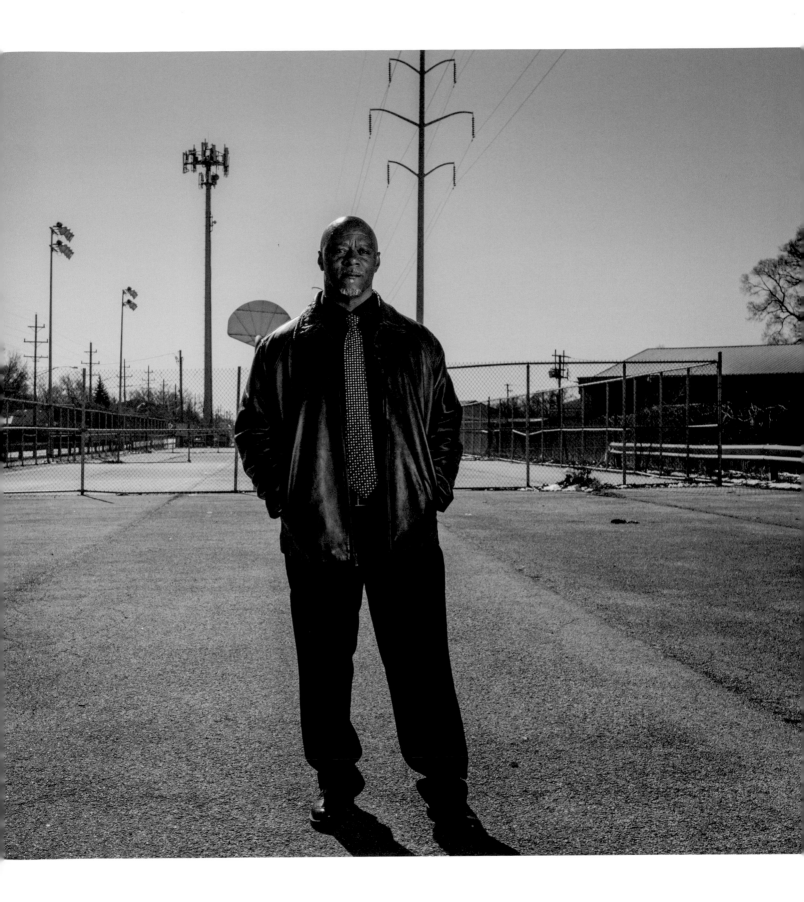

Nuestro Sueño Americano.

Queremos que los trabajadores tengan oportunidades de trabajar con dignidad. Que las mujeres sean tratadas con respeto, y que todos los trabajadores tengan la misma voz, porque hay trabajadores en otras industrias que no pueden reportar los abusos porque hay represalias todavía y no conocen sus derechos.

Nuestro sueño es que este modelo del Programa de Comida Justa llegue a otros trabajadores en otras industrias y que haya mejor vida para los trabajadores y sus familias.

Nuestro Sueño es que cada corporación sea conciente de donde compran sus productos y decidan comprar donde hay derechos para los trabajadores y donde no hay abusos.

Esto es nuestro Sueño Americano.

Immokalee Workers, *Immokalee, Florida, photographed in 2015*
The Coalition of Immokalee Workers is a group that fights against human trafficking of migrant workers and stands up for farmworkers' rights. Their fair food program ensures humane wages and working conditions for the workers on participating farms. Forty-three percent of the population in Immokalee lives below the poverty line.

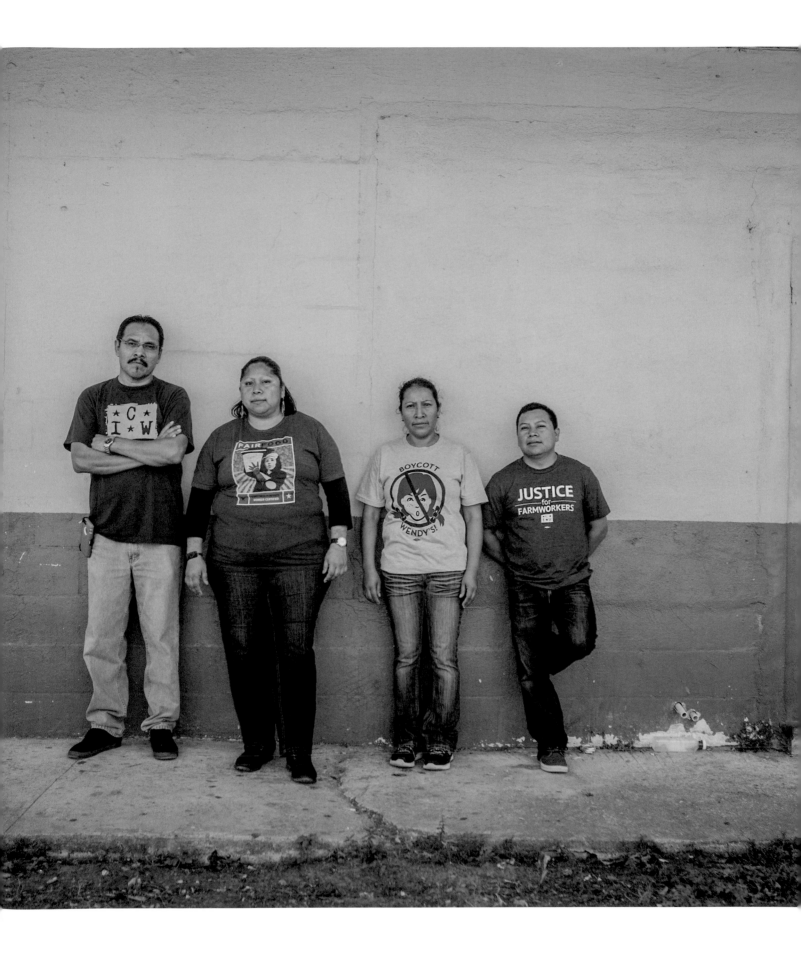

I piss, shit, & eat to refill. *Sleep* + wake up.

My ~~dreams~~ were in my youth & its a nightmare to me as I can do none of ~~the of~~ any of that now. Stupid: that I'd want to

M Sochor Jr.

Milton, *Goldfield, Nevada, photographed in 2017*

As a young man, Milton wanted to be a novelist. He was in love with a girl but was sent away to war with the US Navy; when he returned, she had married someone else. He ended up in an office job for the remainder of his career. Now retired, he lives in the small miner's cabin his father built in rural Nevada.

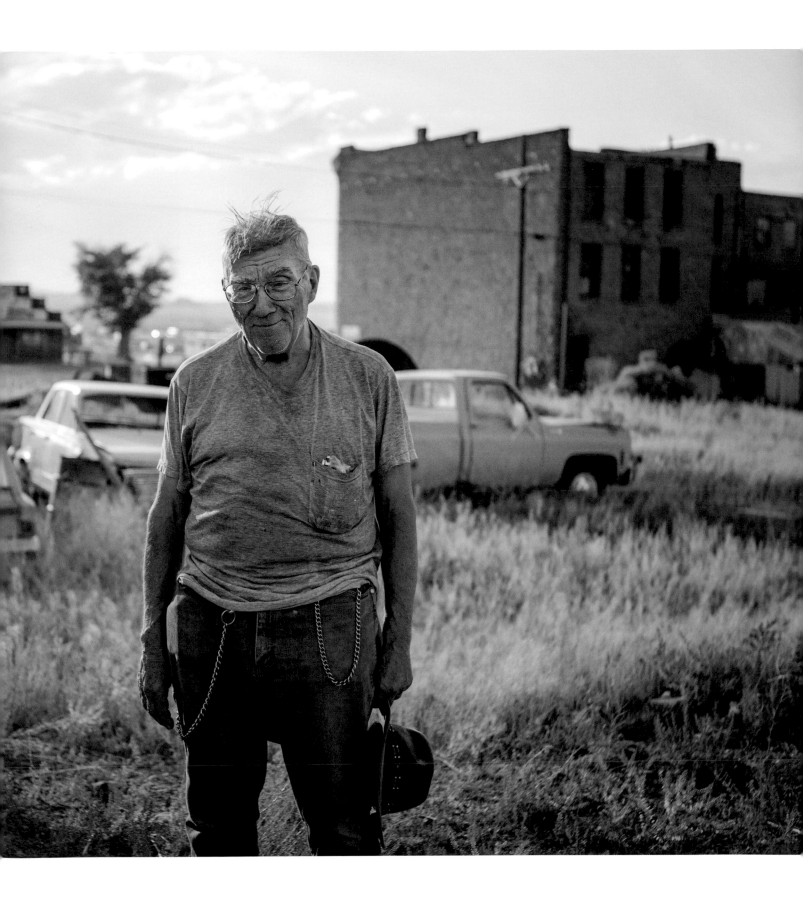

American Dreams

Racism stunts our potential as an American family, and our stunning possibilities. My American Dream involves a great deal of possibility. Part of dreams sees America reaching its' full potential, and becoming a fully realized being.

I commune with my dream openly, and as such I am both fearful and hopeful. As a Back American man, father to a Black American son, and protector of a Black American family, I am fearful that my home is flagrantly resistant to the growth it will need to effectively raise fully functioning, socially aware and grounded citizens. I am hopeful, because I see many of America's corners, and it's center, struggling with that growth, willingly, trying to be better.

We stand at a point where, as an American family, we shift between the fluid racist attitudes of openly hating otherness, being stagnant and bullheaded around the need to change these attitudes, we selfishly and carelessly dismiss ideas that would promote racial progress and we fail to act to promote safety and the emotional well-being of racial others.

The work that I have done has brought me directly into contact with members f the American family who know, without reservation, that we must change. They realize that Black Americans, Americans of color, those who are transgendered, have special needs are "disabled", are not often enough given a fair chance to live a fully actualized life. They cannot live beyond and with their "otherness." That work has also brought me into contact with those who believe that America should not change, that others should learn to adjust accordingly to America, as is.

My American Dream is that the work we do allows our overall American family to develop a better sense of itself around race, that we can see our failures as opportunities and that we very simply grow.

I believe, sincerely, that my American Dream is just outside that door. The last two generations have a more, at least on the surface, inclusive sense of race that allows for them/us to engage these difficult conversations and tasks with a bit more confidence, as this is as it should be, in our minds. We have to better take the perspective of prior American generations, who are still very much with us, and bring them to the table.

I have work to do, as there are still opponents who have identified me, and those like me, as a threat to the existence of what America is. My Dream is that we can shed a skin that we have no more use for and grow one that better suits how truy great we can be.

My Dream is that I can cure racism. I've no doubt that there remains much work to do. It's okay though, I have plenty of help in the task. I need my American family to carry their share of the burden, and that dream will draw closer to reality.

320

Napoleon Wells, *Columbia, South Carolina, photographed in 2015*
Napoleon is a clinical psychologist and a *Star Wars* enthusiast.
He is pictured with his wife and son.

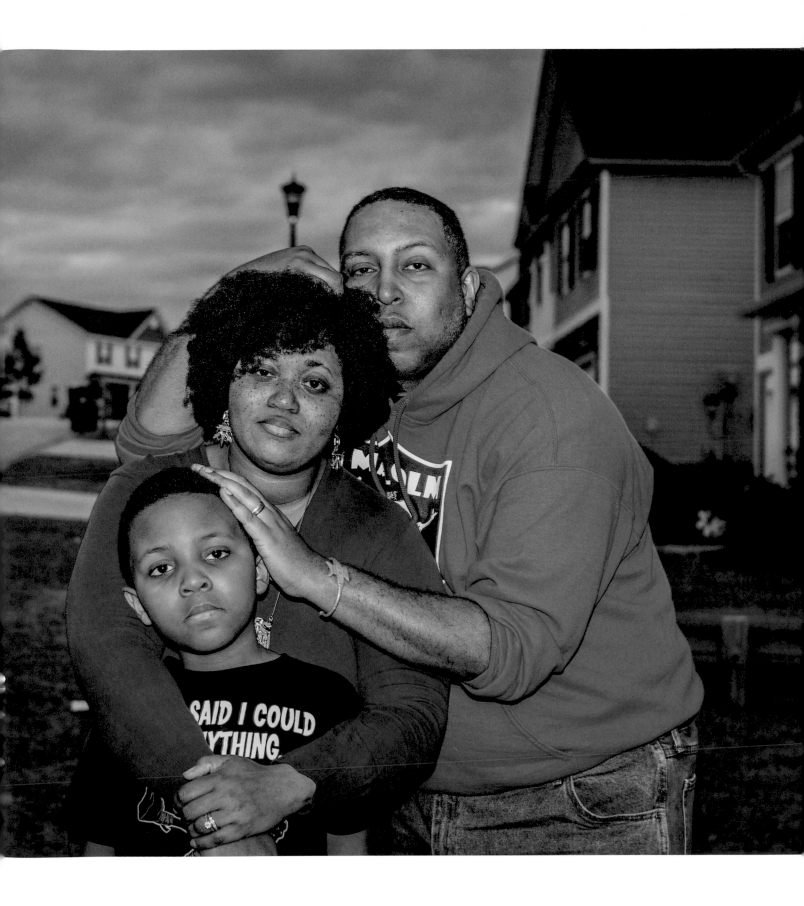

When I was young, I thought I understood the American dream to be that of assurance and establishment; a house, a job, a family, and God. As I grew older and traveled the world, I began to see dreams in a different light.

I saw dreams of independence, dreams of different gods, and dreams of a better life, any life that wasn't where I was. Again, I thought I understood the American dream, this time being that of what lacked in most the world; a dream of safety, stability, and a successful future.

But as I adjust to a life back stateside, and I reflect upon what I have learned in my travels, I accept that I no longer know what the American dream is because America has no uniform consensus on what America really is.

Like the dream, America does not represent a unified ideology but instead the collection of different beliefs, being the source of both its greatest strength and weakness, and that in this country, no matter how insane you are, someone, somewhere, will look at you and say "hey, that's a great idea!"

...even when it's not.

Robert Hoey, *Las Vegas, Nevada, photographed in 2017*
Robert is a former combat medic who now does outreach work with some of the most marginalized
people in America. He provides medical triage, food, water, clean needles, and toiletries to
homeless people who live in abandoned underground storm tunnels beneath the Las Vegas Strip.

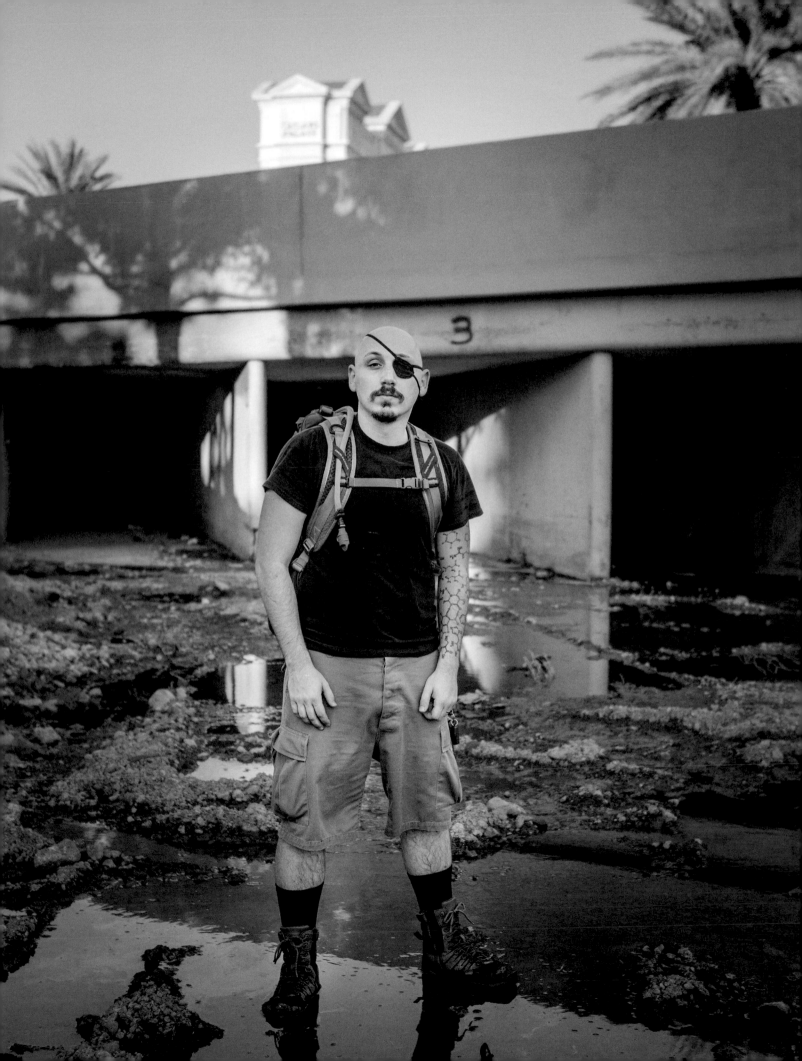

Bruce BonFleur, *Whiteclay, Nebraska, photographed in 2017*
Bruce and his wife, Marsha, are Christian missionaries who live
across the Nebraska state border from the Pine Ridge Oglala
Sioux Reservation in South Dakota.

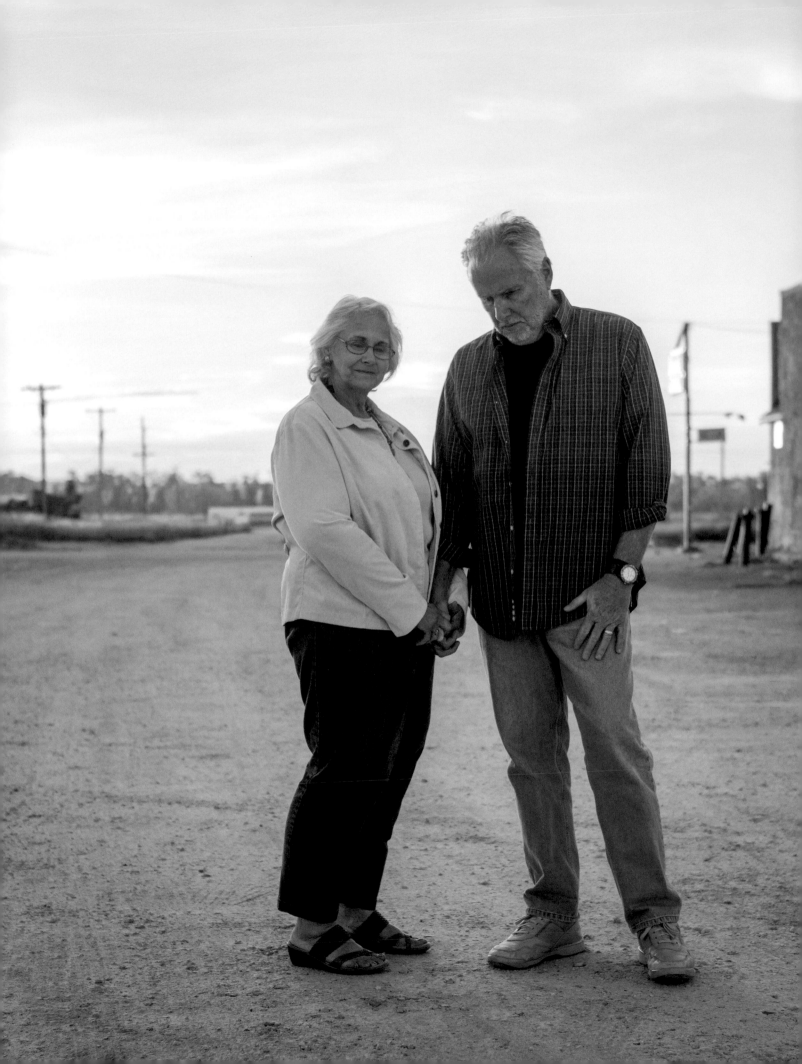

I consider myself a 'patriotic' American, one of the first to stand for the national anthem, to salute veterans in a parade and to tear up when I think of the great privilege of living in this country, but...

But after answering a 'call' by God over twenty years ago and moving my family to one of the poorest places in the western hemisphere, Pine Ridge Indian Reservation, I began to 'tear up' less and grasped the reality that there is NOT '...liberty and justice for all,' certainly not in this place, among the people of the Lakota Nation who continue to struggle on the reservation (actually, historically a remnant prisoner of war camp).

My position as Principal of a small Christian school on the reservation for three years introduced me, and my family, to a beautiful people who live in ugly circumstances, and because of man-made restrictions of various types, are both physically and emotionally stuck and thus deprived of many of the basics we as relatively prosperous Americans take for granted — things like a job, decent housing and food.

I will never forget walking into a typical supermarket in Omaha, Nebraska, shortly after completing our family's first year living on the reservation. We had gathered a group of Lakota youngsters, students who had excelled at our school, and were preparing to fly out the next day to Florida for 10 days of exposure

to much of what we might call advantages of living in the 'American Dream'. They loved Disney's EPCOT, pristine beaches and parks, touring Daytona International Speedway, fine restaurants and much more. Anyway, when I walked into that supermarket the night before our trip the sight of so many shelves filled with thousands of choices, literally stopped me in my tracks — and I teared/choked up at the profound diversity and quantity of just food that was available in that place. I was truly experiencing a sort of 'cultural shock' after having lived the previous year where nothing like it on the reservation came even close. And I grieved as I watched the shoppers, all typical Americans, bask in abundance.

So, I remain a patriot I guess. I still love my country, but now with a tempered and much clearer image — after 19 years now living among the Lakota people — of just how far our country is from realizing 'liberty and justice' — and the pursuit of happiness — 'for all'. God help us, please.

Bruce Bon Fleur, 66
SERVANT/ADVOCATE

My version of the American Dream...

I have the ability to choose how I want to live.
I choose to be free. This in part comes from
priviledge. My motivation & decision to choose the
end result of being sovereign & free is not without
struggle & intense growth. To have this choice &
motivation is part of being American.
I work for our regional community action agency in early
learning system coordination. This is anti-poverty work &
our core goals are to serve children furthest from
opportunity. In the foundation of many lives is trauma.
Building protective factors and resiliency in ourselves &
our community is one branch of the path to healing.
We have individual & collective priviledge & responsibility
as Americans to do this work. Among the deep layers
of crisis this world is in, we are in a climate crisis.
The NO LNG campaign is the most critical issue in
this community - the South Coast of Oregon. This is
fighting against the construction of the Jordan Cove/
Pembina LNG export terminal & pipeline. This is a
social & environmental justice issue. The lifetime of this
facility is less than 20 years. Yet the ecosystems & region
will be irreversibly decimated by the construction of this
facility. This includes bedrock blasting in the bay,
destruction of cultural heritage sites, and a potential
catastrophe that would incinerate a several mile radius
of Coos Bay/ North Bend. My son & I live in the immediate
death zone. Furthermore, destroying one community &
environment (by fracking) for the economic benefit
of another is an example of our broken system.
Life does not survive & thrive this way.
My healing process holds two vital threads:
1. No one is going to save me.
2. I have to trust myself.
These tenets are integral to choosing to be free,
and are guiding me through the most difficult
year of my life, my first year as a single mom.
I am grateful for my ability to create a better life
for myself & my son. One of LOVE, safety, sovereignty,
and freedom. I believe this is my American Dream.
The other side of this is many people here & across the
country do not have the same wherewithal & opportunities.
This is in part from historical & present trauma, and a
flawed if not altogether broken system. I am
motivated to do what I can to shore up my community,
share my gifts & light, & fight against the LNG project.
This begins with me: 1) saving myself; 2) trusting
myself. I know my son will be fine & thrive if I do
this. Hopefully, our positive energy will extend into
our orbit & environment. The freedom to live with
this intention is part of the priviledge of being
American.

Skaidra, *Coos Bay, Oregon, photographed in 2019*
Skaidra works in healthcare and is a single mom.

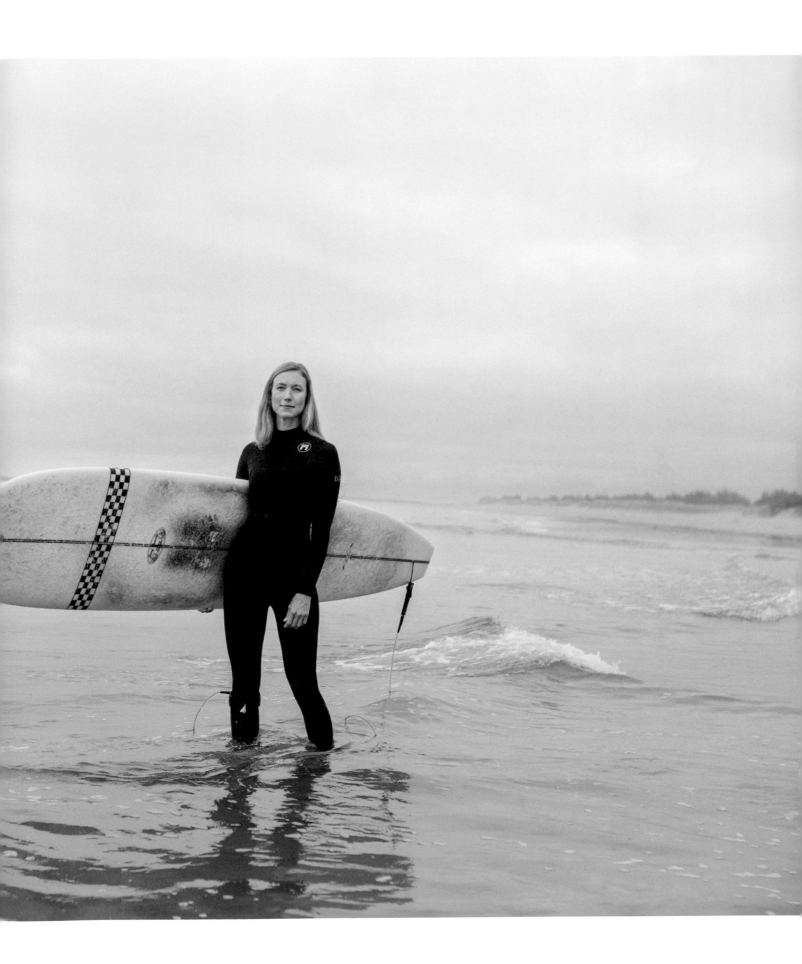

My AMERICAN DREAM is...
to make enough MONEY with
My QUEER, WORKING CLASS
and INUPIAQ INUIT art to
pay my Grandma's rent and
let my mom play BINGO
EVERY NIGHT.

David Leslie, *Fairbanks, Alaska, photographed in 2019*
David is an aspiring screenwriter who performs burlesque
and works part time in film production.

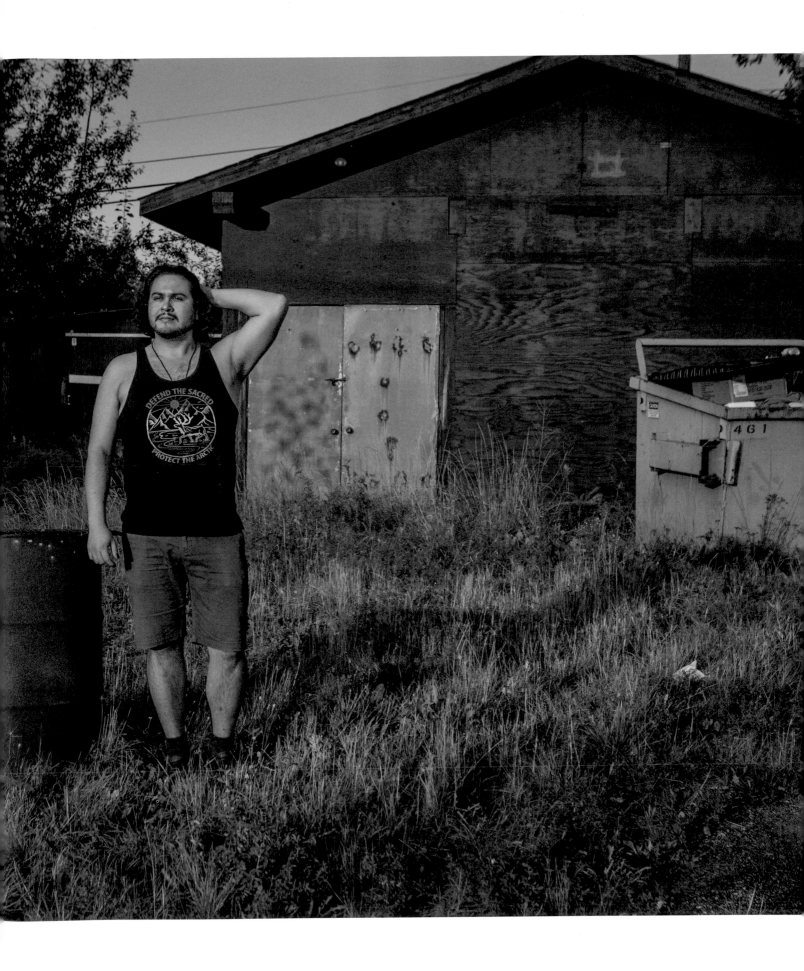

American Dream;

Well being older,on the twilite of my life, my dreams are much different then they used to be. No longer do I have delusions of grandure. I don't think too much about my future but I think a lot about the future for my kids and grand kids and young people in general.

I seem to have spent a lot of time thinking that someone else would fix things and that everything will be ok in the end. Boy was I wrong we have let America get away from us and now we must work doubly hard to turn things back around. I don' t want to get all political but there is a faction in this country who ate working very hard to bring down the America I thought we all wanted, where the americian dream was alive. I don't want to take us back in time that is foolish.

However all through my youth I thought things wete getting steadily better until some time in th 90's we began to lose our way. I grew up in the economic growth of the 50's and 60"s and the improved relations of the civil rights movement. Then again good economic growth of the late 80's and early 90's. We had our bumps and some disasters like Viet Nam, Watergate, high inflation and not to mention some personal mistakes and wrong turns. I thought we were overcomeing all that. And then long about 92 something happened and we began to lose ground. A few things happened on the world stage and our gains began to errode and we began to lose liberty and our country.

Now I am in fear of loseing it all. So in final my personal dream is that Americia can be saved from those who would drag us down into a socialist collective where we are subsetvient to the state and bound in a authoritian collective where the individual is slave to the state. That can only happen by distroying self reliance and individual liberty. So aftwr all that my dream is for the young to remain free.

Charles Erickson, *Fremont County, Wyoming, photographed in 2019*
Charles lives alone in rural Wyoming in a twelve-by-fifteen-foot one-room
shack he built himself. He is a veteran of the Vietnam War.

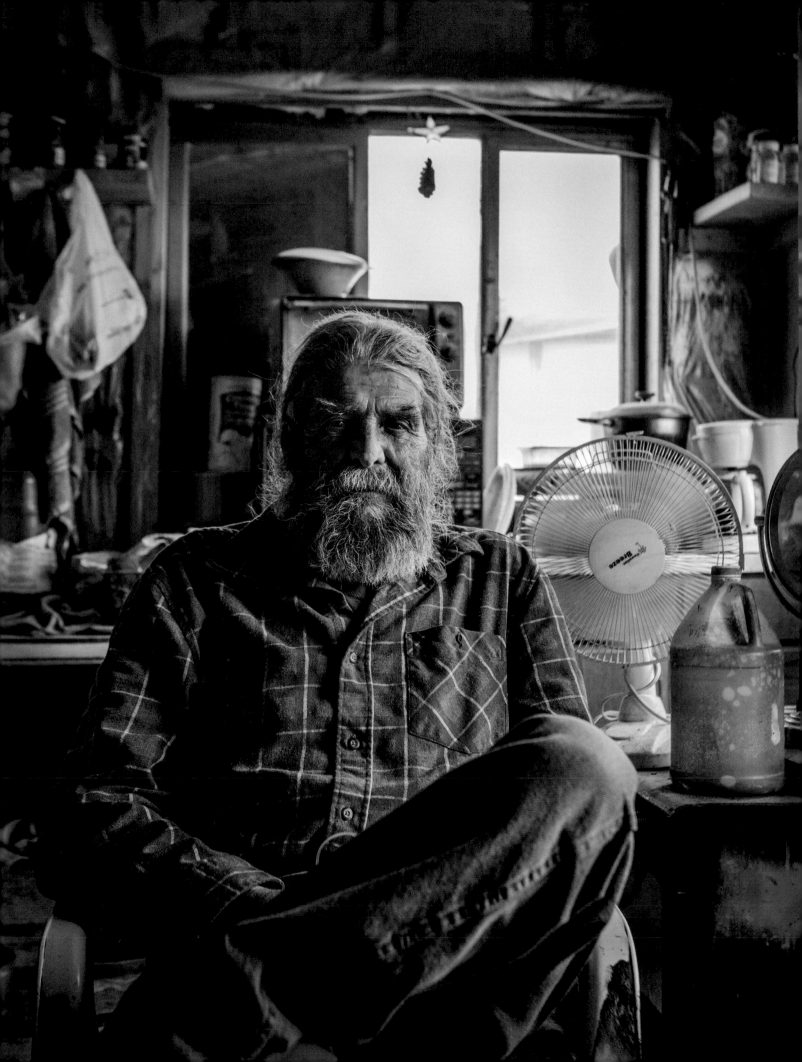

I am black.

I am a woman.

Those are the only two things that I absolutely cannot change about myself. As a black woman, my dream is to have a dream worth dreaming. My dream is to have a dream that is valid in the eyes of each and every individual that bears witness to it. Right now, in the current state of America, everything about who I am is under attack. My anatomical makeup suggests that my body, mind, and humanity are not worthy of respect. My worth as a woman weighs less than the ego of a man with no value system. The amount of melanin in my body is apparently threatening enough to warrent **murder** and call it **reporting for duty**. To me, my American dream is pathetic. It's past due. It's necessary. My dream requires no sleep. It requires no imagination. My dream is the same every single day: I want to wake up tomorrow and walk down the street without the fear of being **sexually assaulted** or **killed** while people record it. Of course I want to travel the world, I want to be married, I want 2.5 children and a freaking white picket fence... BUT, I **DON'T HAVE TIME** TO DREAM THOSE DREAMS! I dream of having no student loans as much as the next 20-something. I want to make six figures and not worry about basic needs, but there's no room for those dreams. I HAVE to dream of survival. I have to dream of equality. I have to dream that someone will see me for who I am and deem it as enough. My dream is to be able to walk down the street without feeling like I have to hustle for my worthiness. My dream is for someone to look at me, take note of our differences, and realize that different does not equal deficient. **Curly hair** is not a deficiency. **Brown skin** is not a deficiency. **A vagina** is not a deficiency. I don't want another nightmare of my little brother becoming a hashtag. I don't want to march for my right to breathe or have **clean water**.

I don't want to protest for my right to exist. My dream is that instead of saying "this is who I hate," we can ask "what can I find to love about this person?" My dream is for every single person on the face of this earth to come to realize how much they are **loved**. My dream is for the person reading this right now to know that you are a masterpiece, created with intention. You are a one of a kind, beautiful human. You are here to make a positive impact on every single life that you come across. You are worthy of respect. You are worthy of love. **You belong here.** You deserve a full life. Your mistakes are not the entirety of your character. If you can believe that about yourself, knowing everything you've ever done - you can believe that about **anyone**. My dream is that the citizens of this country will wake up every single day, **disarm themselves of disgust** and ask "whose shoes can I walk a mile in today?" When we can do that, when we can seek understanding, when we can do things from a place of love, when we can realize that **kindness has no prerequisits**... maybe I will have time for bigger dreams. Until then, I am a black woman dreaming of having dreams worth dreaming.

Jordyn Taylor
2016

Jordyn Taylor, *Cleveland, Ohio, photographed in 2016*
Jordyn was photographed while the 2016 Republication National Convention was happening in Cleveland

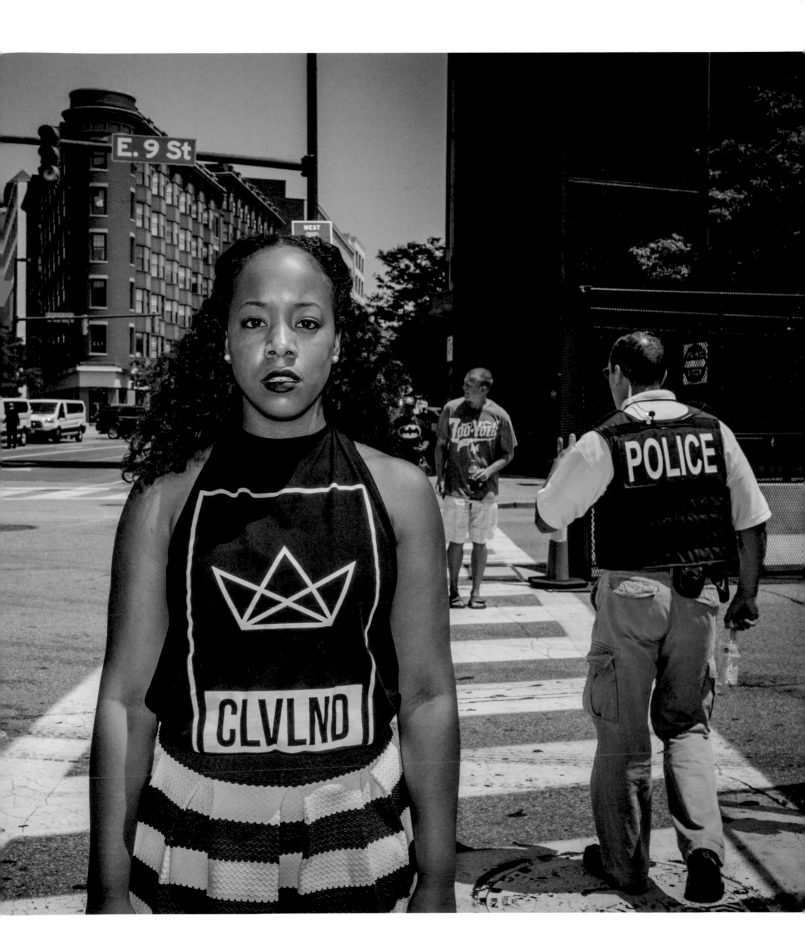

The American Dream

Whose Standards ~~set up~~ set up the American Dream.? Is the dream of equality a part of the quest? ~~Is it dream or a~~ Is it dream or a quest? Who coined the term "American Dream"?

This dream is not based on tradition or culture! It is a lifestyle of greed & selfish Individualism based on puritan ethics of Hard Work. But even the hard work is an economic disparity. The harder work is done by those who recieve less money. The dream is the mythological story of white ~~privileged~~ privileged ~~plantation~~ plantation owners. When education of higher learning shackles you down to pay for the rest of your life, while white privileged can afford their white privileged education. ~~White Privileged~~ Colonized brainwashing is The American Dream.

Juan Mancias

Juan Mancias, *Floresville, Texas, photographed in 2018*
Juan is an elder in the Carrizo/Comecrudo tribe in South Texas.

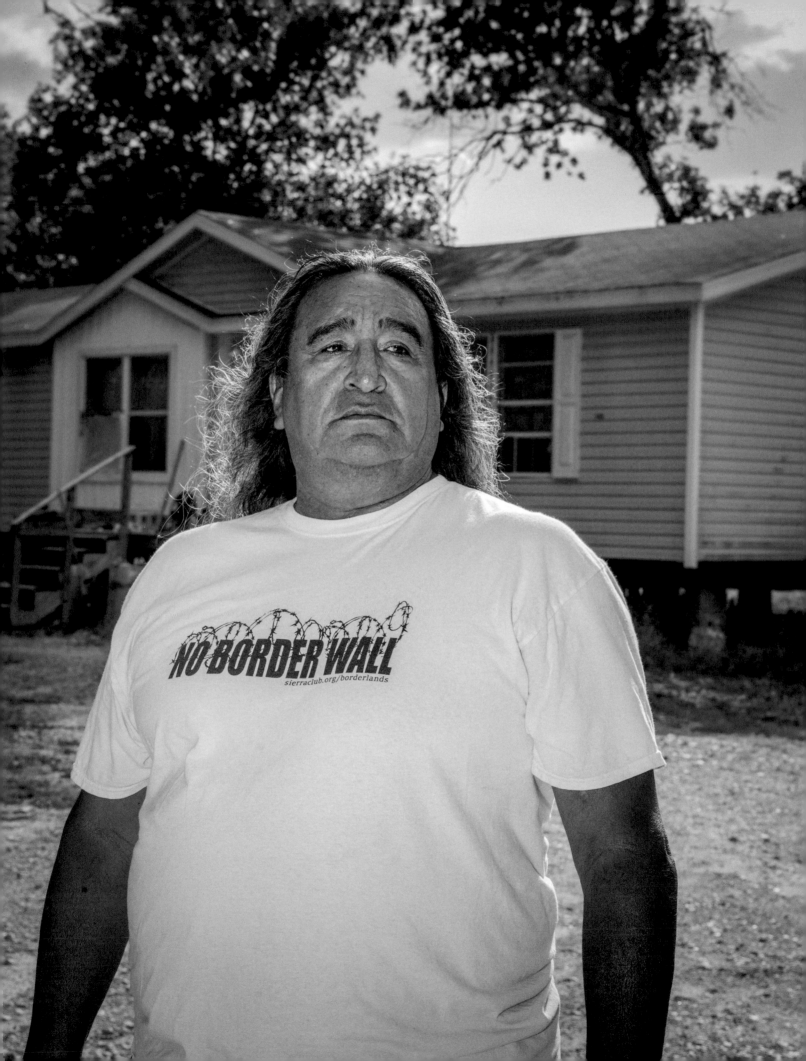

"It's now or never"

Our American Dream started unexpectedly. It was the right time and place. In 2015 we met at a rockabilly festival called "Viva Las Vegas". Meghi saw Mikey on the dance floor and wished she could be out there one day. That dream came true! They both went home, Meghi to Colorado and Mikey all the way to Mexico City and longed to be back. In 2017 we fell in love at the same festival. The next year we declared our love and had a rockabilly wedding at Viva Las Vegas with our family and friends

We have found that we share more than we could imagine. We try to keep the passion from the 1950's America alive by loving Rock and Roll and never missing a chance to dance to the classic tunes. We love to collect and preserve Americana items that we consider treasures

We believe that there's NO BORDERS to our love and we can live the life that we want! IT'S NOW OR NEVER ♡

Meghi + Mikey

338

Mikey and Meghann, *Estes Park, Colorado, photographed in 2019*
Meghann works as a hairstylist. She and Mikey share a love of
American memorabilia.

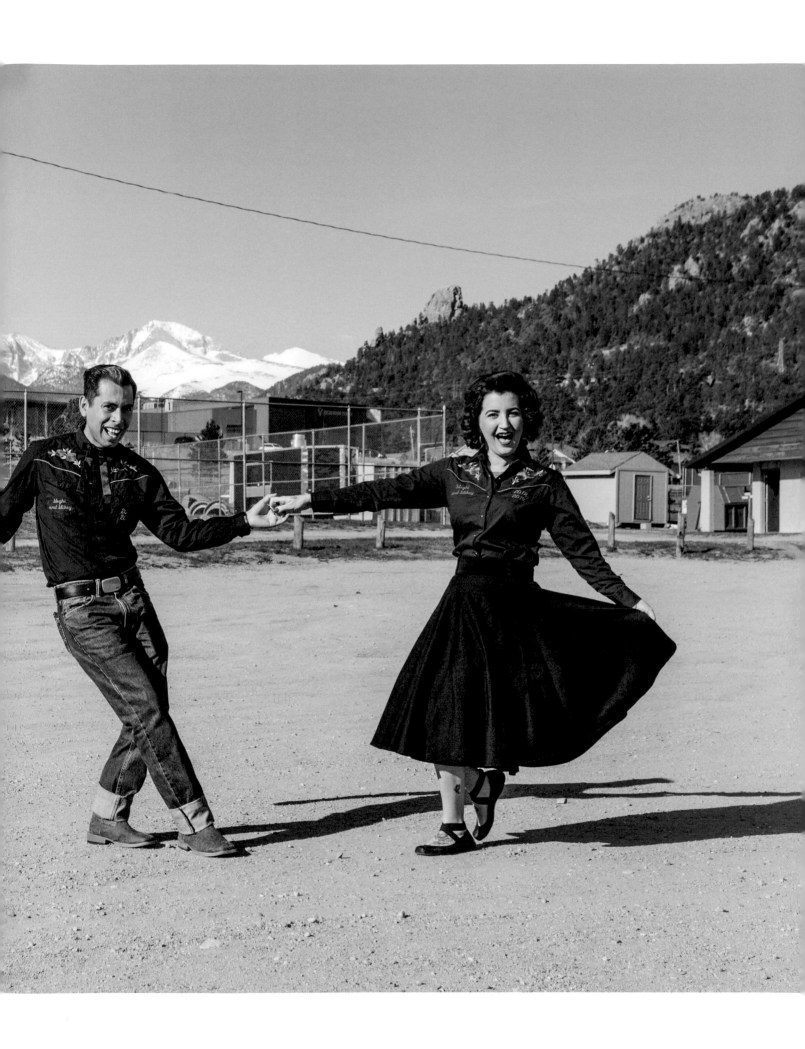

I have never believed in the "American Dream,"
but I believe Americans have dreams!
I dream of a day when:

1. The rich and wealthy pay their fair share of taxes to help give others the same opportunity they have had.

2. We make protecting and caretaking the Earth, our natural home, and living sustainably a TOP PRIORITY.

3. Being "right" has nothing to do with religious morality, but means we make choices based on fairness, equality, and respect.

4. Everyone, regardless of gender, skin color, disability, or sexual orientation has access to affordable housing, healthcare, education, clean water, and nutritious food.

5. Self awareness, compassion, mindfulness, and building community are values shared by everyone in our society.

I hope for this future.
I work towards this future.
This is my American Dream!

Sarah Benoit, *Asheville, North Carolina, photographed in 2014*
Sarah works in web design and social media.

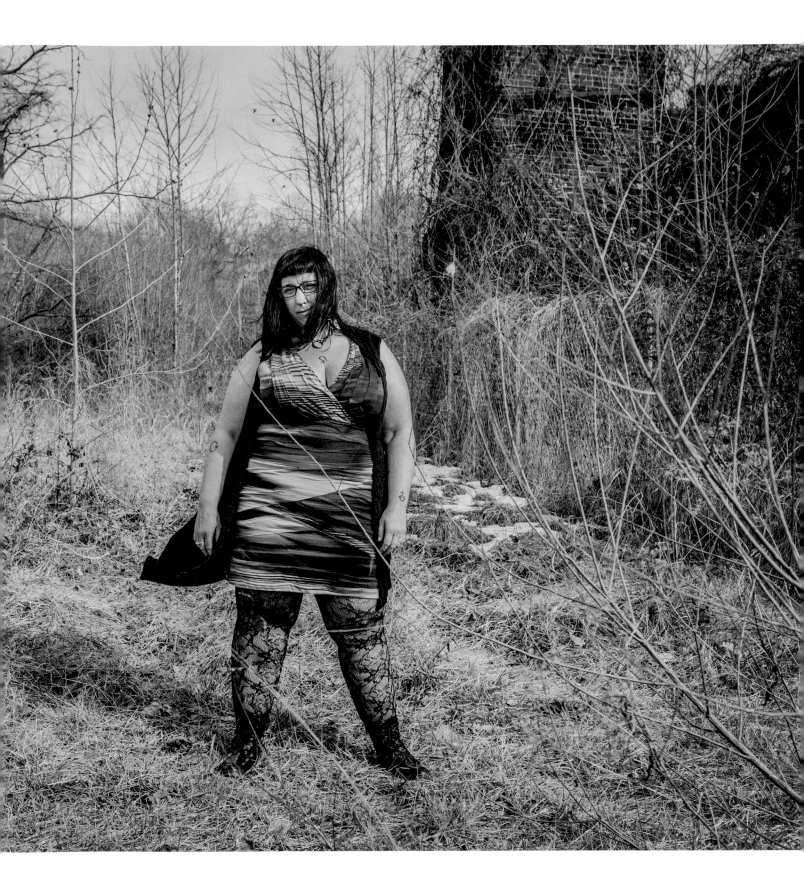

Allan Hill, *Detroit, Michigan, photographed in 2014*
Allan lives in a portion of the former Packard Automotive Plant, which was the largest
abandoned building in the world. At its peak, the plant employed forty thousand workers.
Abandoned since the 1980s, the plant is now slated to be redeveloped.

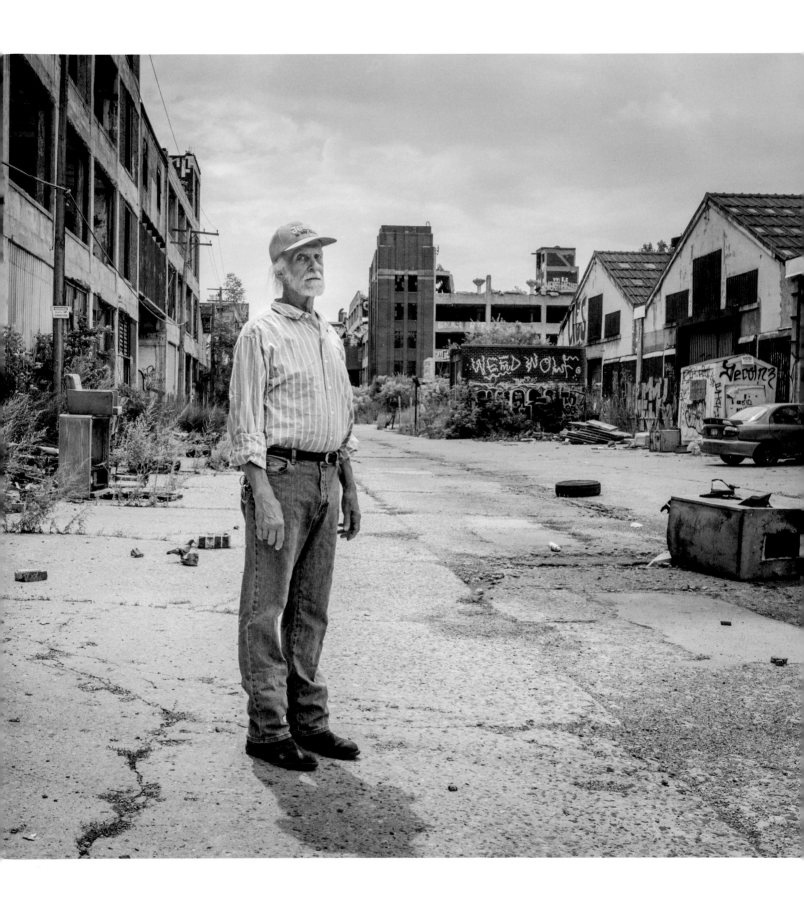

The American Dream is a myth, a social construct created to bind a large group of humans over a vast area of land. And while this myth has evolved over the course of American history, its essence remains rooted in individual liberty — that all our (# male caucasian) individual dreams have merit and we are free to pursue them with virtually no constraint. Manifest Destiny told us the land of this country was our God-given birthright, regardless of whether other people or species already inhabited the land. We accrued substantial wealth on the backs of human slaves. And when millions of years of undecomposed plants and plankton became available right under our feet, we fed this energy into our fledgling myth one heaping spoonful at a time. All the while we mowed down forests, re-routed rivers, dismantled mountains, and gorged great canyons in order to commodify every possible atom of this great untapped land.

And soon the myth spread far and wide. "You too can strike it rich if you have the will to achieve your dreams!" An appealing myth, no doubt. But we didn't quite understand the consequences then. All that energy we used to attain that wealth — that black gold mainlined from the earth into the veins of our ever-expanding myth — didn't die once we burned through it. It found its way freed into the heavens to cavort with the sun's light and amplified itself into the dark recesses of the oceans where it incubated.

And then we knew. Coral reefs began to die as the water became too hot. Weather patterns grew chaotic with the ever-increasing energy in the oceans. Ice began to melt sooner each year opening up more dark blue waters to collect the sun's energy. The sea began to rise. Fires started to pop up within the Arctic Circle. Permafrost melted, releasing Earth-sized burps of methane into the atmosphere. Large native land mammal populations plummeted. We lost 2.5% of insect biomass each and every year. And yet our myth persisted. Other places emulated our myth, even if their individual liberty was only afforded to a select few. Meanwhile the Sixth Mass Extinction Event unfolded right before our eyes, in real time.

If you're reading this from the distant future, I'm sorry. I'm sorry we didn't leave this place better than we found it. I could have done better. We all could have. But our myth became too powerful for us to control. The American Dream burrowed its roots deep into our soul and we wouldn't dare uproot it for fear it would destroy us. So we let it destroy you instead.

Dan and Mischa, *Myrtle Point, Oregon, photographed in 2019*
Dan and Mischa run a twenty-seven acre organic farm in the
foothills of the southern Oregon Coast Range Mountains.

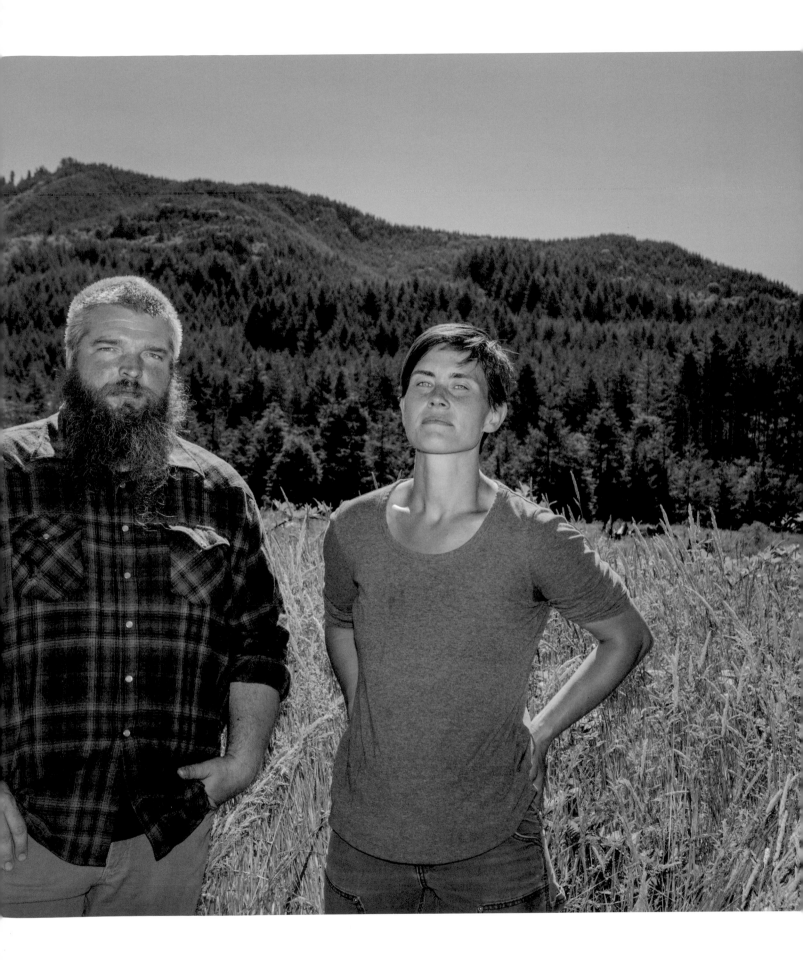

My American Dream is to have people love each other, Peace, and support for each other as a whole. For young Americans to finish school and make something out of themselves. To stop all this fighting and killing each other. I want to be able to help kids that are being bullied and also help the ones that are the bullies to see if we can change them to not bully people.

My American Dream for my kids are to be the best mother I can be, to love and support them to give them what they need to become the adult they should be. I want to open up my own business as well to help my daughter open up her own Cafe. I want to buy me some land in the country and have a house built so my kids can play outside without me worrying about people shooting or something happening to them. This is the American Dream of Talia Hunter.

Talia Hunter, *Selma, Alabama, photographed in 2018*
One week after this photograph was taken, Talia and her husband Evan's house and all of their possessions burned to the ground. Their community rallied to help get them back on their feet. They subsequently moved to Florida.

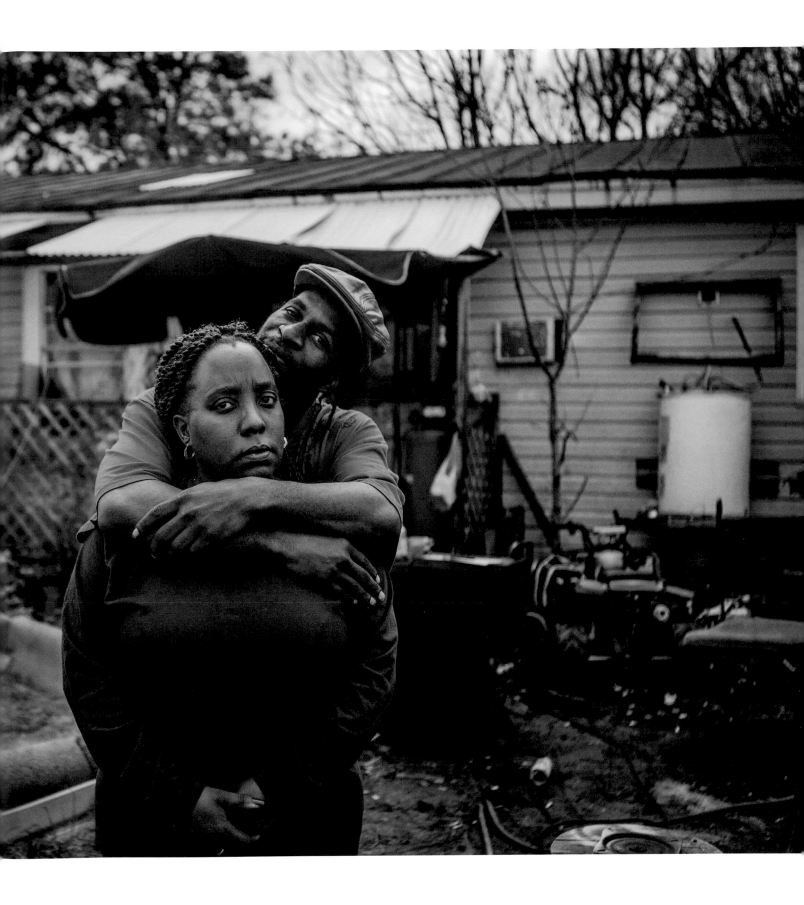

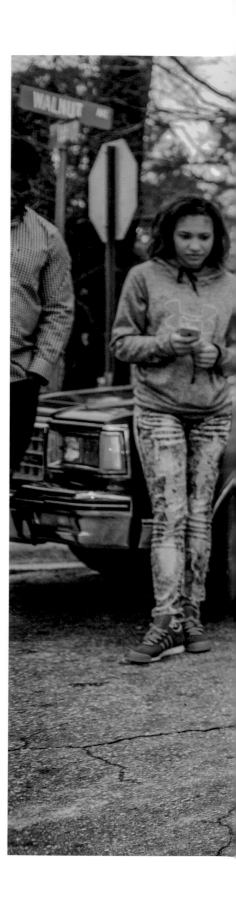

My AMERICA Dream is...

To be famous and bless the word, write a book. The name of my book are: Love, give, and forgive; Open 24 hour churchs across the world. I have 171 books to write and my book will be like. One ~~book~~ of my life and everyone in the world will be able to responed. Have funds for people with lights, water, I am a member of church of god by faith. Paster Larry Coffee and Lady K. Coffee.

Believe in thyself

Believe in each other

Believe in "US" as a people!

Shawana, *Turner County, Georgia, photographed in 2017*
Shawana is a longtime resident of Turner County and her son, Dylan, attended the county high school. After decades of racially segregated proms, the high school had its first integrated prom in 2007. More than 30 percent of the county's youth population lives below the poverty line.

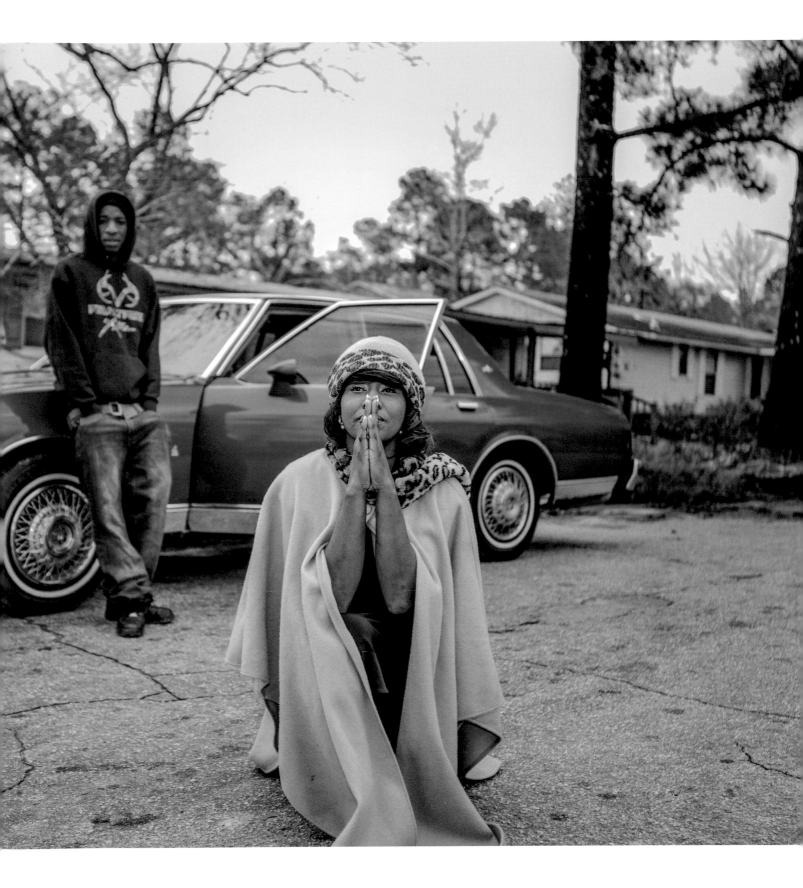

Ranada and Karin West-Pelz

Our American Dream

Both of us were children of divorce in the 1970's on separate ends of the nation. We knew struggles and heartache. We knew laughter and love. Our paths crossed so many times throughout the course of 42 years. A chance meeting brought us together in 2013 and like and unstoppable whirlwind we built an amazing life together quickly. We were married in Hawaii in December 2013 as it was the 14th state to recognize same sex marriage. One dream realized. Karin, being a disabled veteran realized another dream of her service when I received her medical benefits federally. I lost my job while still on our honeymoon. Devastation and fear during such a beautiful moment. We flew back only to be introduced to an opportunity of owning our own restaurant for minimal start up. It was a dream come true. So, our American dream is multifaceted and our dreams continue to build and grow. We found each other amidst Bible Belt discrimination. We were married in paradise and we are recognizing the dream of building an incredible future with our inspiring and welcoming restaurant. Love!

350

Karin and Ranada, *Lexington, Kentucky, photographed in 2014*
When this photograph was taken, Karin (left) and Ranada had just taken possession as the new owners of a restaurant in downtown Lexington.

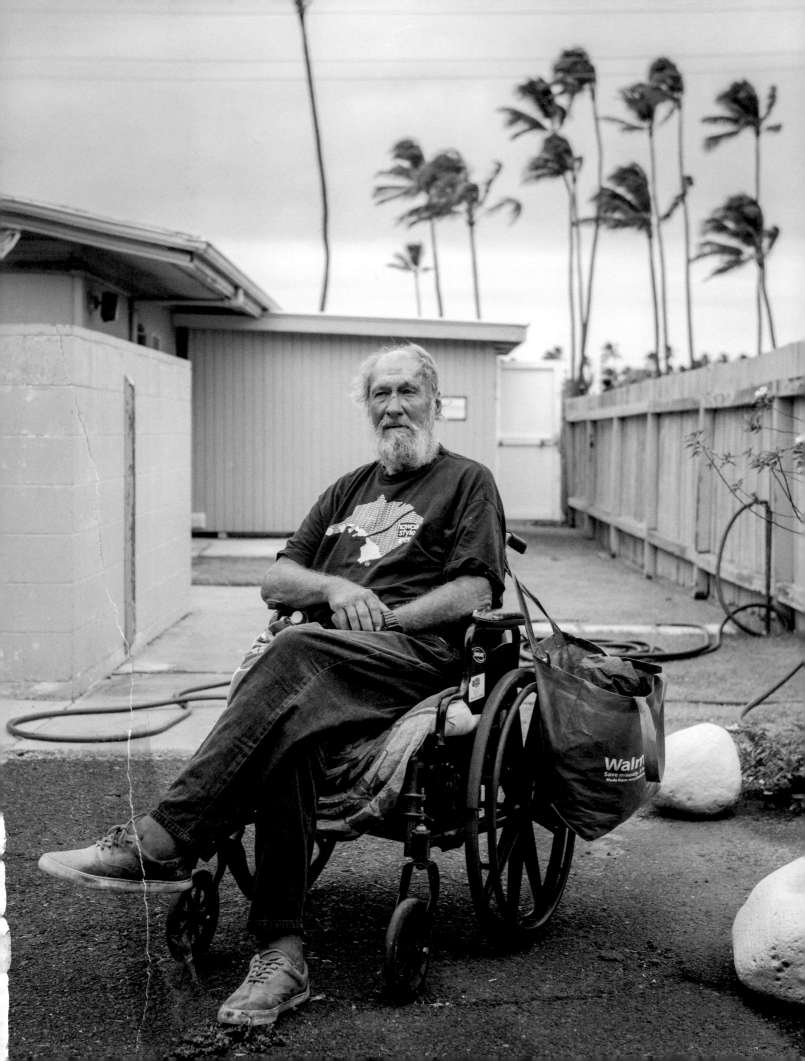

My dream for America is that every American can have HOPE, in their Lives to Live a better day.

I am a suicide attempt survival.

I have survived my beautiful son's suicide.

I have survived sexual abuse, emotional and physical abuse.

My God has saved me from death many times. I AM A Strong Person.

My strength comes from my Mother who told me "Pick yourself up by your boot straps and go on." She had a very hard Life but Remained strong. She past this to me and her Faith in God

I now Fight hard for my community that they receive the best mental illness treatment.

You can have a mental illness and still have a happy productive Life.

HOPE, one that gives promise for the future

"Hope" is your Life Line

Betty J Barrett
2019

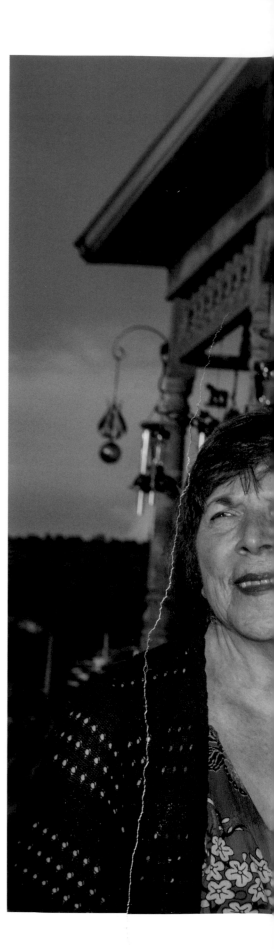

354

Betty Barrett, *Newport Center, Vermont, photographed in 2019*
Betty is on disability. Chris, her husband, worked as a prison guard but was injured on the
job. After Chris lost his job, it took more than a year for their medical insurance to come
through, during which time they survived on little more than peanut butter sandwiches.

MY AMERICAN DREAM

I would like to see more people get off the streets. get health care. I have medicare and medicade but so many people have no health care. I would like to get another education. I would like a new pair of tennis shoes. I have spinal newropathy and drag me feet when I roll. I used to write and wanted to write a book but Ive had 5 strokes. I would like to see my kids but they are too far.

Charles May, *Maui, Hawai'i, photographed in 2019*
Charles has been homeless for the last fifteen years. He is originally from Illinois, then lived in Florida, where he had a job installing flooring. He moved to Hawai'i in search of work but ended up living on the street. He says that his misfortune is a result of being unable to pay medical bills related to various illnesses over the years.

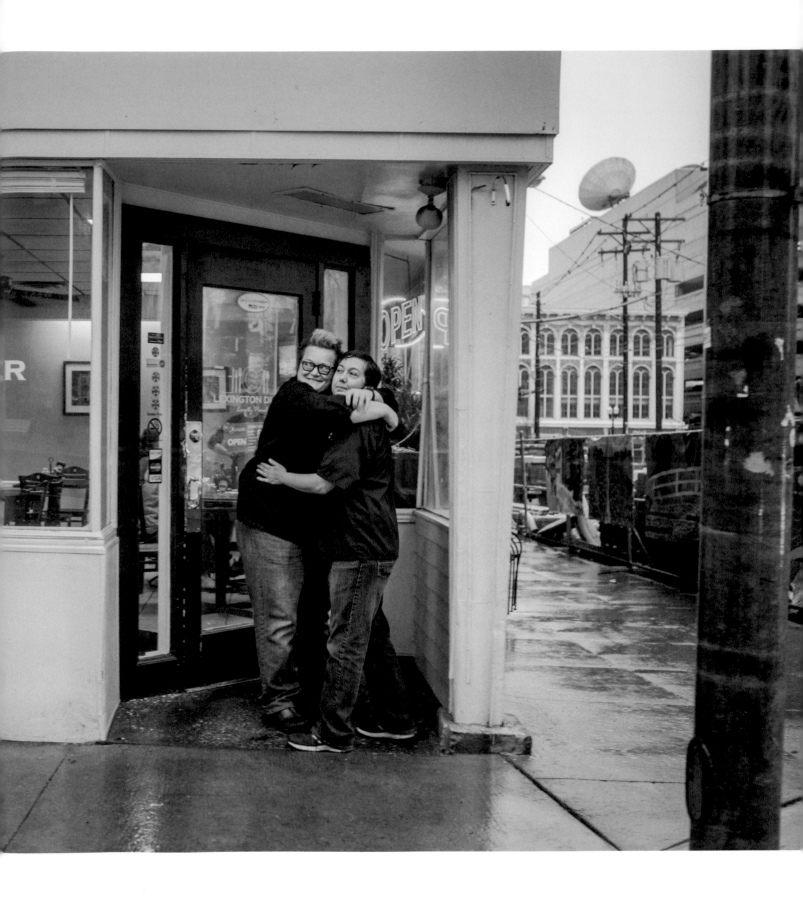

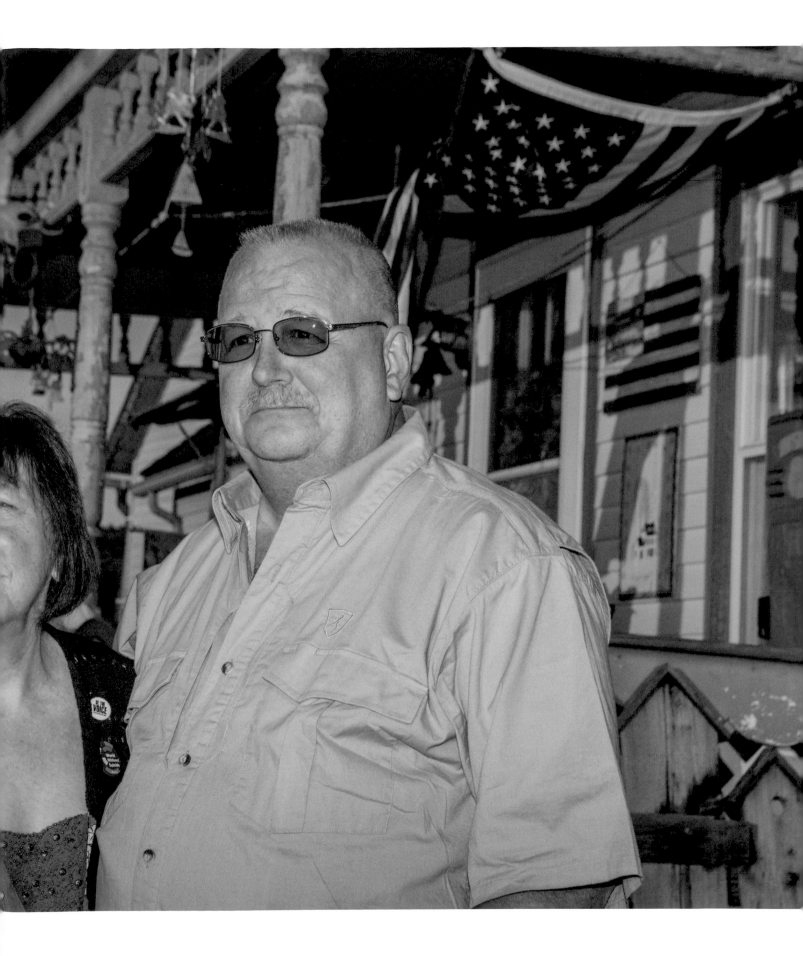

As a mixed student of nationalitys my "American Dream" is the chance for all people of every kind to be accepted and valued the same as wealthy people. From a small city with people who constely say I can't make it big when I know I can and will show it. ~Dakota Aguilar

Dakota Aguilar, *Central Falls, Rhode Island, photographed in 2019*
Dakota is a recent high school graduate and is considering following
in her brother's footsteps by joining the army.

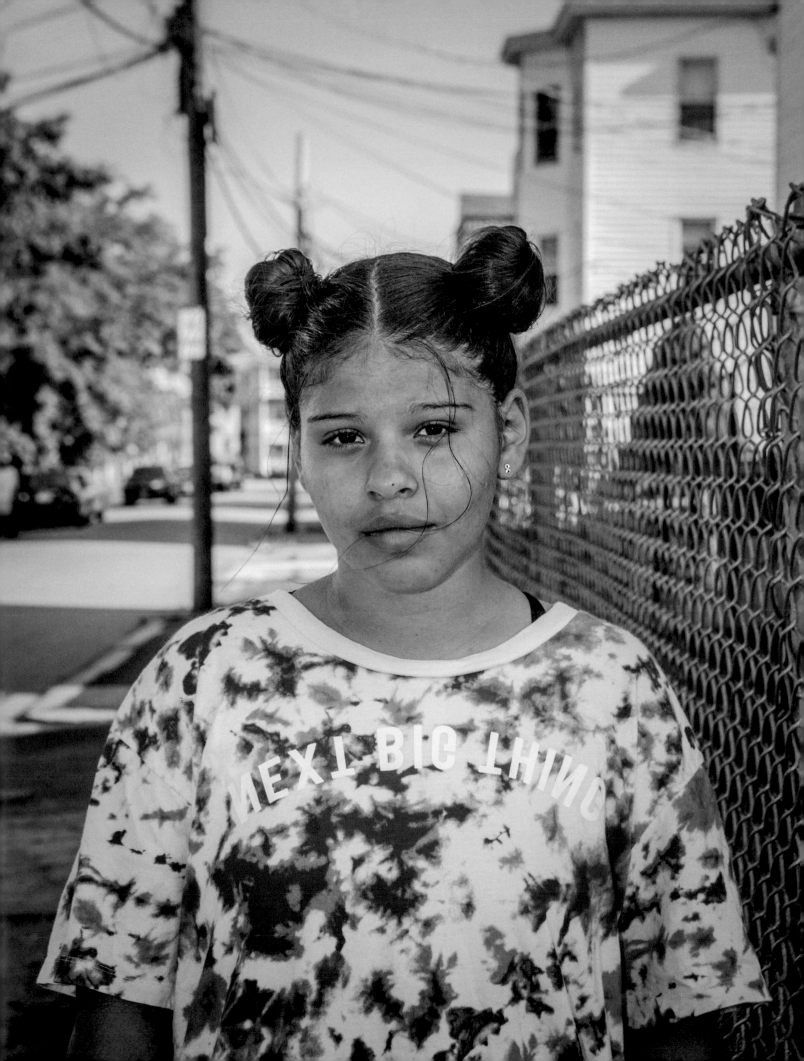

> Daniel Gayetaye
> American dream
> —————
> It's great to be in
> America,
> It's all about freedom,
> Makes thing happen for yourself
> Adopt new life style
> System.
> To own and life in a
> better place.
> To own my business which
> I like to do.
>
> To own church building
> and lead people to God.
> To help other Sucessed.

Daniel Gayetaye, *Sioux Falls, South Dakota, photographed in 2014*
Daniel and his family moved to South Dakota through the United Nations
refugee resettlement program. Daniel named his youngest son—born in
America—after his hero. His son's name is Georgebush Gayetaye.

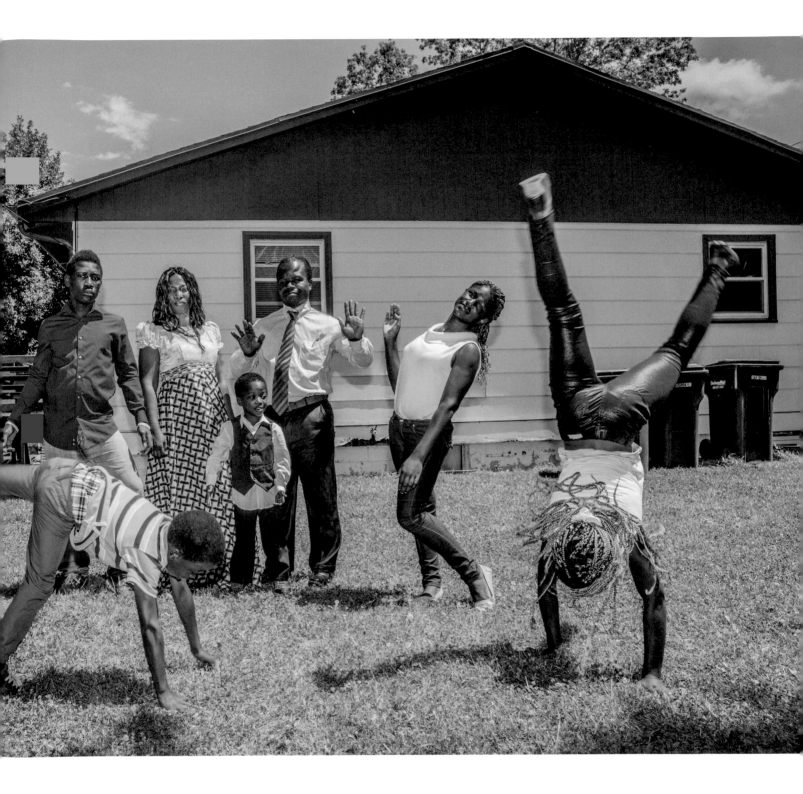

My dream for America's future is for a Nation that provides programs that help of our young people to succeed at whatever level they can deal with most effectively. The post-World War II G.I. Bill of Rights made college possible for many young men (including my husband), the opportunity to benefit from a college education. And youth services to our country (CCC camps during the Great Depression, for one) had many positive results. These are not handouts; they are the best possible thanks we can give for those who have served us so well. We also have programs which enable public schools in poverty areas the benefit of trained and enthusiastic teachers to bring new resources to the students.

But everyone does not need a college education. Industry needs to return to America and our empty factory buildings could be filled with talented and reliable workers who are earning a good wage and contributing to our economic well being — and theirs.

This dream of mine is for all our children, children of all our families, enjoying for generations to come the good things that has happened to mine.

Verna Kordack, *Bedford, New Hampshire, photographed in 2016*
Verna is pictured with her husband of more than fifty years, Vincent, who is a World War II veteran.

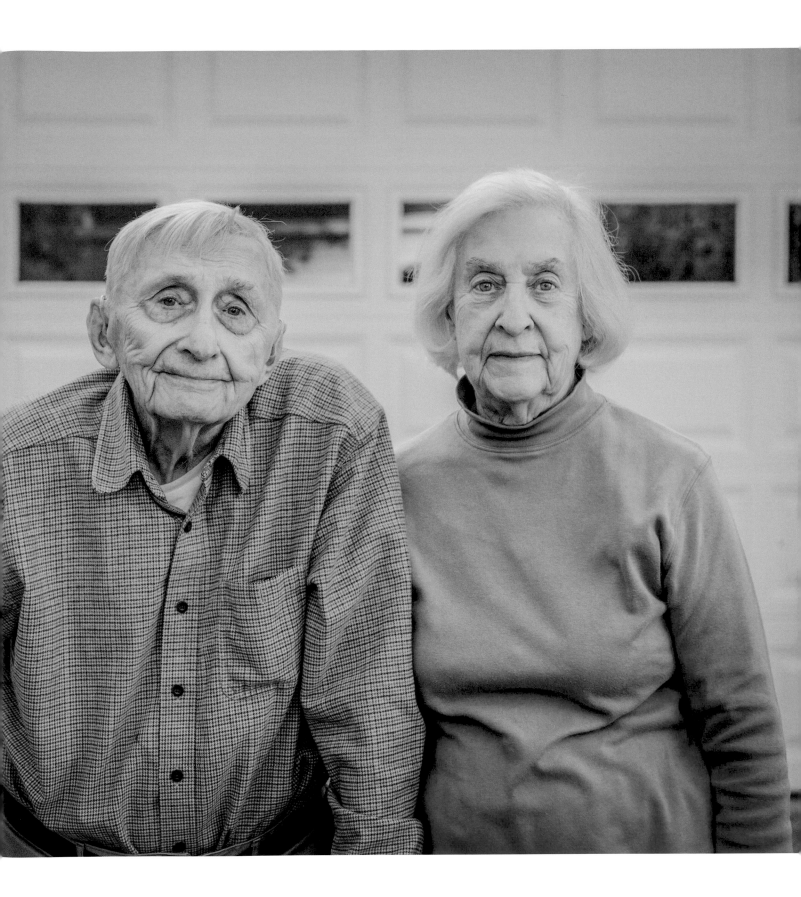

There's a perception that America is a place of prosperity. Where a person can find meaningful work and be paid a living wage. This perception is literally a dream. The reality is that most Americans work hard to keep poverty at bay. Even those in the "middle class" are chained to our jobs by the unbearable weight of student debt, or are one illness away from bankruptcy.

But it doesn't have to be like this. Our founding fathers dreamed of an America where each (white) man has the right to life, liberty, and the pursuit of happiness. I believe in the promise of a Green New Deal to expand those rights to ALL people, including immigrants who are risking everything to chase this dream.

We can create an economy based on equity. One that does not rely on the destruction of our vital resources - clean air, clean water, and clean soil. We can create a democracy for all people, not just for the wealthy.

That's my American Dream. I hope we can get enough people to care and to believe in this dream so that it has a chance to become reality.

Daniella Jokela, *Vancouver, Washington, photographed in 2019*
Daniella (center left) is member of the Sunrise Movement, a youth-led
organization that advocates political action on climate change.

Being Bajan American has taught me that despite the challenges, the trauma and sacrifices we may endure, the future is worth it. I and so many of my family, my community, has been thru the ringer. Despite my own trauma and hardships, I recognize that I have so much priviledge and so much to give. I want to help build a future and a community where our cultures, histories, bodies, minds, spirits, lands, waters, and our futures are respected, protected, and celebrated. We deserve nothing less. We deserve true happiness, health, liberation, equity, love, care, and justice. We deserve to feel and be good. So we need to act good, to ourselves and others around us. We deserve to thrive, and not just survive. And we need to everything we can to make that those who come after us have that same chance. The future is worth it. It's uncertain, but it is worth it. So with that, my american dream is more of a vision. Dreams are made for reflection, but Vision are made for action.

Alyssa Quintyne, *North Star Borough, Alaska, photographed in 2019*
Alyssa has a degree in political science and works as a grassroots organizer.

About the Author

Ian Brown is an award-winning photographer whose work focuses on the human condition and the intersection of social and cultural divides. His portraits are acclaimed for their simple depth of emotion and honesty.

Brown grew up dividing his time between urban Toronto and the rural highlands of Northern Ontario. The aesthetic juxtaposition of these two locations informed his appreciation for a sense of culture, place, and landscape.

He survived cancer at the age of nineteen, a heart attack at thirty-two, and being shot at in the middle of a civil war in Colombia while on assignment for Doctors Without Borders/Médecins Sans Frontières (MSF).

Brown's other notable photography projects include documenting HIV survivors in Malawi, Africa; a continuing documentary series on the opioid epidemic; and a long-term study on the urban anthropology of Detroit.

He began the American Dreams Project in 2007. While logging more than 80,000 miles of driving across America, Brown had the privilege of being invited onto front porches and into people's homes in all fifty states. This is his first book.

He divides time between Toronto and a cabin outside Algonquin Park in Canada.

For more on the American Dreams Project, and to see transcriptions of all of the dreams in this book, visit americandreamsproject.org.

Acknowledgments

As with any creative endeavor, this project is the culmination of a lot of people's assistance, contributions, sacrifice, and trust. The most intimidating point of any long-term undertaking is generally mile one, when the end seems so far off. It takes vision to both see the objective and to understand the value of things revealing themselves naturally. So, first, a huge thanks for the discussions, assistance, and sound advice from my longtime friends James Fraser, Scott Yamada, Ruth Zuchter, and Bob Stronach. I am grateful for our many formidable talks and moments of realignment. A heartfelt thanks to Eric Firstenberg and Scott Spector, who have provided laughter, a place to lay a weary head, positive support, and intelligent advice over a great many excursions to America. To the Eibs—a huge thanks to you and Kim for so many funny and enlightening conversations, and for helping out and being supportive when things looked bleak.

There are many more people who deserve mention: Rob and Tanya Fraser, Laura Janzen, Michelle Fraser, Aig and Mary Holmes, Ian and Kathryn Nicol, Elena Pacienza, Liz Hampton, Ian Arnold, Jesse Bond, Lindsay Brown and Ziggy Strawczynski, Shea Post, and Antoinette Harrell. You have all been so helpful and supportive. A big thanks to Leonard Tam for seeing the vision of this and helping me make it come to fruition.

Serendipity is a magical thing, and for that I am grateful to Maya Mavjee for her belief. Immense thanks go to Kaitlin Ketchum and Lorena Jones at Ten Speed Press for taking a leap of faith on this project; especially to Kaitlin for keeping the compass pointed in the right direction. Likewise, many thanks to Emma Campion, who is a design guru. To the rest of the team at Ten Speed Press and Penguin Random House, especially Serena Sigona, Jane Chinn, Mari Gill, Windy Dorresteyn, and David Hawk, a big thanks for all your efforts and enthusiasm. To Hilary McMahon, my agent, for smoothing out the wrinkles and being so behind all this.

A common theme of which people wrote when asked about their American Dream is the notion of family. In my case, I am lucky to have family who offer guidance, positivity, and love. Patty McCarthy, my mom, taught me that you should leave a place better than when you arrived, and I try to live by that credo. To my dad, Ron Brown, and his wife, Margo McCuthcheon, thank you for all of your caring nature and consistent ebullience. Kelly Greene, my sister, has more strength and compassion than most people I have known, and she has helped me in numerous ways on countless occasions. To my grandparents, Ethel and John Brown, who were there for that first experience on that hot summer day so long ago, I have to say thanks for instilling in me the importance of being kind, gracious, and always curious.

A huge penultimate thanks has to go to everyone I met along the way of this project, to all the people who are in this book, and to the many other people I photographed and have crossed paths with. I have been enriched with a lifetime of experiences and stories, and have learned so much from being able to share in your lives. I am so grateful that you all believed in this idea, and, despite having no prior connection to me, that you opened your doors and became part of something that hopefully is enduring and important. I'm grateful and humbled.

Last, for my daughter Miya. She's nine years old, but wise and caring and funny beyond her years. When I called her from a desolate location in Texas, she asked where I was. When I said "I'm in the middle of nowhere," she paused and replied, "Nope, that's not possible, Dad, you always have to be in the middle of somewhere." All the miles of driving, being away from home, working hard to make enough to keep this going and see it through to the last mile—this is for you, Miya Grace. You remind me to always be present and to be where you are.

Ten Speed Press and the Ten Speed Press colophon are
registered trademarks of Penguin Random House LLC.

Library of Congress Cataloging-in-Publication Data is on file with the publisher.

Hardcover ISBN: 978-1-9848-5829-0
eBook ISBN: 978-1-9848-5830-6

Printed in China

Design by Emma Campion

10 9 8 7 6 5 4 3 2 1

First Edition

—

Additional Photo Captions:

Page 2: Glynnis Vernon Gordon, *Amite City, Louisiana, photographed in 2017*
Glynnis is the former director of a church.

Page 4: Carmen Gomez, *Cleveland, Ohio, photographed in 2016*
Carmen is pictured with her niece.